ULTIMATE LONDON DESIGN

ULTIMATE
LONDON
DESIGN

teNeues

Editors and texts:	Christian Datz, Christof Kullmann
Layout:	adk publishing, Mainz
Pre-press:	ScanComp, Wiesbaden
Translations:	Translation by SAW Communications, Dr. Sabine A. Werner, Mainz Mo Croasdale (English), Brigitte Villaumié (French) Carmen de Miguel (Spanish), Alessandra Carboni-Riehn (Italian)
Copy editing:	Mareike Ahlborn, Carmen García

Produced by adk publishing, Mainz
www.adk-publishing.de

Published by teNeues Publishing Group

teNeues Verlag GmbH + Co. KG
Am Selder 37, 47906 Kempen, Germany
Tel.: 0049-(0)2152-916-0, Fax: 0049-(0)2152-916-111

teNeues Verlag GmbH + Co. KG
International Sales Division
Speditionstraße 17
40221 Düsseldorf, Germany
Tel.: 0049-(0)211-994597-0, Fax: 0049-(0)211-994597-40
Press department: arehn@teneues.de

teNeues Publishing Company
16 West 22nd Street, New York, NY 10010, USA
Tel.: 001-212-627-9090, Fax: 001-212-627-9511

teNeues Publishing UK Ltd.
P.O. Box 402, West Byfleet KT14 7ZF, Great Britain
Tel.: 0044-1932-403509, Fax; 0044-1932-403514

teNeues France S.A.R.L.
4, rue de Valence, 75005 Paris, France
Tel.: 0033-1-55 76 62 05, Fax: 0033-1-55 76 64 19

teNeues Ibérica S.L.
C/ Velázquez, 57 6.° izda., 28001 Madrid, Spain
Tel.: 0034-657-132 133

teNeues Representative Office Italy
Via San Vittore 36/1, 20123 Milano, Italy
Tel.: 0039-(0)347-76 40 55 1

www.teneues.com

ISBN-10:	3-8327-9138-8
ISBN-13:	978-3-8327-9138-4

© 2006 teNeues Verlag GmbH + Co. KG, Kempen

Printed in Italy

Bibliographic information published by
Die Deutsche Bibliothek. Die Deutsche Bibliothek lists
this publication in the Deutsche Nationalbibliografie;
detailed bibliographic data is available in the Internet
at http://dnb.ddb.de.

Contents

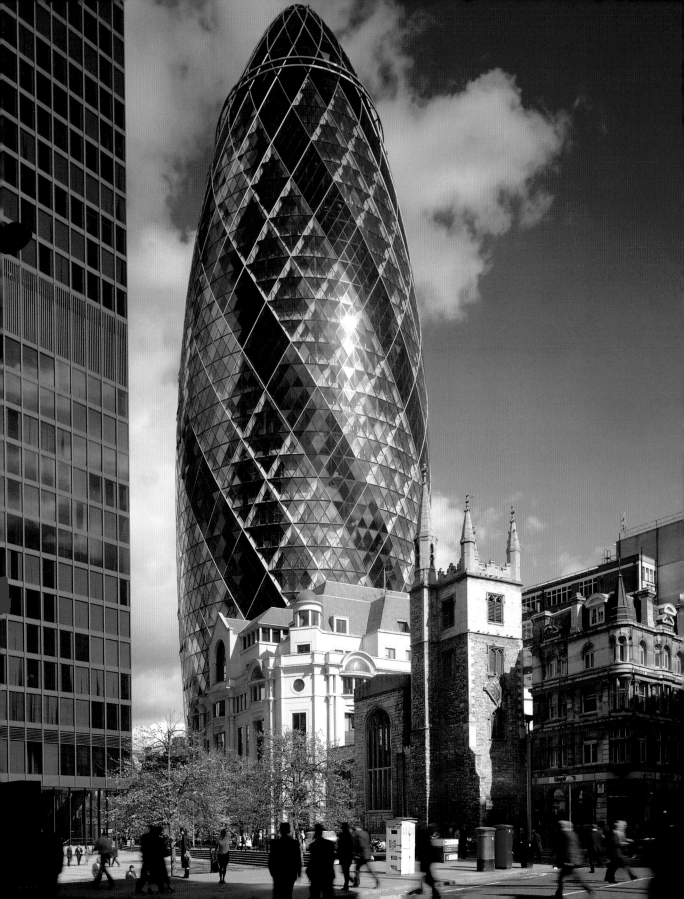

Introduction

London – City of Diversity

Few other cities in the world are as important as London in their role as style-forming design movements. The cliché of the tradition-bound British capital disappeared without a trace with the arrival of the brightly coloured variety of Swinging London in the sixties – suddenly the city was seen as the "cradle of pop" whose rebellious youth set radical new standards in every area and aspect of culture. Since then, the city has continuously brought forth new styles and trends with various disciplines such as fashion, art, film, design and music, offering an abundance of inspiration and influence.

London is also a leader on the international architecture scene. It is home to two of the world's most important architectural schools, the Architectural Association and the Bartlett School of Architecture, both of whom attract many aspiring architects and designers from all over the world every year. In recent years in particular, Lord Norman Foster has done much to create the face of the city with buildings such as the City Hall and Swiss Re. In addition to these spectacular major projects, there have also been numerous office and residential buildings, restaurants, shops and galleries, all designed and built to the highest architectural level by a collection of young and aspiring architectural studios such as Project Orange and drmm.

London also boasts an equally lively and varied assortment of furniture and product designers: large established companies such as Seymourpowell and PDD, who design items ranging from mobile phones to aircraft interiors; big names such as Mark Newson and Tom Dixon, but also smaller, newer studios such as Doshi Levien and Industrial Facility. The fashion designers are equally important – memorable names such as Stella McCartney and Ozwald Boateng, whose creations never fail to amaze and delight the fashion world with every new collection.

People come to London from every corner of the world to live and work in this fascinating city. They find their creative home in the combination of old British flair and the internationality of modern London. This is the key to the unique quality and innovative variety of "Ultimate London Design".

Christian Datz, Christof Kullmann

Einleitung

London – Stadt der Vielfalt

Nur wenige Städte der Welt haben als Zentren stilbildender Designbewegungen einen vergleichbaren Stellenwert wie London. Spätestens mit der bunten Vielfalt des Swinging London der sechziger Jahre verschwand das Klischee von der traditionsverhafteten britischen Hauptstadt – plötzlich galt die Stadt als „Wiege des Pop", in der eine rebellische Jugend in allen kulturellen Bereichen radikal neue Maßstäbe setzte. Seither bringt die Stadt unermüdlich neue Stile und Trends hervor, innerhalb derer sich die verschiedenen Disziplinen wie Mode, Kunst, Film, Design und Musik wechselseitig in hohem Maße inspirieren und beeinflussen.

Auch in der internationalen Architekturszene nimmt London eine herausragende Position ein. Mit der Architectural Association und der Bartlett School of Architecture finden sich hier zwei der wichtigsten Architekturschulen der Welt, die jedes Jahr Scharen von jungen Talenten aus aller Welt anziehen. Besonders nachdrücklich hat in den letzten Jahren Lord Norman Foster mit Bauten wie der City Hall und dem Swiss-Re-Hochhaus das Bild der Stadt geprägt. Neben diesen spektakulären Großprojekten entstanden jedoch auch unzählige Büro- und Wohnungsbauten, Restaurants, Läden und Galerien auf höchstem architektonischen Niveau, durch die eine Reihe junger, aufstrebender Architekturbüros wie beispielsweise Project Orange oder drmm auf sich aufmerksam machen konnten.

Darüber hinaus gibt es in London eine lebendige und vielfältige Szene von Möbel- und Produktdesignern: Große, etablierte Firmen wie Seymourpowell oder PDD, die Mobiltelefone ebenso gestalten wie die Innenausstattung von Flugzeugen, Szenestars wie Mark Newson oder Tom Dixon, aber auch kleinere, junge Büros wie Doshi Levien oder Industrial Facility. Einen weiteren, wichtigen Stellenwert besitzen die Modedesigner – klingende Namen wie Stella McCartney oder Ozwald Boateng, deren Kreationen die Modewelt in jeder Saison aufs Neue verblüffen.

Aus allen Teilen der Erde kommen Menschen nach London, um in dieser faszinierenden Stadt zu leben und zu arbeiten. In der Mischung aus altem britischen Flair und der Internationalität des modernen London finden sie ihre kreative Heimat. Hierin liegt der Schlüssel für die einzigartige Qualität und innovative Vielfalt des „Ultimate London Design".

Christian Datz, Christof Kullmann

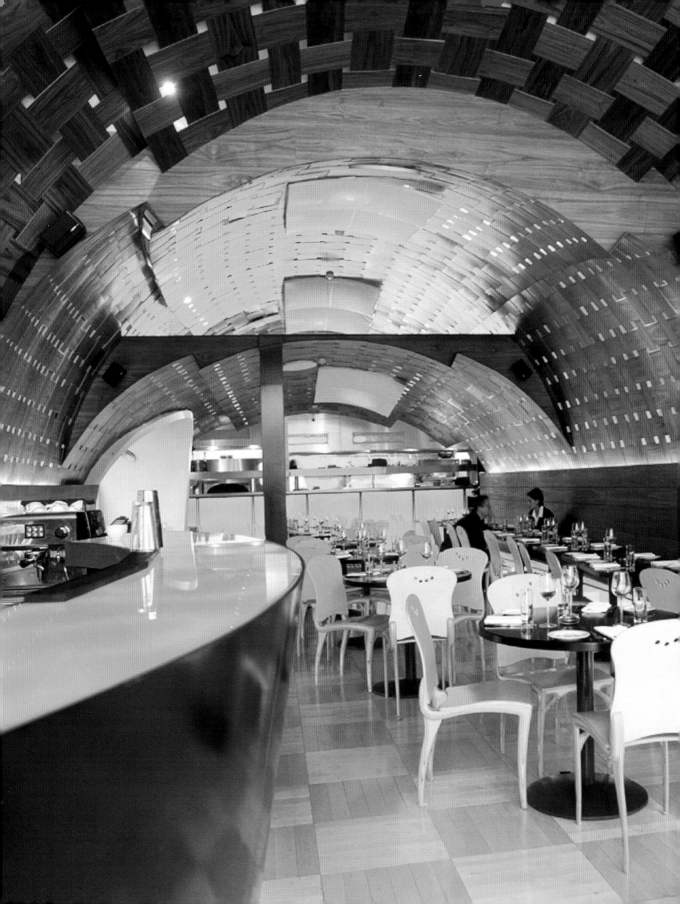

Introduction

Londres – une ville riche en diversité

Peu de villes au monde, ayant un rôle d'épicentre des mouvements créateurs de style dans le domaine du design, revêtent une importance comparable à celle de Londres. Le cliché d'une capitale britannique engluée dans ses traditions disparut au plus tard avec la diversité colorée du Swinging London des années soixante – tout à coup, la ville passait pour être le « berceau de la pop », dans lequel une jeunesse rebelle posait radicalement de nouveaux jalons dans tous les domaines de la culture. Depuis, la ville engendre inlassablement de nouveaux styles et tendances, au sein desquels de diverses disciplines comme la mode, l'art, le cinéma, le design et la musique s'inspirent et s'influencent beaucoup mutuellement.

Sur la scène de l'architecture internationale aussi, Londres occupe une position prééminente. Elle abrite l'Architectural Association et la Bartlett School of Architecture, les deux écoles d'architecture les plus importantes au monde, qui attirent chaque année une kyrielle de jeunes talents du monde entier. Ces dernières années, Lord Norman Foster a marqué l'image de la ville de façon déterminante avec des bâtiments tels que le City Hall et l'immeuble de Swiss Re. Outre ces grands projets spectaculaires se sont construits de nombreux immeubles de bureaux et d'habitations, des restaurants, des magasins et des galeries d'un très haut niveau architectural, permettant à une série de jeunes et ambitieux cabinets d'architectes tels que Project Orange oder drmm d'attirer l'attention sur eux.

De plus, il existe à Londres une scène aussi vivante que diversifiée pour les designers de meubles et de produits : de grandes entreprises bien établies comme Seymourpowell ou PDD, capables de concevoir aussi bien des téléphones portables que des aménagements intérieurs d'avion, des stars de la scène comme Mark Newson ou Tom Dixon, mais aussi de jeunes cabinets plus modestes comme Doshi Levien ou Industrial Facility. Les créateurs de mode ont aussi une place particulière – des noms familiers comme Stella McCartney ou Ozwald Boateng, dont les créations ébahissent toujours le monde de la mode à chaque saison.

De tous les coins du monde, les hommes viennent à Londres pour vivre et travailler dans cette ville fascinante. Entre le charme britannique vieillot et l'internationalité du Londres moderne, ils se trouvent un terrain fertile à la création. C'est là que se trouve la clé de l'exceptionnelle qualité et de la diversité innovante d' « Ultimate London Design ».

Christian Datz, Christof Kullmann

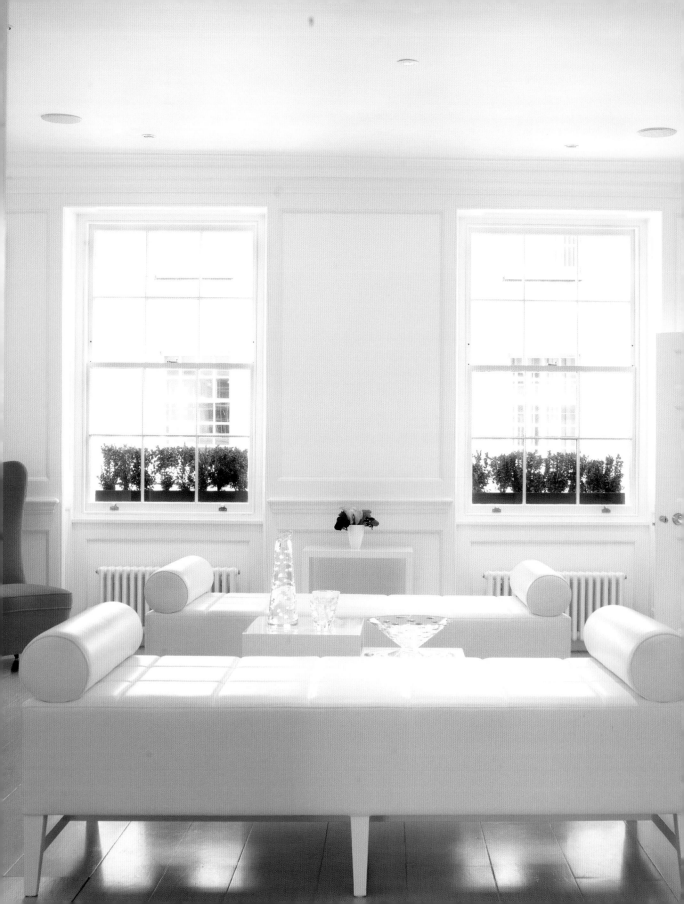

Introducción

Londres –La ciudad de la diversidad

Pocas ciudades en el mundo gozan de lugar tan privilegiado como centros de movimientos de diseño creadores de estilos del modo que lo hace Londres. Fue a más tardar con la diversidad del Swinging London de los años sesenta cuando desapareció el cliché de ciudad anclada en la tradición en el que se enmarcaba a la capital británica. De pronto la ciudad se convirtió en "cuna del pop" de una juventud rebelde que comenzó a establecer radicalmente nuevos baremos en todos los ámbitos culturales. Desde entonces la ciudad lanza incansable nuevos estilos y tendencias, en los que las diversas disciplinas, arte, moda, cine, diseño y música, se dejan inspirar e influenciar mutua e intensamente.

También en la escena internacional arquitectónica Londres cuenta con una posición destacada. La Architectural Association y la Bartlett School of Architecture son dos de las escuelas de arquitectura más importantes del mundo, focos de atracción a los que cada año acuden en masa jóvenes talentos de todo el mundo. En los últimos años Lord Norman Foster ha configurado decididamente la imagen de la ciudad con construcciones como el City Hall y el edificio Swiss Re. Junto a tales espectaculares proyectos se han erigido además innumerables edificios de oficinas y viviendas, restaurantes, comercios y galerías al más alto nivel arquitectónico, gracias a los cuales han podido captar la atención una serie de estudios de arquitectura jóvenes y ambiciosos, como es el caso de Project Orange o drmm.

En Londres la escena de diseñadores de muebles y otros productos es también diversa y activa. De ésta forman parte grandes empresas ya consagradas como Seymourpowell y PDD, que diseñan tanto teléfonos móviles como interiores de aviones, conocidas estrellas como Mark Newson o Tom Dixon, pero también oficinas pequeñas y jóvenes: el caso de Doshi Levien e Industrial Facility. Los diseñadores de moda cuentan con un papel igualmente importante; entre ellos destacan nombres como el de Stella McCartney y Ozwald Boateng, cuyas creaciones cada temporada reinterpretan el mundo de la moda de forma novedosa e impactante.

A Londres acuden personas de todos los rincones del planeta con el propósito de vivir y trabajar en la fascinante ciudad. Todos encuentran su hogar creativo en la miscelánea del encanto británico y el carácter internacional del Londres moderno. Esta es sin duda la clave de la exclusiva calidad y la diversidad innovadora de "Ultimate London Design".

Christian Datz, Christof Kullmann

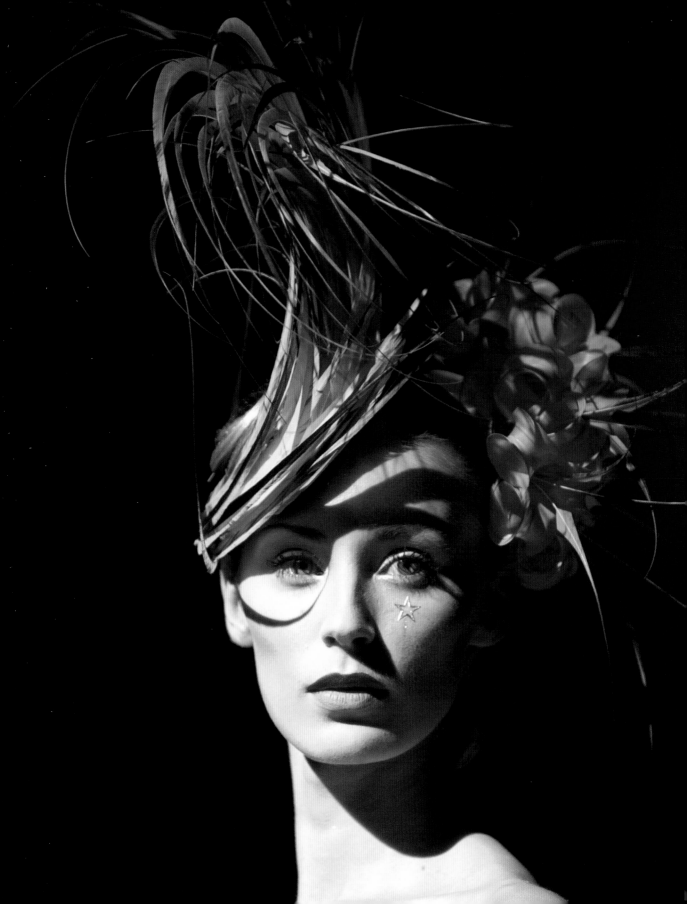

Introduzione

Londra – Città della diversità

Solo poche città al mondo sono paragonabili a Londra in quanto centro di movimenti di design determinanti per l'evoluzione dello stile. Al più tardi con la variopinta complessità della Swinging London degli anni Sessanta si è dissolto il cliché di una capitale britannica ancorata alle tradizioni: improvvisamente la città si è trovata ad essere una "culla del pop", in cui una gioventù ribelle fissava parametri radicalmente nuovi per tutti i settori della cultura. Da allora Londra non cessa di produrre instancabilmente nuovi stili e trend, nell'ambito dei quali discipline diverse come la moda, l'arte, il cinema, il design e la musica si ispirano ed influenzano a vicenda in misura considerevole.

Anche nell'ambiente internazionale dell'architettura Londra riveste una posizione di spicco: qui, con l'Architectural Association e la Bartlett School of Architecture, hanno sede due delle più importanti scuole di architettura del mondo, che attraggono ogni anno schiere di giovani talenti da ogni dove. Negli ultimi anni è stato Lord Norman Foster a dare un'impronta particolarmente caratteristica alla città, con edifici come la City Hall e il grattacielo della Swiss Re. Ma accanto a questi spettacolari progetti in grande scala sono sorti anche innumerevoli edifici per uffici ed abitazioni, ristoranti, negozi e gallerie di altissima qualità architettonica, grazie ai quali tutta una serie di giovani studi di architettura emergenti, come ad esempio Project Orange o drmm, sono riusciti ad imporsi all'attenzione del grande pubblico.

A Londra esiste però anche un giro altrettanto vivace e vario di designer di mobili e di prodotti: grandi aziende già affermate come Seymourpowell o PDD, le cui realizzazioni vanno dal telefono cellulare agli interni di un intero aeroplano, celebrità del settore come Mark Newson o Tom Dixon, ma anche studi più piccoli e giovani come Doshi Levien o Industrial Facility. Rivestono un ruolo importante anche i designer di moda: si pensi a nomi altisonanti come Stella McCartney o Ozwald Boateng, autori di creazioni che in ogni stagione tornano a stupire il mondo della moda.

Attratte dalla possibilità di vivere e lavorare in questa affascinante metropoli, giungono a Londra persone delle origini più disparate, che nella mescolanza di antica atmosfera britannica ed internazionalità della Londra moderna trovano la loro "patria" creativa. Così si spiegano la singolare qualità e la complessità innovativa dell' "Ultimate London Design".

Christian Datz, Christof Kullmann

 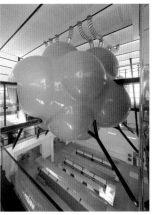 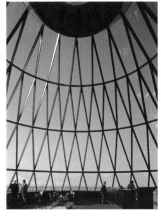 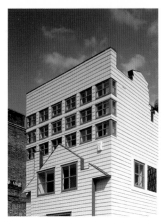

Architecture

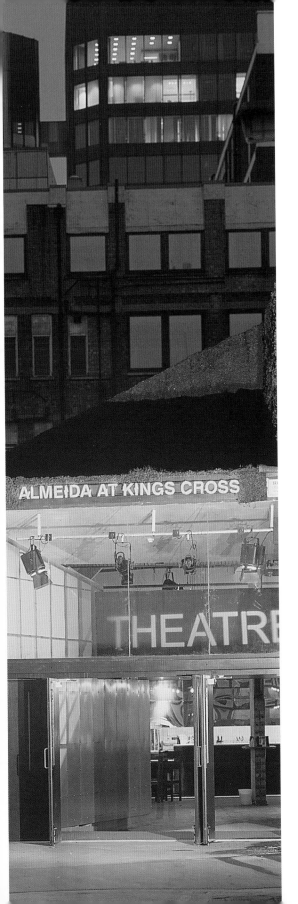

Adjaye/Associates

Alsop Architects

Stephen Davy Peter Smith

drmm

FAT

Foster and Partners

Tony Fretton Architects

Haworth Tompkins

Hopkins Architects

Lifschutz Davidson Sandilands

Henning Stummel Architects

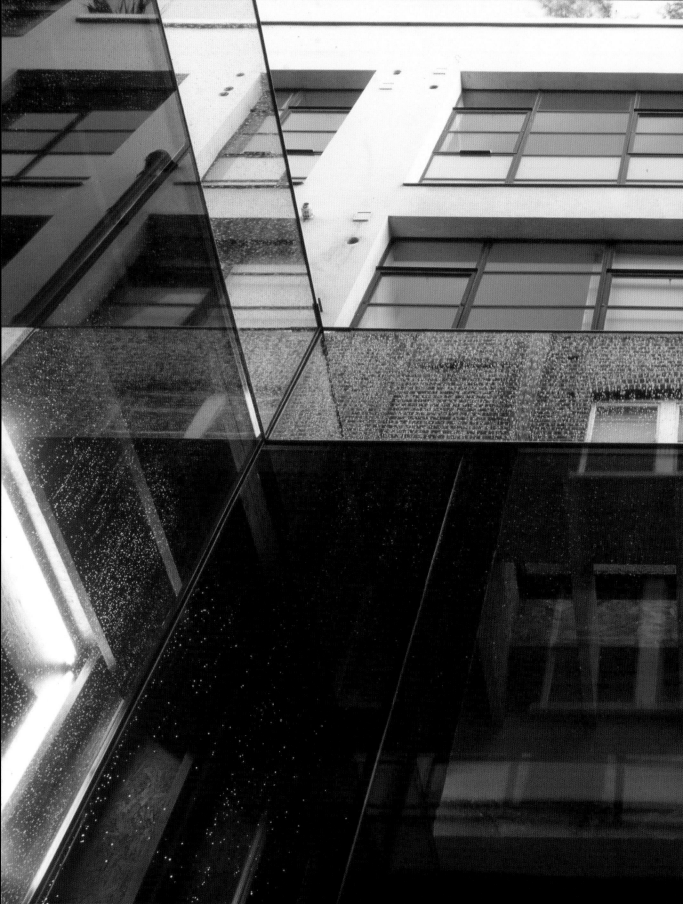

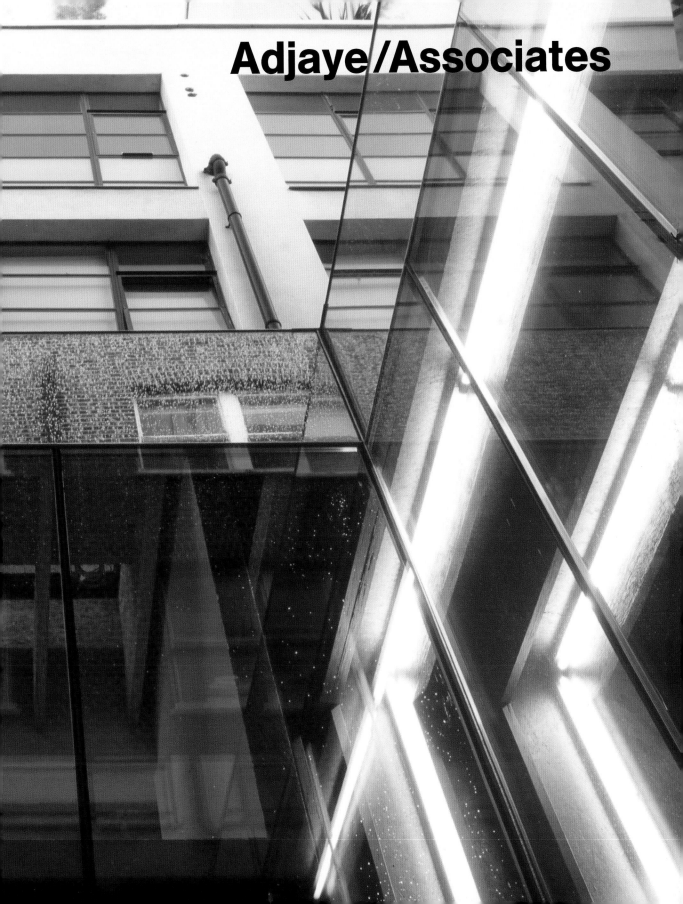

Adjaye/Associates

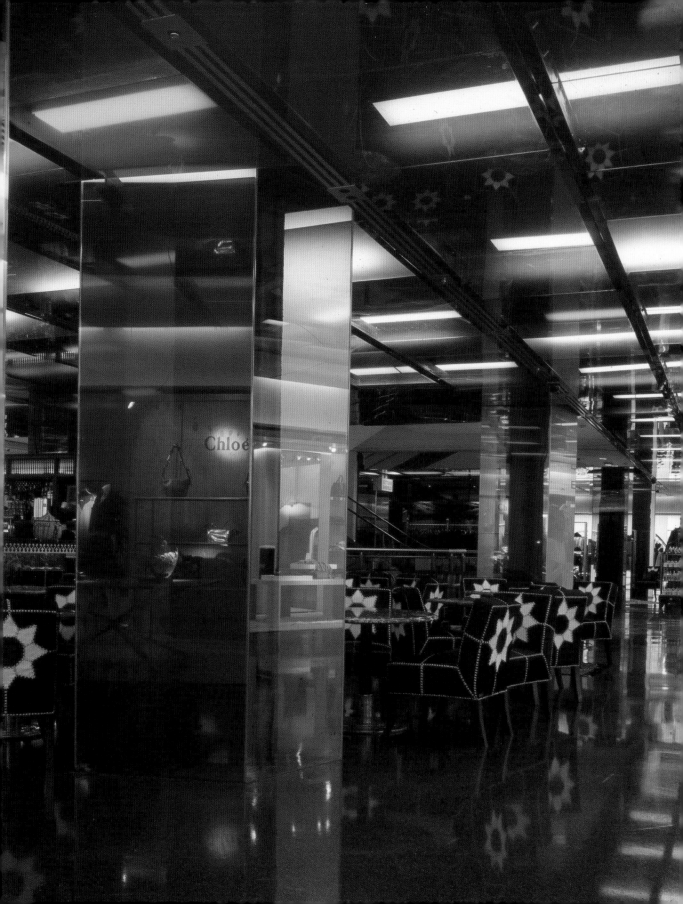

Adjaye/Associates

23–28 Penn Street, London N1 5DL

P +44 20 7739 4969

F +44 20 7739 3484

www.adjaye.com

info@adjaye.com

David Adjaye

1966
born in Dar-Es-Salam,
Tanzania

1994
Adjaye and Russell

2000
Adjaye/Associates

David Adjaye is widely regarded as one of the most interesting architects of the current generation in England. Working on the boundary between architecture and art, he experiments with sculptural forms and unusual materials without adhering to a particular style. His friends and clients include the renowned artists Chris Ofili and Jake Chapman, actor Ewan McGregor and fashion designer Alexander McQueen. David Adjaye's first major project, the Idea Store Chrisp Street community centre and library, was opened in 2004.

David Adjaye gilt als einer der interessantesten Architekten der jungen Generation in England. Als Grenzgänger zwischen Architektur und Kunst experimentiert er mit skulpturalen Formen und ungewöhnlichen Materialien, ohne sich auf einen bestimmten Stil festzulegen. Zu seinen Freunden und Auftraggebern zählen prominente Künstler wie Chris Ofili und Jake Chapman, der Schauspieler Ewan McGregor und der Modedesigner Alexander McQueen. Als erstes Großprojekt von David Adjaye in London wurde 2004 der Idea Store Chrisp Street – ein Gemeindezentrum mit Bibliothek – eingeweiht.

David Adjaye est considéré comme l'un des architectes les plus intéressants de la jeune génération en Angleterre. A la frontière entre art et architecture, il expérimente avec des formes sculpturales et des matériaux insolites sans se fixer sur un style déterminé. Parmi ses amis et clients se trouvent des artistes célèbres tels que Chris Ofili et Jake Chapman, l'acteur Ewan McGregor et le créateur de mode Alexander McQueen. Le premier grand projet de David Adjaye à Londres, l'Idea Store sur Chrisp Street, un centre paroissial avec une bibliothèque, a été inauguré en 2004.

David Adjaye es considerado uno de los arquitectos más interesantes de la joven generación de Inglaterra. Experimenta con formas esculturales y materiales poco habituales, difuminando así los límites entre la arquitectura y el arte, y sin ajustarse a un estilo concreto. Entre sus amigos y clientes figuran los prominentes artistas Chris Ofili y Jake Chapman, el actor Ewan McGregor y el diseñador de moda Alexander McQueen. El primer gran proyecto llevado a cabo en Londres por David Adjaye fue la Idea Store Chrisp Street, un centro cívico con biblioteca inaugurado en 2004.

David Adjaye è considerato uno dei più interessanti architetti della nuova generazione in Inghilterra. Muovendosi sempre al confine tra architettura e arte, Adjaye sperimenta con forme sculturali e materiali insoliti, senza fissarsi su di uno stile particolare. Tra i suoi amici e committenti si annoverano artisti di fama come Chris Ofili e Jake Chapman, l'attore Ewan McGregor e lo stilista di moda Alexander McQueen. Nel 2004 è stato inaugurato il primo grande progetto di David Adjaye a Londra: l'Idea Store Chrisp Street, un centro civico con annessa biblioteca.

Interview | David Adjaye

How would you describe the basic idea behind your design work? I form spaces around a programme of ideas which I think question and open up new possible ways of thinking to people, not just about space, but about the context in which the space is being animated. This, for me, is the key thing.

To what extent does working in London inspire your creativity? London is one of the most metropolitan cities in the world – it is hardly perfect or perfectible – that's what makes it interesting.

Is there a typical London style in contemporary architecture? I don't think so – London is too diverse.

Which project is so far the most important one for you? Two public buildings: The Idea Store Whitechapel and the Nobel Peace Center, Oslo. Most people don't even know what "public" means anymore. People can feel completely free in a street, it is still a place where people can show themselves off, or be alone, or watch each other. In my architecture I want to try and capture and amplify this quality.

Wie würden Sie die Grundidee beschreiben, die hinter Ihren Entwürfen steht? Durch meine Architektur versuche ich, die üblichen Denkmuster der Menschen in Frage zu stellen und neue Sichtweisen aufzuzeigen. Dabei geht mir es nicht um die Räume an sich, sondern um Zusammenhänge, darum, wie die Räume belebt werden. Das ist mir das Wichtigste.

Inwiefern inspiriert London Ihre kreative Arbeit? London ist eine der vielfältigsten Metropolen der Welt. Die Stadt ist sicher nicht ohne Fehler, sie kann gar nicht fehlerlos sein – das macht sie so interessant.

Gibt es einen typischen Londoner Stil in der aktuellen Architektur? Das glaube ich nicht. London ist einfach zu vielfältig.

Welches ist für Sie Ihr bislang wichtigstes Projekt? Zwei öffentliche Gebäude: Der Idea Store Whitechapel und das Nobel Peace Center in Oslo. Die meisten Leute wissen nicht einmal mehr, was das Wort „öffentlich" bedeutet – dass Menschen sich auf der Straße frei bewegen, sich zeigen, alleine sein oder sich gegenseitig beobachten können. In meiner Architektur möchte ich diese Qualitäten aufgreifen und verstärken.

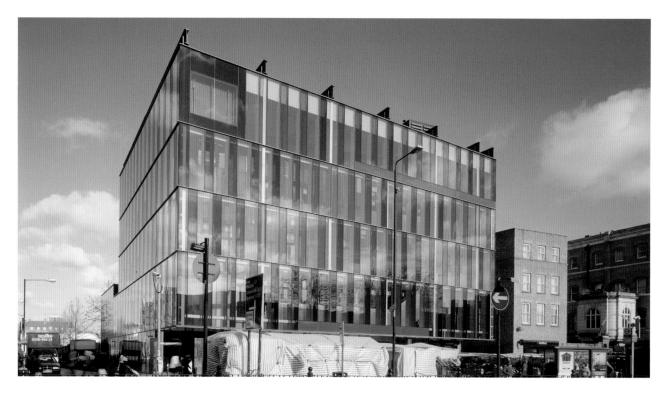

Quelle est, d'après vous, l'idée de base qui sous-tend votre travail de conception ? À travers mon architecture, je cherche à remettre en question les schémas de pensée traditionnels de mes contemporains et à ouvrir de nouvelles perspectives. Je ne pense pas seulement à l'espace mais au contexte, à la façon dont l'espace est animé. C'est, pour moi, l'élément clé.

Dans quelle mesure Londres inspire-t-il votre créativité ? Londres est l'une des métropoles les plus multiples du monde. Cette ville n'est certainement pas parfaite et elle ne peut pas l'être – c'est ce qui la rend si intéressante.

Y a-t-il un style typiquement londonien dans l'architecture contemporaine ? Je ne crois pas. Londres est bien trop multiple.

Quel est le projet le plus important pour vous à l'heure actuelle ? Deux bâtiments publics : l'Idea Store Whitechapel et le Nobel Peace Center à Oslo. La plupart des gens ne savent même plus ce que signifie le mot « public » – c'est-à-dire, la possibilité pour les gens de se sentir entièrement libres dans la rue, de se montrer, d'être seul ou de s'observer. Dans mon architecture, je veux appréhender et amplifier ces qualités.

¿Cómo definiría la idea básica que encierran sus diseños? A través de mi arquitectura intento cuestionar los esquemas de pensamiento humano típicos y mostrar nuevas visiones. Para ello no me centro sólo en los espacios en sí sino en los contextos en los que se da vida a los espacios. Esto es lo más importante para mí.

¿En qué medida inspira la ciudad de Londres su trabajo creativo? Londres es la metrópoli con mayor diversidad del mundo. Por supuesto que la ciudad también tiene fallos, no puede ser perfecta, y esto es lo que la hace tan interesante.

¿Existe un estilo típico londinense en la arquitectura actual? No creo. Londres simplemente tiene demasiada diversidad.

¿Cuál ha sido su proyecto más importante hasta el momento? Dos edificios públicos: El Idea Store Whitechapel y el Nobel Peace Center en Oslo. La mayoría de la gente ya no sabe qué significa la palabra "público"; es decir que las personas puedan moverse libremente por la calle, mostrarse, estar en solitario u observarse unos a otros. En mi arquitectura pretendo retomar y pontenciar esta calidad.

Come descriverebbe l'idea originaria che sta alla base delle Sue creazioni? Tramite la mia architettura io tento di mettere in discussione i consueti schemi mentali della gente e di indicare nuove prospettive: quello che mi interessa non sono gli spazi in sé, ma il contesto in cui questi si inseriscono, il modo in cui vengono riempiti di vita. È questa per me la cosa più importante.

In che misura Londra ispira la Sua creatività? Londra è una delle metropoli più caleidoscopiche del mondo. Certo non è una città perfetta, né perfettibile – ma è questo che la rende così interessante.

Esiste uno stile tipico di Londra nell'architettura contemporanea? Non credo proprio. Londra ha troppi aspetti differenti.

Qual è per Lei il più importante tra i progetti realizzati finora? Due edifici pubblici: l'Idea Store Whitechapel e il Nobel Peace Center a Oslo. La maggior parte della gente non sa neanche più cosa significhi la parola "pubblico": che per strada le persone possano muoversi in assoluta libertà, farsi vedere, essere sole o anche osservarsi a vicenda. Sono queste le qualità che intendo catturare ed amplificare con la mia architettura.

Adjaye/Associates | Selfridges London 2003

Lost House

Year: 2004

Location: York Way, Kings Cross, London N1

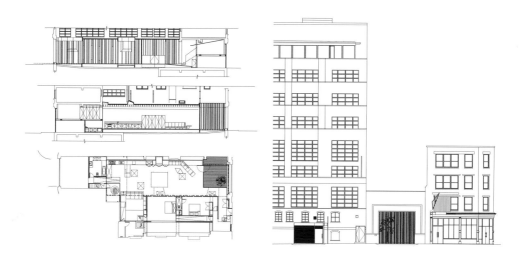

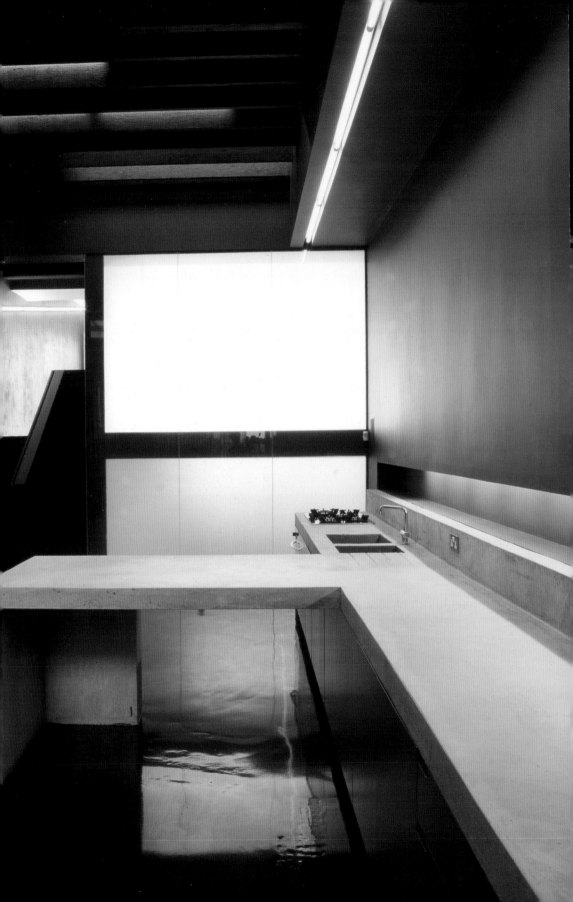

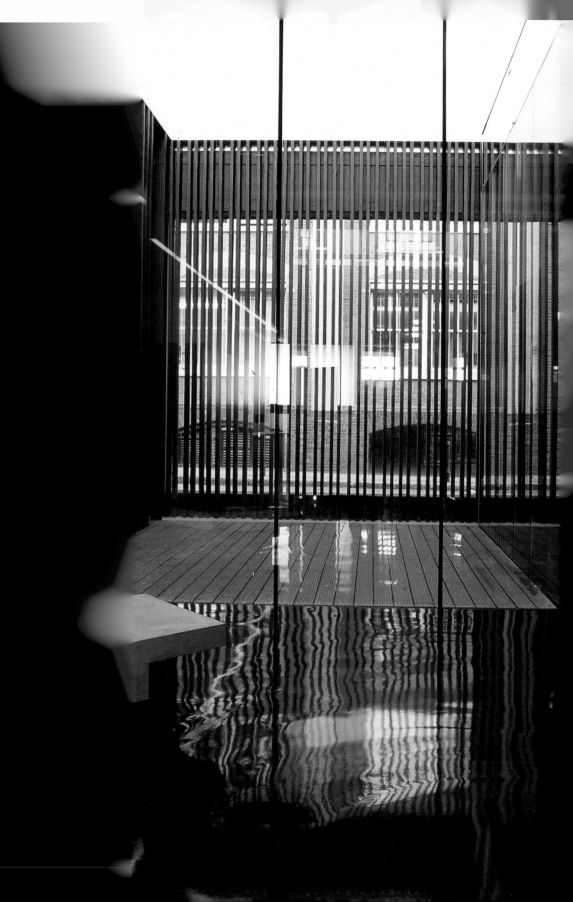

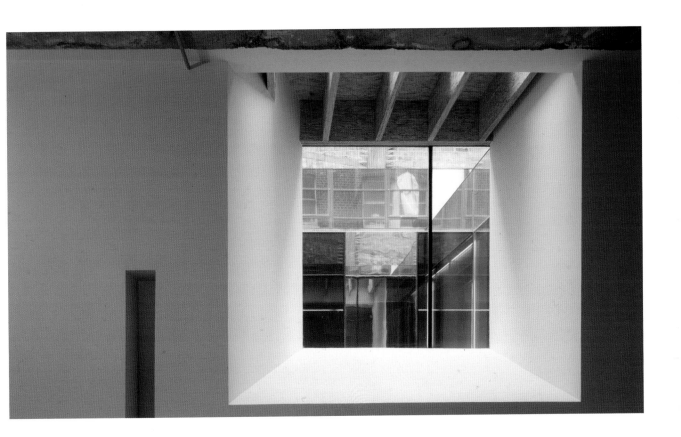

David Adjaye calls this house, which was designed for a fashion designer and completed in 2004, the Lost House. Strong colours and light-and-dark contrasts set the scene inside the building; the design language and details have deliberately been kept simple.

Lost House nennt David Adjaye dieses 2004 fertiggestellte Wohnhaus für eine Modedesignerin. Starke Farb- und Hell-Dunkel-Kontraste bestimmen das Innere des Gebäudes, Formensprache und Details sind bewusst einfach gehalten.

David Adjaye appelle Lost House cette résidence destinée à une créatrice de mode, achevée en 2004. Les contrastes de couleurs prononcés et l'alternance luminosité-obscurité caractérisent l'intérieur du bâtiment, le langage des formes et les détails étant volontairement sobres.

David Adjaye llama Lost House a esta vivienda realizada en 2004 para una diseñadora de moda. Los interiores se definen a través de grandes contrastes de color, claridad y oscuridad. El lenguaje de formas y los detalles se han mantenido sencillos a propósito.

Lost House: così David Adjaye chiama questo edificio, costruito per ospitare l'abitazione di una stilista di moda e completato nel 2004. Gli interni sono caratterizzati da forti contrasti cromatici e chiaroscurali, mentre il linguaggio formale e i dettagli rivelano una voluta semplicità.

Dirty House

Year: 2001–2002

Location: 2–4 Chance Street, London E2

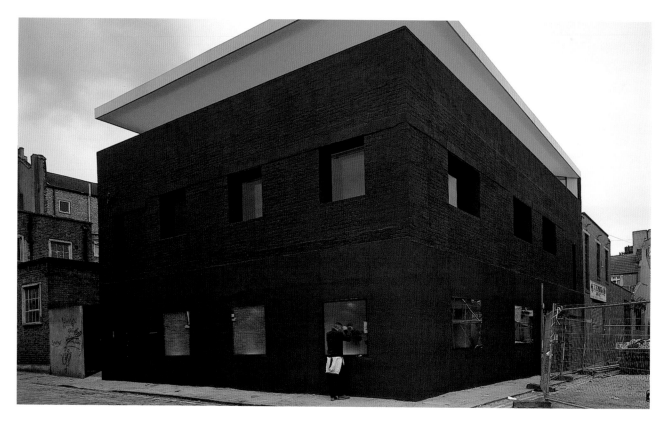

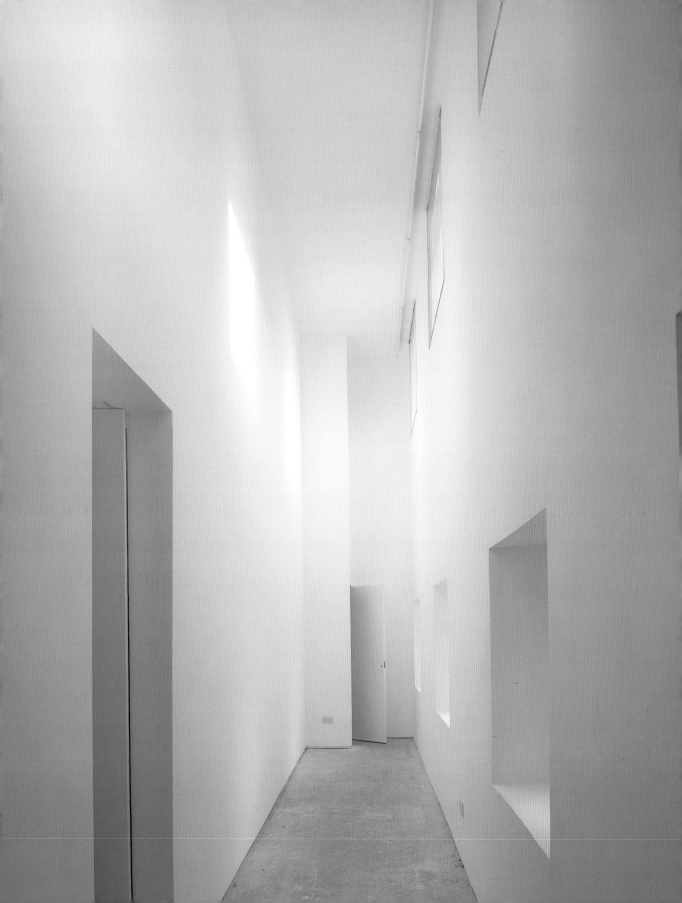

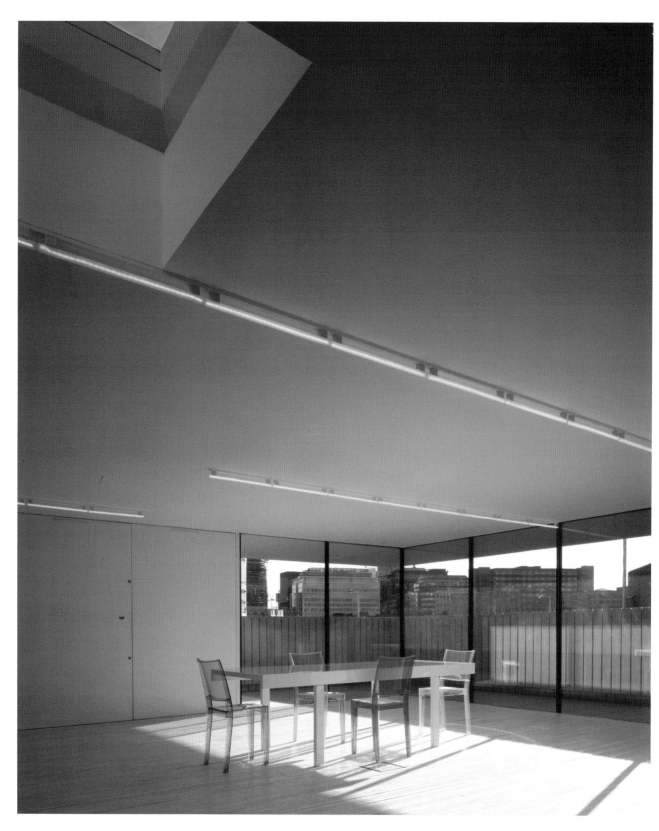

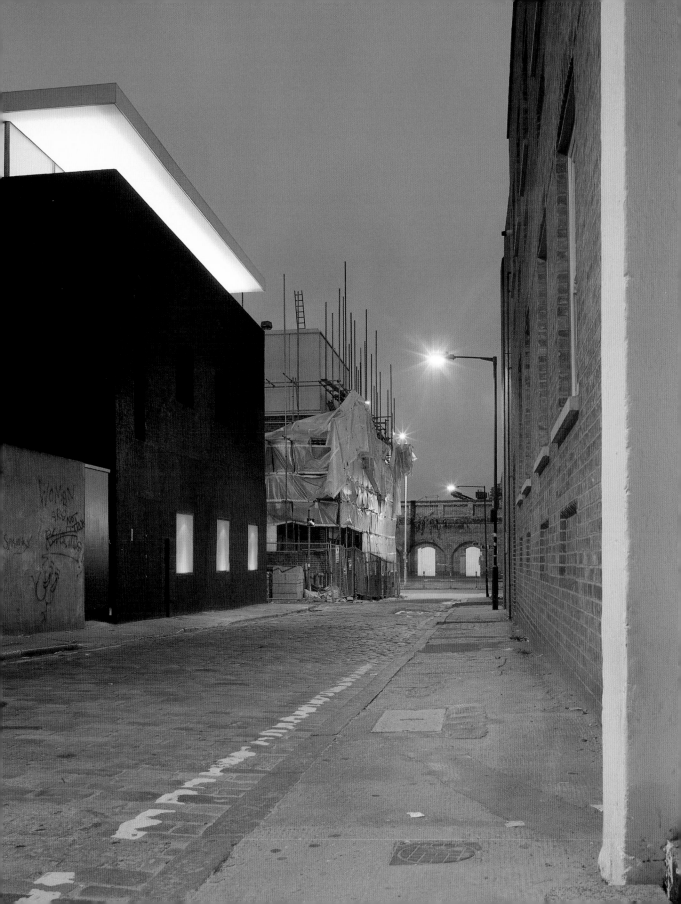

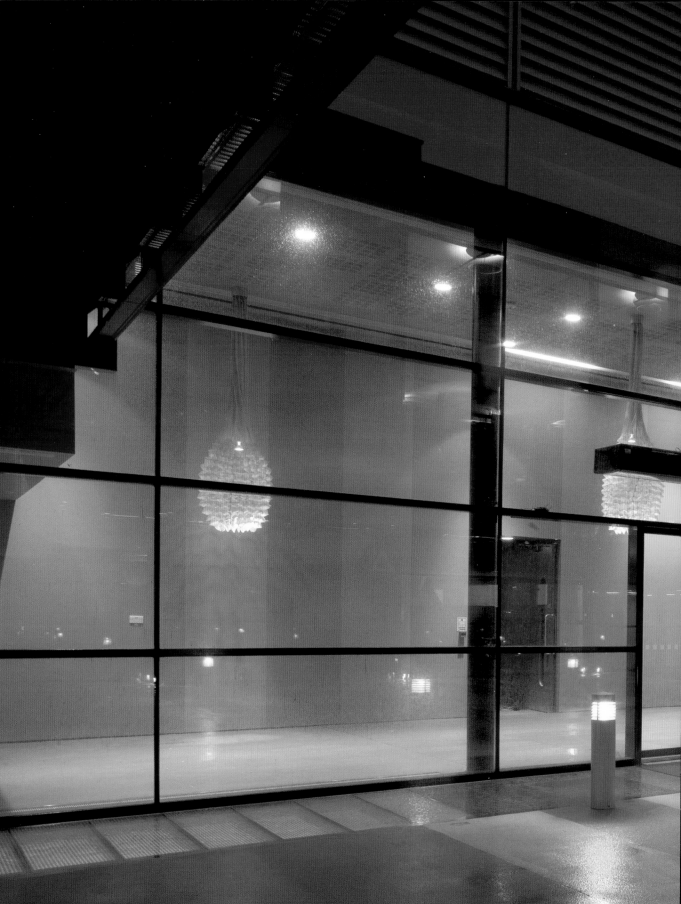

Alsop Architects

Alsop Architects

Parkgate Studio, 41 Parkgate Road, London SW11 4NP

P +44 20 7978 7878

F +44 20 7978 7879

www.alsoparchitects.com

William Alsop

1947
born in Northampton, UK

1981
Alsop & Lyall

1991
Alsop & Störmer

2000
Alsop Architects

William Alsop sees architecture primarily as an impulse and expression of social changes and renovation. He consistently refuses to be bound to a recognisable style; for him, the design process is at the forefront. This unusual attitude has made Alsop one of Britain's most prominent architects. Alsop also teaches and works as a sculptor – and several of his architectural projects testify to his two talents.

William Alsop sieht Architektur zunächst als Anstoß und Ausdruck sozialer Veränderungen und Erneuerungen. Er verweigert sich konsequent einem wiedererkennbaren Stil – stattdessen steht für ihn der Entwurfsprozess im Vordergrund. Diese ungewöhnliche Haltung machte Alsop zu einem der prominentesten britischen Architekten. Parallel dazu lehrt und arbeitet Alsop auch als Bildhauer – nicht wenige seiner Architekturprojekte sind ganz offensichtlich von dieser Doppelbegabung geprägt.

William Alsop considère que l'architecture est d'abord l'impulsion et l'expression de modifications et d'innovations sociales. Il se refuse donc logiquement à tout style reconnaissable – au lieu de cela, le processus de projection est au premier plan. Cette attitude inhabituelle a fait d'Alsop l'un des architectes britanniques les plus éminents. Parallèlement, Alsop enseigne et travaille également comme sculpteur – nombre de ses projets architecturaux sont, à l'évidence, marqués par ce double don.

Para William Alsop la arquitectura es primeramente impulso y expresión de los cambios sociales y de la renovación. Rechaza de forma consecuente el vínculo a un estilo reconocible, y para él el proceso de concepción juega el papel principal. Esta atípica visión es lo que ha convertido a Alsop en uno de los arquitectos británicos más celebrados. Paralelamente enseña y trabaja como escultor, otro de sus talentos, que se hace claramente patente en muchos de sus proyectos arquitectónicos.

William Alsop ritiene che l'architettura sia anzitutto stimolo ed espressione di mutamenti ed innovazioni sociali. Rifiuta coerentemente di esprimersi in uno stile riconoscibile, anzi: per lui, è il processo dell'ideazione ad essere in primo piano, e proprio questa sua insolita impostazione ha fatto di Alsop uno degli architetti britannici più di spicco. Parallelamente alla sua attività di architetto, Alsop insegna e lavora anche come scultore – non pochi dei suoi progetti architettonici portano il segno evidente del suo duplice talento.

Interview | William Alsop

How would you describe the basic idea behind your design work? As I get older, I try to get rid of the idea of having an idea. It seems to me, that the many parts of our built environments, that we don't enjoy, are designed by people who try to follow pre-formulated styles or theories.

To what extent does working in London inspire your creativity? For me London is a very relaxing place. On the other hand it is a very complex and diverse city and surely a congenial place to work.

Is there a typical London style in contemporary architecture? There seems to establish a certain style in residential buildings, but that could also be described as a British or European style. When I take my own idea of getting rid of any styles and theories seriously, I should actually not answer this question.

Which project is so far the most important one for you? Probably the Sharp Center in Toronto. This project is extremely popular: I have been told that tourism in Toronto increased appreciably only because of this building.

Wie würden Sie die Grundidee beschreiben, die hinter Ihren Entwürfen steht? Mit zunehmendem Alter versuche ich, mich von der Idee einer allgemein gültigen Grundidee zu verabschieden. Es scheint mir, dass gerade der Teil der gebauten Umgebung, der uns nicht gefällt, von Menschen entworfen wurde, die versuchen, bestimmten Stilen oder Theorien zu folgen.

Inwiefern inspiriert London Ihre kreative Arbeit? Für mich ist London vor allem ein sehr entspannender Ort. London ist aber auch eine extrem komplexe und vielseitige Stadt und damit sicherlich ein kongenialer Ort zum Arbeiten.

Gibt es einen typischen Londoner Stil in der aktuellen Architektur? Im Wohnungsbau scheint sich ein bestimmter Stil zu etablieren, den man jedoch ebenso als britischen oder europäischen Stil bezeichnen könnte. Wenn ich jedoch meine Haltung der Ablehnung von Stilen und Theorien ernst nehme, dann darf ich diese Frage eigentlich gar nicht beantworten.

Welches ist für Sie Ihr bislang wichtigstes Projekt? Vielleicht das Sharp Centre in Toronto. Der Bau ist ungeheuer populär: Man sagte mir, der Tourismus in Toronto habe allein aufgrund dieses Gebäudes spürbar zugenommen.

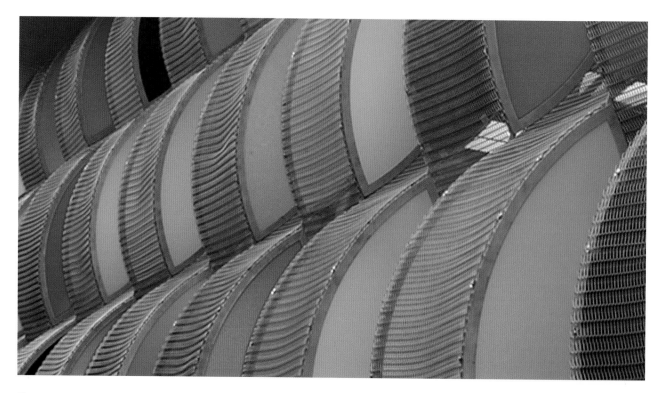

Alsop Architects | Fawood Children's Centre 2004

Quelle est, d'après vous, l'idée de base qui sous-tend votre travail de conception ? En vieillissant, j'essaie d'abandonner l'idée d'une idée de base universellement valable. Il me semble que la partie construite de notre environnement qui nous déplaît a précisément été conçue par des gens qui essaient de suivre des styles ou des théories déterminés.

Dans quelle mesure Londres inspire-t-il votre créativité ? Pour moi, Londres est avant tout un lieu très relaxant. Mais c'est aussi une ville extrêmement complexe et diversifiée et assurément un endroit quasi génial pour travailler.

Y a-t-il un style typiquement londonien dans l'architecture contemporaine ? Dans le domaine de la construction d'habitations, un certain style semble s'établir que l'on pourrait qualifier à la fois de britannique et d'européen. Cependant, si je prends au sérieux mon attitude de rejet des styles et des théories, je ne devrais pas répondre à cette question.

Quel est le projet le plus important pour vous à l'heure actuelle ? Peut-être le Sharp Centre à Toronto. Ce bâtiment est extrêmement populaire : on m'a dit que l'augmentation sensible du tourisme à Toronto était due uniquement à ce bâtiment.

¿Cómo definiría la idea básica que encierran sus diseños? A medida que me voy haciendo mayor intento desprenderme de la idea de tener determinadas ideas. Me da la impresión de que precisamente la parte del entorno construido que no nos gusta ha sido esbozado por personas que intentaban seguir determinadas teorías o estilos.

¿En qué medida inspira la ciudad de Londres su trabajo creativo? Para mí Londres es ante todo un lugar relajante. Pero a la vez se trata de una ciudad extremadamente compleja y diversa y por lo tanto seguramente un lugar congenial para trabajar.

¿Existe un estilo típico londinense en la arquitectura actual? En la construcción de viviendas parece que se está estableciendo un determinado estilo que se podría denominar tanto británico como europeo. Si tomo en serio mi postura de rechazo a los estilos y las teorías no puedo por tanto contestar a esa pregunta.

¿Cuál ha sido su proyecto más importante hasta el momento? Tal vez el Sharp Centre en Toronto. Esta construcción es muy popular. Se me ha llegado a decir que tan sólo a causa de este edificio el turismo de Toronto ha aumentado considerablemente.

Come descriverebbe l'idea originaria che sta alla base delle Sue creazioni? Col passare degli anni sto cercando di abbandonare l'idea stessa di un'idea originaria universalmente valida. A mio parere, infatti, proprio gran parte dell'ambiente edificato che non ci piace è stata ideata da persone che tentano di seguire determinati stili o teorie.

In che misura Londra ispira la Sua creatività? Per me Londra è prima di tutto un luogo molto rilassante. Ma è anche una città estremamente complessa e ricca di contrasti, e di conseguenza sicuramente un luogo congeniale per lavorare.

Esiste uno stile tipico di Londra nell'architettura contemporanea? Sembra che nell'edilizia abitativa si stia affermando un certo stile, che, però, si potrebbe anche definire britannico o europeo. Ma se prendo sul serio la mia impostazione di rifiutare stili o teorie, allora a questa domanda non dovrei rispondere affatto.

Qual è per Lei il più importante tra i progetti realizzati finora? Forse il Sharp Centre di Toronto. Si tratta di un edificio incredibilmente popolare: mi è stato detto che a Toronto si è avuto un incremento apprezzabile del turismo solo per via di questo edificio.

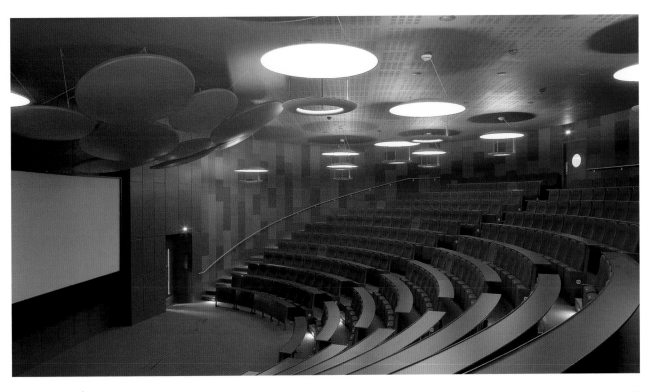

Alsop Architects | Blizard Building, Queen Mary University of London 2005

Blizard Building, Queen Mary University of London

Year: 2005

Location: 4 Newark Street, London E1

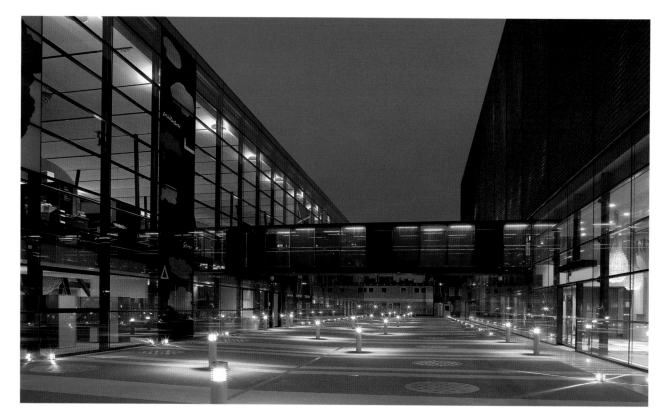

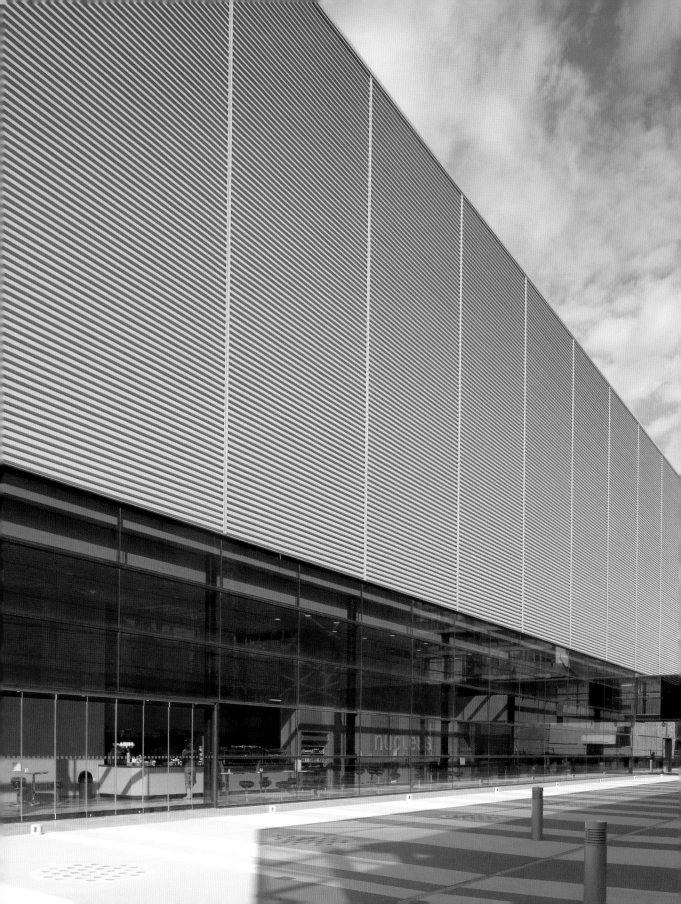

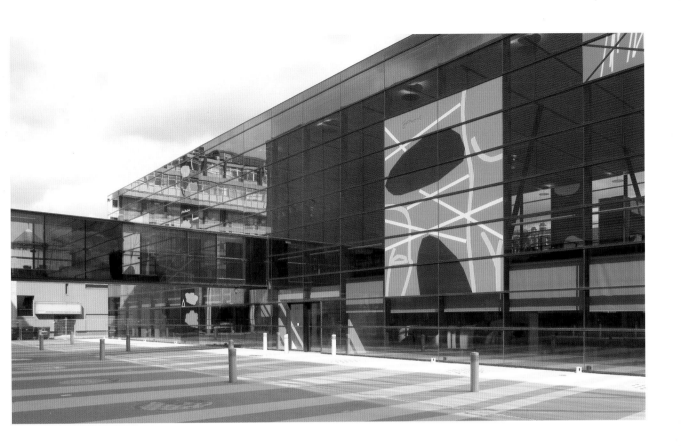

The Blizard Building at London's Queen Mary University offers completely new research and lecture rooms for students and lecturers. The eye-catching building is also intended as a contribution to the revitalisation of the borough of Whitechapel.

Das Blizard Building der Queen Mary University of London bietet völlig neuartige Forschungs- und Unterrichtsräume für Studenten und Lehrende. Außerdem soll der auffällige Neubau einen Beitrag zur Revitalisierung des Stadtteils Whitechapel leisten.

Le Blizard Building de l'université Queen Mary à Londres propose des salles de cours et de recherche d'un type nouveau pour les étudiants et les enseignants. Ce bâtiment tout neuf très frappant doit en outre contribuer à revitaliser le quartier de Whitechapel.

El Blizard Building de la Queen Mary University of London ofrece a profesores y alumnos aulas y salas de investigación con una concepción completamente nueva. Esta novedosa y llamativa construcción hace además su aportación a la revitalización del Whitechapel.

Il Blizard Building della Queen Mary University of London mette a disposizione di studenti e insegnanti locali del tutto innovativi, destinati ad ospitare attività di ricerca e lezioni. Il vistoso edificio, inoltre, intende contribuire a rivitalizzare il quartiere di Whitechapel.

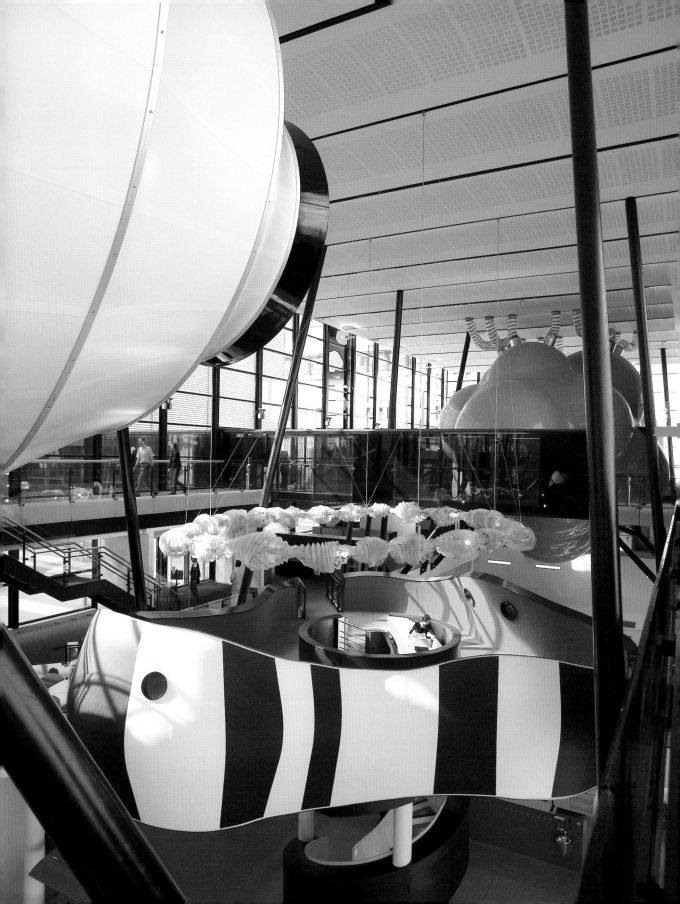

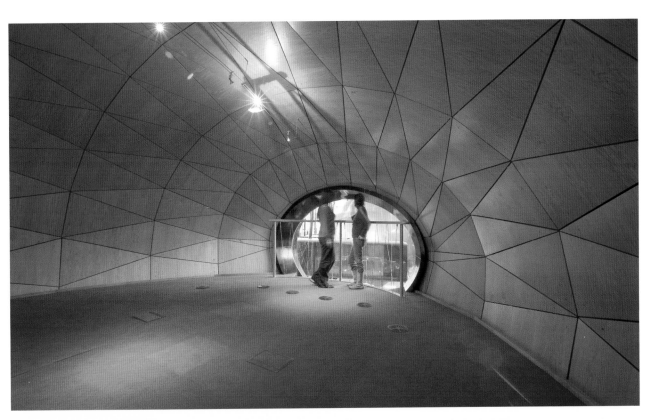

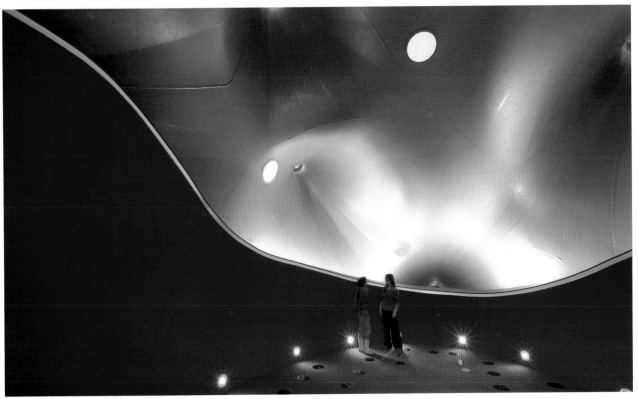

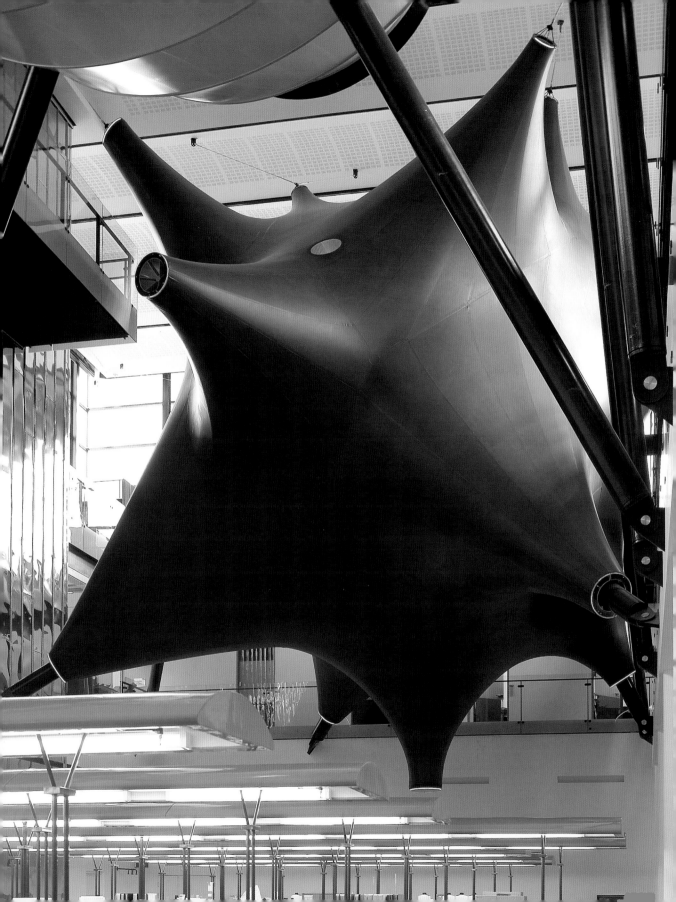

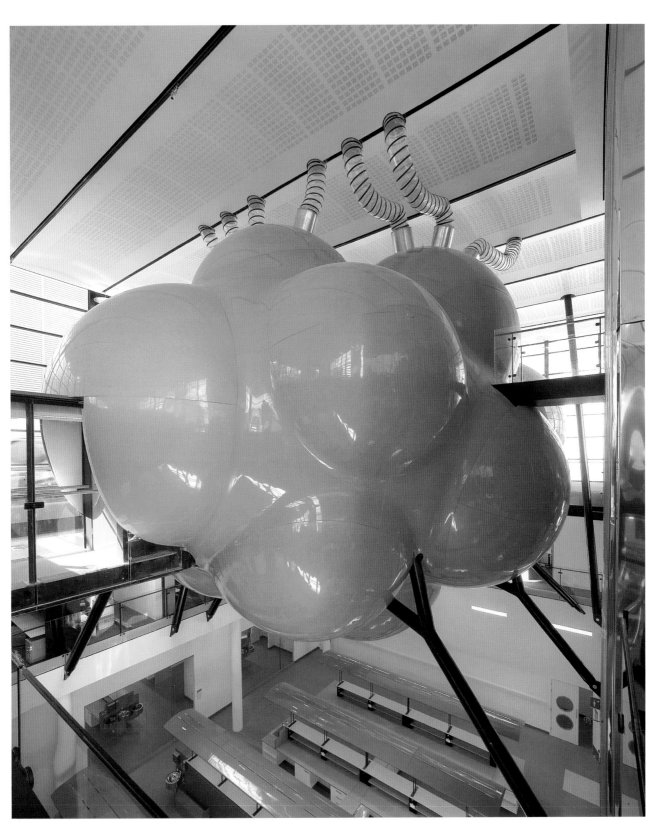

Ben Pimlott Building, Goldsmiths College

Year: 2003–2005

Location: New Cross, London SE14

Alsop Architects | Ben Pimlott Building, Goldsmiths College 2005

Fawood Children's Centre

Year: 2004

Location: 35 Fawood Avenue, London NW10

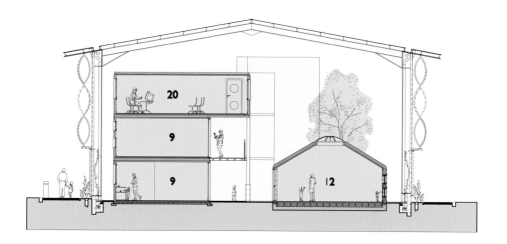

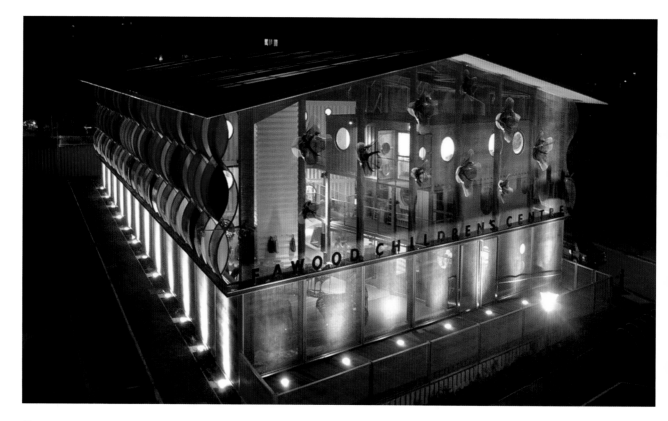

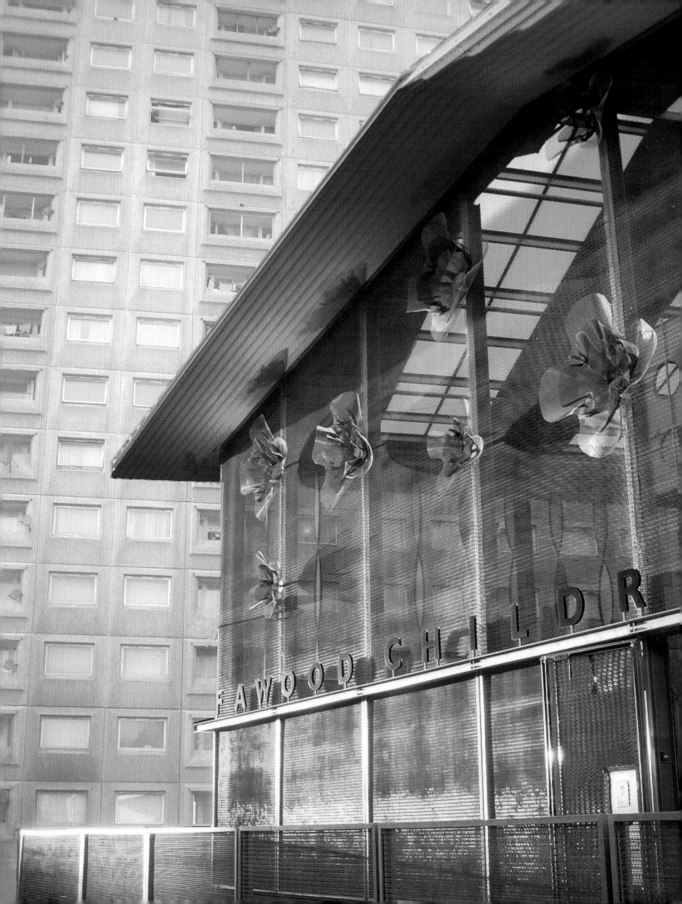

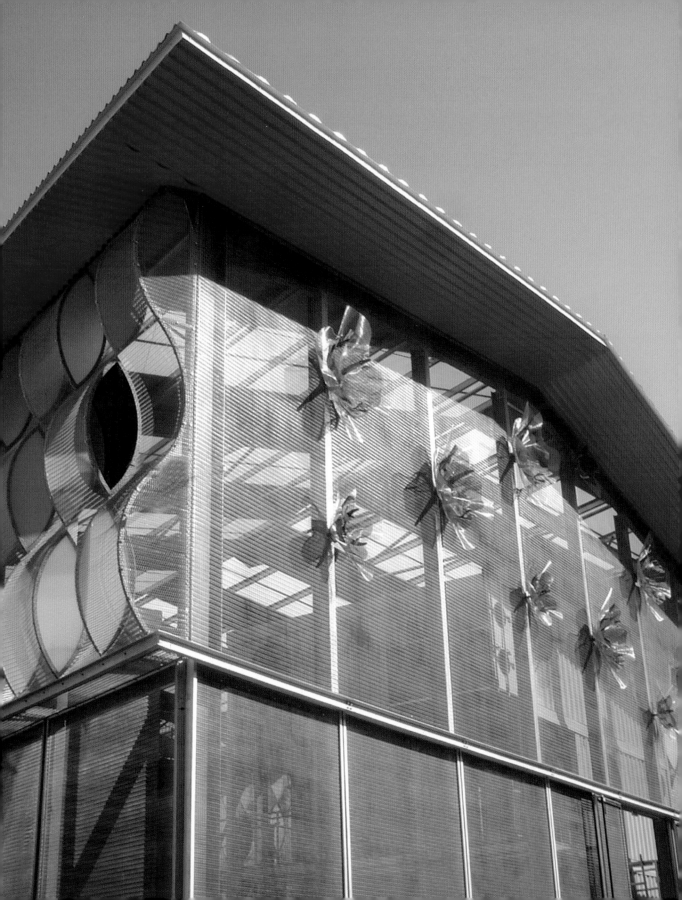

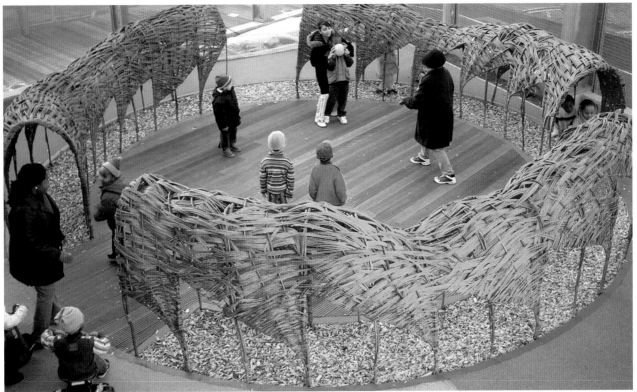

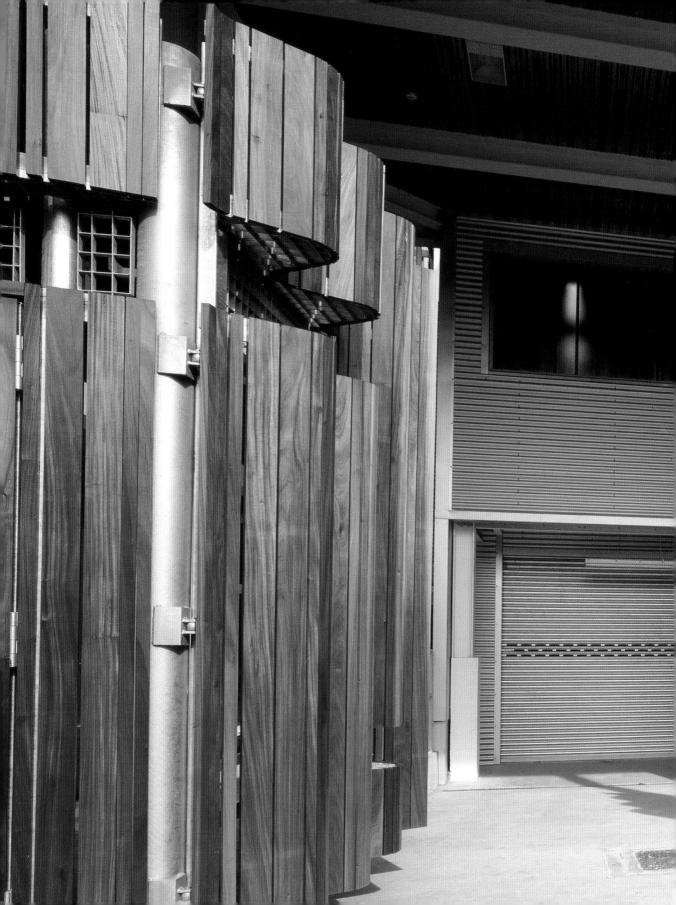

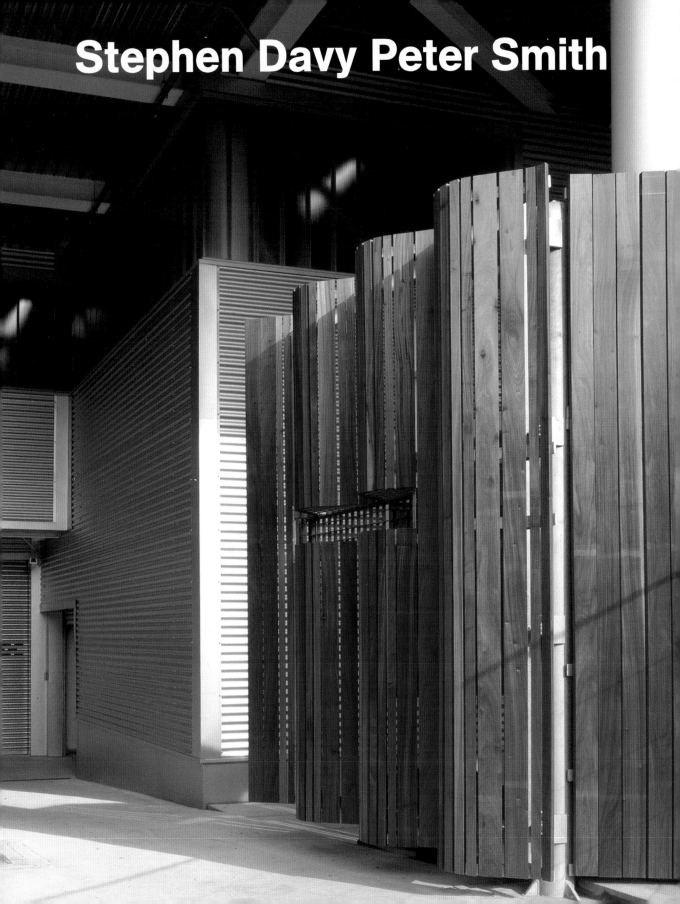

Stephen Davy Peter Smith

Stephen Davy Peter Smith

Fanshaw House, Fanshaw Street, London N1 6HX

P +44 20 7739 2020

F +44 20 7739 2021

www.davysmitharchitects.co.uk

sdpsa@davysmitharchitects.co.uk

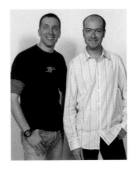

For Stephen Davy and Peter Smith, working as equals in their office is the key to success. The large number of young employees – the average age is 28 – and plentiful opportunities for exchanges with experienced architects ensure there are plenty of ideas and a fresh, open attitude in the office.

Für Stephen Davy und Peter Smith ist die gleichberechtigte Arbeitsweise innerhalb ihres Büros der Schlüssel zum Erfolg. Die hohe Zahl an jungen Mitarbeitern – das Durchschnittsalter liegt bei 28 Jahren – sorgt im Austausch mit den erfahrenen Architekten für vielfältige Ideen und eine frische, offene Grundhaltung des Büros.

Pour Stephen Davy et Peter Smith, la clé du succès est de travailler sur un pied d'égalité au sein du cabinet. Le grand nombre de jeunes collaborateurs – la moyenne d'âge est de 28 ans – suscite, dans l'échange avec les architectes chevronnés, de multiples idées et assure la fraîcheur et l'ouverture d'esprit du cabinet.

Para Stephen Davy y Peter Smith un trabajo igualitario dentro del estudio es la clave del éxito. El número elevado de empleados jóvenes, con una media de edad de 28 años, tiene como consecuencia el intercambio con los arquitectos experimentados, la diversidad de ideas y una actitud dinámica y abierta en el despacho.

La chiave del successo di Stephen Davy e Peter Smith è il clima lavorativo paritario che si respira all'interno del loro studio d'architettura. L'elevato numero di giovani collaboratori (l'età media si aggira sui 28 anni), in costante interazione con gli architetti esperti, consente allo studio di elaborare idee sempre nuove e di avere un'impostazione di base fresca e aperta.

Peter Smith

1964
born in England

Stephen Davy

1963
born in England

1995
Stephen Davy Peter Smith

Interview | Steven Davy

How would you describe the basic idea behind your design work? Our aim is to produce good quality modern housing. This is achieved through careful consideration of site, material and cost. We also try to maximising light into the dwellings and to create places in and around the buildings.

To what extent does working in London inspire your creativity? We were both born and brought up in London, so it's a city that is very familiar to us. I guess we draw on our knowledge of the city and understanding of the city. It would be interesting to challenge ourselves overseas where our knowledge of the site/city would not be immediate to us.

Is there a typical London style in contemporary architecture? I don't think so. Practices look at "contemporary" from different standpoints and I guess interpret it in their own architectural language.

Which project is so far the most important one for you? I suppose Kings Wharf is a good example of what can be achieved if you consider all the issues carefully, siting, spatial quality, material and budget.

Wie würden Sie die Grundidee beschreiben, die hinter Ihren Entwürfen steht? Unser Büro steht für hochwertigen, modernen Wohnungsbau. Wir erreichen dies durch sorgfältige Betrachtung des Grundstücks, der Materialien und der Kosten. Außerdem versuchen wir, möglichst viel Tageslicht in die Wohnungen zu lassen und innerhalb und außerhalb der Gebäude besondere Orte zu schaffen.

Inwiefern inspiriert London Ihre kreative Arbeit? Wir beide wurden in London geboren und sind dort aufgewachsen. Die Stadt ist uns also sehr vertraut. Ich denke, daraus ziehen wir unsere Kenntnisse und unser Verständnis der Stadt. Es wäre eine interessante Herausforderung, einmal im Ausland zu arbeiten, wo uns Ort und Grundstück nicht so unmittelbar vertraut sind.

Gibt es einen typischen Londoner Stil in der aktuellen Architektur? Das glaube ich nicht. Die Büros haben unterschiedliche Auffassungen davon, was „aktuell" bedeutet und interpretieren dies in unterschiedlichen Architektursprachen.

Welches ist für Sie Ihr bislang wichtigstes Projekt? Ich halte das Kings-Wharf-Projekt für ein gutes Beispiel unserer Arbeit. Es zeigt, was man erreichen kann, wenn man alle Aspekte eines Entwurfes, wie Lage, räumliche Qualität, Material und Kosten, sorgfältig aufeinander abstimmt.

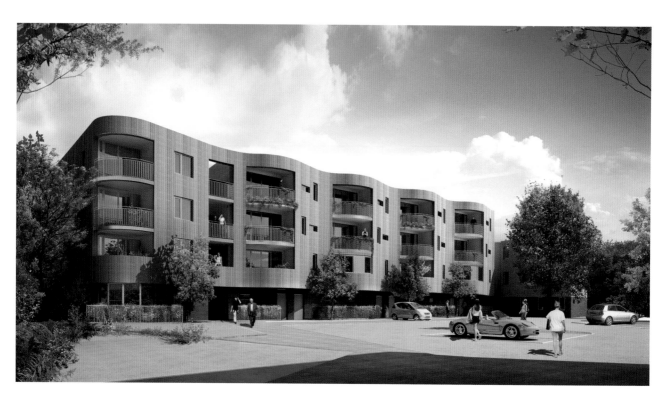

Stephen Davy Peter Smith | Beckenham Road

Quelle est, d'après vous, l'idée de base qui sous-tend votre travail de conception ? Notre objectif est de produire des habitations modernes de très bonne qualité. Nous y parvenons en étudiant attentivement le terrain, les matériaux et les coûts. Nous essayons également d'optimiser la lumière du jour dans les appartements et de créer des espaces particuliers, à l'intérieur comme à l'extérieur des bâtiments.

Dans quelle mesure Londres inspire-t-il votre créativité ? Nous sommes tous deux nés à Londres, où nous avons également grandi. La ville nous est donc particulièrement familière. C'est probablement de là que nous tirons nos connaissances et notre compréhension de la ville. Ce serait un défi intéressant d'aller travailler à l'étranger où les lieux et le terrain ne nous seraient pas immédiatement connus.

Y a-t-il un style typiquement londonien dans l'architecture contemporaine ? Je ne crois pas. Les cabinets d'architectes ont des conceptions différentes du « contemporain » et l'interprètent dans leur propre langage architectural.

Quel est le projet le plus important pour vous à l'heure actuelle ? Je considère que le projet de Kings Wharf est un bon exemple de ce que l'on peut obtenir quand on fait concorder soigneusement tous les aspects d'un projet, tels que la situation, la qualité de l'espace, les matériaux et les coûts.

¿Cómo definiría la idea básica que encierran sus diseños? Nuestro estudio se centra en la construcción de viviendas modernas y de calidad. Para alcanzar ese objetivo consideramos cuidadosamente el solar, los materiales y los gastos. Además intentamos proporcionar a los pisos el máximo de luz natural posible y crear lugares especiales en el interior y los exteriores de los edificios.

¿En qué medida inspira la ciudad de Londres su trabajo creativo? Ambos nacimos y crecimos en Londres; por lo tanto la conocemos muy bien. Creo que de ahí extraemos nuestro conocimiento y comprensión de la ciudad. Sería un reto interesante trabajar algún día en el extranjero, donde el lugar y los solares no nos resulten tan familiares.

¿Existe un estilo típico londinense en la arquitectura actual? Creo que no. Los estudios tienen diversos puntos de vista sobre lo que significa "actual" y lo interpretan con diferentes lenguajes arquitectónicos.

¿Cuál ha sido su proyecto más importante hasta el momento? El proyecto Kings Wharf es un buen ejemplo de nuestro trabajo. Muestra lo que se puede alcanzar cuando se adaptan cuidadosamente todos los aspectos de un boceto, es decir, situación, calidad del espacio, materiales y costes.

Come descriverebbe l'idea originaria che sta alla base delle Sue creazioni? Il nostro studio d'architettura ha per obiettivo una moderna edilizia abitativa di qualità. Per realizzarla consideriamo con grande attenzione il terreno edificabile, i materiali e i costi. Inoltre tentiamo di massimizzare l'illuminazione naturale delle abitazioni e di creare dei luoghi particolari tanto nell'edificio quanto intorno ad esso.

In che misura Londra ispira la Sua creatività? Siamo nati e cresciuti entrambi a Londra, quindi la città ci è molto familiare. Credo che da questo derivi il nostro modo di conoscere e comprendere Londra. Per noi sarebbe una sfida interessante provare a lavorare all'estero, dove la città e il terreno edificabile non ci sarebbero così immediatamente familiari.

Esiste uno stile tipico di Londra nell'architettura contemporanea? Non credo. Gli studi d'architettura hanno idee differenti di che cosa significhi "contemporaneo" e ne danno la loro interpretazione in differenti linguaggi architettonici.

Qual è per Lei il più importante tra i progetti realizzati finora? Credo che il progetto del complesso Kings Wharf sia un buon esempio del nostro modo di lavorare: è la dimostrazione di cosa si possa ottenere armonizzando accuratamente tra loro tutti gli aspetti di un progetto, come posizione, qualità spaziale, materiali e costi.

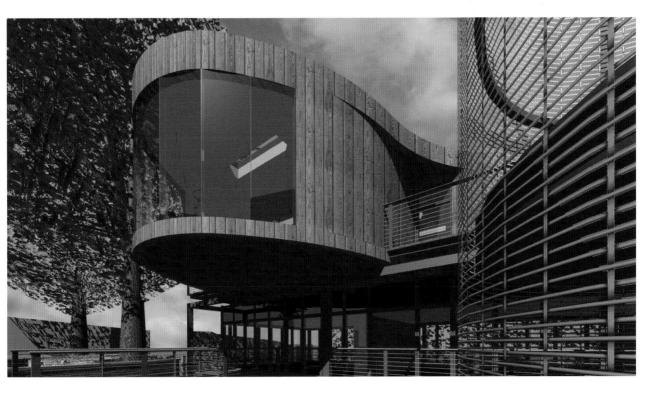

Stephen Davy Peter Smith | St Ursulas Convent School

Morrell's Yard

Year: 2005

Location: 1–7 Morrell's Yard, London SE11

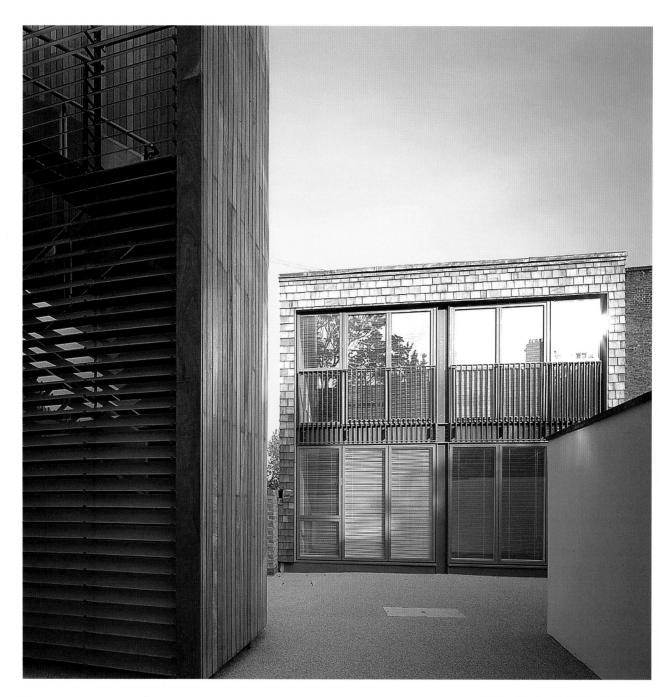

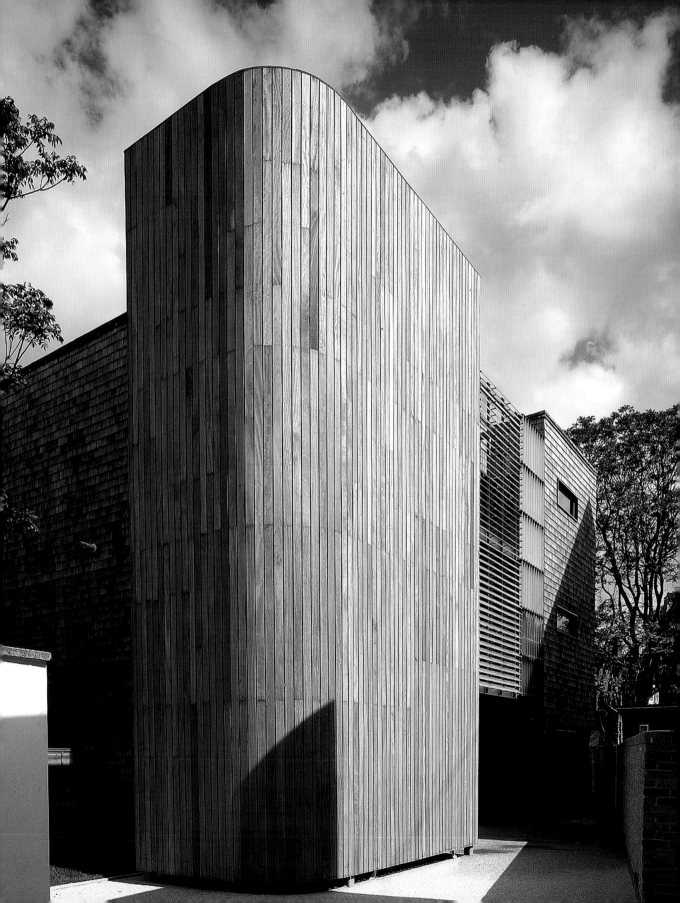

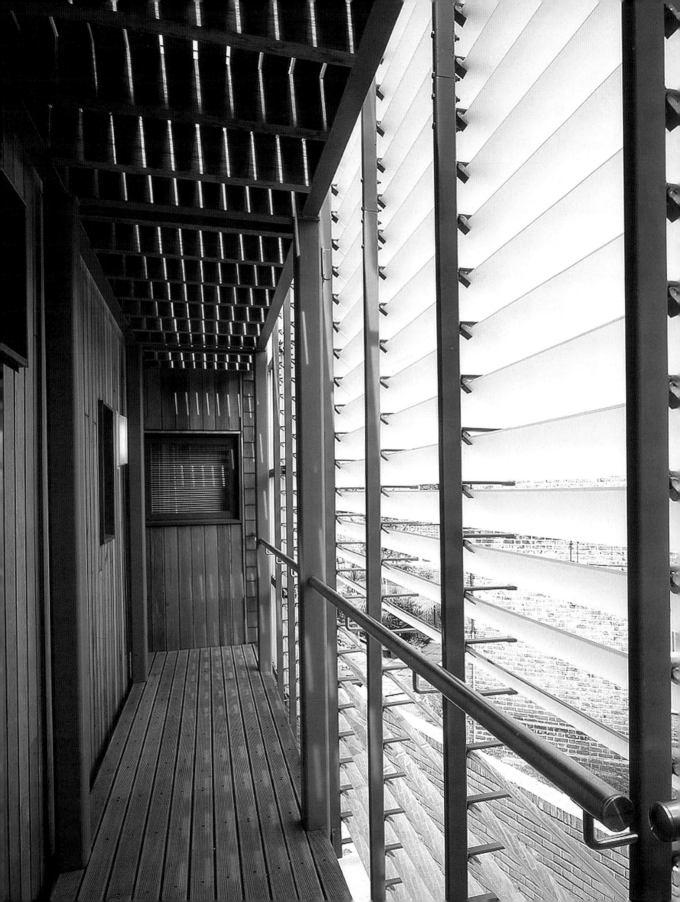

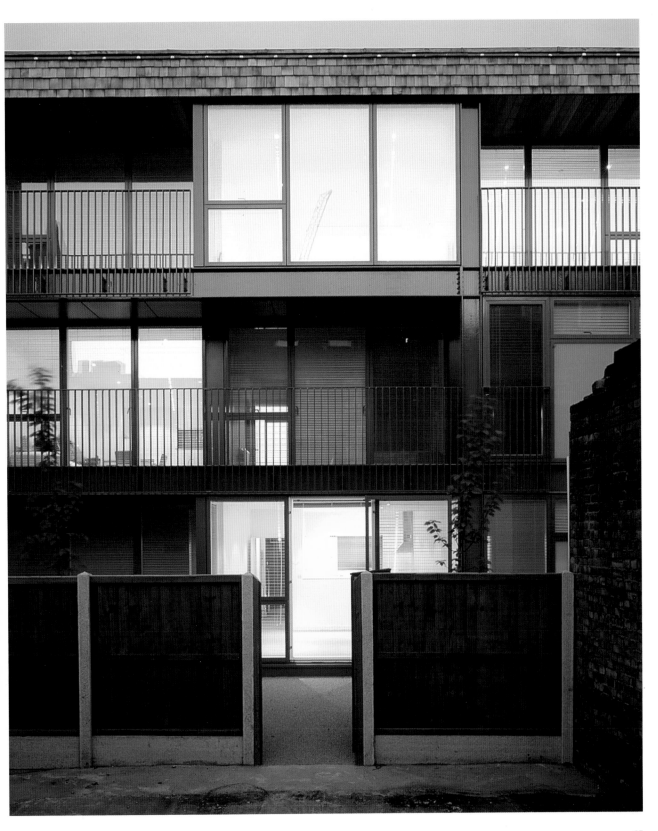

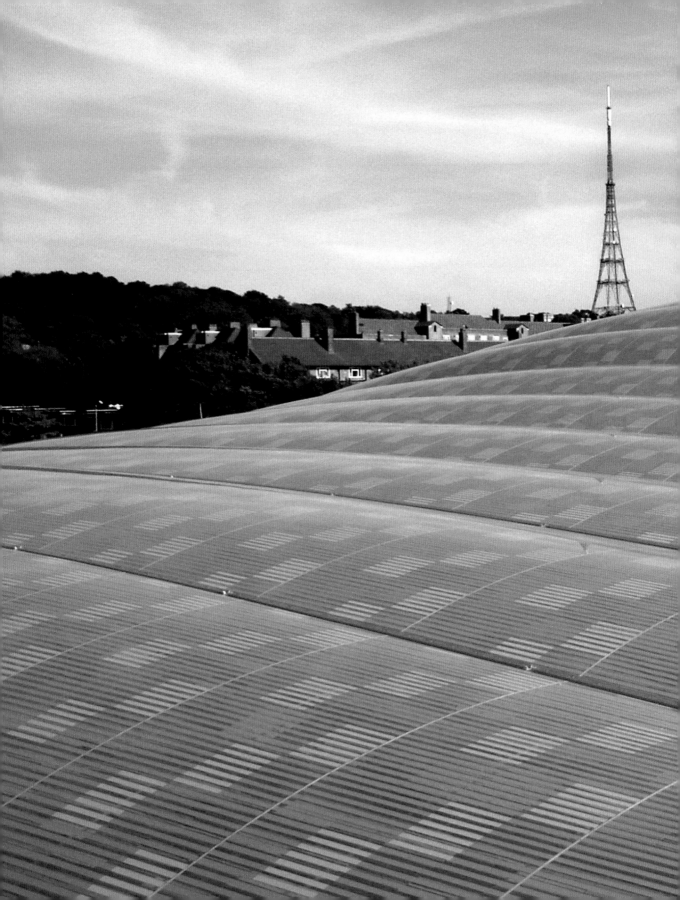

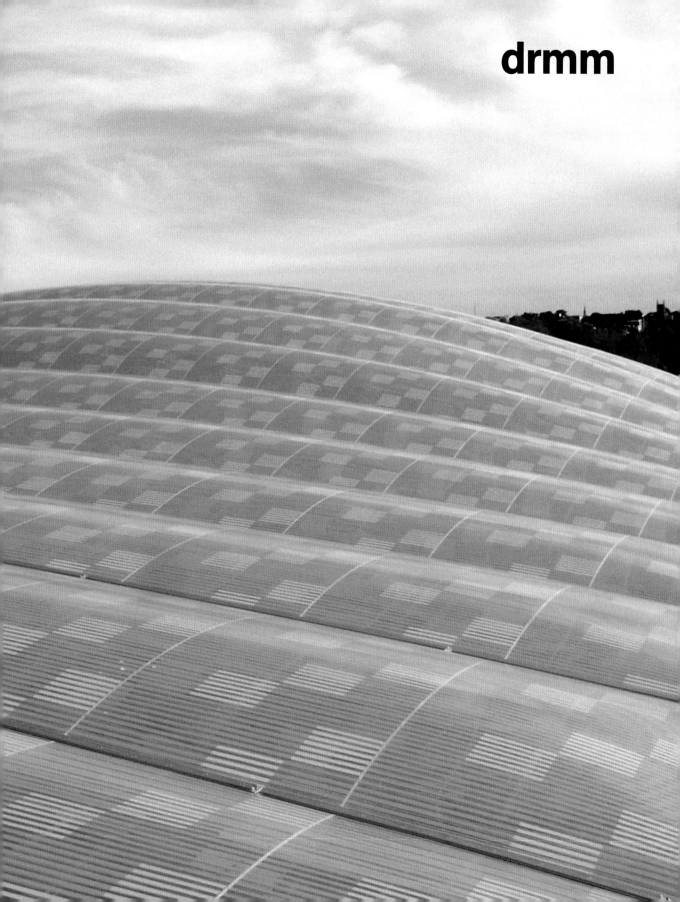

drmm

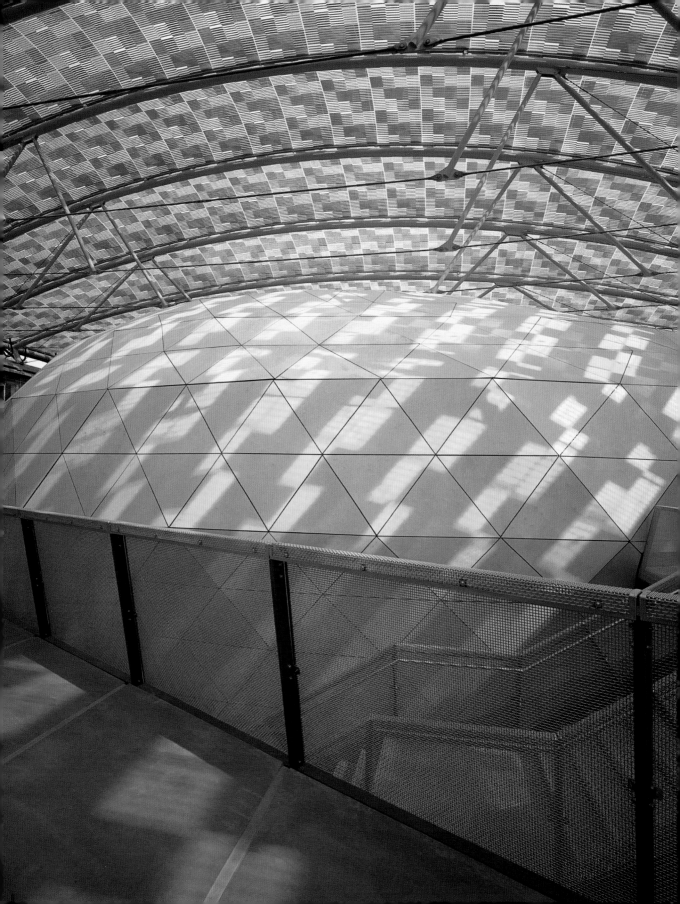

drmm

de Rijke Marsh Morgan Ltd, 1 Centaur Street, London SE1 7EG

P +44 20 7803 0777

F +44 20 7803 0666

www.drmm.co.uk

mail@drmm.co.uk

Conceptual clarity and innovative construction methods are key features of the designs by drmm. The company dedicates itself to all its projects, large and small, with the same energy and commitment. The architects seek special and unique solutions for every task and client. The conversion of Kingsdale School, a style icon of the late fifties, has received particular attention. Following its refurbishment and extension by drmm, it is now once more a shining example of a modern school building.

Konzeptionelle Klarheit und innovative Bauweisen kennzeichnen die Entwürfe von drmm. Das Büro widmet sich kleinen und großen Projekten mit gleicher Energie und Hingabe – für jede Aufgabe und jeden Bauherrn suchen die Architekten spezielle, einzigartige Lösungen. Besondere öffentliche Aufmerksamkeit erfuhr der Umbau der Kingsdale School, einer Stil-Ikone aus den späten fünfziger Jahren, die durch die Sanierungen und Ergänzungen von drmm wieder zu einem beispielhaften, modernen Schulgebäude wurde.

La clarté de la conception et des méthodes de construction innovatrices caractérisent les projets de drmm. Le cabinet se consacre aux petits et grands projets avec une énergie et un dévouement similaires – pour chaque objectif et chaque maître d'ouvrage, les architectes recherchent des solutions spécifiques uniques. Le public a porté une attention particulière à la transformation de la Kingsdale School, une icône de la fin des années cinquante en matière de style, qui est redevenue un bâtiment scolaire moderne et exemplaire grâce aux réhabilitations et agrandissements de drmm.

La claridad de concepción y las formas de construcción innovadoras son las marcas de estilo de los bocetos de drmm. El estudio se consagra a proyectos de pequeña o de gran envergadura con la misma energía y dedicación. Los arquitectos se encargan de buscar soluciones especiales y únicas para cada labor y para cada contratista. Uno de los proyectos que han sido objeto de la atención pública fue la reconstrucción de la Kingsdale School, un icono estilístico de finales de los cincuenta, que a través del saneamiento y la ampliación llevada a cabo por drmm volvió a convertirse en un edificio escolar ejemplar y moderno.

Le creazioni di drmm sono caratterizzate da chiarezza progettuale e modalità di costruzione innovative. Lo studio si dedica con uguale energia e passione a progetti grandi e piccoli: per ogni incarico e ogni committente, gli architetti cercano soluzioni speciali, uniche. Particolare interesse pubblico ha destato la ristrutturazione della Kingsdale School, una delle icone stilistiche dei tardi anni Cinquanta, che grazie ai lavori di risanamento e integrazione attuati da drmm è tornata ad essere un edificio scolastico esemplare e moderno.

Alex de Rijke

1960
born in the UK

Philip Marsh

1966
born in the UK

Sadie Morgan

1969
born in the UK

1995
drmm

Interview | Alex de Rijke

How would you describe the basic idea behind your design work? Our work focuses on content rather than form. We look for correlation between particular materials, contexts and uses, in order to make extraordinary architecture from the ordinary constraints and components of the construction industry.

To what extent does working in London inspire your creativity? Only in the sense that it's hard to succeed here, so you try harder. Like in the Wild West your aim has to be good, or you die.

Is there a typical London style in contemporary architecture? There are 33,000 registered architects in the UK. Most are in London doing a kind of polite modernism without the social programme or cutting edge technical exploration.

Which project is so far the most important one for you? Currently, my Naked House flatpack housing prototype is being built. We've recently completed Kingsdale School in London, a long and complex project with many levels of experiment and innovation.

Wie würden Sie die Grundidee beschreiben, die hinter Ihren Entwürfen steht? Unsere Entwürfe sind mehr vom Inhalt als von der Form bestimmt. Wir suchen nach Übereinstimmungen zwischen bestimmten Materialien, Zusammenhängen und Nutzungen, um mit den normalen Mitteln und unter den üblichen Zwängen der Bauindustrie außergewöhnliche Architektur zu entwickeln.

Inwiefern inspiriert London Ihre kreative Arbeit? Nur insofern, dass es schwer ist, hier Erfolg zu haben. Also arbeitet man umso härter. Es ist wie im Wilden Westen: Entweder man zielt gut, oder man stirbt.

Gibt es einen typischen Londoner Stil in der aktuellen Architektur? Es gibt über 33.000 registrierte Architekten in Großbritannien. Die meisten davon sind in London, wo sie eine Art vornehmen Modernismus ohne sozialen Anspruch oder technische Innovationen praktizieren.

Welches ist für Sie Ihr bislang wichtigstes Projekt? Zurzeit wird gerade der Prototyp meines Naked-House-Fertighauses errichtet. Außerdem haben wir kürzlich die Kingsdale School in London fertiggestellt, ein langwieriges und komplexes Projekt, bei dem wir auf verschiedenen Ebenen experimentieren und innovativ sein konnten.

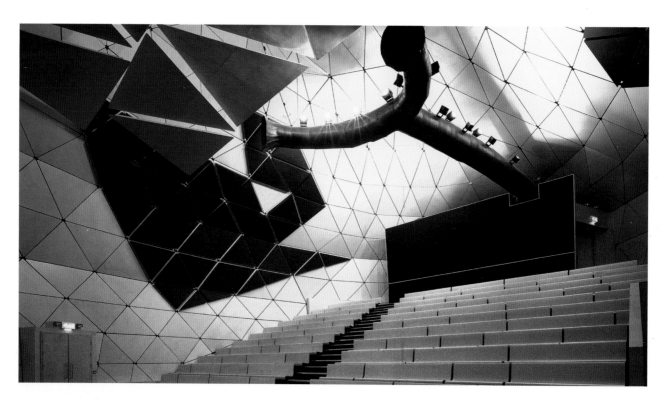

Quelle est, d'après vous, l'idée de base qui sous-tend votre travail de conception ? Nos projets se concentrent davantage sur le fond que sur la forme. Nous recherchons l'équilibre entre des matériaux, des contextes et des utilisations donnés pour développer une architecture exceptionnelle avec des moyens normaux et sous les contraintes habituelles de l'industrie du bâtiment.

Dans quelle mesure Londres inspire-t-il votre créativité ? Seulement dans la mesure où il est difficile d'avoir du succès ici. C'est pourquoi on travaille d'autant plus dur. C'est comme au Far West : soit on vise bien, soit on meurt.

Y a-t-il un style typiquement londonien dans l'architecture contemporaine ? Il y a plus de 33.000 architectes inscrits au registre en Grande-Bretagne. La plupart d'entre eux sont à Londres, où ils pratiquent une sorte de modernisme distingué sans prétention sociale ni innovations techniques.

Quel est le projet le plus important pour vous à l'heure actuelle ? Actuellement, le prototype de ma maison préfabriquée, Naked House, est en train d'être érigé. De plus, nous avons récemment terminé la Kingsdale School à Londres, un projet long et complexe sur lequel nous avons eu la possibilité d'expérimenter et d'innover à plusieurs niveaux.

¿Cómo definiría la idea básica que encierran sus diseños? Nuestros diseños se rigen más por el contenido que por la forma. Buscamos afinidades entre materiales determinados, vínculos y usos, para desarrollar una arquitectura atípica empleando los medios comunes y las exigencias normales de la industria de la construcción.

¿En qué medida inspira la ciudad de Londres su trabajo creativo? Sólo en el sentido de que aquí es difícil alcanzar el éxito. De ahí que se trabaje aún más duro. Es como en el lejano Oeste, dar en el blanco o morir.

¿Existe un estilo típico londinense en la arquitectura actual? En Gran Bretaña hay más de 33.000 arquitectos colegiados. Las mayoría de ellos está en Londres y practica una especie de modernismo distinguido sin pretensiones sociales o innovaciones técnicas.

¿Cuál ha sido su proyecto más importante hasta el momento? Actualmente se está construyendo el prototipo de mi casa prefabricada Naked House. Hace poco hemos concluido además la Kingsdale School en Londres, un proyecto largo y complejo en el que pretendíamos experimentar e innovar en diversos ámbitos.

Come descriverebbe l'idea originaria che sta alla base delle Sue creazioni? I nostri progetti sono definiti più dal contenuto che dalla forma. Noi cerchiamo correlazioni tra determinati materiali, contesti e utilizzi per poter sviluppare un'architettura fuori dal comune, pur usando i normali mezzi ed essendo soggetti alle comuni costrizioni dell'industria edile.

In che misura Londra ispira la Sua creatività? Solo nel senso che qui è difficile avere successo, e quindi si lavora ancora più duramente. È come nel Far West: o miri bene o muori.

Esiste uno stile tipico di Londra nell'architettura contemporanea? In Gran Bretagna vi sono più di 33.000 architetti registrati. Per la maggior parte hanno sede a Londra, dove praticano una sorta di signorile modernismo, privo di ambizioni sociali e di innovazioni tecniche.

Qual è per Lei il più importante tra i progetti realizzati finora? Attualmente è in costruzione il prototipo del mio prefabbricato Naked House. Inoltre abbiamo recentemente portato a termine i lavori alla Kingsdale School di Londra, un progetto lungo e complesso, durante il quale abbiamo potuto fare esperimenti ed essere innovativi a vari livelli.

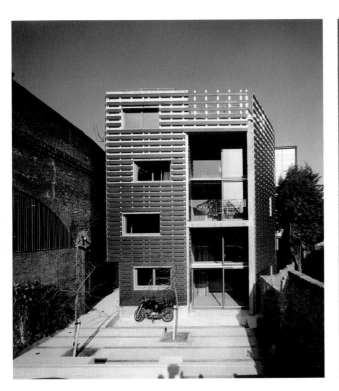

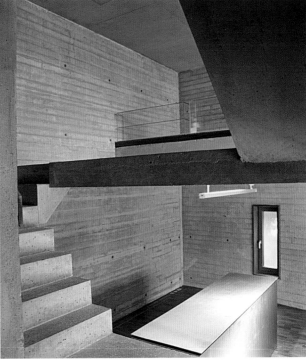

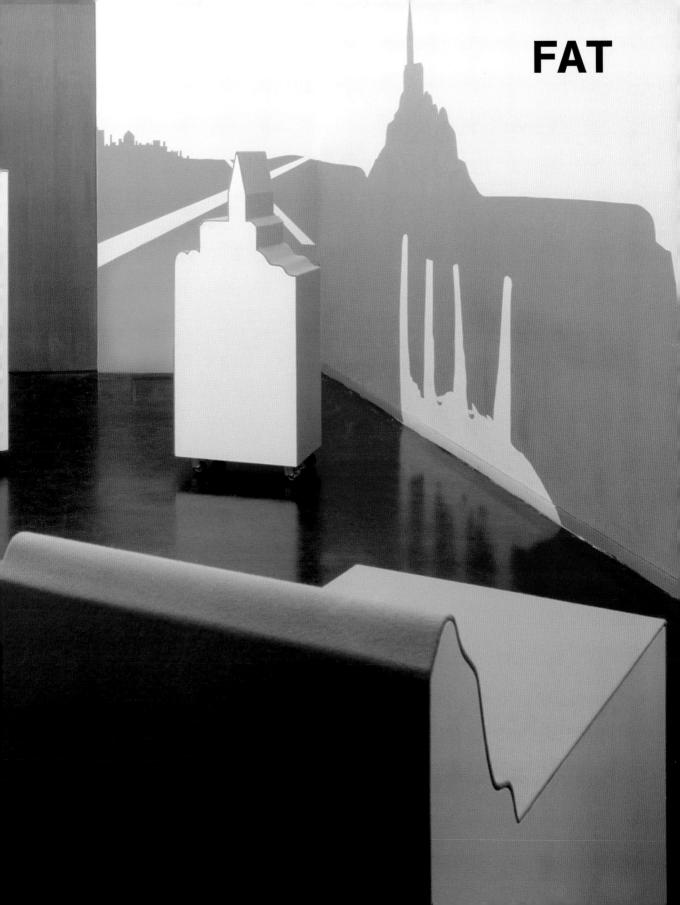

FAT

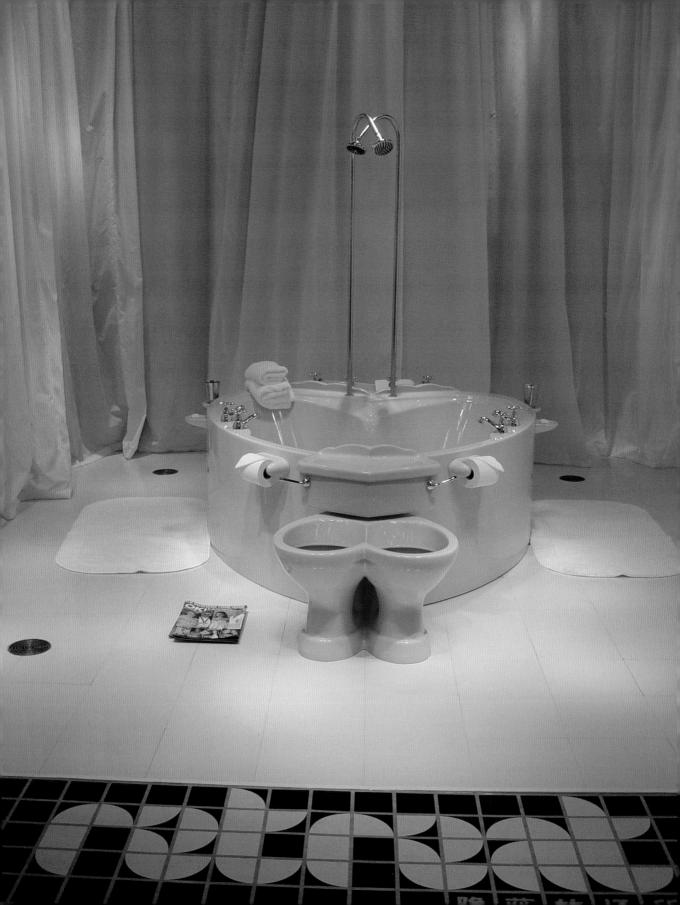

FAT

Appletree Cottage, 116–120 Golden Lane, London EC1Y OTL

P +44 20 7251 6735

F +44 20 7251 6738

www.fat.co.uk

fat@fat.co.uk

Sean Griffith

1966
born in Liverpool, UK

1997
FAT

By their own admission, FAT produce architecture, art and everything in between. Their aim is to investigate the leeway between creativity and commerce and to find strategies and solutions that combine conceptual desire, social relevance and aesthetic expression. Projects such as the Blue House prove that FAT's provocative and often shrill designs can be carried out with absolute ease.

FAT produzieren, wie sie selbst sagen, Architektur, Kunst und alles Mögliche dazwischen. Ihr Anspruch ist es, die Spielräume zwischen Kreativität und Kommerz zu erkunden und dabei Strategien und Lösungen zu finden, in denen sich konzeptioneller Anspruch, gesellschaftliche Relevanz und ästhetischer Ausdruck verbinden lassen. Projekte wie beispielsweise das Blue House beweisen, dass sich die oftmals schrillen, provokativen Entwürfe von FAT durchaus realisieren lassen.

FAT produisent, comme ils le disent eux-mêmes, de l'architecture, de l'art et tout ce qu'il y a entre les deux. Leur but est d'explorer la marge de manœuvre entre créativité et commerce et de trouver des stratégies et des solutions qui allient l'exigence conceptuelle, la pertinence sociale et l'expression esthétique. Des réalisations tels que la Blue House, par exemple, prouvent que les projets souvent tapageurs et provocateurs de FAT sont absolument faisables.

FAT producen, como afirman ellos mismos, arquitectura, arte y todo lo posible entre medias. Sus requisitos se basan en explorar los márgenes de juego entre la creatividad y la comercialización y al mismo tiempo encontrar estrategias y soluciones, en las que sea posible vincular los requerimientos creativos, la relevancia social y la expresión estética. Trabajos tales como la Blue House demuestran que los proyectos de FAT, con frecuencia llamativos y provocadores, son sin lugar a duda siempre realizables.

Gli architetti della FAT producono, come essi stessi dichiarano, architettura, arte e ogni possibile espressione intermedia. Li ispira l'intento di esplorare gli ambiti d'interazione tra creatività e commercio, trovando strategie e soluzioni in cui sia possibile fondere aspirazioni progettuali, rilevanza sociale ed espressione estetica. Progetti come, per esempio, il Blue House dimostrano quanto le creazioni spesso appariscenti e provocatorie di FAT siano perfettamente realizzabili.

Interview | FAT

How would you describe the basic idea behind your design work? Our idea is to find things that have nothing to do with architecture and turn them into architecture.

To what extent does working in London inspire your creativity? There's not much "good design" in London which inspires us to provide a much needed antidote to good design.

Is there a typical London style in contemporary architecture? There are probably about three to four different styles. Thankfully none of them has anything to do with our work.

Which project is so far the most important one for you? We are very unsuccessful and don't have many projects. Therefore all of them are the most important.

Wie würden Sie die Grundidee beschreiben, die hinter Ihren Entwürfen steht? Unsere Idee ist es, Dinge zu finden, die nichts mit Architektur zu tun haben und diese in Architektur zu verwandeln.

Inwiefern inspiriert London Ihre kreative Arbeit? Es gibt nicht viel „gutes Design" in London, das uns zur Herstellung des dringend benötigten Gegengifts für gutes Design inspirieren könnte.

Gibt es einen typischen Londoner Stil in der aktuellen Architektur? Wahrscheinlich gibt es etwa drei oder vier unterschiedliche Stile. Zum Glück hat keiner davon etwas mit unserer Arbeit zu tun.

Welches ist für Sie Ihr bislang wichtigstes Projekt? Wir sind ziemlich erfolglos und haben nur wenige Projekte. Darum ist jedes Projekt für uns das wichtigste.

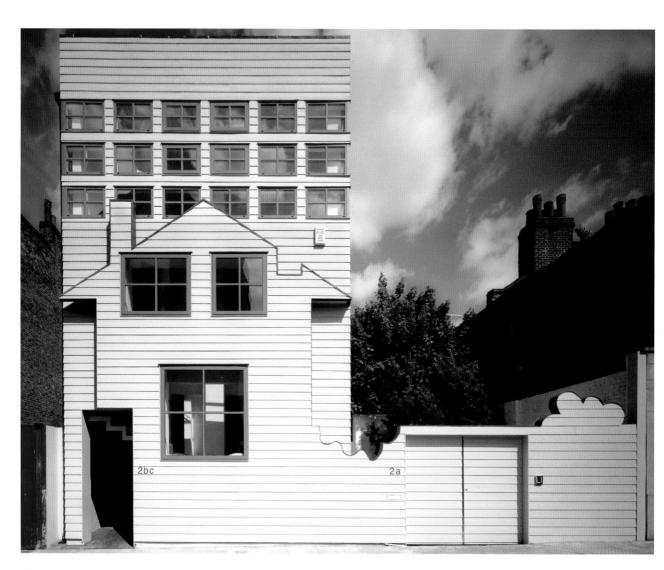

Quelle est, d'après vous, l'idée de base qui sous-tend votre travail de conception ? Notre idée est de trouver des choses qui n'ont rien à voir avec l'architecture et de les transformer en architecture.

Dans quelle mesure Londres inspire-t-il votre créativité ? Il n'y a pas beaucoup de « bon design » à Londres, qui pourrait nous inspirer à produire l'antidote si nécessaire au bon design.

Y a-t-il un style typiquement londonien dans l'architecture contemporaine ? Il y a vraisemblablement trois ou quatre styles différents. Par chance, aucun d'eux n'a quelque chose à voir avec notre travail.

Quel est le projet le plus important pour vous à l'heure actuelle ? Nous avons très peu de succès et seulement quelques projets. C'est pourquoi chaque projet est le plus important pour nous.

¿Cómo definiría la idea básica que encierran sus diseños? Nuestra idea es encontrar cosas que no tienen que ver con la arquitectura y transformarlas en arquitectura.

¿En qué medida inspira la ciudad de Londres su trabajo creativo? En Londres no hay demasiado "buen diseño" que nos pudiera inspirar a buscar urgentemente un antídoto contra el buen diseño.

¿Existe un estilo típico londinense en la arquitectura actual? Probablemente existan tres o cuatro estilos diferentes. Afortunadamente ninguno de ellos tiene que ver con nuestro trabajo.

¿Cuál ha sido su proyecto más importante hasta el momento? Apenas tenemos éxito y contamos con pocos proyectos. De ahí que para nosotros cada proyecto sea primordial.

Come descriverebbe l'idea originaria che sta alla base delle Sue creazioni? La nostra idea ispiratrice è di trovare cose che non hanno nulla a che fare con l'architettura per trasformarle in architettura.

In che misura Londra ispira la Sua creatività? A Londra non c'è molto "buon design" che sia in grado di ispirarci a produrre il tanto necessario antidoto al buon design.

Esiste uno stile tipico di Londra nell'architettura contemporanea? Probabilmente ci sono circa tre o quattro stili diversi. Per fortuna nessuno di questi ha a che fare con il nostro lavoro.

Qual è per Lei il più importante tra i progetti realizzati finora? Abbiamo scarso successo e solo pochi progetti, quindi per noi ogni progetto è il più importante.

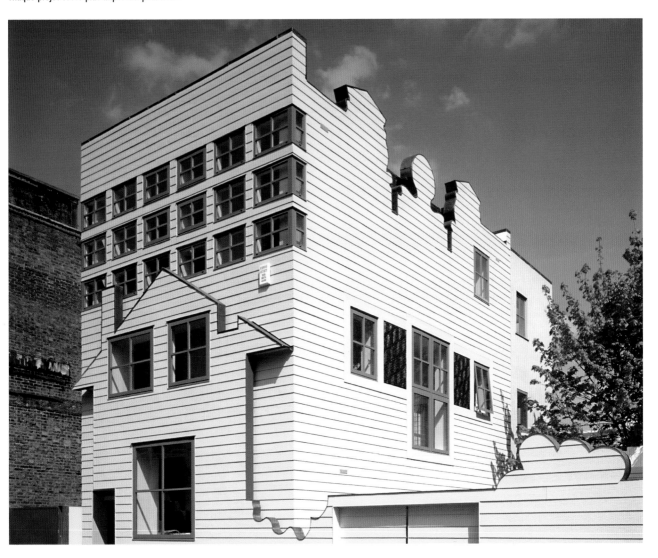

FAT | Blue House 2002

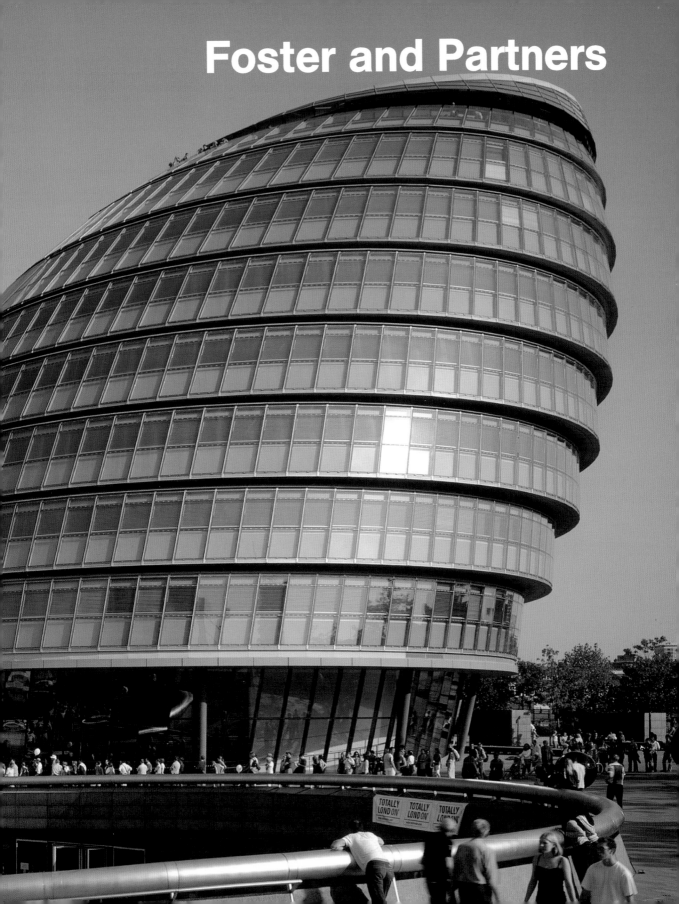

Foster and Partners

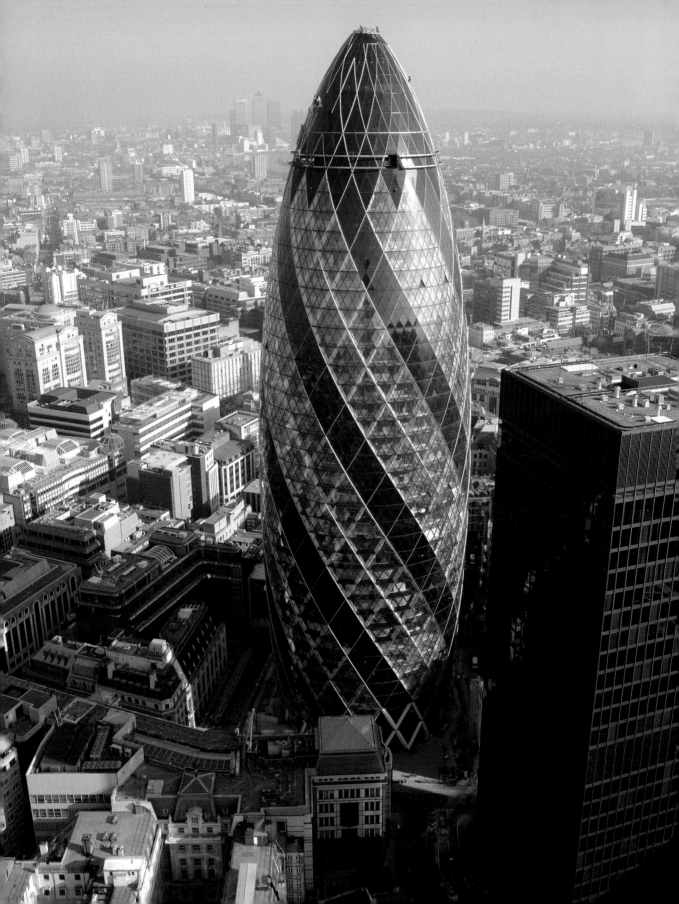

Foster and Partners

Riverside Three, 22 Hester Road, London SW11 4AN

P +44 20 7738 0455

F +44 20 7738 1107

www.fosterandpartners.com

enquiries@fosterandpartners.com

Lord Norman Foster

1935
born in Manchester, UK

1963
Team Four

1967
Foster Associates

1999
Foster and Partners

Lord Norman Foster is one of the most successful contemporary architects in the world. Founded in London in 1967, his office has developed into a global player with projects in 48 countries. However, Foster and Partners have always had the same base and head office close to the Thames, where numerous architects, engineers and designers work in a vast hall, seeking innovative solutions for a wide range of projects.

Lord Norman Foster zählt zu den weltweit erfolgreichsten Architekten der Gegenwart. 1967 in London gegründet, entwickelte sich sein Büro bis heute zu einem echten Global Player mit Projekten in 48 Ländern der Erde. Basis und Hauptquartier von Foster and Partners ist aber bis heute ihr eigenes Bürogebäude, unmittelbar an der Themse, in dem unzählige Architekten, Ingenieure und Designer in einem riesigen Arbeitssaal nach innovativen Lösungen für die unterschiedlichsten Projekte suchen.

Lord Norman Foster compte parmi les architectes contemporains les plus couronnés de succès au monde. Fondé à Londres en 1967, son cabinet est devenu au fil du temps un véritable « global player » avec des projets dans 48 pays au monde. Jusqu'à maintenant, la base et le quartier général de Foster and Partners est leur propre cabinet directement sur la Tamise, où d'innombrables architectes, ingénieurs et designers recherchent, dans une immense salle de travail, des solutions innovantes pour les projets les plus variés.

Lord Norman está considerado actualmente uno de los arquitectos de mayor éxito a escala mundial. En 1967 inauguró su estudio de Londres, que a lo largo del tiempo se ha ido convirtiendo en una auténtico "jugador internacional" con proyectos en 48 países del mundo. La base y cuartel general de Foster and Partners sigue siendo sin embargo hasta hoy su edificio de oficinas propio a orillas del Támesis. En la enorme sala de trabajo innumerables arquitectos, ingenieros y diseñadores se lanzan a la búsqueda de soluciones innovadoras para los más diversos proyectos.

Lord Norman Foster è uno degli architetti contemporanei di maggior successo a livello mondiale. Fondato nel 1967 a Londra, il suo studio è cresciuto fino a divenire un vero global player, con progetti in 48 paesi diversi. Base e quartiere generale della Foster and Partners è però ancora oggi l'edificio sede dello studio, situato direttamente sul Tamigi, dove, in una gigantesca sala, innumerevoli architetti, ingegneri e designer si dedicano alla ricerca di soluzioni innovative per i progetti più svariati.

Swiss Re Headquarters

Year: 1997–2004

Location: 30 St Mary Axe, London EC3

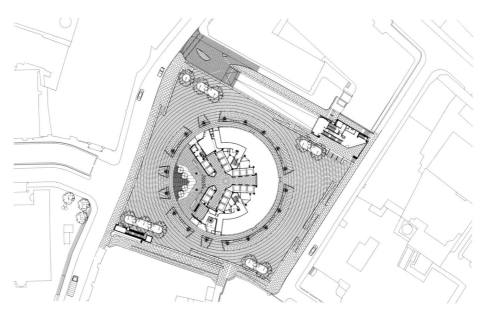

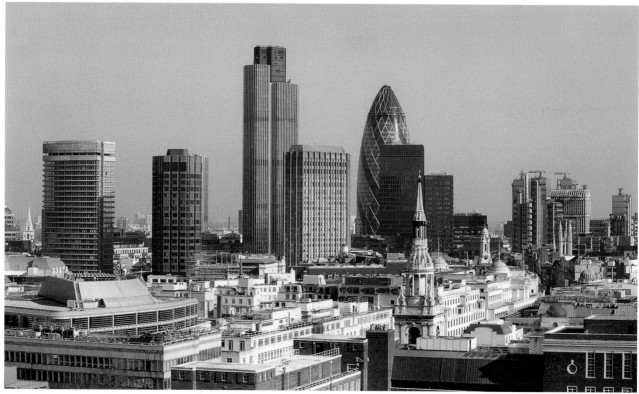

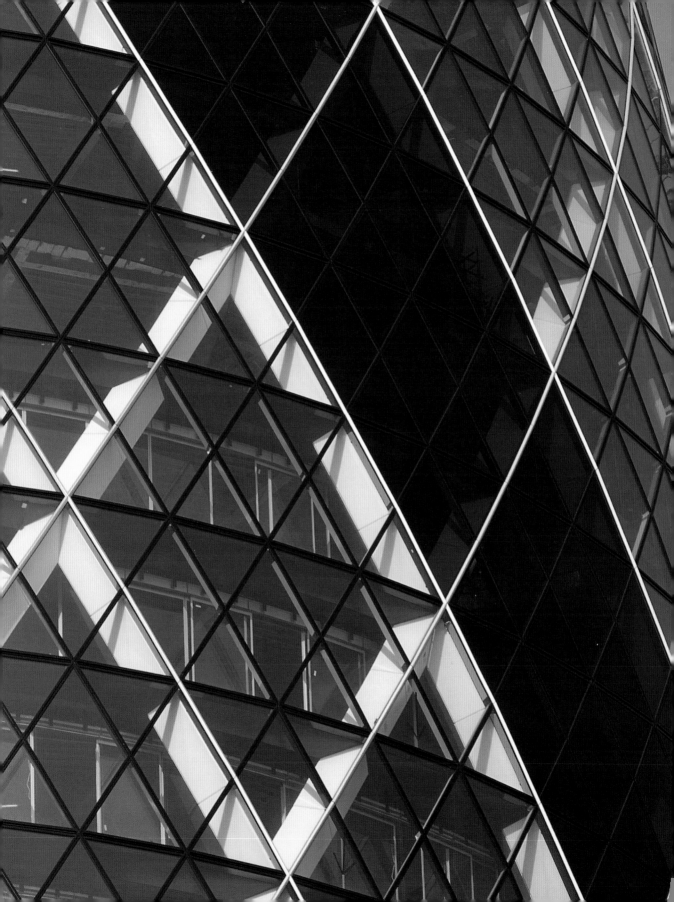

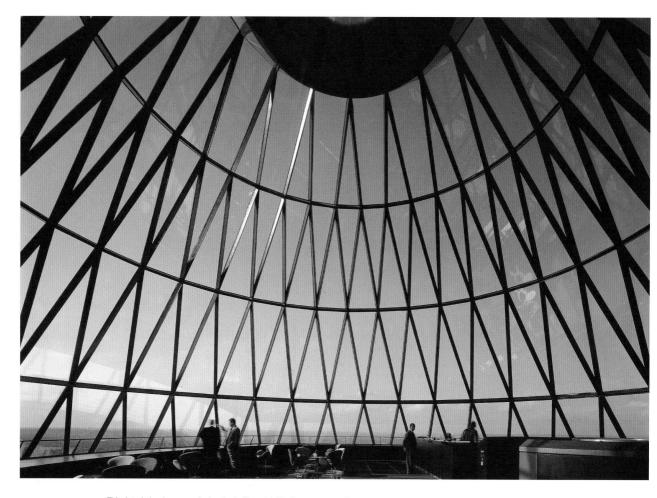

This futuristic skyscraper in London's Financial District was soon given an entirely appropriate nickname: the Gherkin – entirely understandable in view of the particular design of the building. The structure is also the city's first-ever ecological multi-storey building.

Das futuristische Hochhaus in Londons Financial District erhielt schnell einen Spitznamen: The Gherkin – die Gurke – eine Bezeichnung, die angesichts der speziellen Formensprache leicht nachvollziehbar ist. Darüber hinaus gilt der Bau als das erste Öko-Hochhaus der Stadt.

Ce building futuriste du quartier des affaires de Londres a été immédiatement baptisé The Gherkin – « le concombre » – une comparaison évidente, vu sa forme spéciale très expressive. Celui-ci est en outre considéré comme le premier immeuble écologique de la ville.

Esta futurista torre ubicada en el Financial District de Londres recibió en seguida un mote: The Gherkin, el pepino; una denominación fácil de entender dada la especial forma del edificio. Además es considerado el primer rascacielos ecológico de la ciudad.

Il futuristico grattacielo che sorge nel Financial District di Londra non ha tardato a guadagnarsi il nomignolo di "The Gherkin" (il cetriolo): un appellativo di cui è facile comprendere il motivo, considerando il suo particolare linguaggio formale. Da notare, inoltre, che questo edificio è considerato il primo grattacielo ecologico della città.

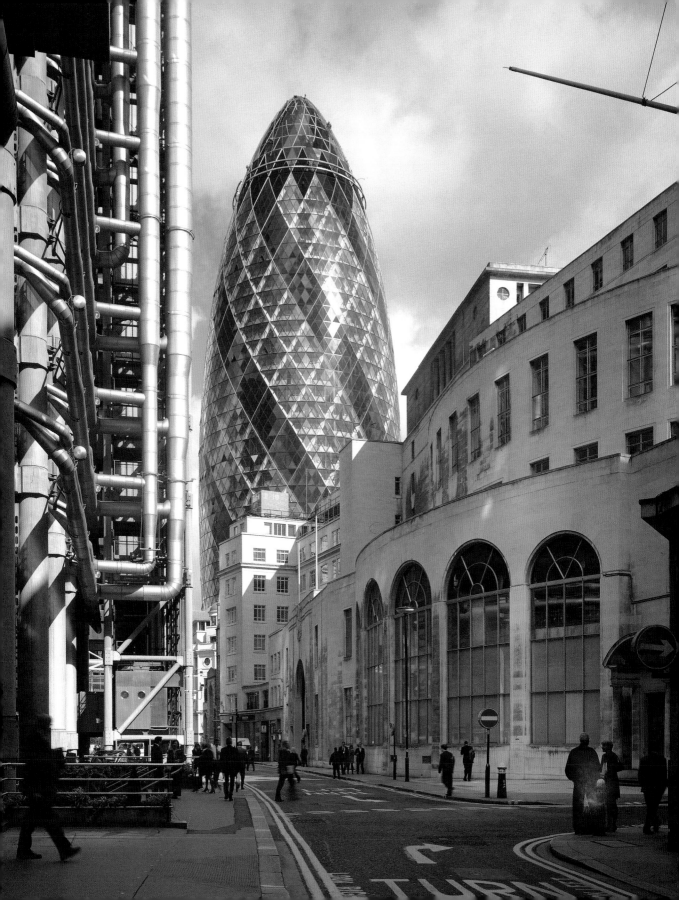

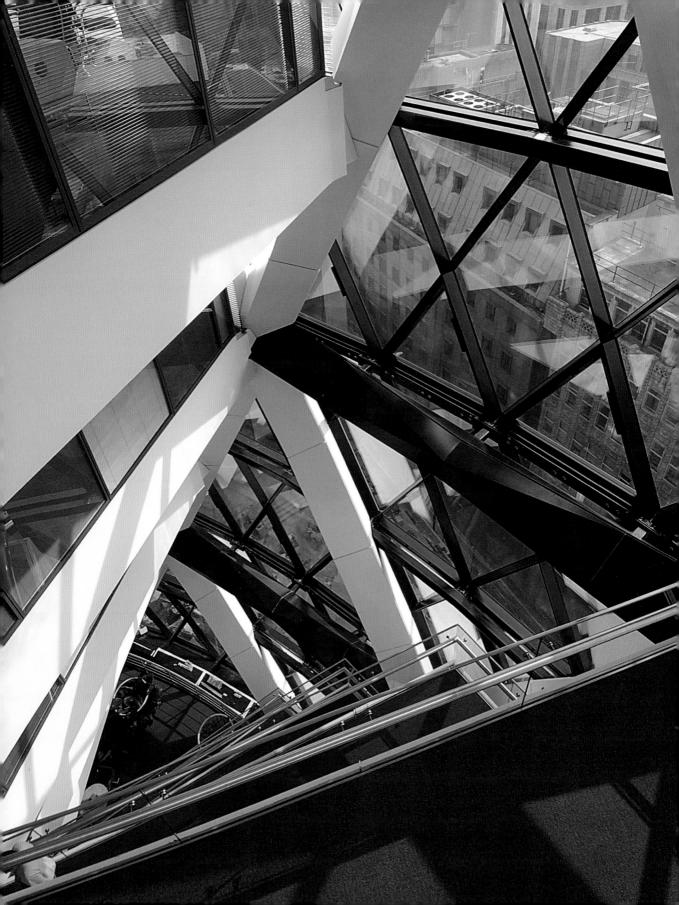

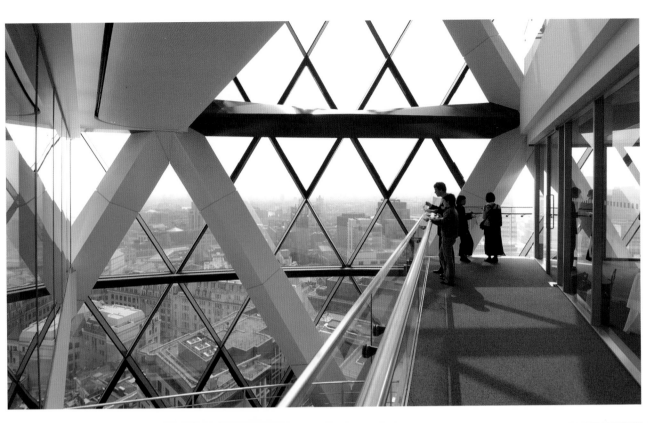

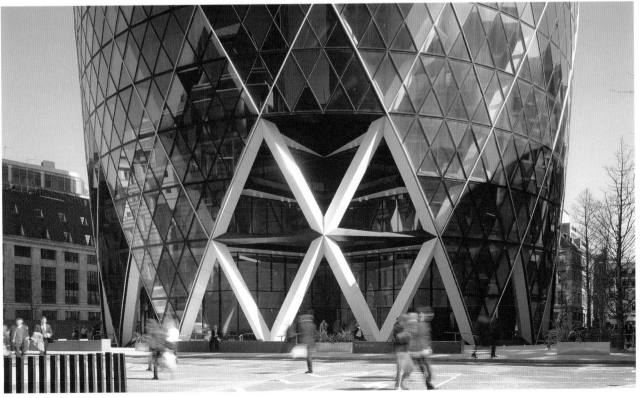

Imperial College Faculty Building

Year: 2004

Location: South Kensington Campus, London SW7

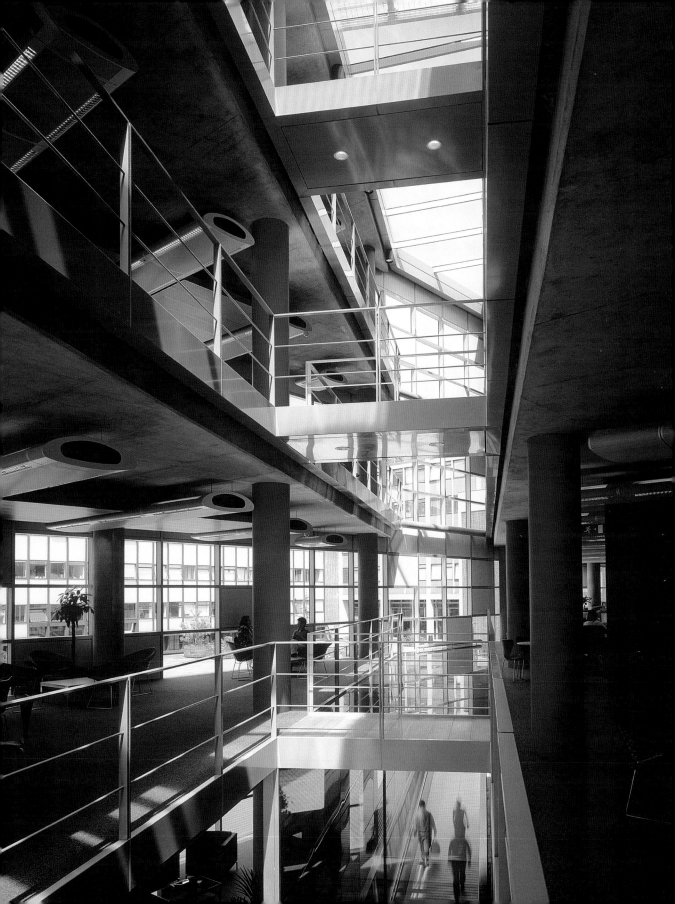

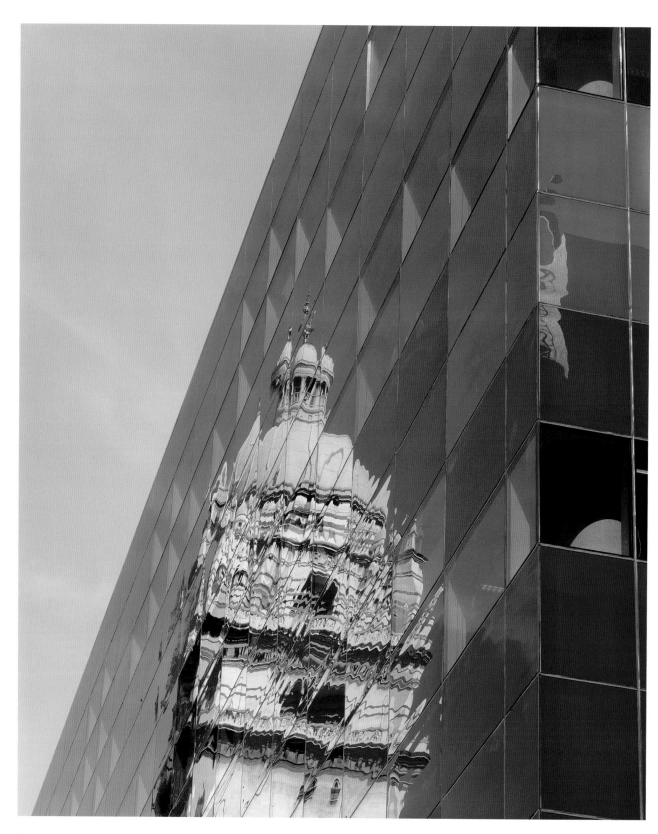

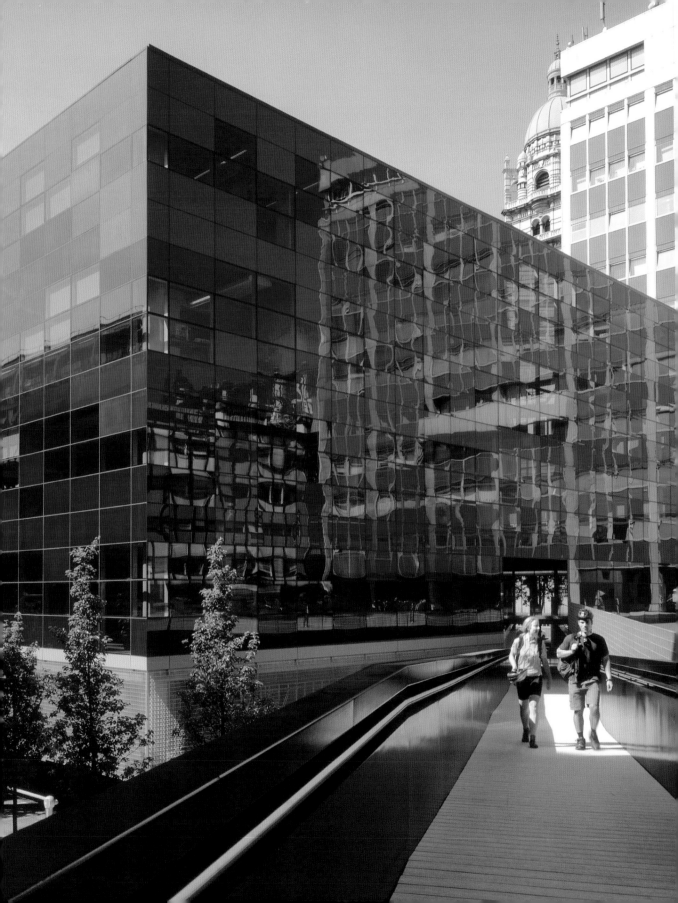

Tanaka Business School

Year: 2004

Location: Exhibition Road, South Kensington Campus, London SW7

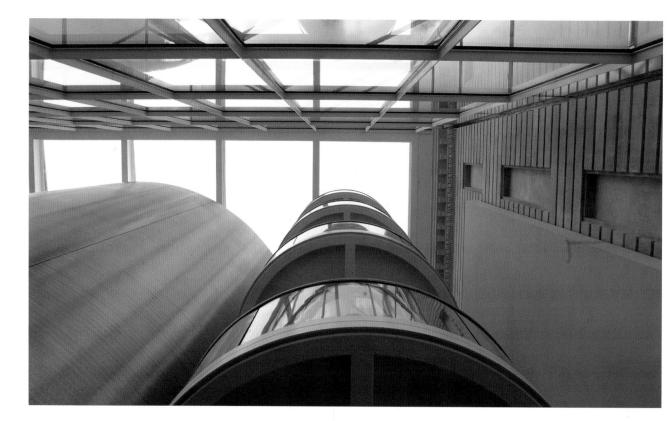

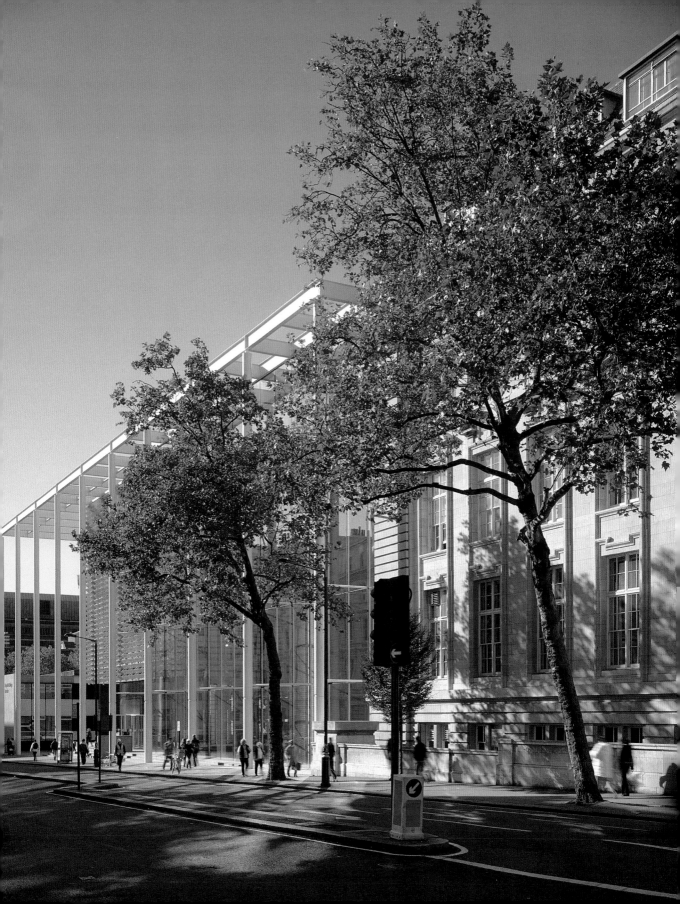

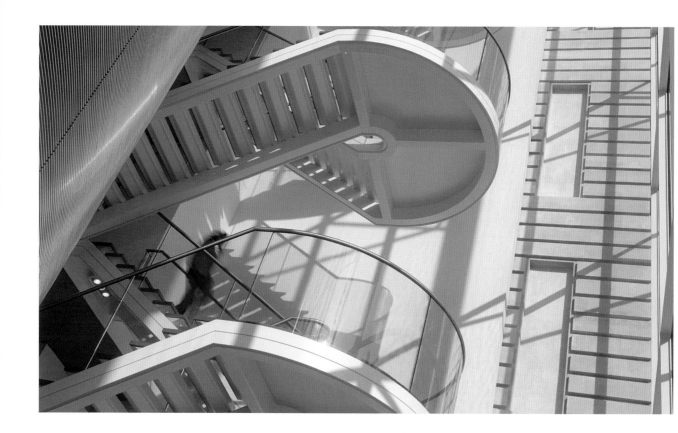

This elegant new building houses the classrooms of the Tanaka Business School. The school's offices are in a listed neighbouring building. The new building has been carefully designed to match the proportions of the old structure.

Der elegante Neubau bietet den Unterrichtsräumen der Tanaka Business School Platz. Die dazugehörigen Bürobereiche befinden sich in einem denkmalgeschützten Nachbargebäude. Mit großer Sorgfalt wurde das neue Gebäude auf die Proportionen des Altbaus abgestimmt.

Cette élégante construction neuve abrite les salles de cours de la Tanaka Business School. Ses bureaux administratifs se trouvent dans un bâtiment voisin, classé monument historique. L'architecte a veillé avec grand soin à harmoniser les proportions du nouvel immeuble avec celles de l'ancien.

La nueva y elegante construcción ofrece espacio a las aulas de la Tanaka Business School. A ello se suma un recinto de oficinas ubicadas en el edificio vecino, considerado patrimonio nacional. El nuevo edificio ha sido adaptado cuidadosamente a las proporciones del antiguo.

Nei locali dell'elegante edificio di nuova costruzione hanno luogo i corsi della Tanaka Business School, i cui uffici invece si trovano in un attiguo edificio sottoposto a tutela monumentale. Si è proceduto con grande accuratezza ad armonizzare le linee dell'edificio moderno con le proporzioni dell'edificio storico.

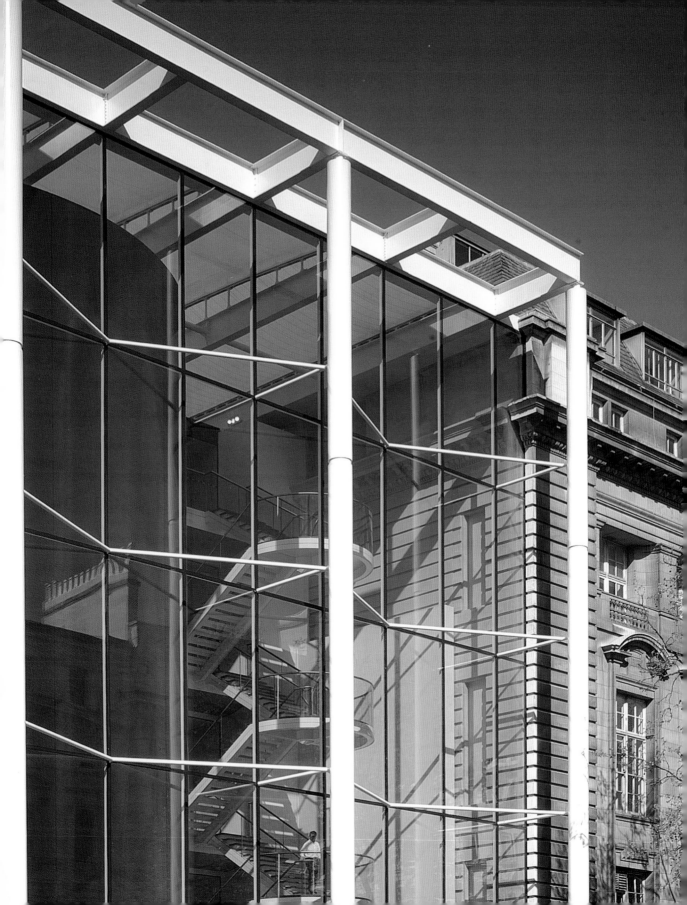

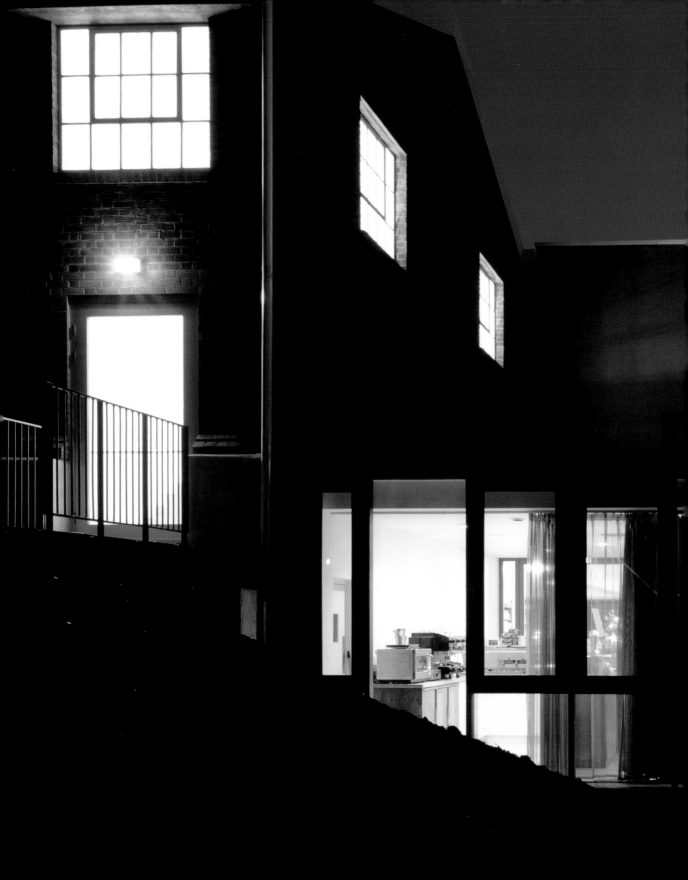

Tony Fretton Architects

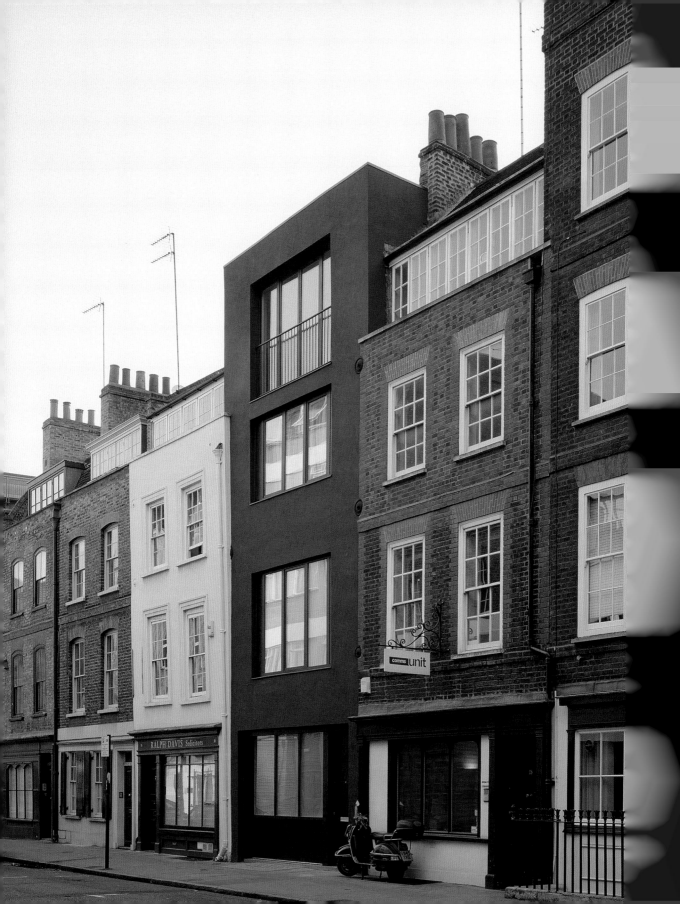

Tony Fretton Architects

109–123 Clifton Street, London EC2A 4LD

P +44 20 7729 2030

F +44 20 7729 2050

www.tonyfretton.com

admin@tonyfretton.com

Tony Fretton

1945
born in London, UK

1982
Tony Fretton Architects

Tony Fretton is regarded as the spiritual prophet of the British minimalists. He has been influenced by artists such as Sol Lewitt and Donald Judd. Fretton's conversion and new construction for the Lisson Gallery in North West London created a huge stir in the mid-nineties. Besides working as an architect, Tony Fretton is a highly influential teacher and tutor of international renown.

Tony Fretton gilt als geistiger Vordenker der britischen Minimalisten. Dabei ist er beeinflusst von Künstlern wie Sol Lewitt oder Donald Judd. Besondere Aufmerksamkeit erregte Mitte der neunziger Jahre Fretton's Um- und Neubau für die Lisson Gallery im Nordwesten Londons. Neben seiner Arbeit als Architekt ist Tony Fretton ein höchst einflussreicher Lehrer und Tutor von internationalem Ruf.

Tony Fretton passe pour le maître à penser des minimalistes britanniques. Pourtant, il est influencé par des artistes tels que Sol Lewitt ou Donald Judd. Au milieu des années quatre-vingt-dix, la restructuration et la nouvelle construction de la Lisson Gallery au nord-ouest de Londres par Fretton ont particulièrement attiré l'attention. Outre son activité d'architecte, Tony Fretton est un professeur et tuteur extrêmement influent, de réputation internationale.

Tony Fretton es considerado el precursor de los minimalistas británicos. Las influencias que ha percibido vienen de artistas como Sol Lewitt o Donald Judd. La reconstrucción y transformación de la Lisson Gallery en el noroeste de Londres llevada a cabo por Fretton causó especial interés a mediados de los años noventa. Además de sus actividades como arquitecto, Tony Fretton ejerce como uno de los docentes y tutores más influyentes a nivel internacional.

Tony Fretton, considerato il maître à penser dei minimalisti britannici, subisce l'influsso di artisti come Sol Lewitt o Donald Judd. Verso la metà degli anni Novanta suscitarono particolare attenzione i lavori di ristrutturazione e costruzione realizzati da Fretton per la Lisson Gallery nel nord-ovest di Londra. Oltre ad essere attivo come architetto, Tony Fretton è un insegnante molto influente ed un tutor universitario di fama internazionale.

Interview | Tony Fretton

How would you describe the basic idea behind your design work? We are interested in what our buildings can say and do in relation to the physical, cultural and social world around them and the personal experience of people who come in contact with them. We acknowledge that architecture, like film and literature, relies on shared conventional knowledge.

To what extent does working in London inspire your creativity? London offers an empirical, associative tradition of thought in which to design. Denmark and Holland, where we are now working, has a more structured European style of thought, and from that we have learned to work both creatively and strategically.

Is there a typical London style in contemporary architecture? London is a creative metropolis in which there are many different styles.

Which project is so far the most important one for you? There are two projects that have significance for us: The Camden Arts Centre because we have been able to make great gallery spaces and a real social venue. Fuglsang because the beauty of the locale and the social and regional value of its art collection inspired a serene building.

Wie würden Sie die Grundidee beschreiben, die hinter Ihren Entwürfen steht? Uns interessiert, wie sich unsere Gebäude in Bezug auf das physische, kulturelle und soziale Umfeld artikulieren, und die persönlichen Empfindungen ihrer Nutzer. Wir erkennen an, dass sich Architektur – ähnlich wie Film oder Literatur – auf ein geteiltes, gängiges Wissen bezieht.

Inwiefern inspiriert London Ihre kreative Arbeit? In London gibt es eine empiristische und assoziative Denktradition des Entwerfens. In Dänemark und Holland, wo wir zurzeit arbeiten, herrschen eher europäische Denkweisen vor. Von ihnen haben wir gelernt, zugleich kreativ und strategisch zu arbeiten.

Gibt es einen typischen Londoner Stil in der aktuellen Architektur? London ist eine kreative Metropole, in der es viele verschiedene Stile gibt.

Welches ist für Sie Ihr bislang wichtigstes Projekt? Zwei Projekte sind für uns von besonderer Bedeutung: Das Camden Arts Centre, weil wir dort großartige Ausstellungsräume und einen wichtigen gesellschaftlichen Treffpunkt schaffen konnten. Und Fuglsang, weil die Schönheit des Ortes und die gesellschaftliche und regionale Bedeutung seiner Kunstsammlung ein heiteres Gebäude inspirierten.

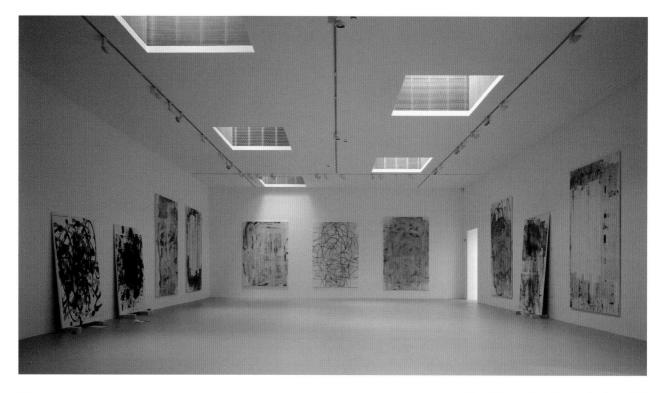

Quelle est, d'après vous, l'idée de base qui sous-tend votre travail de conception ? Ce qui nous intéresse, c'est de voir ce que nos bâtiments ont à exprimer dans leur environnement physique, culturel et social, et la façon personnelle dont les utilisateurs les perçoivent. Nous admettons que l'architecture, à l'instar du cinéma ou de la littérature, s'appuie sur un savoir commun courant.

Dans quelle mesure Londres inspire-t-il votre créativité ? A Londres, on pense traditionnellement le design par empirisme et associationnisme. Au Danemark et aux Pays-Bas où nous travaillons actuellement, il y a une façon de penser plus européenne, qui nous a appris à travailler à la fois de manière créative et stratégique.

Y a-t-il un style typiquement londonien dans l'architecture contemporaine ? Londres est une métropole créative où il y a de nombreux styles différents.

Quel est le projet le plus important pour vous à l'heure actuelle ? Deux projets revêtent pour nous une importance particulière : le Camden Arts Centre, parce que nous avons pu y créer de formidables salles d'exposition et un point de rencontre social important. Et Fuglsang, parce que la beauté du lieu et l'importance sociale et régionale de sa collection d'art ont inspiré un bâtiment plein de sérénité.

¿Cómo definiría la idea básica que encierran sus diseños? A nosotros nos interesa el modo en el que nuestros edificios se articulan con respecto al entorno físico, cultural y social y las apreciaciones personales de quienes hacen uso de él. Reconocemos que la arquitectura, al igual que el cine o la literatura, se basa en un conocimiento convencional compartido.

¿En qué medida inspira la ciudad de Londres su trabajo creativo? En Londres se da una tradición de pensamiento empírico y asociativo a la hora de diseñar. En Dinamarca y Holanda, en donde trabajamos actualmente, existe más bien una forma de pensamiento europeo. De ellos hemos aprendido a trabajar de modo creativo y estratégico a la vez.

¿Existe un estilo típico londinense en la arquitectura actual? Londres es una metrópoli creativa en la que existen muchos y diversos estilos.

¿Cuál ha sido su proyecto más importante hasta el momento? Para nosotros hay dos proyectos de especial importancia: el Camden Arts Centre, porque allí logramos crear fabulosos espacios de exposiciones y un importante punto de encuentro social; y Fuglsang, porque la belleza del lugar y la importancia social y regional de su colección de arte inspiraron un sereno edificio.

Come descriverebbe l'idea originaria che sta alla base delle Sue creazioni? Ci interessa il modo in cui i nostri edifici si articolano in relazione all'ambiente fisico, culturale e sociale circostante e il tipo di esperienza personale che ne fanno i loro utenti. Riconosciamo che l'architettura, come anche il cinema o la letteratura, fa riferimento ad un insieme di conoscenze comuni e condivise.

In che misura Londra ispira la Sua creatività? A Londra per il design esiste una scuola di pensiero empirica ed associativa, mentre in Danimarca e in Olanda, dove stiamo lavorando attualmente, dominano mentalità più tipicamente europee. È da queste ultime che abbiamo imparato a lavorare in modo creativo e strategico ad un tempo.

Esiste uno stile tipico di Londra nell'architettura contemporanea? Londra è una metropoli creativa, in cui esistono molti stili diversi.

Qual è per Lei il più importante tra i progetti realizzati finora? Due sono i progetti che per noi rivestono particolare importanza: il Camden Arts Centre, perché lì abbiamo potuto realizzare grandiosi spazi espositivi ed un importante punto di aggregazione sociale. E poi Fuglsang, perché la bellezza del luogo e l'importanza sociale e regionale della sua collezione d'arte ci hanno ispirato un edificio sereno.

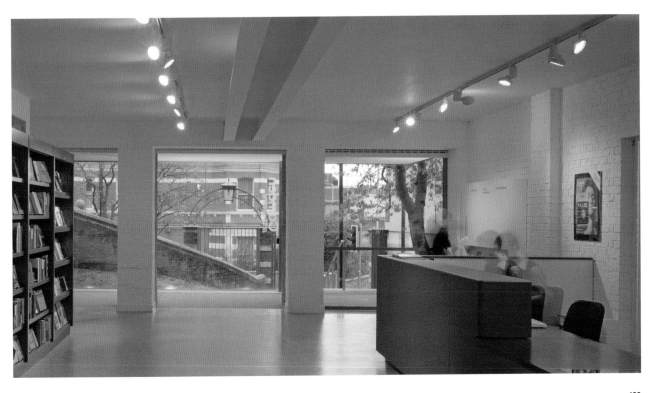

Tony Fretton Architects | Camden Arts Centre 2004

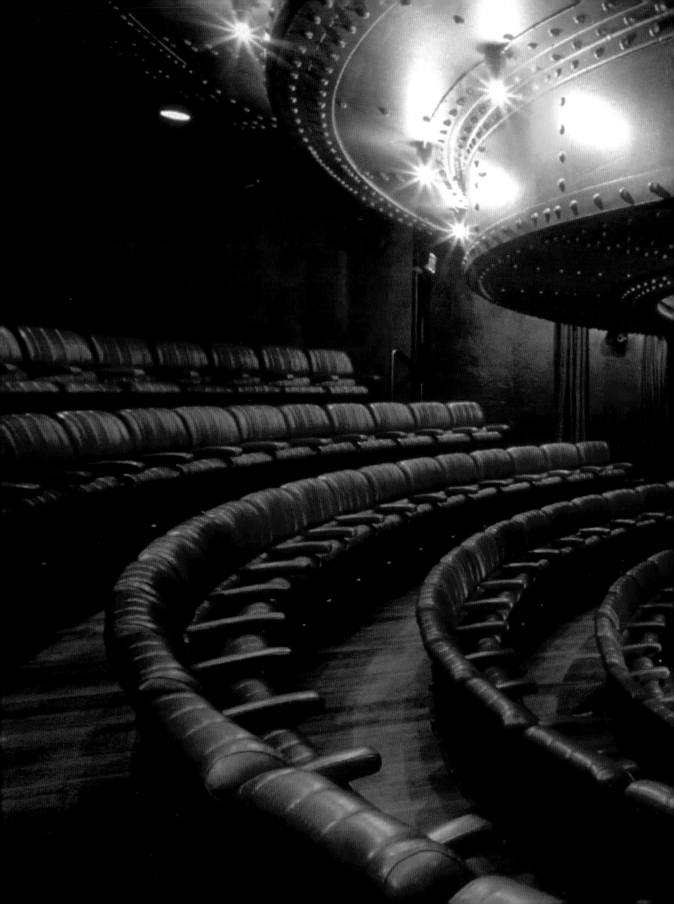

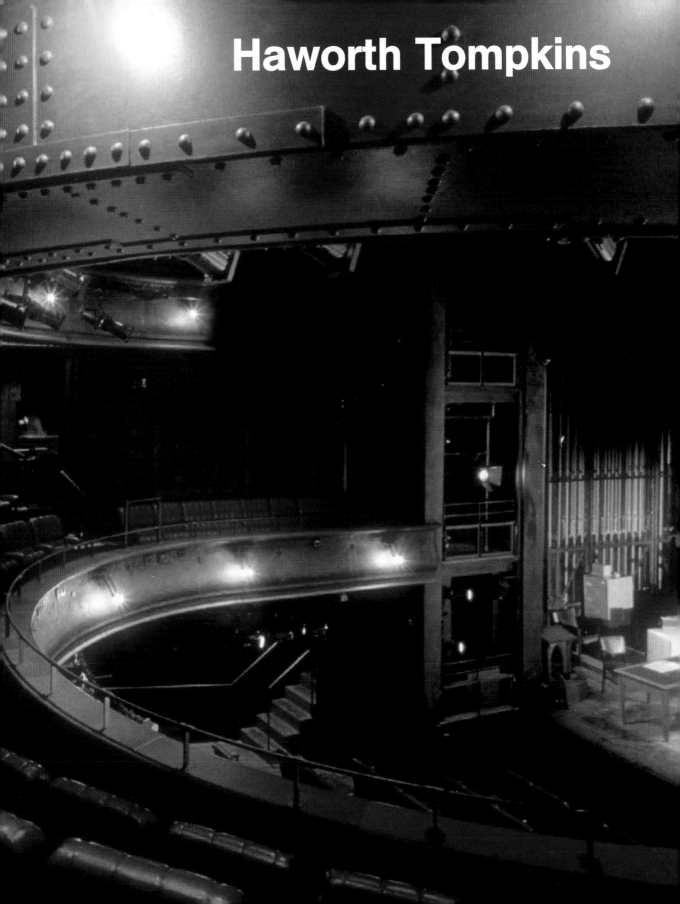

Haworth Tompkins

Haworth Tompkins

19–20 Great Sutton Street, London EC1V ODR

P +44 20 7250 3225

F +44 20 7250 3226

www.haworthtompkis.com

info@haworthtompkis.com

Graham Haworth

1960
born in Accrington, UK

Steve Tompkins

1959
born in Wellingborough, UK

1991
Haworth Tompkins

Haworth Tompkins have a wide range of tasks, from building private and council housing, offices and shops to schools and theatres. At Haworth Tompkins, the spirit of a place is the main consideration when planning a project, followed by the client's particular requirements and those of the construction task. Over recent years, the sustainability of their projects has been of increasing importance to Haworth Tompkins.

Haworth Tompkins haben ein weites Aufgabenspektrum, vom privaten und öffentlichen Wohnungsbau über Büros und Läden bis hin zu Schulen oder Theatern. Der Genius Loci jedes Projektes steht für Haworth Tompkins beim Entwurf an erster Stelle, dazu kommen die speziellen Anforderungen des Bauherrn und der Bauaufgabe. In den vergangenen Jahren haben Haworth Tompkins verstärkt Wert auf die Nachhaltigkeit ihrer Projekte gelegt.

Haworth Tompkins a un champ d'activités très étendu, de la construction de logements privés ou publics aux bureaux et magasins en passant par les écoles et les théâtres. Pour Haworth Tompkins, le genius loci de chaque projet est au premier plan dès la conception, à quoi s'ajoutent les exigences spécifiques du maître d'ouvrage et de l'objectif. Depuis quelques années, Haworth Tompkins accorde une importance croissante à la durabilité de ses projets.

La paleta de actividades de Haworth Tompkins abarca todos los campos, desde la construcción de viviendas privadas a la pública, pasando por edificios de oficinas, comercios, incluso escuelas y teatros. Para Haworth Tompkins la prioridad al hacer los bocetos de cada proyecto es el Genius Loci, a ello se unen las exigencias específicas de cada contratista y la tarea de construcción. Desde hace algunos años Haworth Tompkins hace especial hincapié en la durabilidad de sus proyectos.

La Haworth Tompkins ha un ampio spettro di attività, che spazia dall'edilizia abitativa pubblica e privata ad uffici e negozi fino alla progettazione di scuole e teatri. In fase di ideazione, per questo studio di architetti ha la priorità il genius loci del singolo progetto, subito seguito dalle speciali esigenze poste dal committente e dal tipo di progetto edilizio. Da alcuni anni la Haworth Tompkins presta particolare attenzione alla sostenibilità ambientale dei suoi progetti.

Interview | Haworth Tompkins

How would you describe the basic idea behind your design work? We have learned to be open to unconventional ways of working and to avoid pre-conception. The resilient heterogeneity and provisionality of the city are recurring interests, underpinned by a commitment to sustainable, socially responsive building practice.

To what extent does working in London inspire your creativity? Depending on location, client, budget and typology there are any number of "Londons" to be examined. The sense of parallel worlds coexisting in London is liberating.

Is there a typical London style in contemporary architecture? London is a very particular, deeply rooted city, full of local sub-plots and micro-regionalisms. We have an opportunity to generate a more authentic London architecture if we are prepared to absorb and distil the nuances of the city more sensitively.

Which project is so far the most important one for you? Because we see our portfolio as a progressing research project, no single building can qualify as more important for us than the rest.

Wie würden Sie die Grundidee beschreiben, die hinter Ihren Entwürfen steht? Wir haben gelernt, unkonventionell zu arbeiten und Voreingenommenheit zu vermeiden. Die robuste Heterogenität und das Provisorische der Stadt sind immer wiederkehrende Interessen, verbunden mit der Absicht, nachhaltig und sozial verantwortlich zu arbeiten.

Inwiefern inspiriert London Ihre kreative Arbeit? In Abhängigkeit von Ort, Auftraggeber, Budget und Bauaufgabe kann man eine Vielzahl von „Londons" betrachten. Diese Art parallele Welten, die in London nebeneinander bestehen, wirken befreiend.

Gibt es einen typischen Londoner Stil in der aktuellen Architektur? London ist eine sehr spezielle Stadt mit tiefen Wurzeln, vielen Unterzentren und lokalen Besonderheiten. Wenn wir die feinen Nuancen der Stadt sensibler erkennen und verstärken, haben wir die Chance, eine authentischere Londoner Architektur zu schaffen.

Welches ist für Sie Ihr bislang wichtigstes Projekt? Wir sehen unsere Arbeit als ein sich immer weiter entwickelndes Forschungsprojekt, in dem kein Einzelprojekt wichtiger ist als das andere.

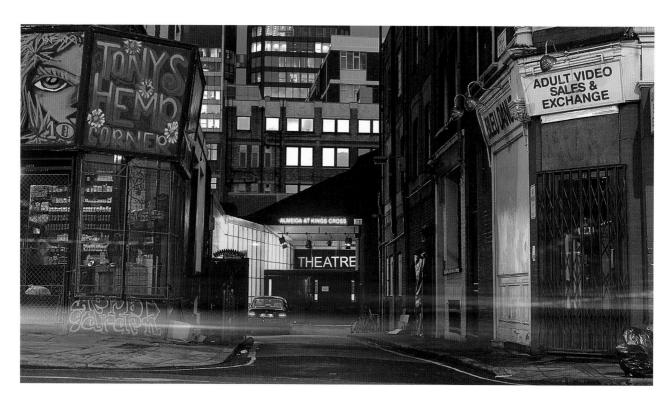

Haworth Tompkins | Almeida Kings Cross Temporary Theatre 2001

Quelle est, d'après vous, l'idée de base qui sous-tend votre travail de conception ? Nous avons appris à travailler de façon non conventionnelle et à éviter la partialité. L'hétérogénéité résiliente et le caractère provisoire de la ville sont des sources d'intérêt récurrentes, liées à l'intention de mettre en œuvre une architecture durable et socialement responsable.

Dans quelle mesure Londres inspire-t-il votre créativité ? Selon le lieu, le commanditaire, le budget et la fonction de la construction, il y a plusieurs « Londres » à considérer. Ces espèces de mondes parallèles qui coexistent à Londres ont un effet libérateur.

Y a-t-il un style typiquement londonien dans l'architecture contemporaine ? Londres est une ville très particulière avec de profondes racines, de nombreux sous-ensembles et particularités locales. En reconnaissant et en renforçant de façon sensible les nuances de la ville, l'occasion nous est donnée de créer une architecture londonienne plus authentique.

Quel est le projet le plus important pour vous à l'heure actuelle ? Nous considérons notre travail comme un projet de recherche en évolution permanente dans lequel aucun projet n'est plus important qu'un autre.

¿Cómo definiría la idea básica que encierran sus diseños? Hemos aprendido a trabajar de forma no convencional y a evitar las ideas preconcebidas. La profunda heterogeneidad y el carácter provisional de la ciudad son intereses que siempre se retoman, unidos a la intención de trabajar de forma duradera y responsable socialmente.

¿En qué medida inspira la ciudad de Londres su trabajo creativo? Dependiendo del lugar, cliente, presupuesto y tarea de construcción se pueden observar cantidad de Londres diversos. Ese estilo de mundos paralelos que habitan en Londres provoca un sentimiento liberador.

¿Existe un estilo típico londinense en la arquitectura actual? Londres es una ciudad muy especial con profundas raíces, cantidad de subcentros y peculiaridades locales. Si apreciamos y acentuamos los delicados matices de la ciudad con sensibilidad, tendremos la posibilidad de crear una auténtica arquitectura londinense.

¿Cuál ha sido su proyecto más importante hasta el momento? Nosotros vemos nuestro trabajo como un trabajo de investigación en constante desarrollo, en el que ningún proyecto es más importante que los demás.

Come descriverebbe l'idea originaria che sta alla base delle Sue creazioni? Abbiamo imparato a lavorare in modo non convenzionale e ad evitare una posizione di pregiudizio. Nostri interessi ricorrenti sono la robusta eterogeneità della città, la sua provvisorietà, come pure l'intenzione di lavorare in maniera sostenibile e socialmente responsabile.

In che misura Londra ispira la Sua creatività? A seconda del luogo, del cliente, del budget e del tipo di edificio da costruire, è possibile prendere in considerazione molte "Londra" diverse. Il fatto che a Londra coesistano, per così dire, tanti mondi paralleli ha un effetto liberatorio.

Esiste uno stile tipico di Londra nell'architettura contemporanea? Londra è una città molto particolare, dotata di radici profonde e ricca di centri periferici e peculiarità regionali. Se saremo disposti a riconoscere ed amplificare con maggiore sensibilità le sottili sfumature della città, avremo l'opportunità di generare una più autentica architettura londinese.

Qual è per Lei il più importante tra i progetti realizzati finora? Noi consideriamo la nostra attività come un progetto di ricerca in continuo divenire, nell'ambito del quale non esiste un edificio più importante di un altro.

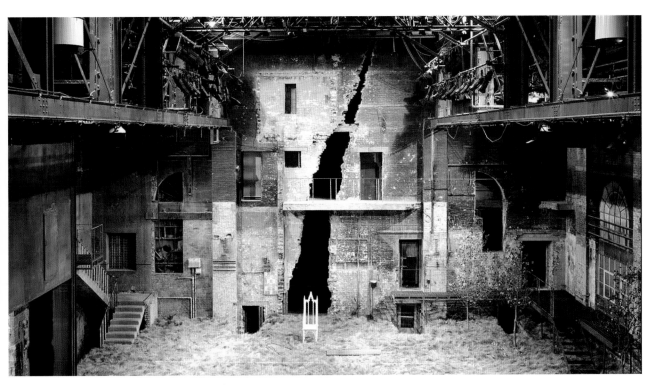

Haworth Tompkins | Almeida Gainsborough Temporary Theatre 2000

Royal Court Renovation

Year: 2000

Location: Sloane Square, London SW1

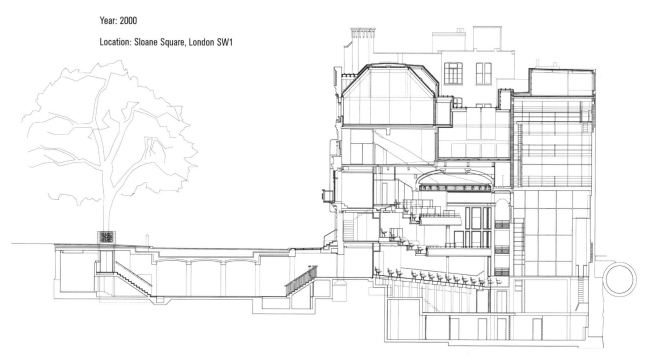

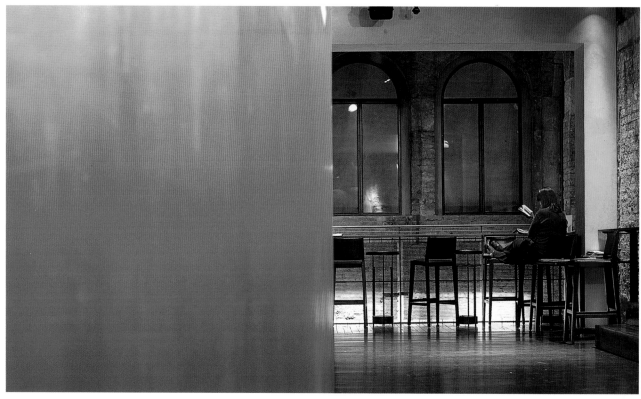

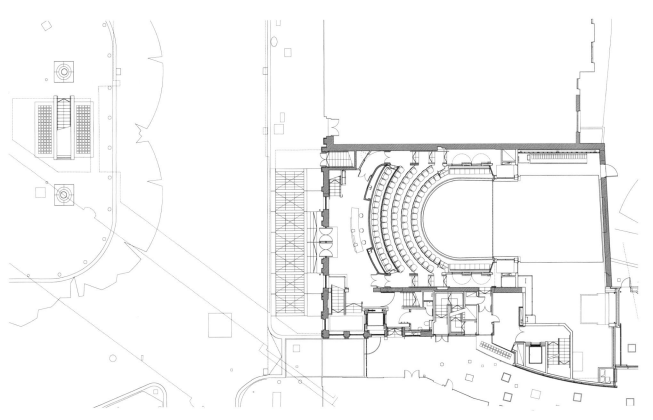

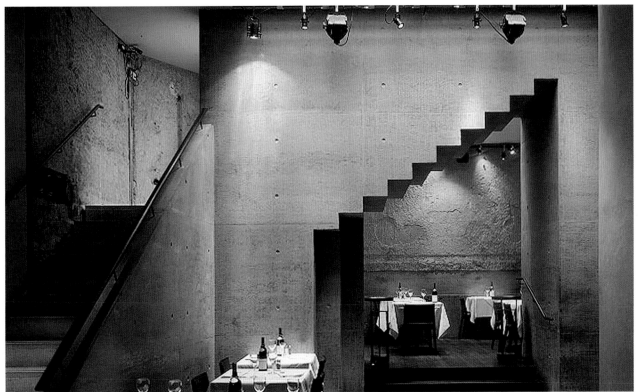

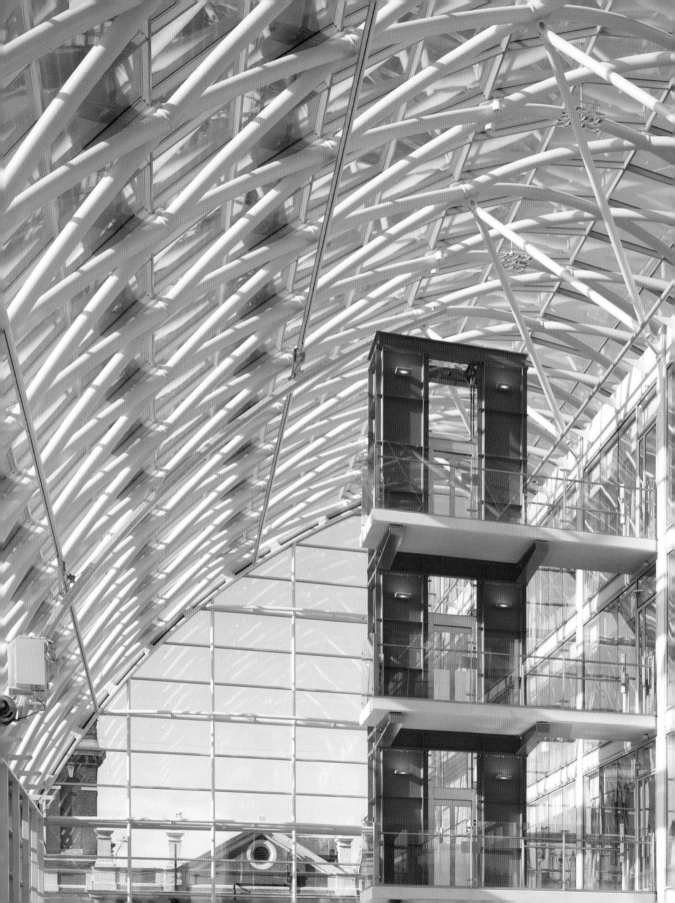

Hopkins Architects

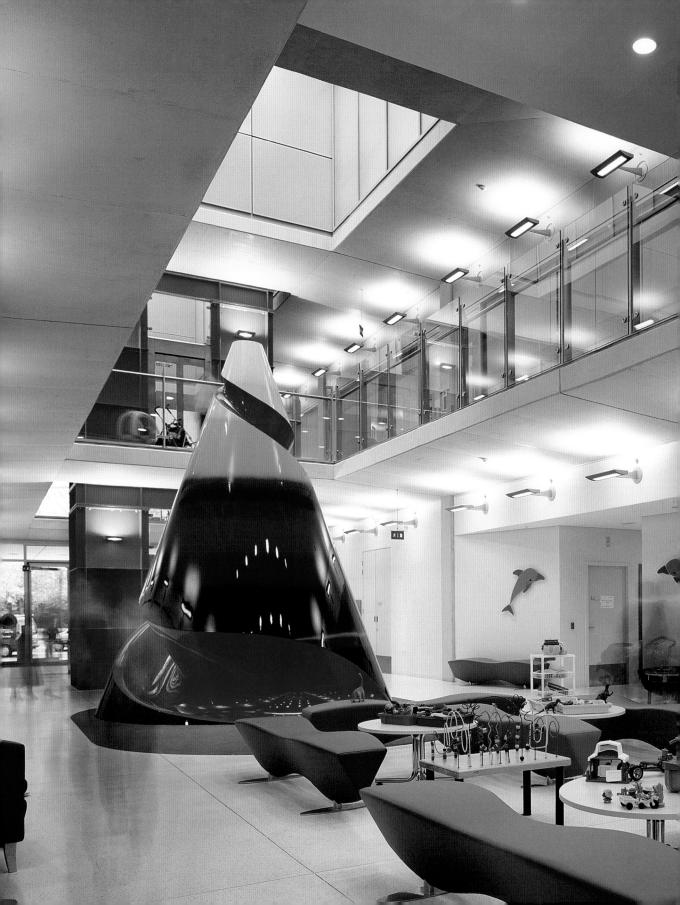

Hopkins Architects

27 Broadley Terrace, London NW1 6LG

P +44 20 7724 1751

F +44 20 7723 0932

www.hopkins.co.uk

mail@hopkins.co.uk

Sir Michael Hopkins

1935
born in Dorset, UK

1976
Michael Hopkins & Partners

2003
Hopkins Architects

To Sir Michael Hopkins, the achievements of his office are a mixture of creative design and rational logic. His constructions are intended to appeal to a wide public whilst also meeting the requirements for contemporary architecture in the 21st century. The office, founded in 1976, is run by three partners – Sir Michael Hopkins, his wife Patty and Bill Taylor – and today employs over 100 people.

Als Mischung aus schöpferischer Kreativität und rationaler Logik sieht Sir Michael Hopkins die Arbeit seines Büros. Seine Bauten sollen eine breite Öffentlichkeit ansprechen, dabei aber gleichzeitig dem Anspruch einer zeitgemäßen Architektur für das 21. Jahrhundert gerecht werden. Drei Partner – Sir Michael Hopkins, seine Frau Patty und Bill Taylor – leiten das 1976 gegründete Büro, das heute über 100 Mitarbeiter hat.

Sir Michael Hopkins considère le travail de son cabinet comme un mélange de créativité constructrice et de logique rationnelle. Ses constructions doivent interpeller un large public tout en satisfaisant aux exigences d'une architecture contemporaine pour le 21ème siècle. Trois associés – Sir Michael Hopkins, son épouse Patty et Bill Taylor – dirigent le cabinet fondé en 1976, comptant aujourd'hui plus d'une centaine de collaborateurs.

Sir Michael Hopkins considera el trabajo de su estudio de arquitectos como una mezcla de capacidad creadora y lógica racional. Sus construcciones están destinadas a responder a un vasto público y a las exigencias de una arquitectura conforme con siglo XXI. El estudio dirigido por Sir Michael Hopkins, su esposa Patty y Bill Taylor fue fundado en 1976 y hoy cuenta con más de 100 colaboradores.

Sir Michael Hopkins considera il lavoro del suo studio d'architettura come una mescolanza di creatività artistica e logica razionale. I suoi edifici sono fatti per piacere al grande pubblico, ma intendono contemporaneamente soddisfare requisiti irrinunciabili per un'architettura moderna all'altezza del XXI secolo. Tre partner – Sir Michael Hopkins, sua moglie Patty e Bill Taylor – dirigono lo studio che, fondato nel 1976, oggi conta più di 100 dipendenti.

Interview | Hopkins Architects

How would you describe the basic idea behind your design work? Our designs are based upon a set of founding principles; logical and legible, expressive of the materials and techniques used in their construction, a "through thickness" quality from design to realisation.

To what extent does working in London inspire your creativity? All of the time – London itself is an architectural treasure, it is diverse and vibrant and is always on the move. London is now a very cosmopolitan city, which attracts talented people from elsewhere.

Is there a typical London style in contemporary architecture? Loosely yes, although it is – ironically – one of pluralism. London is such a varied city architecturally that good design is normally rewarded with acceptance and interest.

Which project is so far the most important one for you? Publicly we don't have favorites, although privately I am sure that each of us does. Milestones in our work are without doubt the Mound Stand at Lord's Cricket Ground or the Jubilee Campus.

Wie würden Sie die Grundidee beschreiben, die hinter Ihren Entwürfen steht? Unsere Entwürfe basieren auf einer Reihe grundlegender Prinzipien: Logik und Lesbarkeit sowie die Verwendung ausdrucksvoller Materialien und Konstruktionstechniken, und das alles durchgängig angewandt vom Entwurf bis zur Realisierung.

Inwiefern inspiriert London Ihre kreative Arbeit? Ständig. London ist eine architektonische Kostbarkeit, vielfältig und pulsierend, immer in Bewegung. London ist heute auch eine sehr kosmopolitische Stadt, die talentierte Leute aus der ganzen Welt anzieht.

Gibt es einen typischen Londoner Stil in der aktuellen Architektur? Im weitesten Sinne ja, obwohl es ironischerweise ein pluralistischer Stil ist. London ist eine architektonisch so bunt gemischte Stadt, dass gutes Design normalerweise mit Interesse und Anerkennung belohnt wird.

Welches ist für Sie Ihr bislang wichtigstes Projekt? Nach außen hin sagen wir das nicht, ich selbst bin jedoch sicher, dass jeder von uns seine Favoriten hat. Meilensteine unsere Arbeit sind zweifellos der Mound Stand des Lord's Cricket Ground oder der Jubilee Campus.

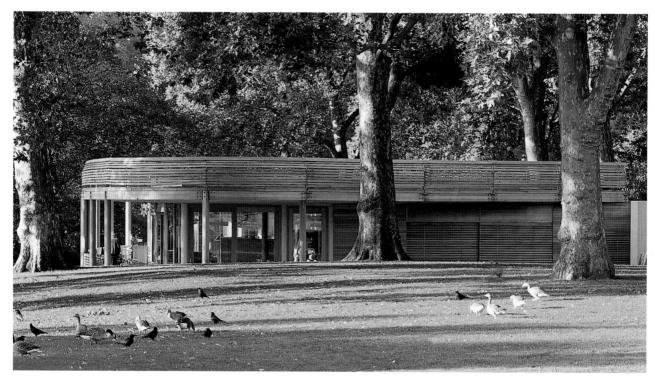

Quelle est, d'après vous, l'idée de base qui sous-tend votre travail de conception ? Nos projets reposent sur quelques principes fondamentaux : logique, lisibilité et expressivité des matériaux et des techniques de construction employés, le tout appliqué de façon conséquente, de la conception à la réalisation.

Dans quelle mesure Londres inspire-t-il votre créativité ? En permanence. Londres est un trésor d'architecture, multiple et vibrant, toujours en mouvement. Aujourd'hui, Londres est également une ville très cosmopolite qui attire des talents du monde entier.

Y a-t-il un style typiquement londonien dans l'architecture contemporaine ? Au sens large, oui. Même si – quelle ironie – c'est un style pluraliste. Au plan architectural, Londres est une ville tellement mélangée qu'un bon design est généralement accueilli avec intérêt et reconnaissance.

Quel est le projet le plus important pour vous à l'heure actuelle ? Publiquement, nous n'avons aucune préférence. Personnellement, je suis persuadé que chacun d'entre nous a ses favoris. Le Mound Stand du Lord's Cricket Ground ou le Jubilee Campus sont assurément des jalons de référence dans notre carrière.

¿Cómo definiría la idea básica que encierran sus diseños? Nuestros bocetos se basan en una serie de principios elementales: lógica y legibilidad así como el empleo de materiales y técnicas de construcción cargados de expresión; todo ello puesto en práctica desde el boceto hasta la realización final.

¿En qué medida inspira la ciudad de Londres su trabajo creativo? Constantemente. Londres es una exquisitez arquitectónica, diversa y agitada, siempre en movimiento. Londres es hoy además una ciudad tremendamente cosmopolita que atrae a talentos de todo el planeta.

¿Existe un estilo típico londinense en la arquitectura actual? En el más amplio sentido sí, aunque la ironía es que se trata de un estilo pluralista. Londres es una ciudad tan diversa y multicolor arquitectónicamente hablando que aquí interesa y se galardona todo buen diseño.

¿Cuál ha sido su proyecto más importante hasta el momento? De cara al exterior no lo decimos, pero personalmente estoy seguro de que cada uno de nosotros tiene un favorito. Verdaderos hitos de nuestro trabajo son sin duda el Mound Stand del Lord's Cricket Ground o el Jubilee Campus.

Come descriverebbe l'idea originaria che sta alla base delle Sue creazioni? Le nostre creazioni si basano su tutta una serie di principi fondamentali: logica e leggibilità, ma anche forza espressiva dei materiali utilizzati e delle tecniche costruttive applicate, il tutto perseguito con coerenza dalla fase di progettazione fino al completamento dei lavori.

In che misura Londra ispira la Sua creatività? Continuamente – Londra è un gioiello architettonico, multiforme e vibrante, sempre in movimento. Oggi Londra è anche una città molto cosmopolita, che attrae persone di talento da tutto il mondo.

Esiste uno stile tipico di Londra nell'architettura contemporanea? Sì, se inteso in un'accezione ampia, nonostante si tratti, ironicamente, di uno stile pluralistico: Londra è una città talmente caleidoscopica sotto il profilo architettonico che un buon design normalmente viene premiato con interesse e riconoscimento.

Qual è per Lei il più importante tra i progetti realizzati finora? Anche se non lo ammettiamo in pubblico, per conto mio sono certo che ognuno di noi ha i suoi favoriti. Pietre miliari del nostro lavoro sono senza dubbio il Mound Stand al Lord's Cricket Ground o il Jubilee Campus.

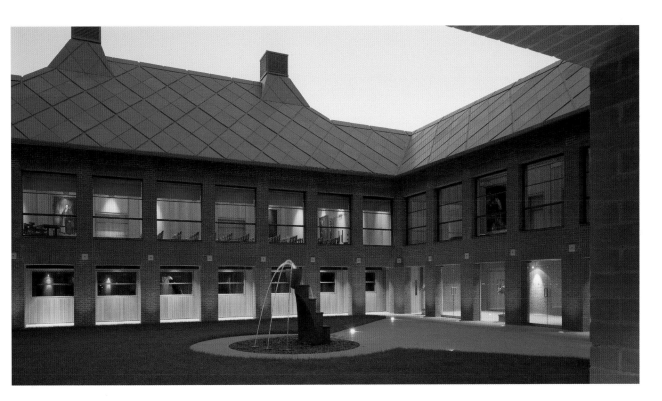

Haberdashers' Hall

Year: 2002

Location: 18 West Smithfield, London EC1A

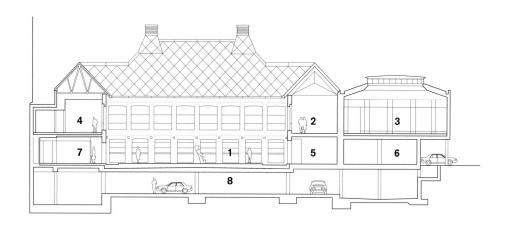

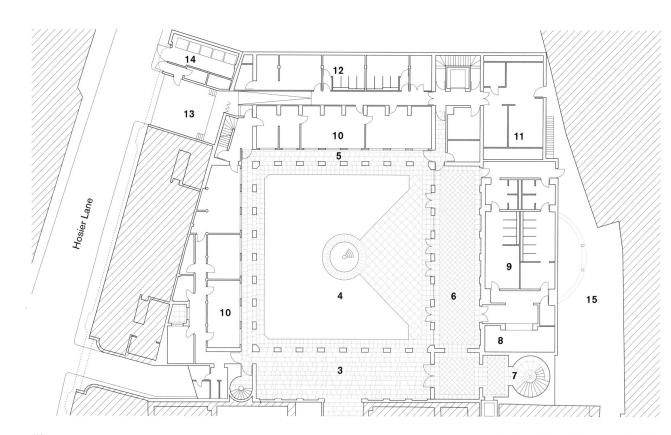

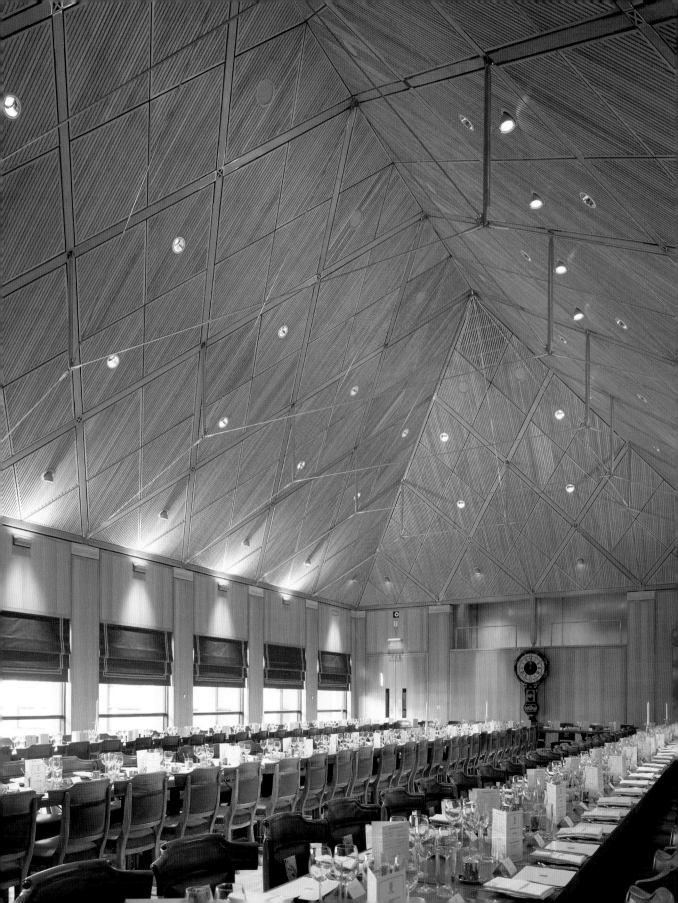

Inn the Park

Year: 2004
Location: St. James's Park, London, SW1

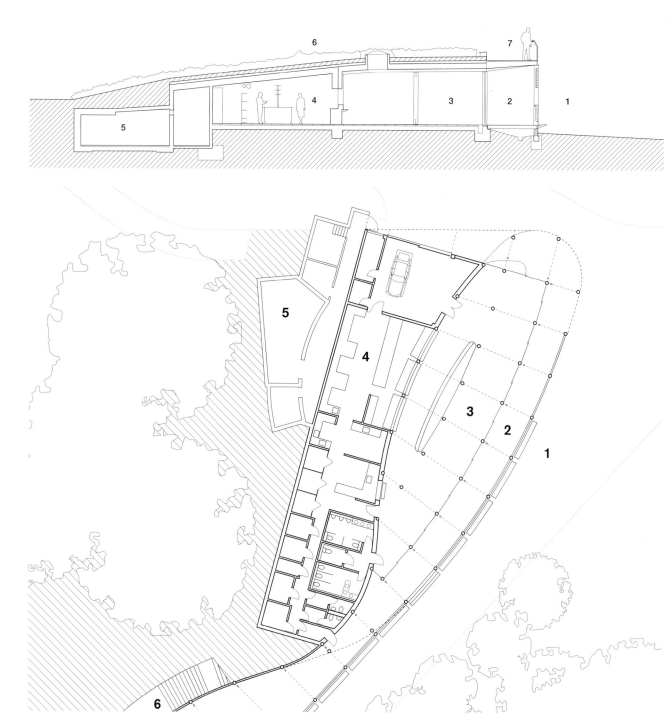

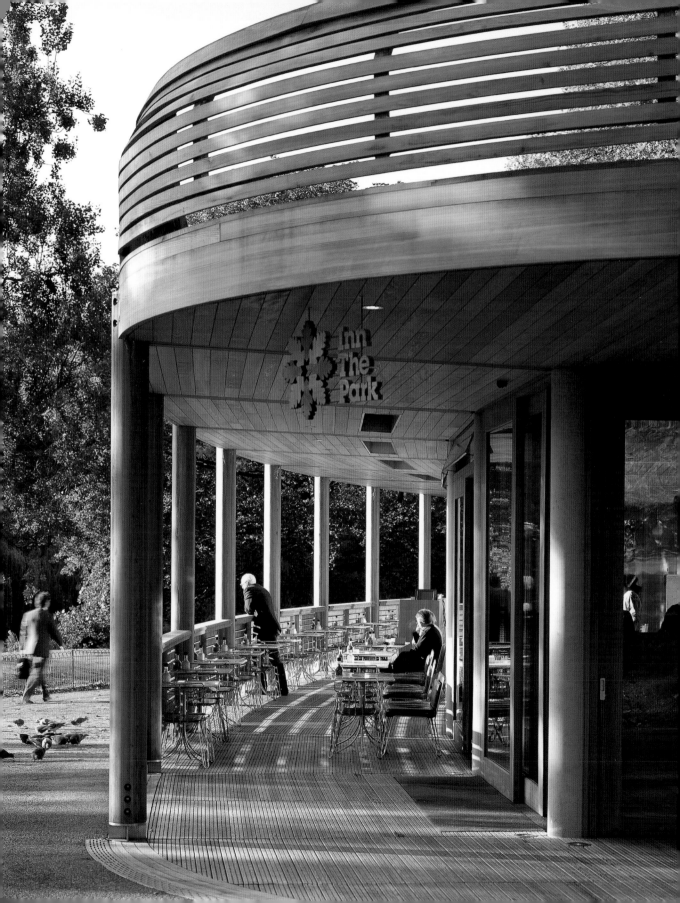

Lifschutz Davidson Sandilands

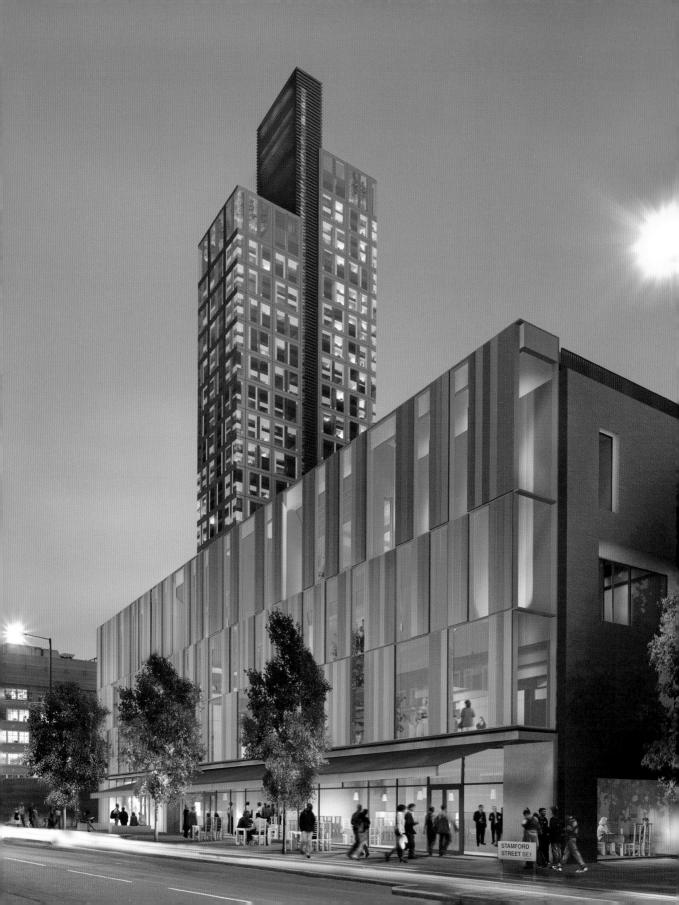

Lifschutz Davidson Sandilands

Island Studios, 22 St. Peter's Square, London W6 9NW

P +44 20 8600 4800

F +44 20 8600 4700

www.lds-uk.com

mail@lds-uk.com

Lifschutz Davidson Sandilands have been working as architects and town planners in London for two decades. They handle projects from the most diverse areas – from urban master planning, offices and homes to the interiors of discerning shops and restaurants. The studio really made a name for itself in the mid-nineties with the renovation of the OXO Tower, one of the first projects associated with the regeneration of the South Bank of the Thames.

Lifschutz Davidson Sandilands arbeiten seit zwei Jahrzehnten als Architekten und Stadtplaner in London. Dabei widmen sie sich Projekten aus den unterschiedlichsten Bereichen, von der urbanen Masterplanung über Büro- und Wohnungsbau bis hin zur Innenausstattung von ambitionierten Geschäften und Restaurants. Bekannt wurde das Büro Mitte der neunziger Jahre mit der Sanierung des OXO-Towers, das als eines der ersten Projekte die Revitalisierung des südlichen Themseufers einleitete.

Lifschutz Davidson Sandilands travaillent depuis 20 ans comme architectes et urbanistes à Londres. Ils se consacrent à des projets dans les domaines les plus variés, du plan directeur urbain à la décoration intérieure d'ambitieux magasins et restaurants, en passant par la construction d'immeubles d'habitation et de bureaux. Le cabinet s'est fait connaître au milieu des années quatre-vingt-dix avec l'assainissement de l'OXO Tower qui a été l'un des premiers projets amorçant la revitalisation de la rive sud de la Tamise.

Lifschutz Davidson Sandilands trabajan desde hace dos décadas como arquitectos y planificadores urbanísticos en Londres. Se dedican a proyectos de los más diversos ámbitos, desde la planificación urbana, diseños de interiores, construcción de oficinas y viviendas, hasta la concepción de los interiores de comercios y restaurantes de élite. El estudio se dio a conocer a mediados de los noventa a través de las labores de saneamiento del OXO Tower, uno de los primeros proyectos llevados a cabo para la rehabilitación de la orilla sur del Támesis.

Lifschutz Davidson Sandilands lavorano da due decenni a Londra come architetti e pianificatori urbanistici, dedicandosi a progetti nei settori più diversi: dalla pianificazione master urbana all'edilizia abitativa o per uffici, per finire con l'arredamento d'interni di negozi e ristoranti emergenti. Lo studio ha raggiunto la notorietà verso la metà degli anni Novanta con la ristrutturazione dell'OXO Tower, uno tra i primi progetti che hanno dato il via alla rivitalizzazione della riva sud del Tamigi.

Alex Lifschutz

1952
born in Bombay, India

Paul Sandilands

1958
born in Birmingham, UK

Ian Davidson †

1986
Lifschutz Davidson

2005
Lifschutz Davidson
Sandilands

Interview | Alex Lifschutz

How would you describe the basic idea behind your design work? Our work focuses on ways of bringing buildings and spaces together to become civilised enjoyable and successful environments.

To what extent does working in London inspire your creativity? London's complex cultural, social and historical context is both inspirational and challenging and each commission is a specific response to this environment.

Is there a typical London style in contemporary architecture? No. There seem to be two aspects to London contemporary architecture. On the one hand, there are several high profile projects that impose on the city a variety of the latest architectural forms while, on the other, there is also an attempt to design from the ground up – working to repair what already exists, integrating with long established buildings and creating more vibrant and accessible neighbourhoods.

Which project is so far the most important one for you? Our body of work on the South Bank. We have been working in this area for almost twenty years during which time we have completed a broad range of work from large scale urban master planning to housing projects, restaurants, bridges and street landscaping.

Wie würden Sie die Grundidee beschreiben, die hinter Ihren Entwürfen steht? Im Mittelpunkt unserer Arbeit steht der Versuch, aus Gebäuden und Räumen angenehme und gelungene Orte zu schaffen.

Inwiefern inspiriert London Ihre kreative Arbeit? Londons komplexer kultureller, gesellschaftlicher und geschichtlicher Kontext ist zugleich Inspiration und Herausforderung. Jedes Projekt reagiert auf seine Weise auf dieses Umfeld.

Gibt es einen typischen Londoner Stil in der aktuellen Architektur? Nein. Gegenwärtig scheint es zwei Richtungen in der Londoner Architektur zu geben: Auf der einen Seite mehrere hochklassige Projekte, die der Stadt eine Auswahl der neuesten architektonischen Formen bescheren, auf der anderen Seite grundlegende Versuche, das Bestehende zu reparieren, vernachlässigte Bauten zu integrieren und lebendigere, offenere Viertel zu schaffen.

Welches ist für Sie Ihr bislang wichtigstes Projekt? Unsere gesamte Arbeit an der South Bank. Dort haben wir fast zwanzig Jahre lang gearbeitet, eine Zeitspanne, in der wir ein breites Spektrum unterschiedlicher Projekte durchgeführt haben – von großflächigen Entwicklungsplänen bis hin zu Wohnungsbauprojekten, Restaurants, Brücken und der Gestaltung von Straßenräumen.

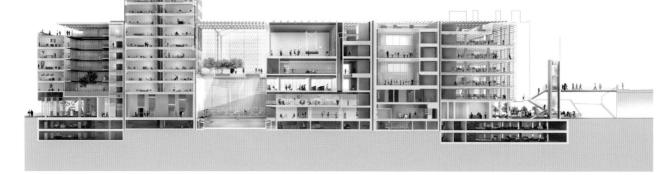

Lifschutz Davidson Sandilands | Doon Street Development

Quelle est, d'après vous, l'idée de base qui sous-tend votre travail de conception ? Notre travail a pour objectif principal de transformer des bâtiments et des espaces en lieux agréables et réussis.

Dans quelle mesure Londres inspire-t-il votre créativité ? Le contexte culturel, social et historique complexe de Londres représente à la fois une source d'inspiration et un défi. Chaque projet est une réponse spécifique à cet environnement.

Y a-t-il un style typiquement londonien dans l'architecture contemporaine ? Non. Actuellement, on dirait qu'il y a deux tendances dans l'architecture londonienne : d'une part, plusieurs projets de grande classe qui offrent à la ville une sélection des plus récentes formes architecturales, d'autre part, une démarche fondamentale visant à réparer ce qui existe déjà, à intégrer les bâtiments négligés et à créer des quartiers plus vivants, plus ouverts.

Quel est le projet le plus important pour vous à l'heure actuelle ? L'ensemble de notre travail sur la South Bank. Nous y avons œuvré sur une période de presque vingt ans, durant laquelle nous avons réalisé une série de projets différents – des plans directeurs d'urbanisme à grande échelle aux projets de construction d'habitations, de restaurants, de ponts et d'aménagement des rues.

¿Cómo definiría la idea básica que encierran sus diseños? En el centro de nuestro trabajo se encuentra el intento de crear lugares logrados y agradables a partir de edificios y espacios.

¿En qué medida inspira la ciudad de Londres su trabajo creativo? El complejo contexto cultural, social e histórico londinense es al mismo tiempo inspiración y reto. Cada proyecto reacciona a su manera ante este entorno.

¿Existe un estilo típico londinense en la arquitectura actual? No. Actualmente parece que se están dando dos tendencias en la arquitectura londinense: por un lado varios proyectos profundamente clásicos, que otorgan a la ciudad una selección de las formas arquitectónicas más modernas, y por otro, intentos fundamentales de reparar lo ya existente, integrar construcciones dejadas en el olvido y crear barrios más abiertos y dinámicos.

¿Cuál ha sido su proyecto más importante hasta el momento? Nuestro trabajo completo en South Bank. Allí hemos trabajado durante casi veinte años, un margen de tiempo en el que hemos llevado a cabo una amplia paleta de proyectos diversos, desde grandes planes de desarrollo hasta proyectos de construcción de viviendas, restaurantes, puentes y la configuración de espacios en las calles.

Come descriverebbe l'idea originaria che sta alla base delle Sue creazioni? Al cuore della nostra attività c'è il tentativo di trasformare edifici e spazi in luoghi piacevoli, riusciti.

In che misura Londra ispira la Sua creatività? Il complesso insieme culturale, sociale e storico di Londra è ad un tempo ispirazione e provocazione: ogni progetto è una specifica risposta a questo contesto ambientale.

Esiste uno stile tipico di Londra nell'architettura contemporanea? No. Attualmente sembrano esserci due indirizzi nell'architettura londinese: da un lato numerosi progetti di alto profilo, grazie ai quali la città ospita una selezione delle più attuali forme architettoniche, dall'altro lato il tentativo fondamentale di riparare il preesistente, di integrare edifici trascurati e creare quartieri più vitali ed aperti.

Qual è per Lei il più importante tra i progetti realizzati finora? Tutto il nostro lavoro sulla South Bank. Abbiamo lavorato in quell'area per quasi vent'anni, un periodo durante il quale abbiamo realizzato una gran varietà di progetti differenti: da piani di sviluppo urbano su grande scala a progetti di edilizia abitativa, ristoranti, ponti e all'allestimento di spazi stradali.

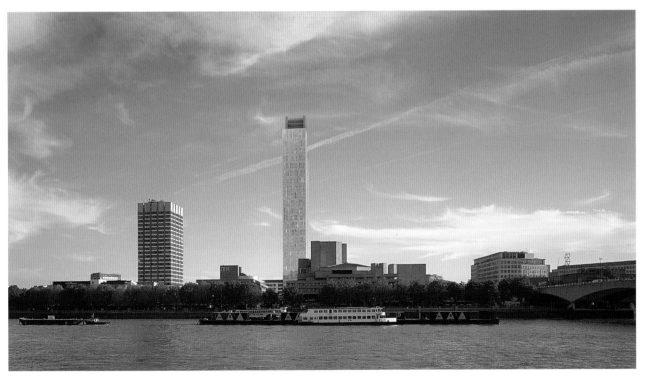

Lifschutz Davidson Sandilands | Doon Street Development

Henning Stummel Architects

Henning Stummel Architects

6 London Mews, London W2 1HY

P +44 20 7262 1778

F +44 20 7439 1932

www.henningstummelarchitects.co.uk

mail@henningstummelarchitects.co.uk

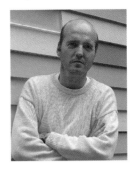

Henning Stummel

1966
born in Frankfurt/Main,
Germany

2000
Henning Stummel
Architects

Before setting up on his own in 2000, German-born Henning Stummel had already spent over ten years working for leading London establishments. Although he has as yet completed only small-scale projects under his own name, his structures – in which careful incorporation of the surrounding environment and ecological durability are a prime concern – have found widespread appeal and acceptance.

Vor der Gründung seines Büros im Jahr 2000 hatte der gebürtige Deutsche Henning Stummel bereits über zehn Jahre in führenden Londoner Büros gearbeitet. Zwar konnte er bislang unter eigenem Namen lediglich kleinmaßstäbliche Projekte realisieren; dennoch erfuhren seine Bauten, bei denen die sorgfältige Einbindung in ihre Umgebung und die ökologische Nachhaltigkeit eine wichtige Rolle spielen, weithin Aufmerksamkeit und große Anerkennung.

Avant de fonder son cabinet en l'an 2000, Henning Stummel, allemand d'origine, avait déjà travaillé plus de dix ans dans de grands cabinets londoniens. Jusqu'à maintenant, il n'a pu réaliser sous son nom que des projets sur une petite échelle ; et pourtant, ses constructions, où l'intégration parfaite dans leur environnement et la durabilité écologique jouent un rôle important, ont beaucoup attiré l'attention et rencontré une large approbation.

Ya antes de fundar su propio estudio en el año 2000, Henning Stummel, nacido en Alemania, había ejercido su actividad durante diez años en algunos de los estudios con más renombre de Londres. Si bien hasta ese momento sólo había podido llevar proyectos de pequeña envergadura bajo su nombre, sus construcciones, caracterizadas por la cuidada adaptación al entorno y la durabilidad desde el punto de vista ecológico, recibían ya entonces una especial atención y reconocimiento.

Prima di fondare il suo studio nel 2000, il tedesco Henning Stummel aveva già lavorato per più di dieci anni in prestigiosi studi d'architettura londinesi. Anche se finora ha potuto realizzare e firmare personalmente solo progetti in piccola scala, i suoi edifici, caratterizzati da una grande attenzione all'inserimento nell'ambiente e alla sostenibilità ecologica, hanno suscitato ampio interesse e raccolto grandi riconoscimenti.

Interview | Henning Stummel

How would you describe the basic idea behind your design work? I prefer to do things simply, in a workmanlike way. I consider architecture to be a responsibility, an art and a craft. I like the idea of our built environment having a spiritual dimension.

To what extent does working in London inspire your creativity? Occasionally you come across very thought provoking individuals and ideas. London – the vast built city – is a subject of life long study and very inspiring.

Is there a typical London style in contemporary architecture? No- There are so many things going on at any one time. Diversity has become the style.

Which project is so far the most important one for you? The extension to a Georgian Townhouse was the first time I managed to realize a completely un-compromised project. It was a huge challenge to convince the planning authorities that this small 150 square feet intervention was benign. I was almost ready to give up and become a sailing instructor – so it's success is very gratifying.

Wie würden Sie die Grundidee beschreiben, die hinter Ihren Entwürfen steht? Ich entwerfe gerne in einem einfachen, handwerklichen Sinne. Ich verstehe Architektur als Verantwortung, als Kunst und als Handwerk. Mir gefällt die Vorstellung, dass unserer gebauten Umwelt eine gewisse Spiritualität innewohnt.

Inwiefern inspiriert London Ihre kreative Arbeit? In London kann man auf außerordentlich anregende Menschen und Ideen treffen. Diese riesige Stadt kann man sein Leben lang erkunden – darum ist sie sehr inspirierend.

Gibt es einen typischen Londoner Stil in der aktuellen Architektur? Nein. Weil so viele unterschiedliche Dinge gleichzeitig passieren, ist der einzige Stil die Vielfalt.

Welches ist für Sie Ihr bislang wichtigstes Projekt? Beim Erweiterungsbau eines georgianischen Hauses konnte ich erstmals ein Konzept ohne Kompromisse umsetzen. Es war eine gewaltige Herausforderung, den Baubehörden klarzumachen, dass der 14 Quadratmeter große Anbau eigentlich ganz harmlos ist. Ich war kurz davor, aufzugeben und Segellehrer zu werden. Umso mehr freut mich der Erfolg des Gebäudes.

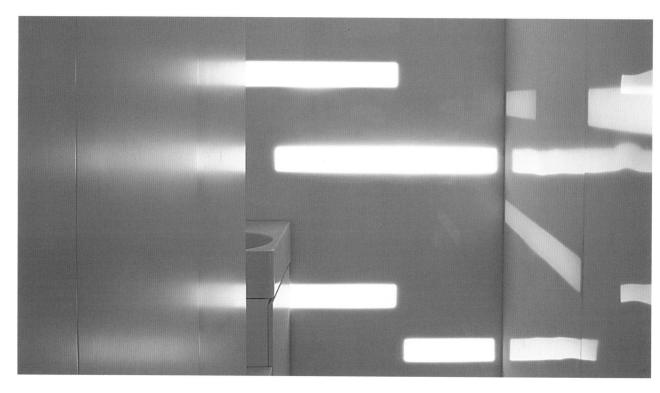

Quelle est, d'après vous, l'idée de base qui sous-tend votre travail de conception ? Je fais volontiers les choses simplement, à la manière d'un artisan. Je considère l'architecture comme une responsabilité, un art et un artisanat. J'aime l'idée que les constructions de notre environnement sont habitées d'une dimension spirituelle.

Dans quelle mesure Londres inspire-t-il votre créativité ? À Londres, on peut rencontrer des gens et des idées particulièrement motivants. On peut explorer cette ville immense sa vie durant – c'est pourquoi elle est si inspirante.

Y a-t-il un style typiquement londonien dans l'architecture contemporaine ? Non. Il se passe tellement de choses différentes, en même temps, que le véritable style, c'est la diversité.

Quel est le projet le plus important pour vous à l'heure actuelle ? Lors de l'agrandissement d'une maison géorgienne, j'ai pu réaliser pour la première fois un projet sans compromis. Cela a été un énorme défi, de faire comprendre au service de l'urbanisme que cette annexe de 14 mètres carrés était une intervention bénigne. J'ai failli abandonner et devenir moniteur de voile. Le succès de ce bâtiment est donc d'autant plus gratifiant.

¿Cómo definiría la idea básica que encierran sus diseños? A mí me gusta diseñar en el sentido manual y sencillo. Entiendo la arquitectura como responsabilidad, como arte y como oficio. Me gusta pensar que en las construcciones que nos rodean habita una cierta espiritualidad.

¿En qué medida inspira la ciudad de Londres su trabajo creativo? En Londres uno se encuentra con personas e ideas fascinantes. Es una inmensa ciudad para explorar durante toda una vida, de ahí que resulte tan inspiradora.

¿Existe un estilo típico londinense en la arquitectura actual? No. Como ocurren tantas y tan diversas cosas al mismo tiempo, el único estilo posible es la diversidad.

¿Cuál ha sido su proyecto más importante hasta el momento? En los trabajos de ampliación de una casa georgiana pude por primera vez aplicar un concepto sin hacer compromisos. Fue un enorme desafío hacer entender a las instituciones responsables de la construcción que una ampliación de 14 metros cuadrados es en realidad totalmente inofensiva. Estuve a punto de abandonar y hacerme profesor de vela. Por eso me alegro aún más del éxito del edificio.

Come descriverebbe l'idea originaria che sta alla base delle Sue creazioni? Amo lavorare in modo semplice, artigianale. Ritengo, infatti, che l'architettura sia una responsabilità, una forma d'arte e di artigianato. Mi piace pensare che l'ambiente edificato intorno a noi abbia una sua dimensione spirituale.

In che misura Londra ispira la Sua creatività? A Londra è possibile imbattersi in persone e idee straordinariamente stimolanti. Questa gigantesca città può essere studiata per tutta una vita – è per questo che suscita tante ispirazioni.

Esiste uno stile tipico di Londra nell'architettura contemporanea? No. Proprio perché vi accadono contemporaneamente così tante cose differenti, l'unico stile è la varietà.

Qual è per Lei il più importante tra i progetti realizzati finora? La prima volta che sono riuscito a realizzare senza compromessi un mio progetto è stato in occasione dell'ampliamento di un palazzo georgiano. Non è stata cosa da poco riuscire a convincere l'ispettorato edile che questo piccolo intervento, della superficie di 14 metri quadrati, in realtà era del tutto innocuo. Ci è mancato poco che gettassi la spugna e decidessi di diventare istruttore di barca a vela; a maggior ragione mi gratifica il successo avuto da questo progetto.

Extension to Georgian Townhouse

Year: 2002–2003

Location: 6 Shouldham Street, London W1H

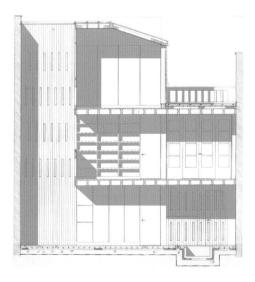

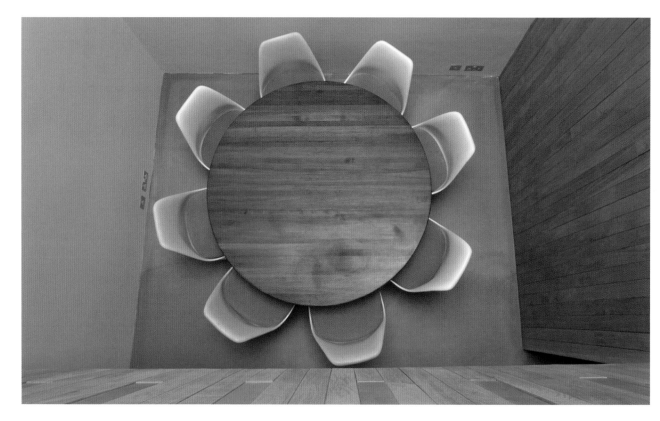

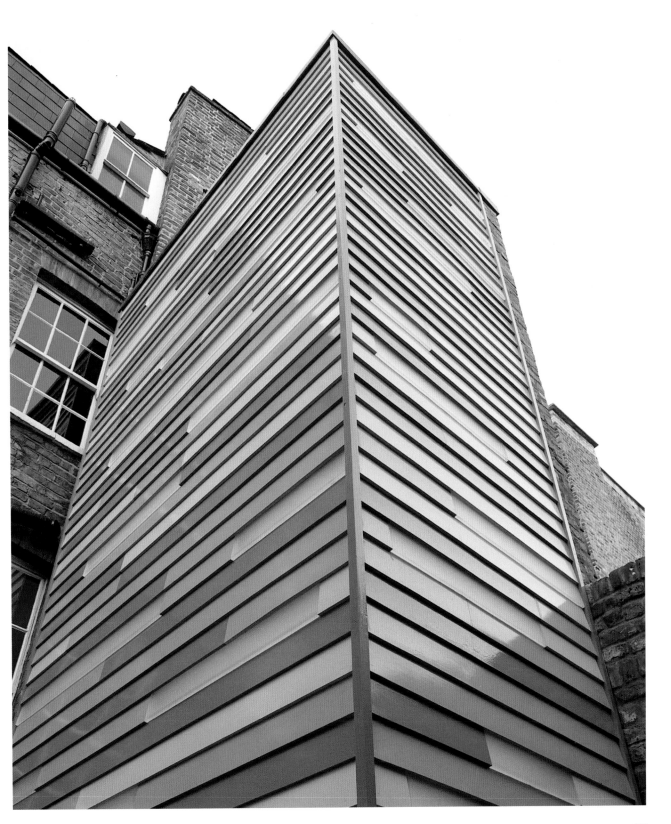

Henning Stummel Architects | Extension to Georgian Townhouse 2003

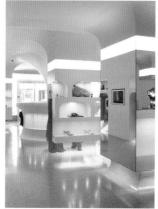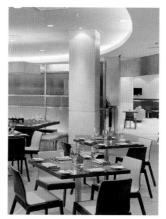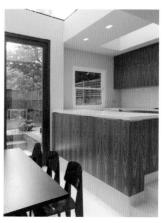

Interior Design

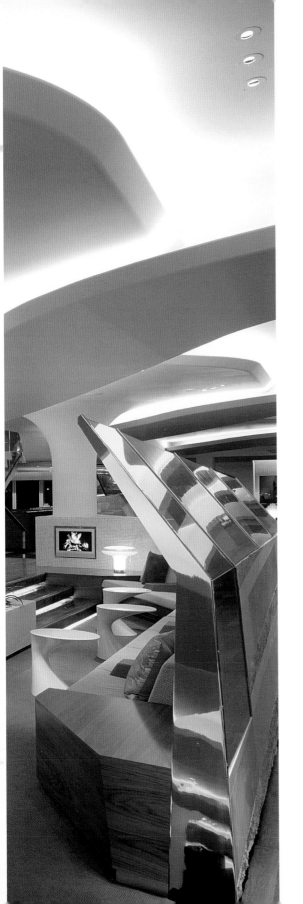

blockarchitecture

DAAM

JESTICO + WHILES

Pentagram

Project Orange

Softroom

United Designers

Universal Design Studio

Helen Yardley

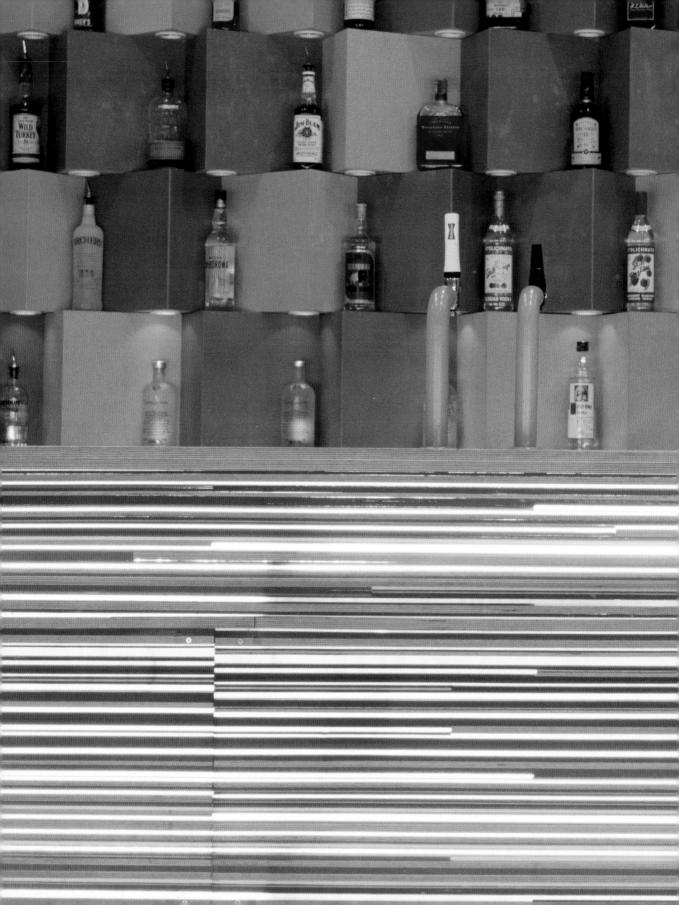

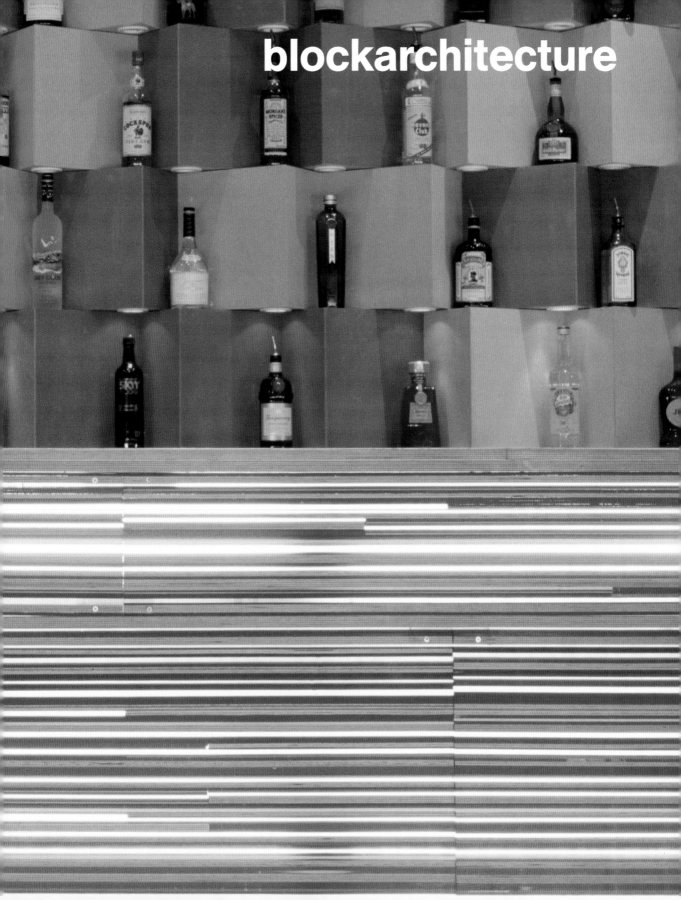

blockarchitecture

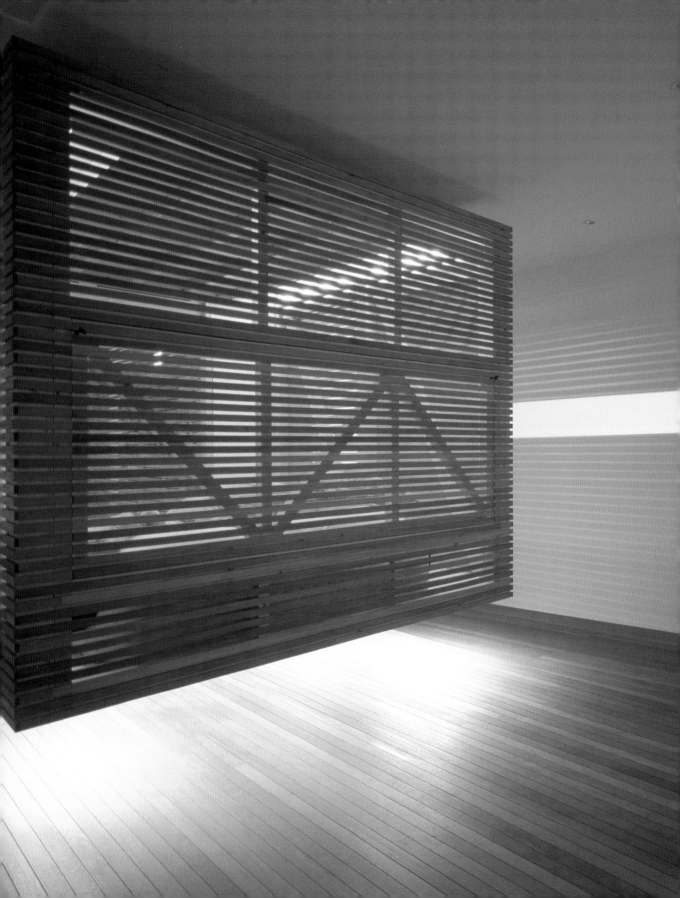

blockarchitecture

83A Geffrye Street, London E2 8HX

P +44 20 7729 9194

F +44 20 7729 9193

www.blockarchitecture.com

mail@blockarchitecture.com

Graeme Williamson and Zoe Smith – the founders of blockarchitecture – do not see themselves as producers of never-seen-before ideas or visionary suggestions. Rather, the source of their inspiration lies in what is available and what is familiar, which they then seek to rediscover, interpret and change through their architectural and artistic efforts.

Graeme Williamson und Zoe Smith – die Gründer von blockarchitecture – sehen sich nicht als Produzenten nie da gewesener Ideen oder visionärer Vorschläge. Die Quellen ihrer Inspiration liegen vielmehr im Vorhandenen und Vertrauten, das sie durch ihre architektonischen und künstlerischen Eingriffe neu entdecken, interpretieren und verwandeln möchten.

Graeme Williamson et Zoe Smith – les fondateurs de blockarchitecture – ne se considèrent pas comme les auteurs d'idées inouïes ou de propositions visionnaires. Leurs sources d'inspiration résident plutôt dans ce qui est disponible et familier, qu'ils souhaitent redécouvrir, interpréter et transformer par leurs interventions architecturales et artistiques.

Graeme Williamson y Zoe Smith, los fundadores de blockarchitecture, no se consideran productores de propuestas visionarias o de ideas inexistentes en el pasado. La fuente de su inspiración se encuentra más bien en lo ya existente y lo familiar, que desean redescubrir, reinterpretar y transformar a través de sus aplicaciones arquitectónicas y artísticas.

Graeme Williamson e Zoe Smith – i fondatori di blockarchitecture – non ritengono di essere produttori di idee senza precedenti o di proposte visionarie, tutt'altro: le sorgenti della loro ispirazione si trovano in elementi preesistenti e familiari, che essi tramite i loro interventi architettonici e artistici intendono riscoprire, interpretare e trasformare.

Zoe Smith

1971
born in Scotland, UK

Graeme Williamson

1971
born in Scotland, UK

1998
24/seven design

2000
blockarchitecture

Interview | blockarchitecture

How would you describe the basic idea behind your design work? We have always tried to steer away from a stylistic agenda or formal palette – we are fundamentally not signature architects. Our work has been described as a form of referential collage or resonant composition. This was in relation to the way in which we use everyday references and reconfigure them to create something that is unexpected.

To what extent does working in London inspire your creativity? London more than most cities "consumes" design at an alarming rate. Ideas are momentary not static and exist until they are replaced by the next one.

Is there a typical London style in contemporary architecture? Of course there are common threads that influence to us all. If there is a style, it is a uniqueness and idiosyncratic approach that is peculiarly British.

Which project is so far the most important one for you? Every time we complete a project it adds something to our experience and develops our approach. There have been certain "milestone" projects along the way that brought steeper learning curves such as our apartment in New York and Shop for Hussein Chalayan in Tokyo.

Wie würden Sie die Grundidee beschreiben, die hinter Ihren Entwürfen steht? Wir haben immer versucht, uns von einem vorgegebenen Stil oder formalen Festlegungen fernzuhalten – darum haben wir aus Prinzip keine spezifische architektonische Handschrift. Man hat unsere Arbeiten als beziehungsreiche Collagen oder Kompositionen beschrieben, die in Erinnerung bleiben. Dies bezieht sich darauf, wie wir Alltägliches umdeuten, um daraus etwas Unerwartetes zu schaffen.

Inwiefern inspiriert London Ihre kreative Arbeit? Mehr als in den meisten anderen Städten wird in London in enormem Umfang Design „verbraucht". Ideen sind kurzlebig, nicht von Dauer und haben nur so lange Bestand, bis sie von der nächsten ersetzt werden.

Gibt es einen typischen Londoner Stil in der aktuellen Architektur? Natürlich gibt es allgemeine Strömungen, die uns alle beeinflussen. Wenn es einen Stil gibt, dann ist dies eine Originalität und Eigentümlichkeit, die speziell britisch ist.

Welches ist für Sie Ihr bislang wichtigstes Projekt? Mit jedem Projekt, das wir fertigstellen, wachsen unsere Erfahrungen und Fähigkeiten. Bei bestimmten „Meilenstein-Projekten" war der Lerneffekt besonders hoch, wie zum Beispiel bei unserem Apartment in New York oder dem Shop für Hussein Chalayan in Tokio.

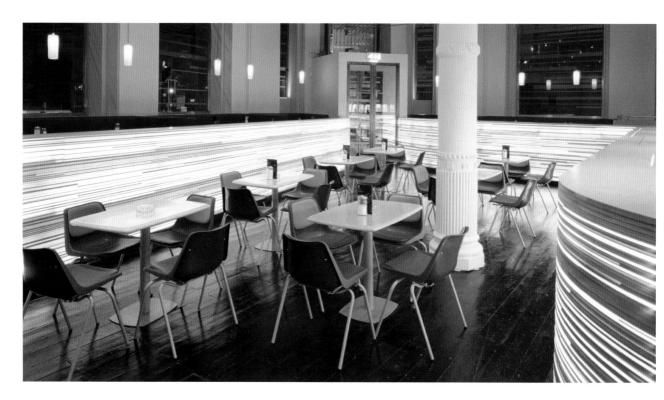

Quelle est, d'après vous, l'idée de base qui sous-tend votre travail de conception ? Nous avons toujours essayé de nous distancier d'un style prédéterminé ou de critères formels – c'est pourquoi, par principe, nous n'avons pas de signature architecturale spécifique. On a décrit nos travaux comme des collages à références multiples ou des compositions qui restent en mémoire. Ceci est relatif à la façon dont nous réinterprétons le quotidien pour en faire quelque chose d'inattendu.

Dans quelle mesure Londres inspire-t-il votre créativité ? A Londres, plus que dans la plupart des autres villes, le design se « consomme » à grande échelle. Les idées sont éphémères, elles n'ont pas cours longtemps et ne résistent que jusqu'à ce que d'autres les remplacent.

Y a-t-il un style typiquement londonien dans l'architecture contemporaine ? Il y a, bien sûr, des courants communs qui nous influencent tous. S'il y a un style, c'est cette forme d'originalité et de singularité typiquement britannique.

Quel est le projet le plus important pour vous à l'heure actuelle ? Notre expérience s'élargit et nos capacités augmentent avec chaque projet que nous achevons. Certains projets ont été des « jalons » et nous ont beaucoup appris, comme par exemple notre appartement à New York ou le magasin pour Hussein Chalayan à Tokyo.

¿Cómo definiría la idea básica que encierran sus diseños? Siempre hemos intentado distanciarnos de un estilo estipulado y de ideas formales fijas. De ahí que, por principio, no tengamos un sello arquitectónico específico. Nuestro trabajo se ha descrito como una serie de collages o composiciones que permanecen en el recuerdo. Esto hace referencia a nuestra manera de reinterpretar lo cotidiano para transformarlo en algo inesperado.

¿En qué medida inspira la ciudad de Londres su trabajo creativo? En Londres, más que en la mayoría de las ciudades, se "consume" diseño en un grado alarmante. Las ideas tienen una vida breve y permanecen sólo hasta que son sustituidas por las siguientes.

¿Existe un estilo típico londinense en la arquitectura actual? Naturalmente que hay corrientes generales que nos influyen a todos. Si existe un estilo, es entonces la originalidad y un enfoque idiosincrático peculiarmente británico.

¿Cuál ha sido su proyecto más importante hasta el momento? Con cada proyecto que llevamos a cabo aumentan nuestras experiencias y capacidades. En nuestros proyectos más significativos el efecto del proceso de aprendizaje fue aún más intenso; este es el caso de nuestro apartamento de Nueva York o de la tienda de Hussein Chalayan en Tokio.

Come descriverebbe l'idea originaria che sta alla base delle Sue creazioni? Abbiamo sempre tentato di stare alla larga da uno stile predeterminato o da rigidità formali: ecco perché, per principio, non abbiamo una specifica grafia architettonica. Delle nostre realizzazioni si è detto che sono collage pieni di richiami, o composizioni che restano impresse nella memoria. Con ciò ci si riferisce a come reinterpretiamo il quotidiano, per crearne qualcosa di inatteso.

In che misura Londra ispira la Sua creatività? A Londra si "consuma" design in maniera allarmante, più che nella maggior parte delle altre città. Le idee hanno vita breve, non sono durature e resistono solo il tempo necessario ad essere sostituite da quelle successive.

Esiste uno stile tipico di Londra nell'architettura contemporanea? Certo esistono correnti comuni che influenzano tutti noi. Se esiste uno stile particolare, allora direi che si tratta di un'originalità e unicità tipicamente britannica.

Qual è per Lei il più importante tra i progetti realizzati finora? Con ogni progetto che portiamo a termine, la nostra esperienza e le nostre capacità crescono. Da alcuni specifici progetti, che si possono definire "pietre miliari" della nostra attività, è conseguito un livello di apprendimento particolarmente alto: si pensi per esempio al nostro appartamento a New York o al negozio per Hussein Chalayan a Tokio.

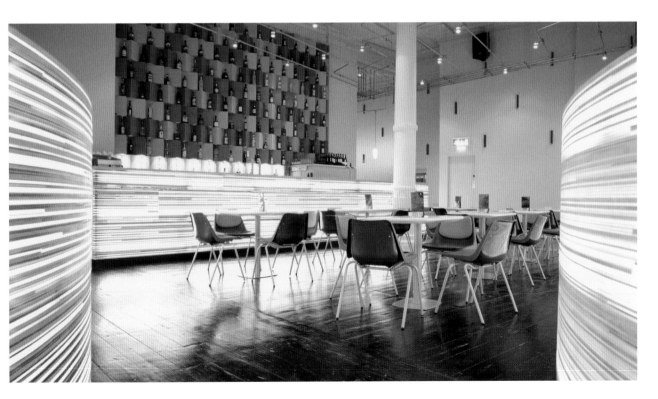

Market Place

Year: 2002

Location: 11 Market Place, London, W1

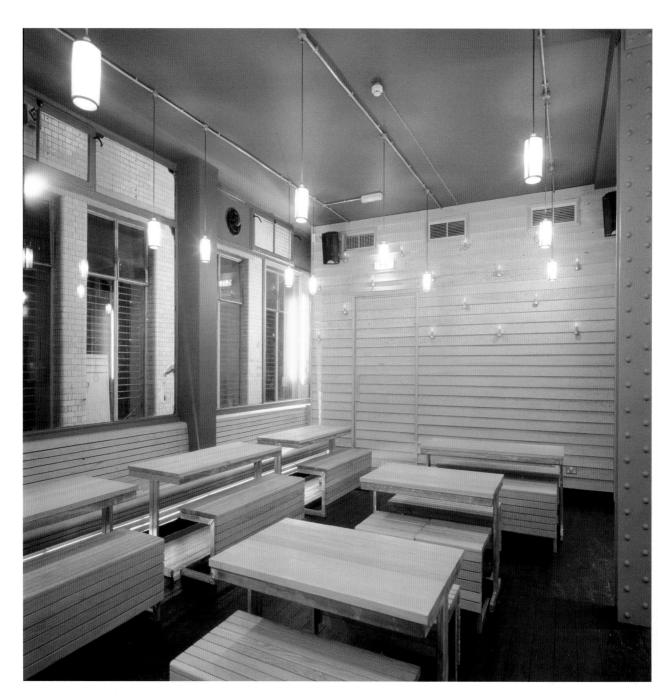

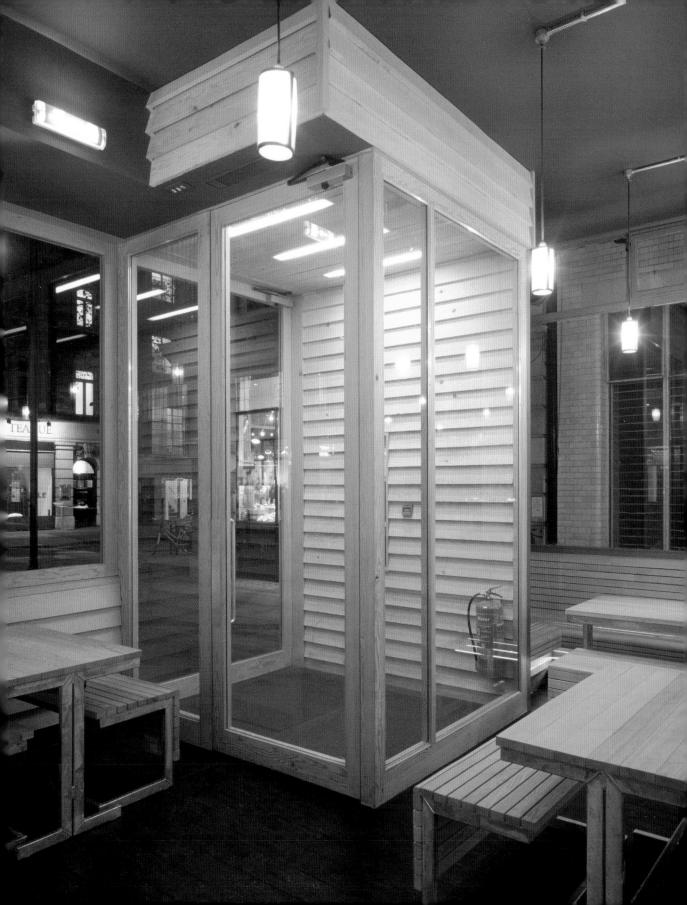

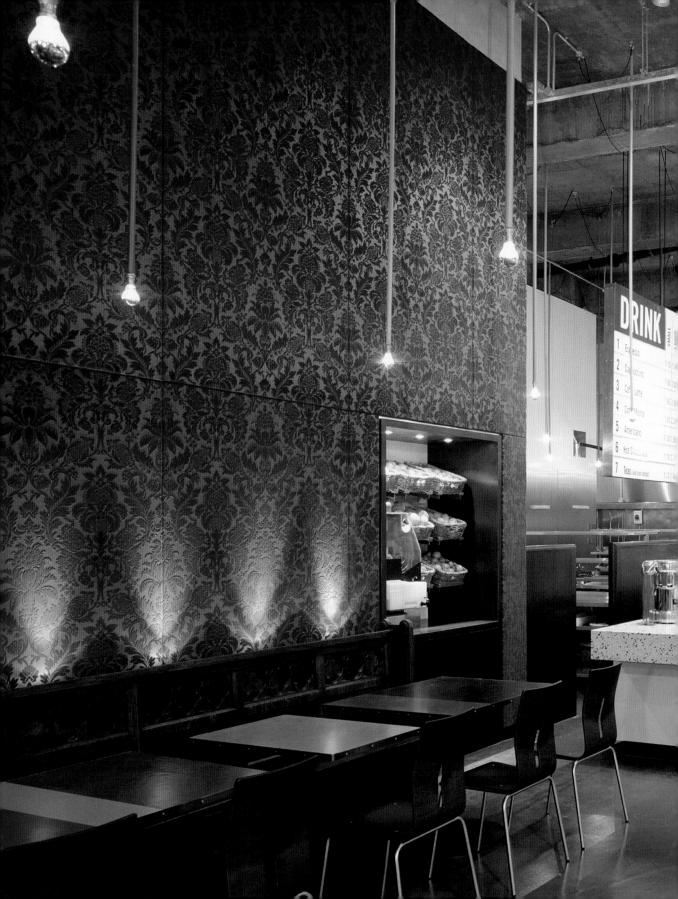

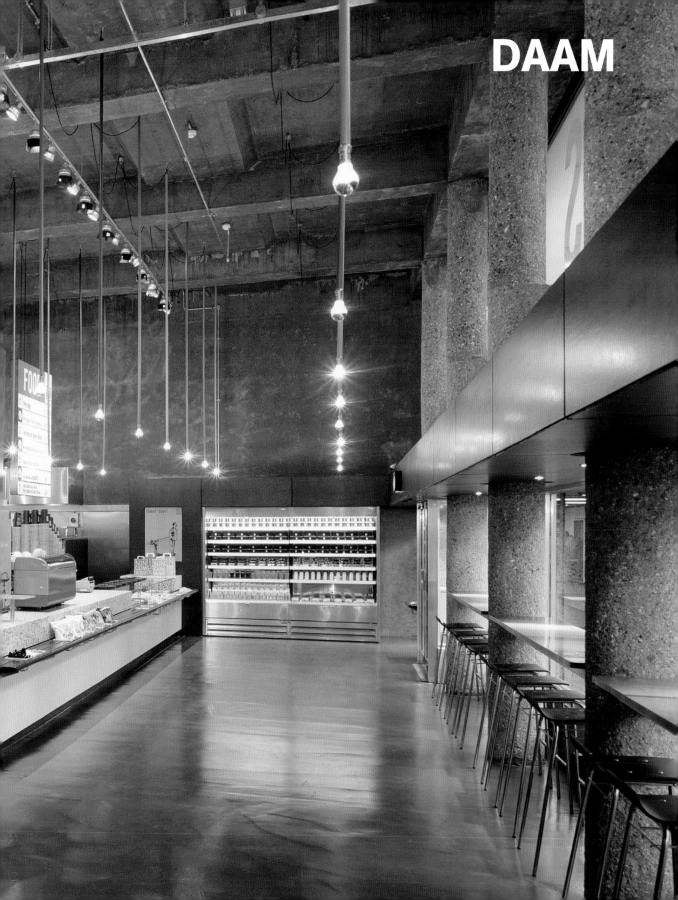

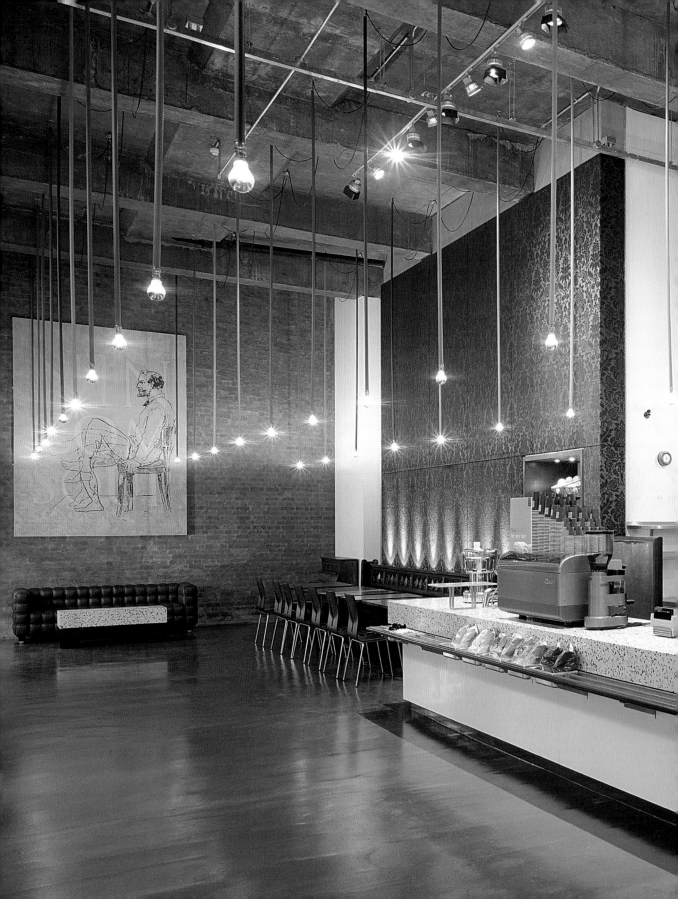

DAAM

16-24 Underwood Street, London N1 7JQ

P +44 20 7490 3520

www.daam.co.uk

info@daam.co.uk

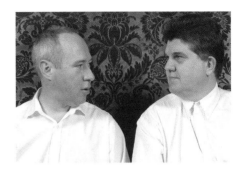

DAAM was founded in 2003 by designer Mike Walter and architect Arthur Collin. The interdisciplinary team at DAAM combines extensive experience in the designing of shops, bars and restaurants, private homes and apartments. The business is currently handling such diverse projects as the renovation of a medieval gaol in London, an apartment for an MP and restaurants in France and Russia.

DAAM wurde 2003 durch den Designer Mike Walter und den Architekten Arthur Collin gegründet. Im interdisziplinären Team von DAAM vereinen sich umfassende Erfahrungen im Design von Geschäften, Bars und Restaurants, aber auch von Privathäusern und Apartments. Gegenwärtig bearbeitet das Büro so unterschiedliche Projekte wie die Renovierung eines mittelalterlichen Gefängnisses in London, ein Apartment für einen Parlamentsabgeordneten sowie die Gestaltung von Restaurants in Frankreich und Russland.

DAAM a été fondé en 2003 par le designer Mike Walter et l'architecte Arthur Collin. L'équipe pluridisciplinaire de DAAM rassemble de larges expériences en matière de design de magasins, bars et restaurants, mais aussi de maisons particulières et d'appartements. Actuellement, le cabinet travaille sur des projets très différents les uns des autres, tels que la rénovation d'une prison du Moyen Âge à Londres, l'appartement destiné à un membre du parlement ainsi que l'aménagement de restaurants en France et en Russie.

DAAM fue inaugurado en 2003 por el diseñador Mike Walter y el arquitecto Arthur Collin. En el equipo interdisciplinario de DAAM se funden experiencias que comprenden el diseño de comercios, bares y restaurantes así como el de casas particulares y apartamentos. Actualmente el estudio trabaja en diversos proyectos, entre ellos la renovación de una cárcel de la Edad Media en Londres, un apartamento para un diputado del parlamento así como la concepción de restaurantes en Francia y Rusia.

Fondati nel 2003 dal designer Mike Walter e dall'architetto Arthur Collin, nel loro team interdisciplinare DAAM uniscono le più ampie esperienze in design di negozi, bar e ristoranti, ma anche di case private ed appartamenti. Attualmente lo studio si occupa di progetti molto differenti tra loro, quali la ristrutturazione di un carcere medievale a Londra, un appartamento per un deputato del parlamento o la progettazione di ristoranti in Francia e in Russia.

Arthur Collin

1962
born in Canberra, Australia

1993
Arthur Collin Architect

Mike Walter

1949
born in Devon, UK

1989
Walter & McNamara

2003
DAAM

Interview | Arthur Collin

How would you describe the basic idea behind your design work? Our work is primarily about Openness, both spatially and culturally. Our completed work exhibits a great attention to detail, a creative use of unusual but inexpensive materials, and an ability to draw open light-filled spaces out of unpromising situations.

To what extent does working in London inspire your creativity? Londoners take it for granted that it is easy to see new and exciting work in any creative field. It takes a few years living elsewhere to realise what a privilege this is.

Is there a typical London style in contemporary architecture? No. There are a number of approaches to design that are very strong in London but they are very different from each other. Intellectual practitioners often work in the same building as style-mongers.

Which project is so far the most important one for you? Nincomsoup was an important project for us because it instigated a close relationship with a great client. After quite some time in practice it is clear to me that a great client/designer relationship is the key to producing really good work.

Wie würden Sie die Grundidee beschreiben, die hinter Ihren Entwürfen steht? In unserer Arbeit geht es in erster Linie um Offenheit – im räumlichen wie im kulturellen Sinne. Unsere realisierten Arbeiten beweisen eine große Liebe zum Detail, den kreativen Umgang mit ungewöhnlichen, aber preiswerten Materialien und die Fähigkeit, zunächst wenig vielversprechende Orte in offene, lichtdurchflutete Räume zu verwandeln.

Inwiefern inspiriert London Ihre kreative Arbeit? Londoner halten es für selbstverständlich, dass man sich ohne weiteres neue und aufregende Arbeiten aus jedem kreativen Bereich ansehen kann. Man muss schon mal ein paar Jahre an einem anderen Ort gelebt haben, um zu begreifen, was für ein Privileg dies ist.

Gibt es einen typischen Londoner Stil in der aktuellen Architektur? Nein. Es gibt ein paar sehr ausgeprägte Designrichtungen in London, die sich jedoch sehr stark voneinander unterscheiden. Oft arbeiten intellektuelle Designer im selben Gebäude wie geschmäcklerische Nachahmer.

Welches ist für Sie Ihr bislang wichtigstes Projekt? Nincomsoup war für uns ein wichtiges Projekt, denn es schuf eine enge Beziehung zu einem bedeutenden Auftraggeber. Mit zunehmender Erfahrung als selbständiger Architekt wurde mir klar, dass die Beziehung zwischen Architekt und Auftraggeber der Schlüssel zu einem gelungenen Projekt ist.

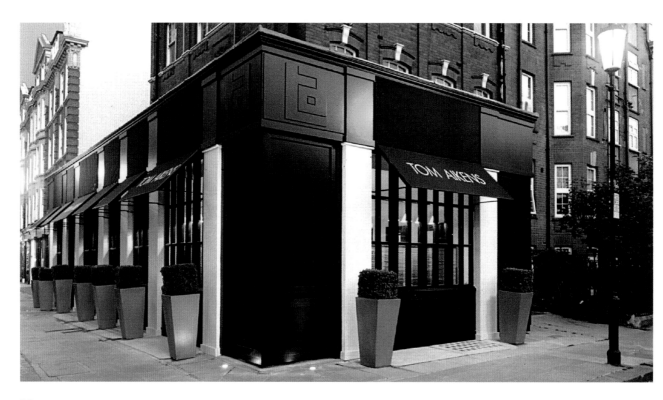

Quelle est, d'après vous, l'idée de base qui sous-tend votre travail de conception ? Dans notre travail il s'agit principalement d'ouverture – tant spatiale que culturelle. Les travaux que nous avons réalisés témoignent d'un grand amour du détail, d'une utilisation créative de matériaux inhabituels mais bon marché et de notre capacité à transformer des lieux au départ peu prometteurs en espaces ouverts, inondés de lumière.

Dans quelle mesure Londres inspire-t-il votre créativité ? Les Londoniens trouvent naturel de pouvoir voir à tout moment des travaux innovants et passionnants dans tous les domaines créatifs. Il faut avoir vécu quelques années ailleurs pour comprendre quel privilège c'est.

Y a-t-il un style typiquement londonien dans l'architecture contemporaine ? Non. Il y a, à Londres, quelques tendances très prononcées en matière de design, qui se distinguent fortement les unes des autres. Souvent, des designers intellectuels travaillent dans le même bâtiment comme des pasticheurs fantaisistes.

Quel est le projet le plus important pour vous à l'heure actuelle ? Nincomsoup fut un projet important pour nous car il suscita une relation étroite avec un important commanditaire. Mon expérience d'architecte indépendant grandissant, je réalise que la réussite d'un projet se fonde sur une bonne relation commanditaire-architecte.

¿Cómo definiría la idea básica que encierran sus diseños? La línea fundamental de nuestro trabajo es la apertura, tanto desde el punto de vista espacial como cultural. Los trabajos que hemos realizado son muestra de nuestra pasión por el detalle, la actividad creativa con materiales inusuales pero económicos y la capacidad de transformar lugares en un principio poco prometedores en espacios abiertos inundados de luz.

¿En qué medida inspira la ciudad de Londres su trabajo creativo? Los londinenses dan por sentado que es fácil ver obras atrayentes en todos los campos de la creación. Hay que haber vivido un par de años en otro lugar para darse cuenta del privilegio que esto supone.

¿Existe un estilo típico londinense en la arquitectura actual? No. En Londres existen un par de líneas de diseño muy marcadas que sin embargo se diferencian mucho unas de otras. Con frecuencia trabajan en el mismo edificio diseñadores intelectuales e imitadores.

¿Cuál ha sido su proyecto más importante hasta el momento? Nincomsoup fue para nosotros un proyecto importante ya que creó un estrecho vínculo con otros grandes clientes. A medida que he ido ganando experiencia como arquitecto autónomo me he dado cuenta de que la relación entre el arquitecto y el cliente es la clave del éxito de un proyecto.

Come descriverebbe l'idea originaria che sta alla base delle Sue creazioni? Nel nostro lavoro la cosa più importante è l'apertura, sia in senso spaziale sia in senso culturale. Le opere da noi realizzate dimostrano un grande amore per il dettaglio, un uso creativo di materiali non comuni ma economici e la capacità di trasformare luoghi inizialmente poco promettenti in spazi aperti, inondati di luce.

In che misura Londra ispira la Sua creatività? Gli abitanti di Londra danno per scontato che sia normale poter vedere opere nuove ed emozionanti di tutti i settori creativi. Ma basta aver vissuto altrove per un paio d'anni per comprendere che grande privilegio sia questo.

Esiste uno stile tipico di Londra nell'architettura contemporanea? No. A Londra ci sono alcune tendenze di design molto affermate, che però si differenziano molto tra loro. Capita spesso che designer intellettuali e imitatori di dubbio gusto lavorino insieme nello stesso edificio.

Qual è per Lei il più importante tra i progetti realizzati finora? Nincomsoup è stato un progetto importante per noi, perché ha dato vita ad un rapporto molto stretto con un cliente di rilievo. Col crescere della mia esperienza di architetto libero professionista, ho capito che il rapporto che si instaura tra l'architetto e il committente è la chiave per la buona riuscita di un progetto.

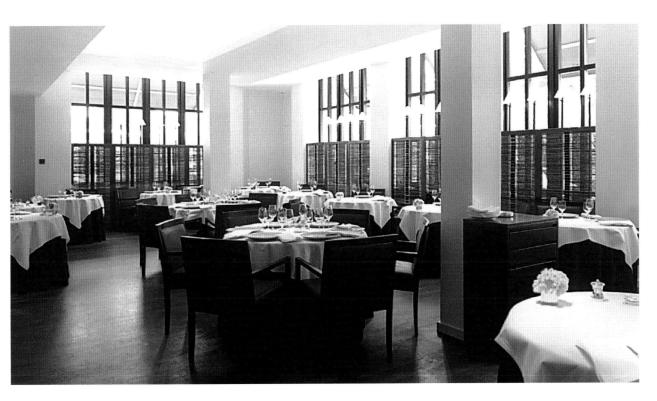

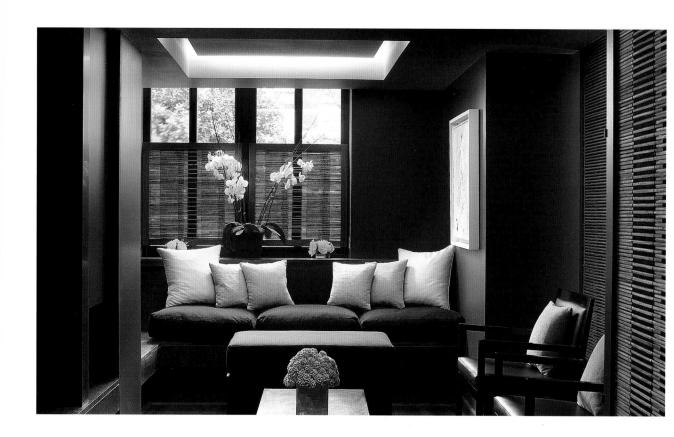

The Tom Aikens Restaurant is situated in the heart of Chelsea. The dining rooms are in the basement and on the ground floor. The elegantly restrained interior provides the perfect setting for visually stunning dishes.

Das Tom Aikens Restaurant liegt inmitten des Stadtteils Chelsea. Die Gasträume erstrecken sich über das Erdgeschoss und das Souterrain des Gebäudes. Die elegante, aber dezente Raumgestaltung bietet den perfekten Rahmen für die auch optisch aufwendig inszenierten Gerichte.

Le restaurant Tom Aikens est situé au cœur du quartier de Chelsea. Les salles à manger occupent le rez-de-chaussée et le sous-sol du bâtiment. La décoration intérieure, élégante mais sobre, constitue un cadre parfait pour des plats dont la présentation inventive flatte l'œil.

El Tom Aikens Restaurant está ubicado en el barrio de Chelsea. Los salones se prolongan por la planta baja y el sótano del edificio. La elegante y a la vez discreta concepción de los interiores ofrece el marco perfecto para el menú, cuyos platos son igualmente complejos y estilizados ópticamente.

Il Tom Aikens Restaurant è situato nel cuore del quartiere di Chelsea. Gli spazi destinati ad ospitare i clienti si trovano al piano terra e nel seminterrato dell'edificio. L'arredamento elegante ma discreto dei locali offre una perfetta cornice ai piatti serviti nel ristorante, messi in scena con grande attenzione anche all'aspetto estetico.

JESTICO + WHILES

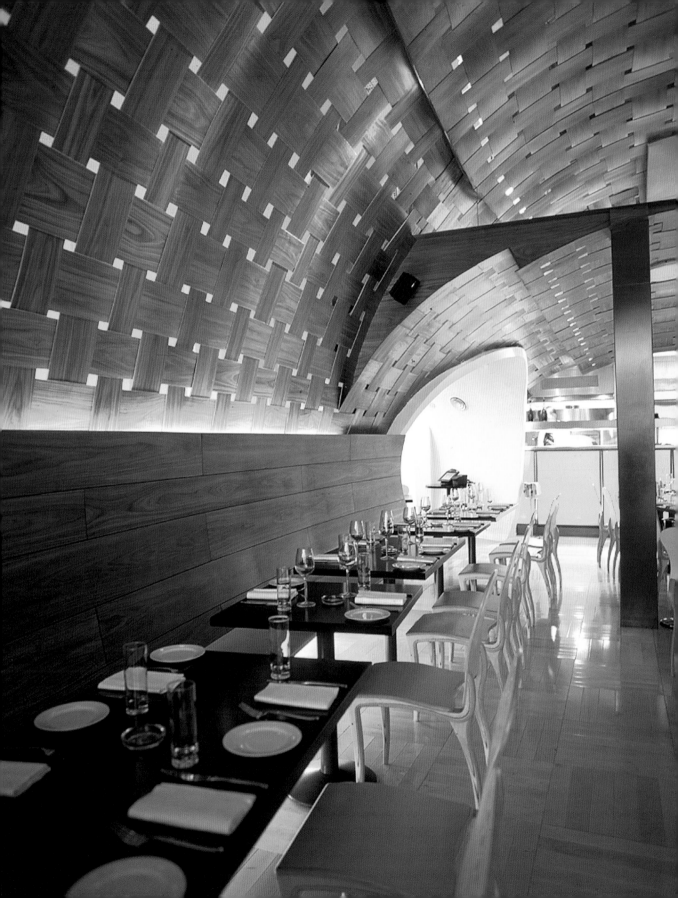

JESTICO + WHILES

1 Cobourg Street, London NW1 2HP

P +44 20 7380 0382

F +44 20 7380 0511

www.jesticowhiles.co.uk

jw@jesticowhiles.co.uk

As well as designing/planning private dwellings, offices and industrial buildings, JESTICO + WHILES also specialise in designing the interiors for bars, restaurants and hotels. By putting materials and lighting to clever use, they manage to create exclusive room interiors of timeless elegance. The Hempel hotel and the new Hilton Canary Wharf are perfect examples of their achievements.

Neben dem Wohnungs-, Büro- und Industriebau liegt ein besonderer Schwerpunkt der Arbeit von JESTICO + WHILES auf der Gestaltung von Interieurs für Bars, Restaurants und Hotels. Durch den geschickten Einsatz von Materialien und Beleuchtung gelingen ihnen exklusive Innenräume von zeitloser Eleganz. Beispiele wie das Hotel The Hempel oder das neue Hilton Canary Wharf belegen dies eindrucksvoll.

Outre la construction d'appartements, de bureaux et de locaux industriels, le travail de JESTICO + WHILES porte essentiellement sur la décoration intérieure de bars, restaurants et hôtels. La mise en œuvre habile des matériaux et des éclairages leur permet de réaliser des intérieurs exclusifs d'une élégance intemporelle. En témoignent, par exemple, de manière impressionnante, l'hôtel The Hempel ou le nouveau Hilton Canary Wharf.

El trabajo de JESTICO + WHILES se centra, a parte de la construcción industrial y de oficinas, en la creación de interiores para bares, restaurantes y hoteles. A través de una hábil aplicación de los materiales y la iluminación obtienen como resultado espacios interiores exclusivos de elegancia atemporal. El hotel The Hempel o el nuevo Hilton Canary Wharf son impresionantes muestras de ello.

Oltre all'edilizia abitativa, per uffici e per l'industria, l'attività di JESTICO + WHILES si concentra in particolare sull'allestimento di interni per bar, ristoranti ed alberghi. Grazie all'accorto utilizzo di materiali ed illuminazione, riescono a creare interni esclusivi di eleganza intramontabile: ne sono una prova di grande effetto esempi come l'hotel The Hempel o il nuovo Hilton Canary Wharf.

John Whiles

1947
born in Surrey, UK

Tony Ingram

1951
born in London, UK

Heinz Richardson

1954
born in Nuremberg, Germany

since 1977
JESTICO + WHILES

Interview | JESTICO + WHILES

How would you describe the basic idea behind your design work? Classic contemporary, and for interiors, comfortable.

To what extent does working in London inspire your creativity? Through the great domestic cultural mix and the almost constant international travel; from being based in one of the leading design hubs in the world.

Is there a typical London style in contemporary architecture? Yes. Context is at the root of London architecture.

Which project is so far the most important one for you? The first project – Epsom Offices and warehouse. It won a great award and kick started us into life.

Wie würden Sie die Grundidee beschreiben, die hinter Ihren Entwürfen steht? Zeitgenössisch-klassisch, und bei der Gestaltung von Innenräumen bequem.

Inwiefern inspiriert London Ihre kreative Arbeit? Durch die großartige kulturelle Mischung vor Ort und den ständigen internationalen Austausch; durch die Tatsache, an einem der wichtigsten Knotenpunkte der internationalen Designwelt zu sitzen.

Gibt es einen typischen Londoner Stil in der aktuellen Architektur? Ja. Der Schlüssel zur Londoner Architektur liegt im Kontext.

Welches ist für Sie Ihr bislang wichtigstes Projekt? Das erste Projekt – Epsom Offices and Warehouse. Es erhielt einen wichtigen Preis und bedeutete den Durchbruch für unser Büro.

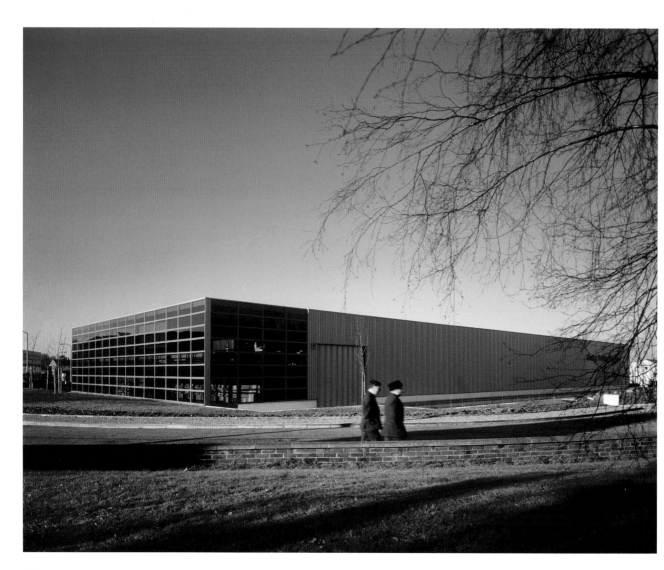

Quelle est, d'après vous, l'idée de base qui sous-tend votre travail de conception ? Classique contemporain, et pour le design des intérieurs, confortable.

Dans quelle mesure Londres inspire-t-il votre créativité ? Par le formidable mélange culturel sur place et les échanges internationaux constants ; par le fait d'être basé sur l'une des plus importantes plaques tournantes de l'univers du design international.

Y a-t-il un style typiquement londonien dans l'architecture contemporaine ? Oui. La clé de l'architecture londonienne réside dans le contexte.

Quel est le projet le plus important pour vous à l'heure actuelle ? Le premier projet – Epsom Offices and Warehouse. Il a reçu un prix important et cela a permis à notre cabinet de percer.

¿Cómo definiría la idea básica que encierran sus diseños? Contemporáneamente clásico y cómodo en la creación de espacios interiores.

¿En qué medida inspira la ciudad de Londres su trabajo creativo? A través de la mezcla cultural in situ y el intercambio internacional constante. Por estar ubicados en uno de los focos más importantes del mundo del diseño internacional.

¿Existe un estilo típico londinense en la arquitectura actual? Sí. La llave de la arquitectura londinense se esconde en el contexto.

¿Cuál ha sido su proyecto más importante hasta el momento? El primer proyecto: Epsom Offices y Warehouse. Recibió un importante galardón y con ello supuso el lanzamiento de nuestro estudio.

Come descriverebbe l'idea originaria che sta alla base delle Sue creazioni? Di una modernità classica e, per quanto riguarda l'arredamento d'interni, comoda.

In che misura Londra ispira la Sua creatività? Grazie all'eccezionale mescolanza di culture che vi si trova ed al continuo scambio internazionale; e per il fatto di trovarsi ad uno dei più importanti crocevia del design internazionale.

Esiste uno stile tipico di Londra nell'architettura contemporanea? Sì, la chiave di accesso all'architettura londinese è nel suo contesto.

Qual è per Lei il più importante tra i progetti realizzati finora? Il nostro primo progetto: Epsom Offices and Warehouse. Ottenne un premio importante e permise al nostro studio di affermarsi.

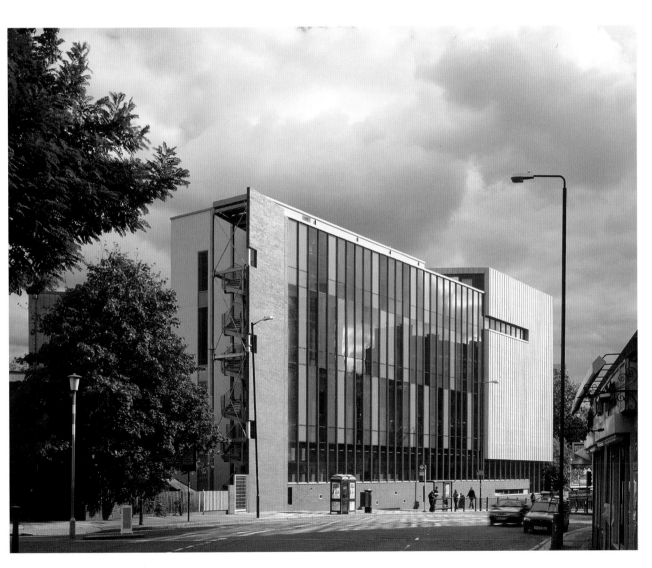

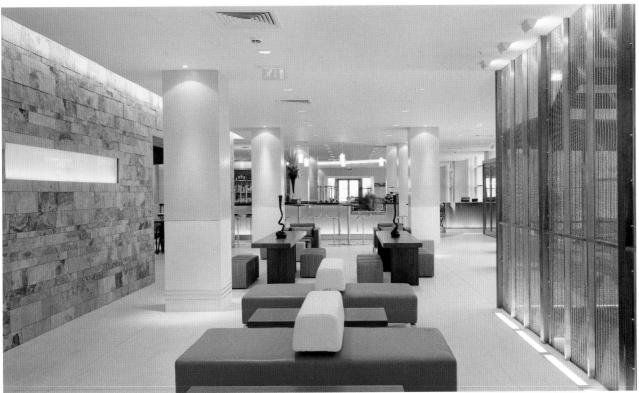

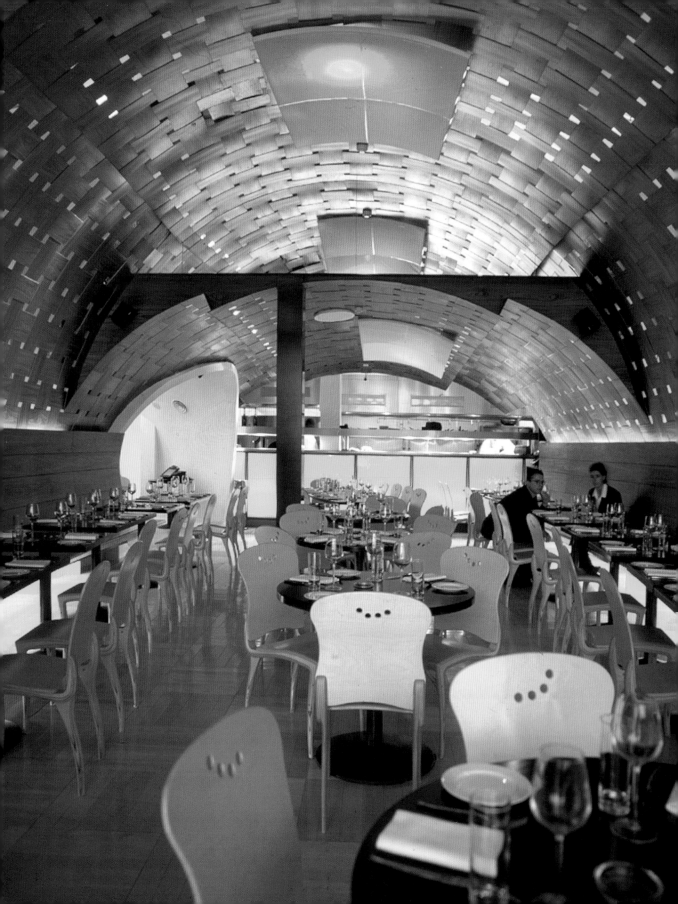

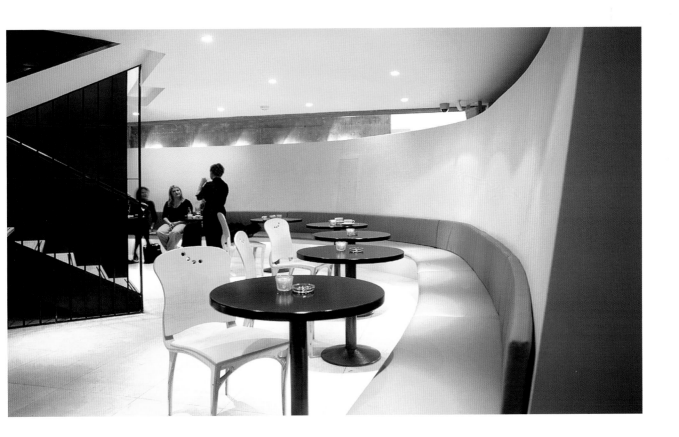

The Innecto is the new interpretation of an Italian restaurant. The visual conclusion to the room is achieved by the vaulted, woven-effect construction made of wood underneath the ceiling, which is about 15 feet high. This creates a friendly, Mediterranean atmosphere that is both modern and urbane.

Das Innecto ist die Neuinterpretation eines italienischen Restaurants. Unter der Decke des viereinhalb Meter hohen Innenraums bildet ein gewölbtes, hölzernes Flechtwerk den optischen Raumabschluss. Dies schafft eine freundliche, mediterrane Atmosphäre, die aber zugleich modern und urban wirkt.

Le Innecto revisite le concept du restaurant italien. Sous le plafond de la grande salle, haute de quatre mètres et demi, l'impression visuelle d'espace est parachevée par une voûte de bois tressé. Ceci crée une atmosphère méditerranéenne accueillante qui paraît en même temps moderne et citadine.

El Innecto es una nueva interpretación de un restaurante italiano. Bajo el techo de una estancia de cuatro metros y medio de altura, un trenzado en madera abovedado encierra ópticamente el espacio. Con ello proporciona un ambiente mediterráneo de efecto urbano y moderno a la vez.

Il Innecto è una reinterpretazione del tipico ristorante italiano: il locale, alto ben quattro metri e mezzo, è dotato di una volta in legno intrecciato che, sospesa sotto il soffitto, delimita visivamente lo spazio. Ciò crea una piacevole atmosfera mediterranea, che fa al contempo un effetto moderno e cittadino.

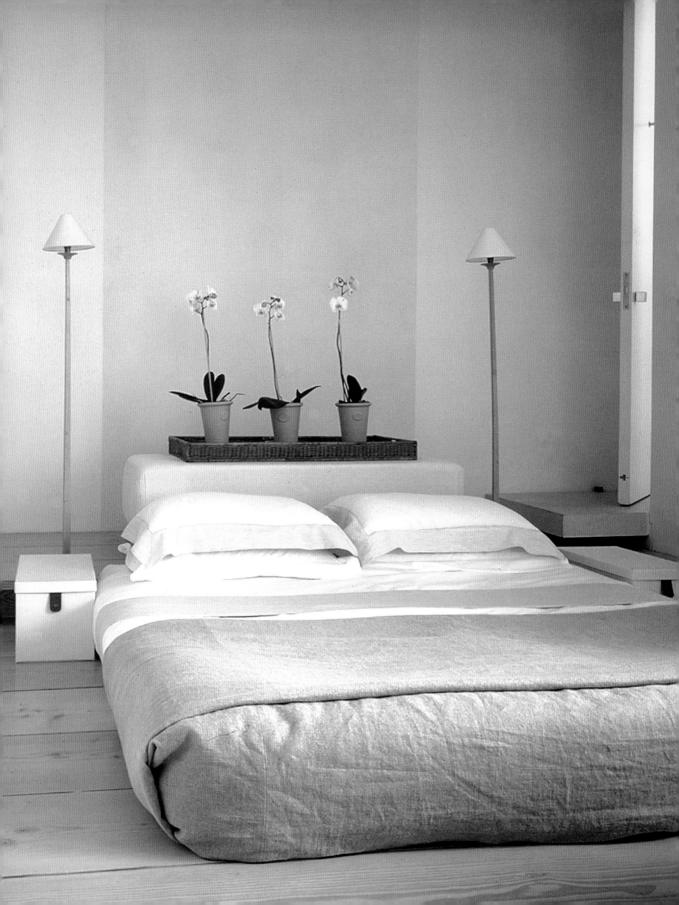

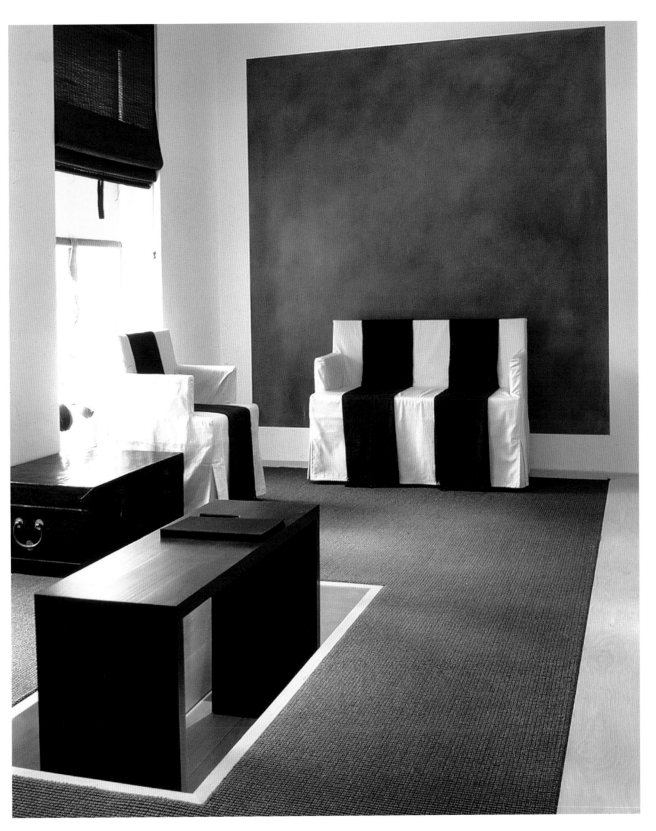

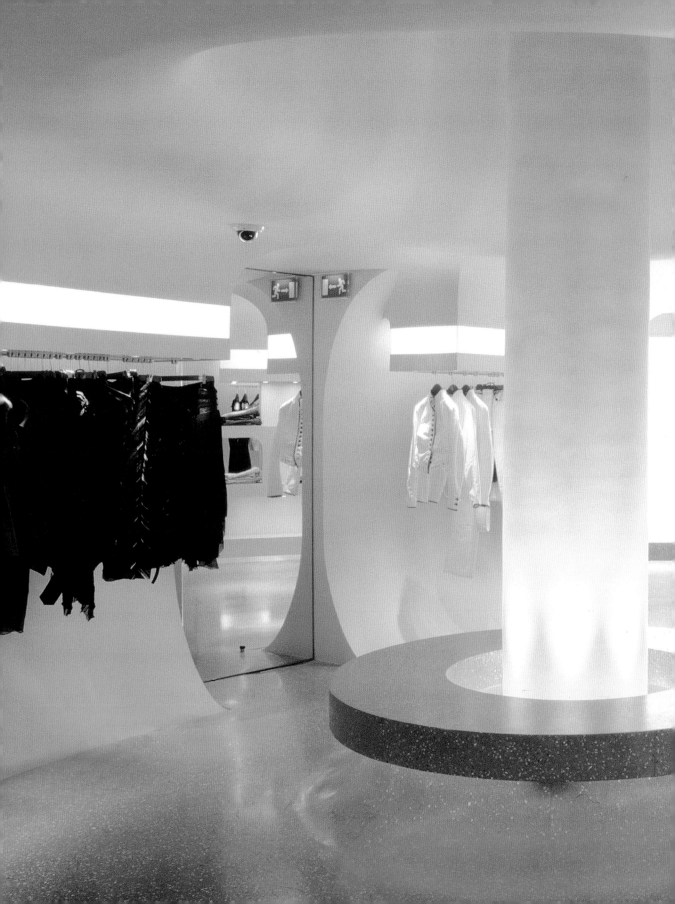

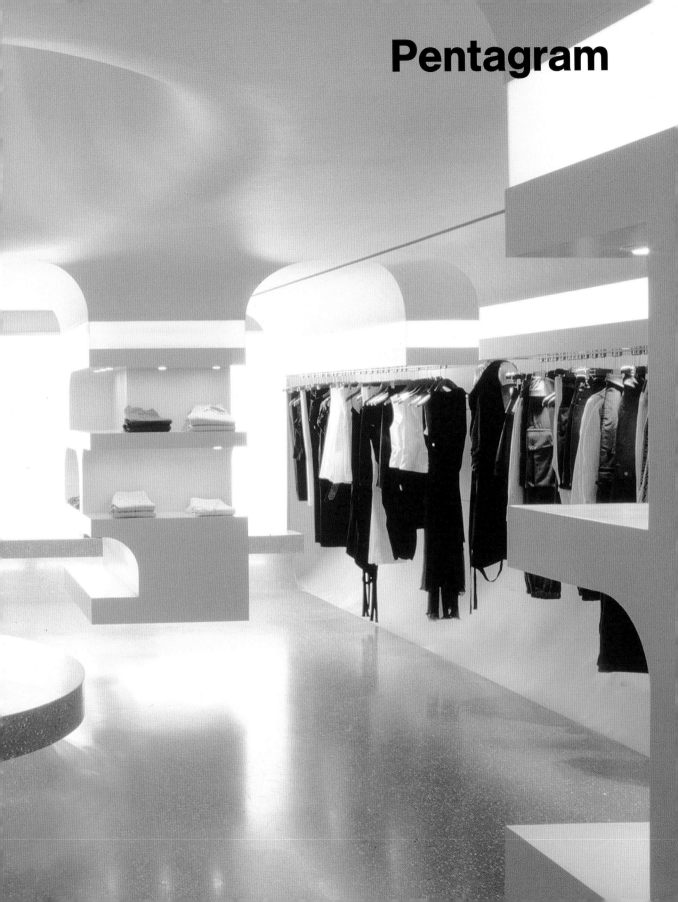

Pentagram

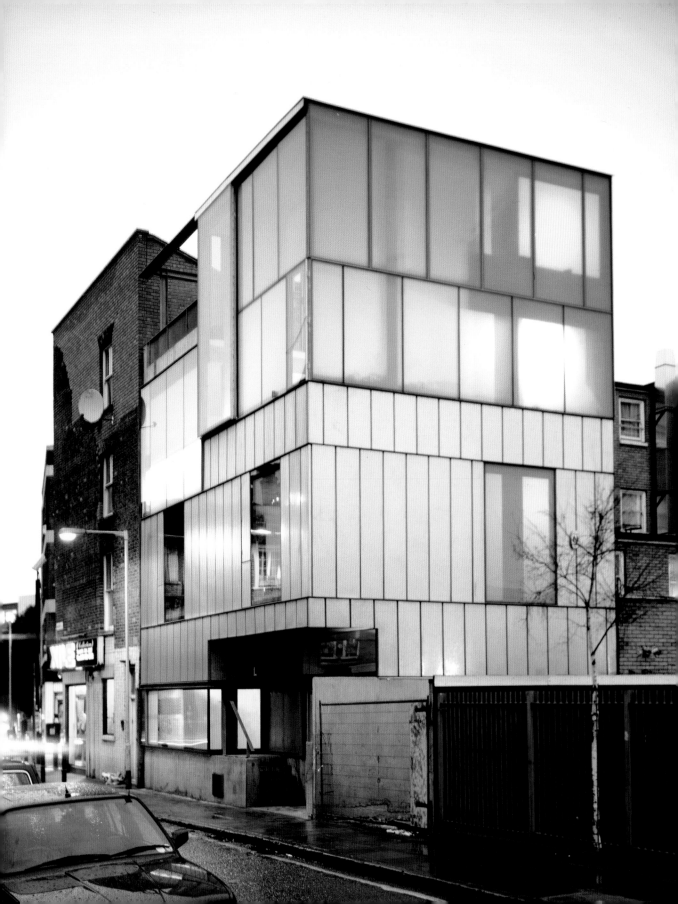

Pentagram

11 Needham Road, London W11 2RP

P +44 20 7229 3477

F +44 20 7727 9932

www.pentagram.co.uk

email@pentagram.co.uk

William Russell

1965
born in the UK

1994
Adjaye and Russell

2000
William Russel
Architecture and Design

2005
Partner in Pentagram Design

Pentagram was founded in 1972, originally by five partners. Today, Pentagram has a total of 19 partners and 170 employees all over the world, working in every aspect of design ranging from graphic, product and interior design to architecture. The current building projects in London are the responsibility of partner William Russell. One of the key aspects of his work is the design of flagship stores for renowned clients such as Alexander McQueen, although his portfolio also includes unusual residential buildings.

Pentagram wurde 1972 von ursprünglich fünf Partnern gegründet. Heute arbeitet die Firma mit weltweit insgesamt 19 Partnern und 170 Mitarbeitern in allen Bereichen des Designs – vom Grafikdesign über Produktdesign und Interiordesign bis hin zur Architektur. Die aktuellen Bauprojekte von Pentagram in London verantwortet der Partner William Russell. Ein Schwerpunkt seiner Arbeit liegt in der Gestaltung von Flagship-Stores für so prominente Auftraggeber wie Alexander McQueen; daneben finden sich in seinem Portfolio aber auch außergewöhnliche Wohngebäude.

Pentagram a été fondé en 1972, à l'origine par cinq associés. Aujourd'hui, Pentagram coopère dans le monde entier avec une équipe de 19 associés et de 170 collaborateurs dans tous les domaines du design – du design graphique au design de produits et d'intérieur et à l'architecture. L'associé William Russell est chargé des projets de construction actuels de Pentagram à Londres. Son travail porte principalement sur la conception des magasins amiral de commanditaires éminents tels qu'Alexander McQueen, mais son carnet de commandes comporte aussi des immeubles d'habitation exceptionnels.

En origen Pentagram fue fundado en 1972 por cinco socios. Hoy cuenta con 19 socios y 170 colaboradores en todo el mundo, activos en los ámbitos del diseño gráfico, diseño de productos e interiores y arquitectura. William Russell es el socio responsable de los actuales proyectos de construcción de Pentagram en Londres. El diseño de las Flagship Stores constituye un foco central de su actividad, para la que cuenta con clientes conocidos como Alexander McQueen. A su carpeta de trabajos se suman también edificios de viviendas fuera de lo convencional.

Pentagram, fondato nel 1972 originariamente da cinque soci, ha oggi un totale di 19 partner e 170 collaboratori con sede in tutto il mondo e lavora in tutti i settori del design: dal design grafico a quello del prodotto e d'interni fino all'architettura. Degli attuali progetti edili di Pentagram a Londra è responsabile William Russel: tra i punti focali della sua attività rientra l'allestimento di flagship store per clienti di prestigio come Alexander McQueen, per quanto nel portfolio dell'architetto non manchino anche edifici abitativi di grande originalità.

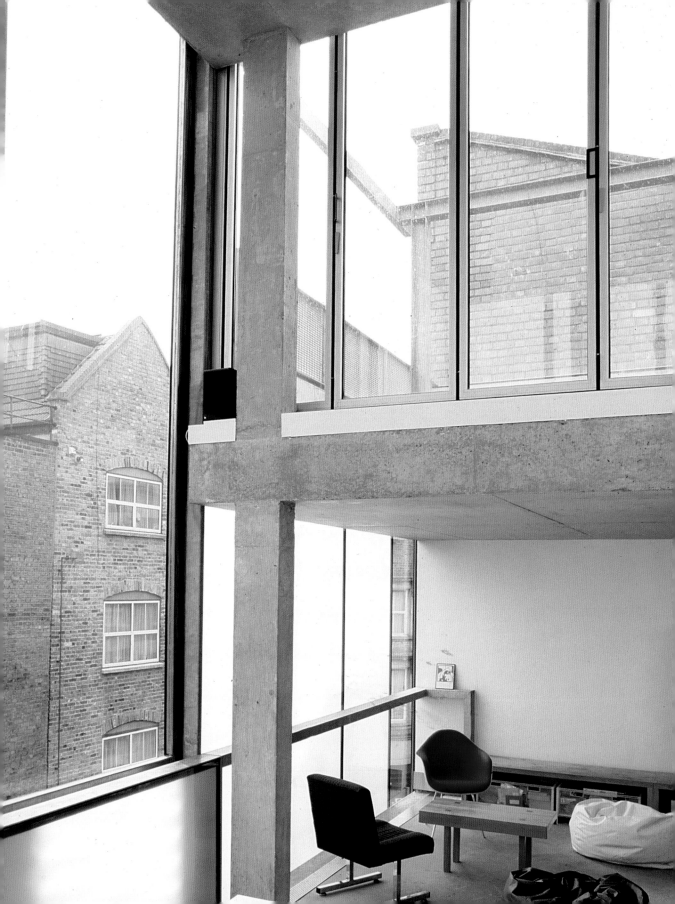

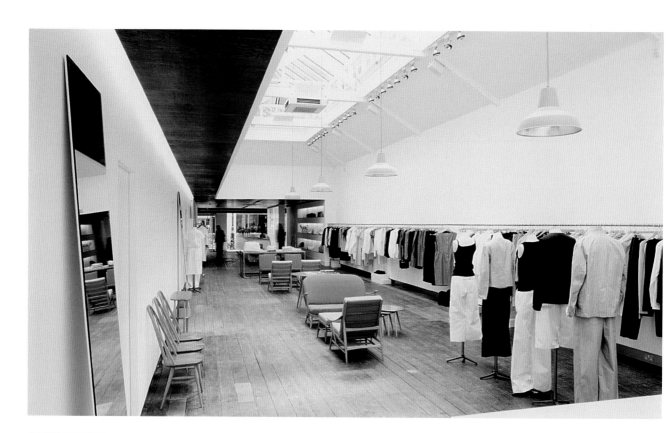

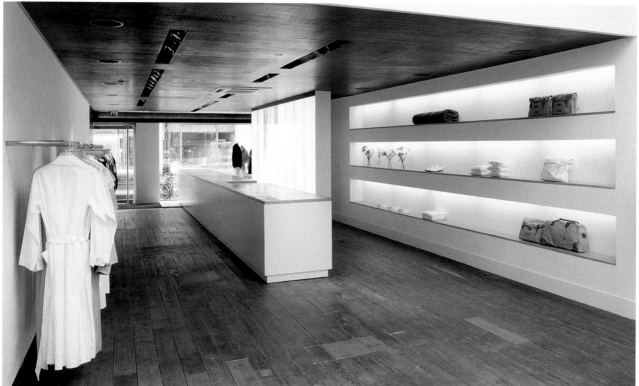

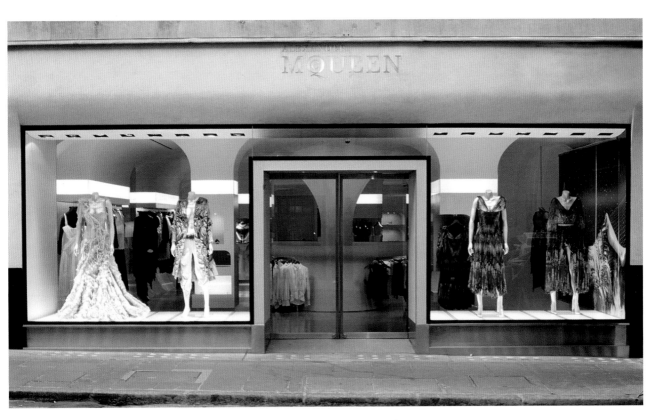

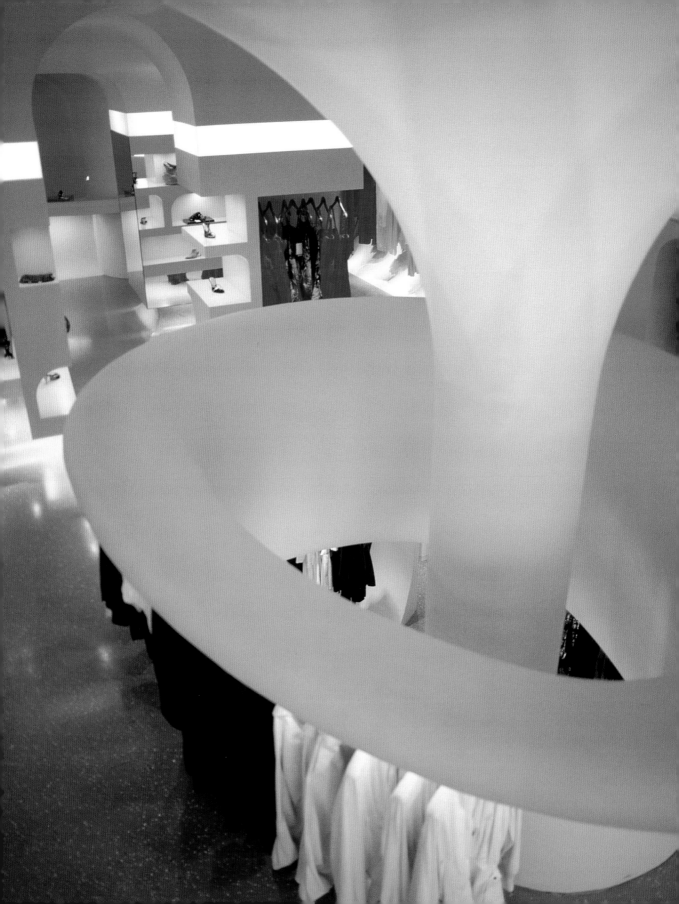

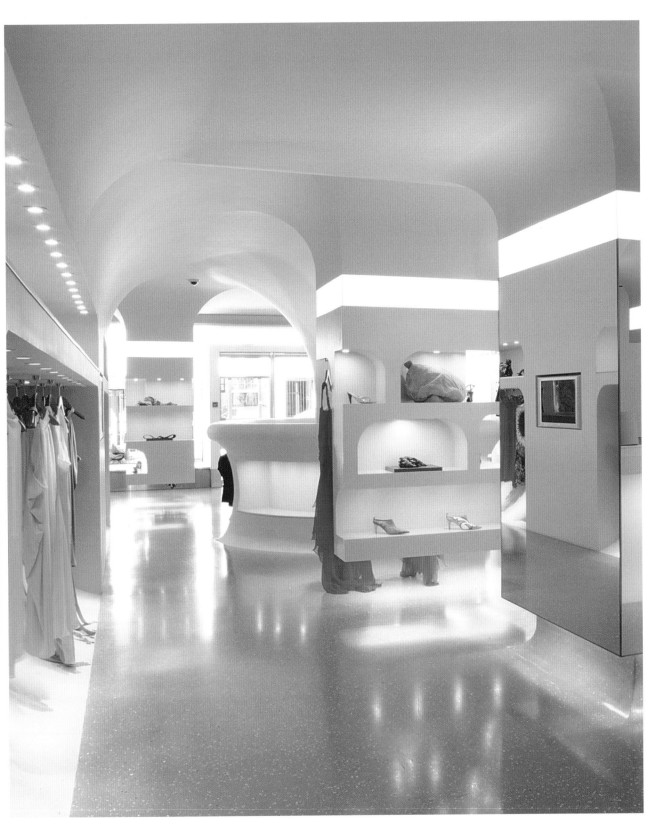

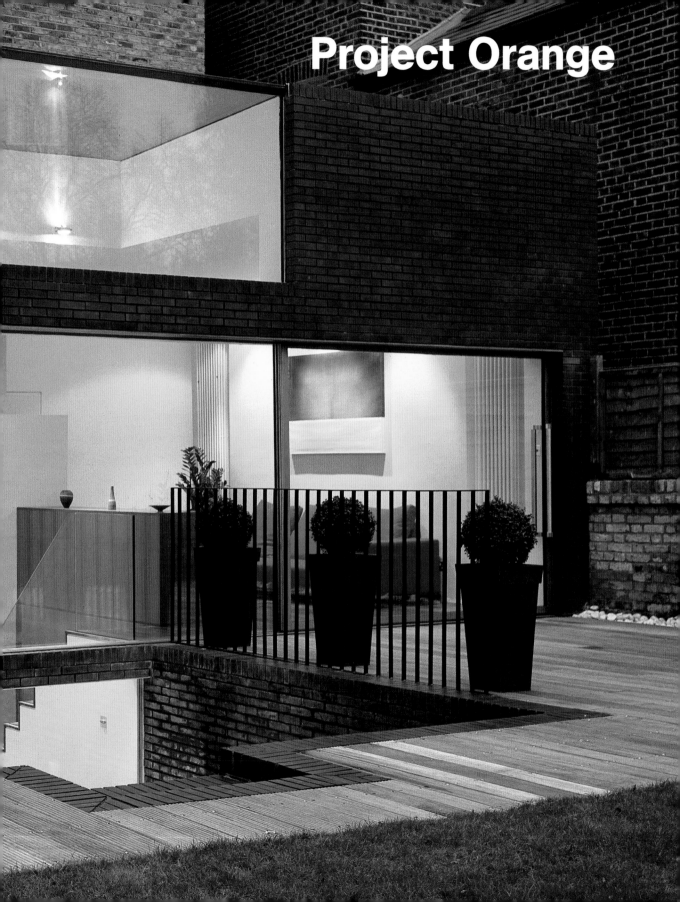

Project Orange

Project Orange

1st Floor, Morelands, 7 Old Street, London EC1V 9HL

P +44 20 7689 3456

F +44 20 7689 3173

www.projectorange.com

mail@projectorange.com

Designs by the team working with office founders James Soane and Christopher Ash are as appealing as they are ambitious; projects include shops, hotels, houses and apartments. Colours, surfaces and materials are carefully chosen by these experienced eclectics and combined in projects that are both exciting and harmonious.

Das Team um die Bürogründer James Soane und Christopher Ash gestaltet ebenso ansprechende wie ambitionierte Bauten und Innenräume – seine Projekte umfassen Läden, Hotels, Wohnhäuser und Apartments. Farben, Oberflächen und Materialien werden von den bekennenden Eklektikern sorgfältig ausgewählt und zu spannungsvollen, aber dennoch harmonischen Gesamtkompositionen kombiniert.

L'équipe qui entoure les fondateurs du cabinet, James Soane et Christopher Ash, crée des constructions et des intérieurs aussi attrayants qu'ambitieux – leurs projets comprennent des magasins, des hôtels, des résidences et des appartements. Couleurs, surfaces et matériaux sont soigneusement sélectionnés par ces éclectiques avoués, et combinés dans des compositions globales hardies mais cependant harmonieuses.

El equipo y los fundadores del estudio, James Soane y Christopher Ash configuran proyectos atractivos y ambiciosos; construcciones e interiores que incluyen comercios, hoteles, edificios de viviendas y apartamentos. Como reconocidos eclécticos, seleccionan minuciosamente colores, superficies y materiales con el fin de crear composiciones cargadas de tensión y armonía al mismo tiempo.

La squadra raccolta intorno ai fondatori dello studio, James Soane e Christopher Ash, realizza edifici ed interni tanto piacevoli quanto ambiziosi: tra i loro progetti rientrano negozi, alberghi, edifici abitativi ed appartamenti. Fieri del loro eclettismo, gli architetti scelgono con cura colori, superfici e materiali, combinandoli fino a raggiungere composizioni d'insieme ad un tempo tese ed armoniche.

Christopher Ash

1966
born in Liverpool, UK

James Soane

1966
born in Sheffield, UK

since 1997
Project Orange

Interview | Project Orange

How would you describe the basic idea behind your design work? Our work is a bold collage of Modernism, decoration and sensual materialism that form enduring statements. We embrace a diverse range of approaches and our house style is eclectic. Each project has its own individual personality; sometimes shy, at other times brash – and often unexpected.

To what extent does working in London inspire your creativity? London is so vast and impossible to take in. It is always full of juxtapositions and surprises. We like the energy that embraces the most unlikely of corners and the new interventions that spike the older fabric of the city.

Is there a typical London style in contemporary architecture? Yes and no. Luckily there is a lot of diversity in London so you can see many of examples of good design. However there is also a very commercial architectural approach which has become a cliché when not carried out to the highest standards.

Which project is so far the most important one for you? For us it has to be a new mixed use building in Sheffield as it is our first building. It took four years from start to finish.

Wie würden Sie die Grundidee beschreiben, die hinter Ihren Entwürfen steht? Unsere Arbeit ist eine gewagte, dennoch zeitlose Mischung aus klassischer Moderne, Dekoration und sinnlichen Materialien. Unser Stil ist eindeutig eklektizistisch und durch eine Vielfalt unterschiedlicher Herangehensweisen gekennzeichnet. Für uns hat jedes Projekt so etwas wie eine eigene Persönlichkeit: mal scheu, mal aufdringlich – und häufig voller Überraschungen.

Inwiefern inspiriert London Ihre kreative Arbeit? London ist so riesig, dass man es nie ganz erfassen kann. Es steckt voller Gegensätze und Überraschungen. Wir lieben die Energie der Stadt, die aus völlig unterschiedlichen Teilen besteht, und die neueren Eingriffe, die die historische Stadtstruktur durchsetzen.

Gibt es einen typischen Londoner Stil in der aktuellen Architektur? Ja und nein. Zum Glück gibt es in London eine große Vielfalt, so dass man eine Menge Beispiele für gute Architektur finden kann. Allerdings gibt es auch einen sehr kommerziellen Ansatz in der Architektur, der, wenn er nicht in höchster Qualität ausgeführt wird, zum Klischee erstarrt.

Welches ist für Sie Ihr bislang wichtigstes Projekt? Unser erster Bau, ein Wohn- und Geschäftsgebäude in Sheffield, an dem wir insgesamt vier Jahre gearbeitet haben.

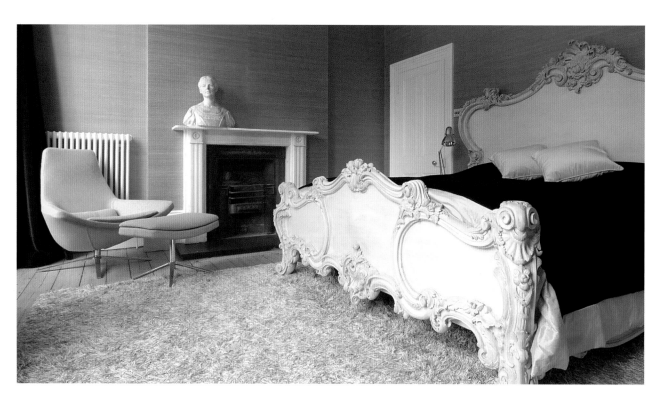

Quelle est, d'après vous, l'idée de base qui sous-tend votre travail de conception ? Notre travail est un mélange audacieux et cependant intemporel de modernisme, de décoration et de matérialisme sensuel. Notre style est incontestablement éclectique et caractérisé par des approches diverses. Pour nous, chaque projet a sa propre personnalité : quelquefois timide, d'autres fois agaçant – et souvent plein de surprises.

Dans quelle mesure Londres inspire-t-il votre créativité ? Londres est si grand qu'il est impossible de l'appréhender entièrement. Il est plein de contradictions et de surprises. Nous aimons l'énergie émanant de tous ses recoins et les récentes interventions qui émaillent le tissu urbain historique.

Y a-t-il un style typiquement londonien dans l'architecture contemporainel ? Oui et non. Il y a heureusement à Londres une grande diversité, si bien qu'on trouve de nombreux exemples d'excellente architecture. Mais il y a aussi une approche très commerciale de l'architecture qui se fige en cliché quand elle n'est pas portée par un niveau de qualité élevé.

Quel est le projet le plus important pour vous à l'heure actuelle ? Notre premier édifice, un immeuble de logements et de bureaux, à Sheffield, sur lequel nous avons travaillé quatre ans du début à la fin.

¿Cómo definiría la idea básica que encierran sus diseños? Nuestro trabajo es una mezcla atrevida, si bien atemporal a la vez, de lo clásico y lo moderno, la decoración y los materiales sensoriales. Nuestro estilo es claramente ecléctico y está influido por diversidad de formas de interpretación diferentes. Para nosotros cada proyecto está dotado de una personalidad propia, unas veces tímida, otras penetrante y con frecuencia cargada de sorpresas.

¿En qué medida inspira la ciudad de Londres su trabajo creativo? Londres es tan inmenso que no se puede abarcar por completo. Está cargado de contradicciones y sorpresas. A nosotros nos apasiona la energía de la ciudad, compuesta de partes absolutamente diferentes, y las nuevas intervenciones que fortalecen la estructura histórica de la ciudad.

¿Existe un estilo típico londinense en la arquitectura actual? Sí y no. Afortunadamente en Londres hay gran diversidad, de manera que se encuentran cantidad de ejemplos de buena arquitectura. Por otro lado existe también un aspecto muy comercial de la arquitectura, que se convierte en cliché si no se lleva a cabo con la mejor calidad.

¿Cuál ha sido su proyecto más importante hasta el momento? Nuestra primera construcción, un edificio comercial y de viviendas en Sheffield, en el que trabajamos durante cuatro años.

Come descriverebbe l'idea originaria che sta alla base delle Sue creazioni? Il nostro lavoro è un collage audace ma senza tempo di modernismo, decorazione e sensuale materialismo. Il nostro stile, chiaramente eclettico, è caratterizzato da una molteplicità di approcci differenti. Per noi, ogni progetto ha una sorta di personalità propria, a volte timida, a volte invadente. Spesso piena di sorprese.

In che misura Londra ispira la Sua creatività? Londra è così gigantesca, che non è mai possibile comprenderla appieno. È piena di contrasti e di sorprese. Amiamo l'energia della città, che consiste di parti del tutto disomogenee, come pure amiamo i nuovi interventi urbanistici che s'infiltrano nella struttura storica della città.

Esiste uno stile tipico di Londra nell'architettura contemporanea? Sì e no. Per fortuna a Londra esiste una grande varietà, così che è possibile trovare tutta una serie di esempi di buona architettura. Esiste però anche un approccio molto commerciale all'architettura che, quando non venga realizzato ad alti livelli qualitativi, rischia di ridursi ad un cliché.

Qual è per Lei il più importante tra i progetti realizzati finora? Il nostro primo progetto, un edificio a destinazione mista abitativa e commerciale a Sheffield, cui abbiamo lavorato complessivamente quattro anni.

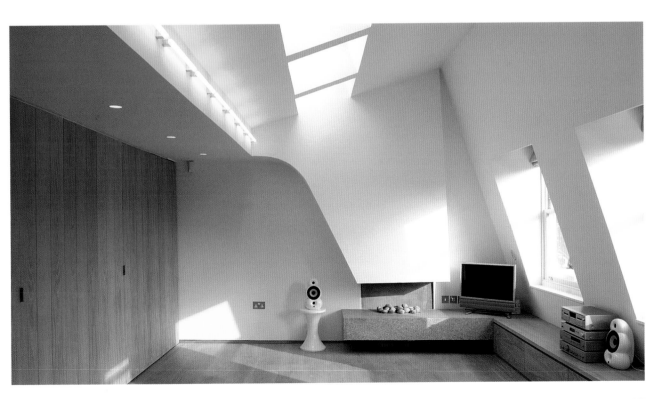

Spencer Road

Year: 2004

Location: Spencer Road, London

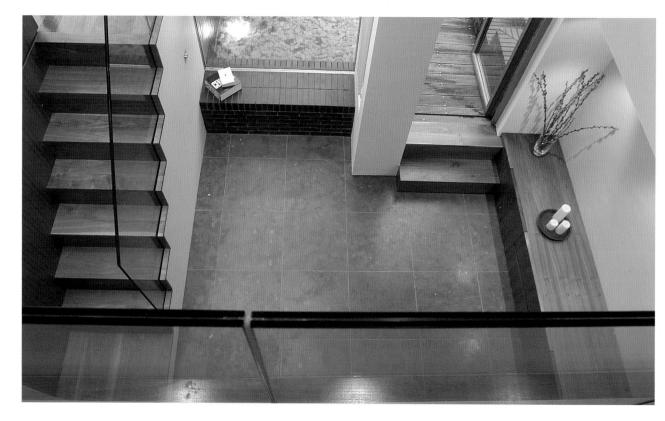

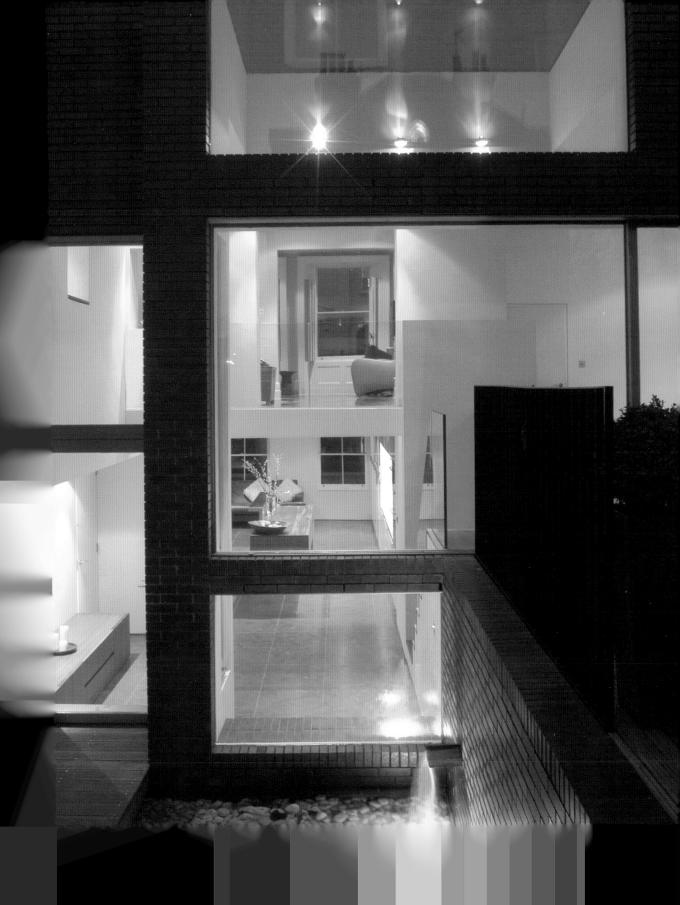

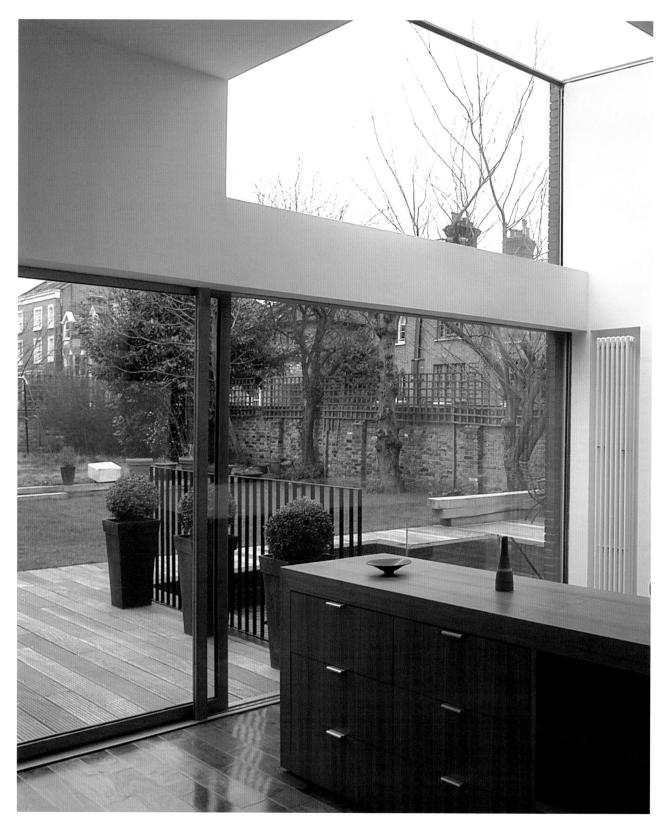

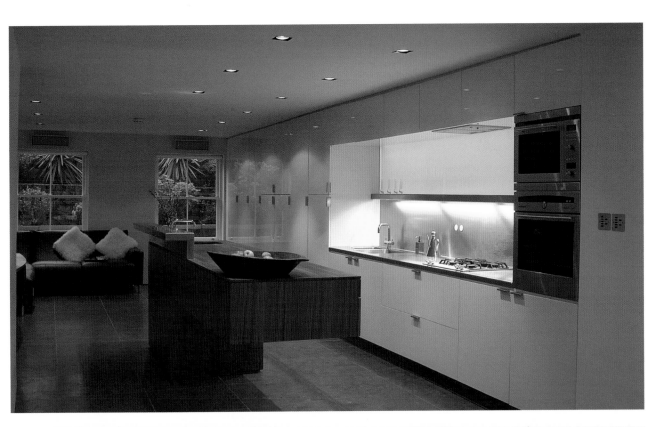

St Pauls Place

Year: 2005

Location: Islington, London

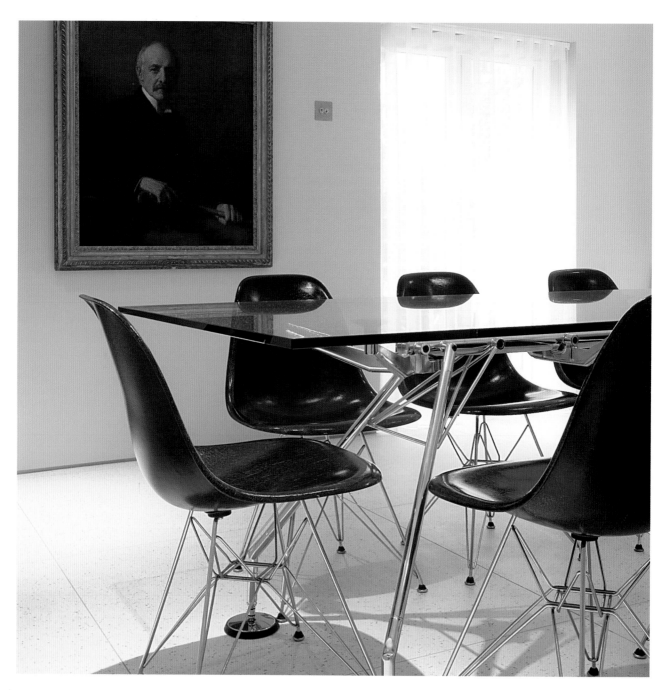

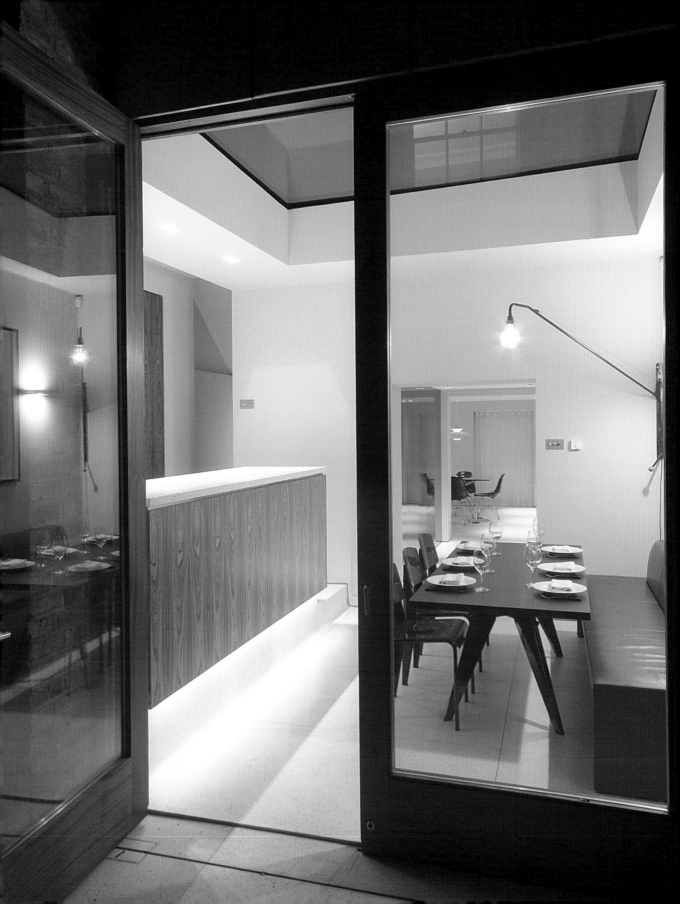

Raoul's

Year: 2005

Location: 105–107 Talbot Road, London W11 2AT

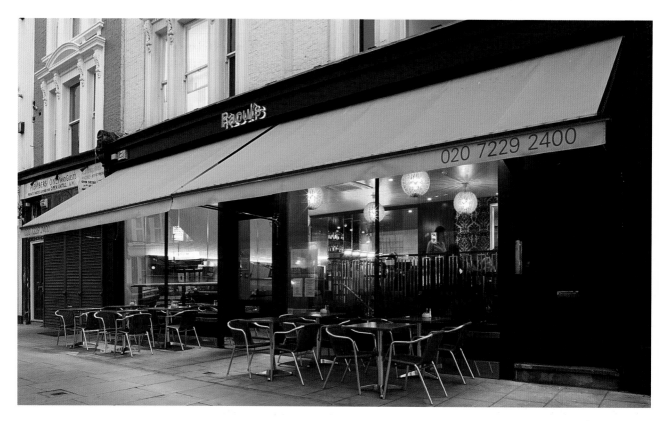

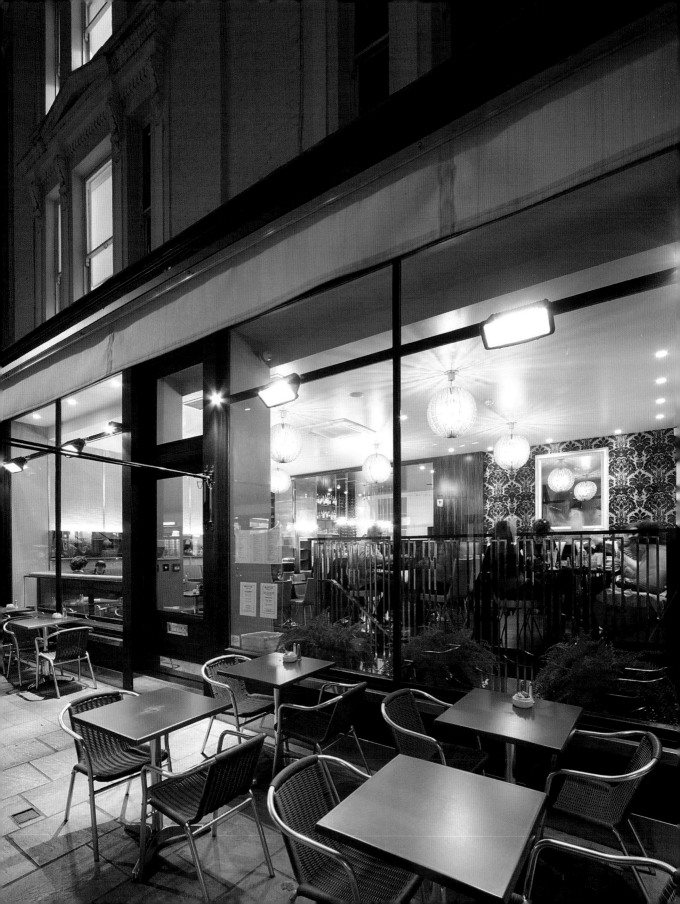

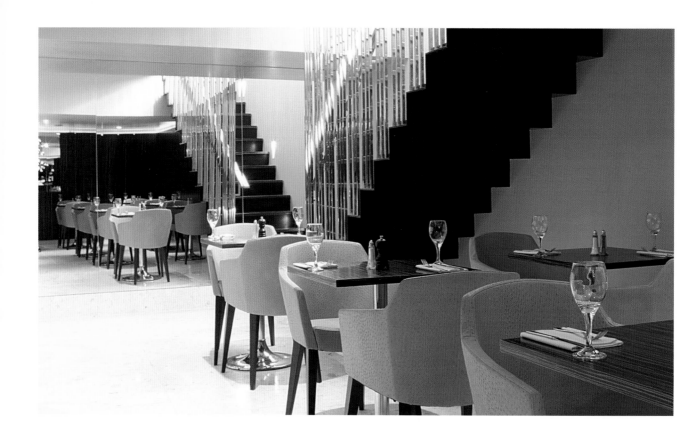

The interior of Raoul's in Talbot Road is a perfect example of Project Orange's eclectic approach: historic wallpaper patterns combined with contemporary furnishings, and stylistic elements and materials reminiscent of the sixties.

Die Innenräume des Raoul's in der Talbot Road illustrieren perfekt den eklektizistischen Ansatz von Project Orange: historische Tapetenmuster, kombiniert sowohl mit aktuellem Mobiliar als auch mit Stilelementen und Materialien, die an die sechziger Jahre erinnern.

Les intérieurs du café Raoul's sur Talbot Road illustrent parfaitement l'approche éclectique de Project Orange : des papiers peints aux motifs historiques, combinés tant avec du mobilier dernier cri qu'avec des éléments de style et des matériaux rappelant les années soixante.

Los interiores de Raoul's en la Talbot Road ilustran a la perfección el carácter ecléctico de Project Orange: diseños históricos en los empapelados de las paredes combinados tanto con mobiliario moderno como con elementos estilísticos y materiales que evocan los años sesenta.

Gli interni del Raoul's in Talbot Road illustrano alla perfezione l'approccio eclettico di Project Orange: tappezzerie dai motivi tradizionali si combinano tanto con mobili contemporanei quanto con materiali ed elementi stilistici che richiamano gli anni Sessanta.

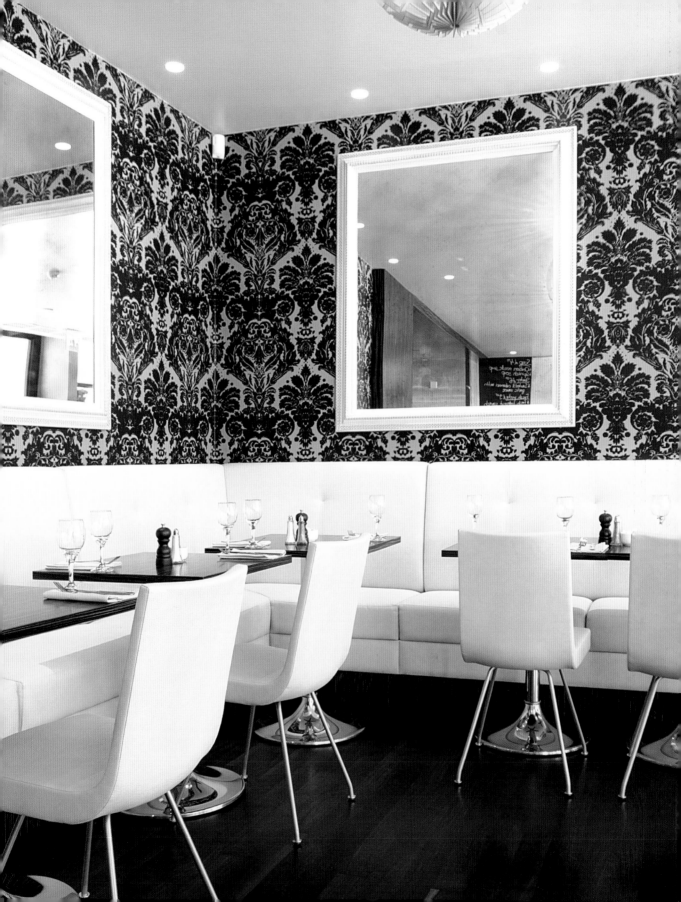

Nile Street

Year: 2005

Location: Nile Street, London

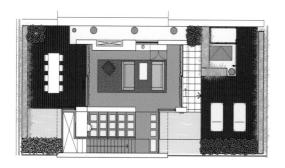
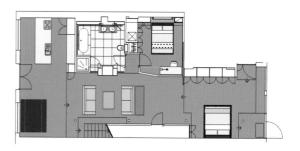

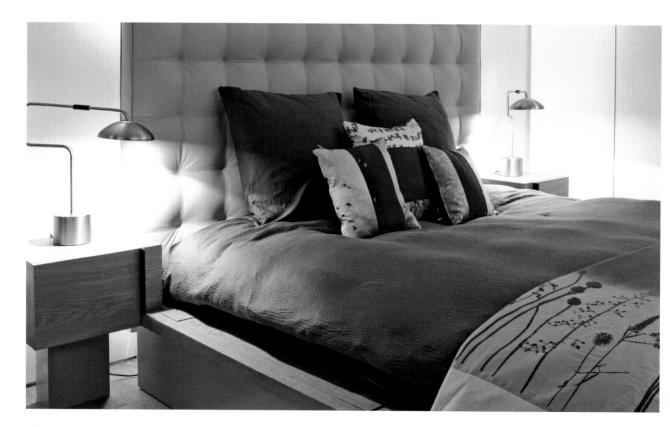

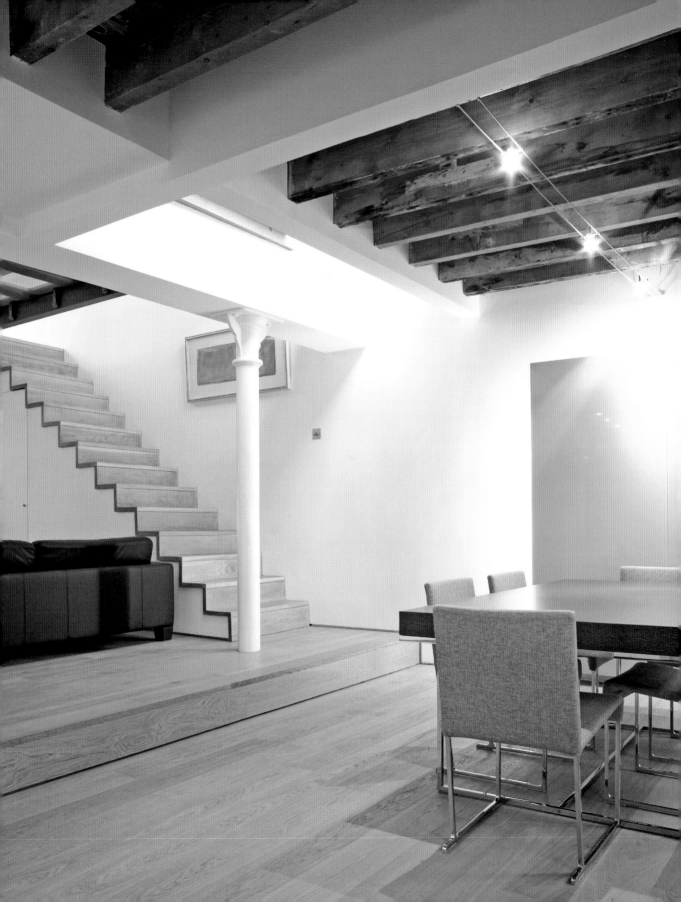

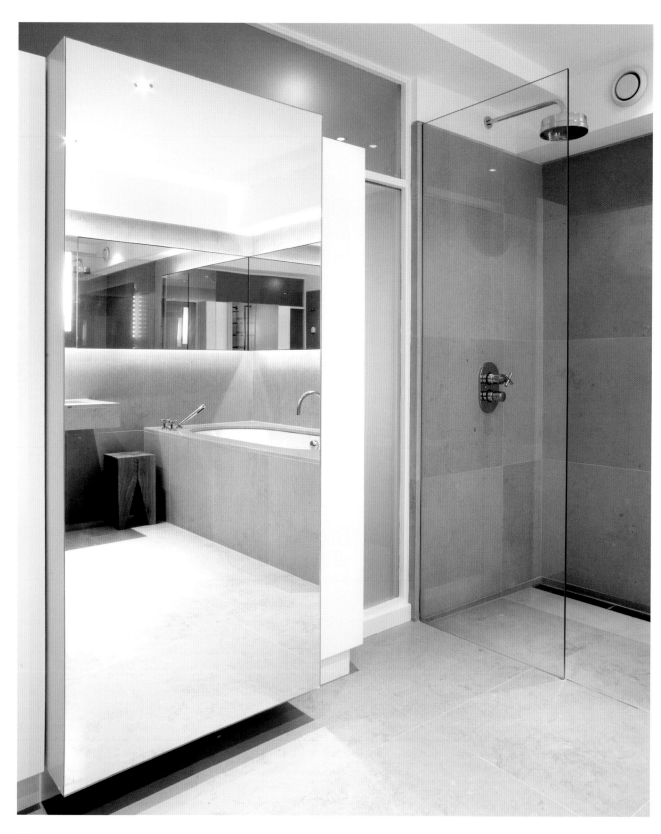

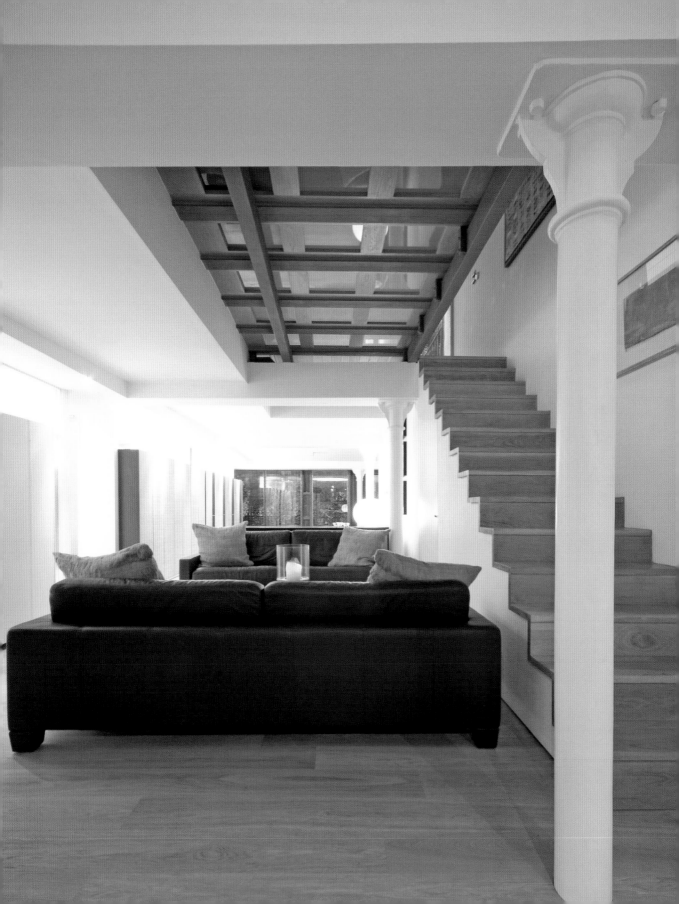

Raoul's Deli

Year: 2004

Location: 10 Clifton Road, London W9

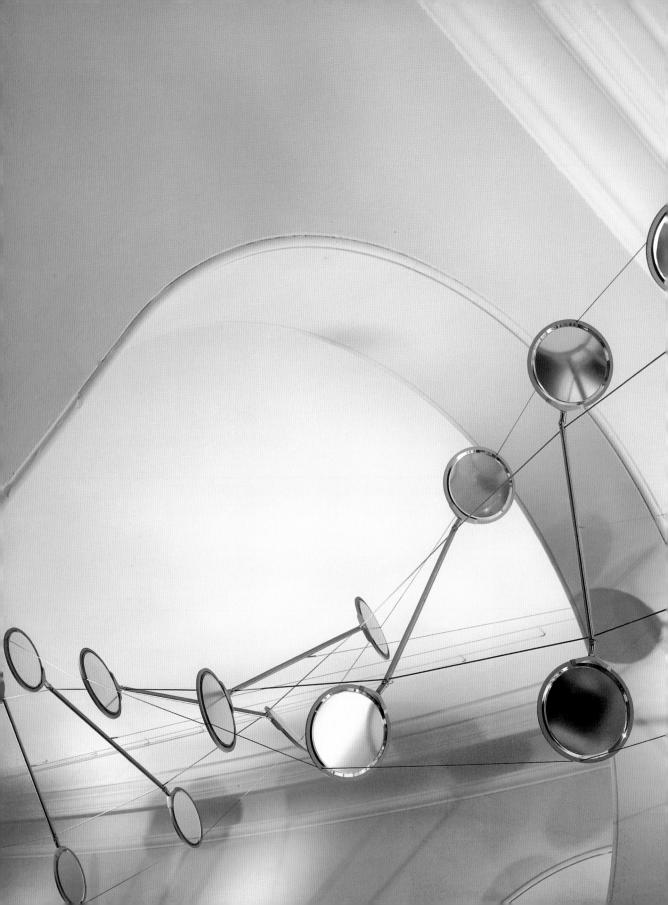

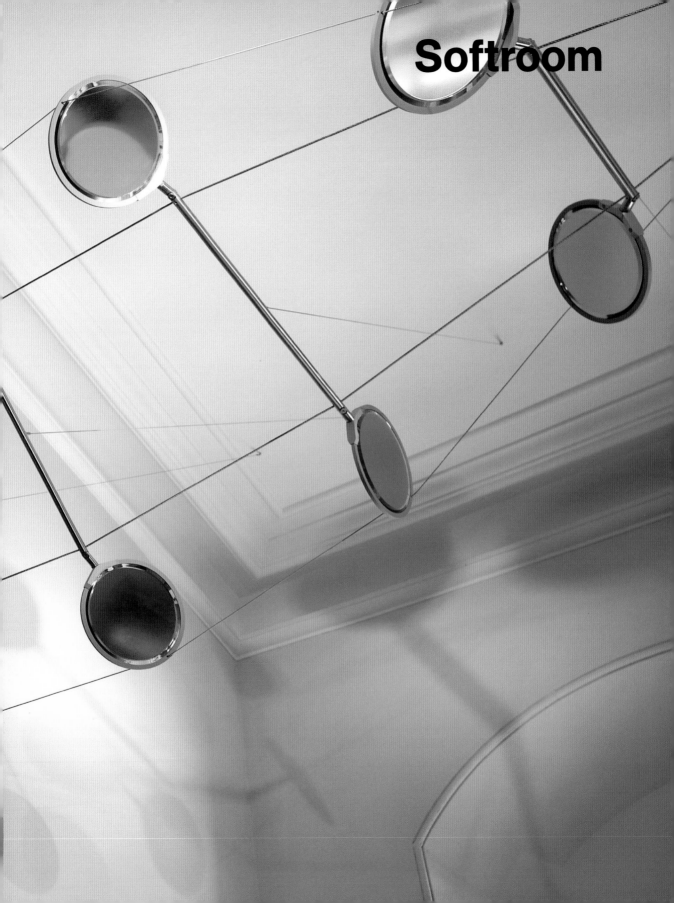

Softroom

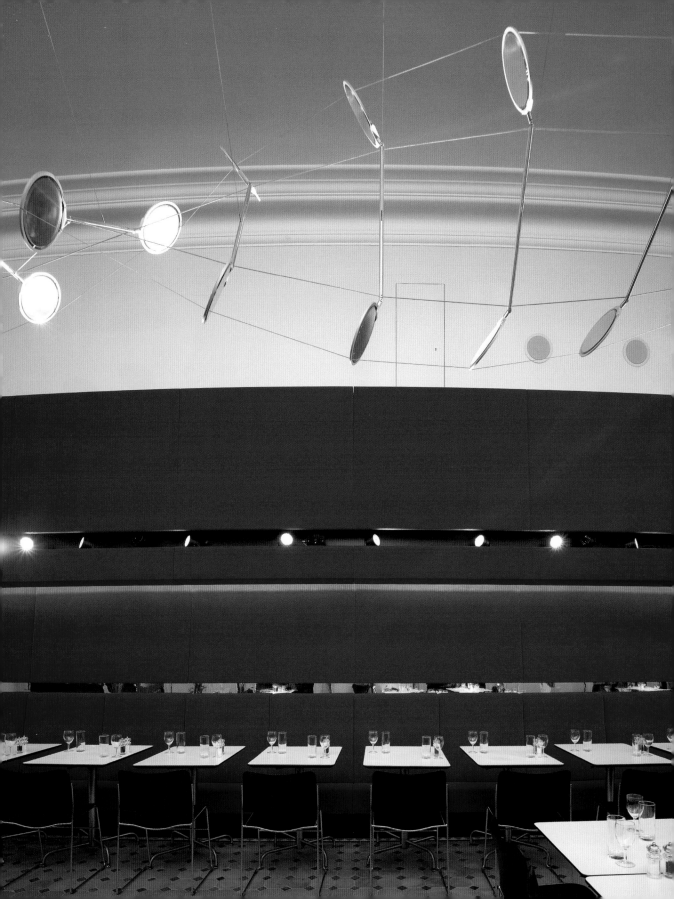

Softroom

341 Oxford Street, London W1C 2JE

P +44 20 7408 0864

F +44 20 7408 0865

www.softroom.com

softroom@softroom.com

Christopher Bagot

1969
born in Guildford, England

Oliver Salway

1970
born in Oxford, England

since 1995
Softroom

Softroom designs rooms – from shops and restaurants, lounges and exhibitions to virtual room settings for TV. Softroom was able to make use of the full range of its experience and expertise when designing the Virgin Upper Class Lounge at London's Heathrow airport: the spectacular world of experience, which measures almost 27,000 square feet, includes a central lobby, bar and restaurant and a luxurious wellness area.

Softroom gestalten Räume – von Läden und Restaurants über Lounges und Ausstellungsarchitekturen bis hin zu virtuellen Rauminszenierungen für Fernsehshows. Bei der Gestaltung der Virgin Upper Class Lounge am Flughafen London-Heathrow konnten Softroom das gesamte Spektrum ihrer Erfahrungen nutzen: Die spektakuläre, fast 2.500 Quadratmeter große Erlebniswelt umfasst eine zentrale Lobby, eine Bar, ein Restaurant sowie einen luxuriösen Wellnessbereich.

Softroom agence des espaces – magasins et restaurants, salons et architectures d'exposition ou mises en scènes virtuelles d'espaces pour des shows télévisés. Lors de l'aménagement du salon d'attente première classe de Virgin à l'aéroport de Londres-Heathrow, Softroom a pu tirer profit de l'éventail complet de ses expériences : cette surface de loisirs spectaculaire couvrant presque 2.500 mètres carrés comprend un foyer central, un bar, un restaurant ainsi qu'un luxueux espace de remise en forme.

Softroom crean espacios, desde comercios, restaurantes, lounges y arquitectura para exposiciones hasta el diseño de escenarios para programas televisivos. En la concepción del Virgin Upper Class Lounge del aeropuerto de Londres-Heathrow a Softroom le fue posible aplicar su amplia gama de experiencias; este espectacular planeta de casi 2.500 metros cuadrados comprende un vestíbulo central, bar, restaurante y un lujoso espacio wellness.

Gli architetti di Softroom creano spazi: non solo negozi e ristoranti, ma anche lounge aeroportuali ed architettura espositiva, fino ad arrivare alla messa in scena di spazi virtuali per spettacoli televisivi. Nel caso della progettazione della Virgin Upper Class Lounge, nell'aeroporto londinese di Heathrow, hanno avuto modo di sfruttare l'intera gamma delle esperienze finora raccolte: la spettacolare lounge, della grandezza di quasi 2.500 metri quadrati, comprende una lobby centrale, un bar, un ristorante e una lussuosa area wellness.

Interview | Softroom

How would you describe the basic idea behind your design work? We aim for our work to be innovative, diverse and high-quality. We also want our work to be accessible in the broadest sense – we strive to create spaces that are engaging and stimulating to as wide an audience as possible.

To what extent does working in London inspire your creativity? The city is multi-cultured, multi-faceted and one of the world's great metropolises. It would be pretty hard to shut all of that out.

Is there a typical London style in contemporary architecture? All of us here are dealing with similar economics, climate, strict legislation and the historical context – so if you look a bit deeper than the facade you start to see these connections – it's more of a "London Feel".

Which project is so far the most important one for you? We worked on both the Virgin Clubhouse and the Jameel Gallery side-by-side over three years. They are equally important and complement each other: the Clubhouse is our biggest project to date and is in the commercial sector, while the Gallery is of great cultural relevance. We'd like to keep that balance in our work going forwards.

Wie würden Sie die Grundidee beschreiben, die hinter Ihren Entwürfen steht? Unsere Arbeit soll innovativ, vielfältig und hochwertig sein. Außerdem soll sie im besten Sinne zugänglich sein – wir versuchen, Räume zu schaffen, die auf möglichst viele Menschen ansprechend und anregend wirken.

Inwiefern inspiriert London Ihre kreative Arbeit? Die Stadt ist multikulturell, facettenreich und eine der größten Metropolen der Welt. Es wäre schwierig, das alles von sich fernzuhalten.

Gibt es einen typischen Londoner Stil in der aktuellen Architektur? Wir alle hier leben unter denselben wirtschaftlichen Bedingungen, im selben Klima, mit den strengen Vorschriften und historischen Zusammenhängen. Wenn man hinter die Fassade sieht, kann man diese Verbindungen erkennen – man könnte sie als eine Art „London-Feeling" bezeichnen.

Welches ist für Sie Ihr bislang wichtigstes Projekt? ? Drei Jahre lang arbeiteten wir parallel am Virgin Clubhouse und der Jameel Gallery. Beide sind gleich wichtig und doch sehr gegensätzlich: Während unser bislang größtes Projekt, das Clubhouse, kommerzieller Natur ist, hat die Galerie eine hohe kulturelle Bedeutung. Diese Balance würden wir in unseren zukünftigen Arbeiten gerne bewahren.

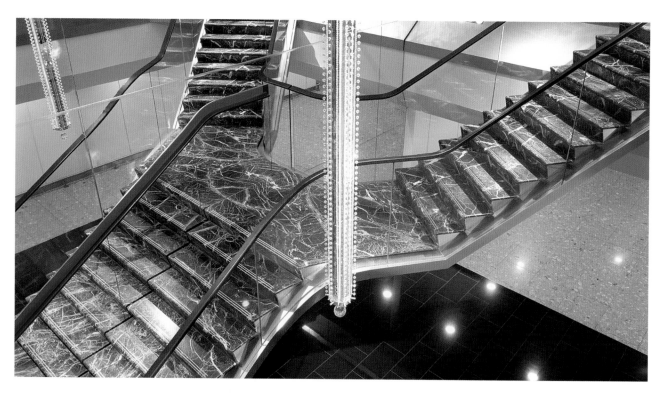

Quelle est, d'après vous, l'idée de base qui sous-tend votre travail de conception ?
Notre travail a pour but d'être innovant, multiple et de grande qualité. De plus, il doit être accessible au meilleur sens du terme – nous essayons de créer des espaces qui ont un effet stimulant et attrayant sur le plus large public possible.

Dans quelle mesure Londres inspire-t-il votre créativité ? C'est une ville pluriculturelle, à multiples facettes et l'une des plus grandes métropoles au monde. Il serait difficile d'en faire abstraction.

Y a-t-il un style typiquement londonien dans l'architecture contemporaine ? Tous ici, nous subissons les mêmes conditions économiques, le même climat, la même législation stricte et le même contexte historique. Quand on y regarde de plus près, on commence à reconnaître ces connexions – c'est ce qu'on pourrait appeler un « feel de Londres ».

Quel est le projet le plus important pour vous à l'heure actuelle ? Pendant trois ans nous avons travaillé parallèlement sur le Virgin Clubhouse et la Jameel Gallery. Tous deux sont pareillement importants et pourtant opposés : alors que notre plus grand projet à ce jour, le Clubhouse, est de nature commerciale, la galerie a une grande importance culturelle. Nous aimerions préserver cet équilibre dans nos futures réalisations.

¿Cómo definiría la idea básica que encierran sus diseños? Nuestro trabajo debe ser innovador, diverso y de alta calidad. Además tiene que ser accesible en el mejor de los sentidos. Intentamos crear espacios que resulten atrayentes y agradables para tanta gente como sea posible.

¿En qué medida inspira la ciudad de Londres su trabajo creativo? La ciudad es multicultural, rica en facetas y una de las metrópolis más grandes del mundo. Sería difícil alejarse de todo esto.

¿Existe un estilo típico londinense en la arquitectura actual? Todos vivimos aquí bajo las mismas condiciones económicas, en el mismo clima, con normas estrictas y vínculos históricos. Si se mira detrás de esta fachada es posible reconocer estas relaciones a las que se podría denominar como una especie de "London Feel".

¿Cuál ha sido su proyecto más importante hasta el momento? Durante tres años estuvimos trabajando paralelamente en la Virgin Clubhouse y la Jameel Gallery. Ambas tienen la misma importancia y al mismo tiempo son opuestas: mientras que nuestro mayor proyecto hasta el momento, la Clubhouse, cuenta con carácter comercial, la galería está dotada de un alto significado cultural. En proyectos futuros desearíamos mantener este equilibrio.

Come descriverebbe l'idea originaria che sta alla base delle Sue creazioni? Il nostro lavoro vuol essere innovativo, vario e ad alto livello qualitativo. Inoltre, vogliamo che sia accessibile nel miglior senso della parola: cerchiamo di creare spazi che abbiano l'effetto di attrarre e stimolare il maggior numero di persone possibile.

In che misura Londra ispira la Sua creatività? Questa città è multiculturale e ricca di sfaccettature, è una delle più grandi metropoli del mondo: sarebbe ben difficile non subirne l'influenza!

Esiste uno stile tipico di Londra nell'architettura contemporanea? Noi tutti qui viviamo nelle stesse condizioni economiche, con lo stesso clima, sottoposti alle stesse severe prescrizioni e nello stesso contesto storico. Se si guarda dietro alla facciata, si cominciano a riconoscere questi legami, che si potrebbero definire come una sorta di "London feel".

Qual è per Lei il più importante tra i progetti realizzati finora? Per tre anni abbiamo lavorato contemporaneamente al Virgin Clubhouse e alla Jameel Gallery. Questi due progetti, pur avendo la stessa importanza, sono molto differenti tra loro: mentre il nostro progetto di maggiori dimensioni finora, il Clubhouse, è di natura commerciale, la galleria ha una grande rilevanza culturale. Ci piacerebbe poter mantenere questo equilibrio nella nostra futura attività.

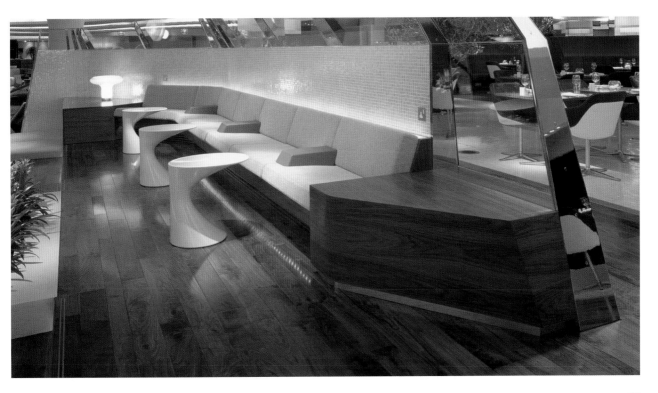

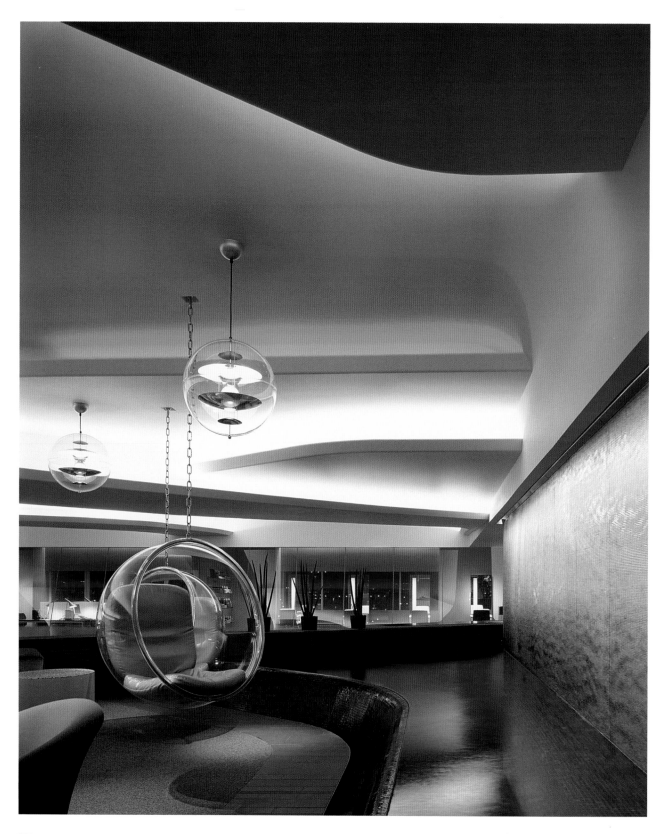

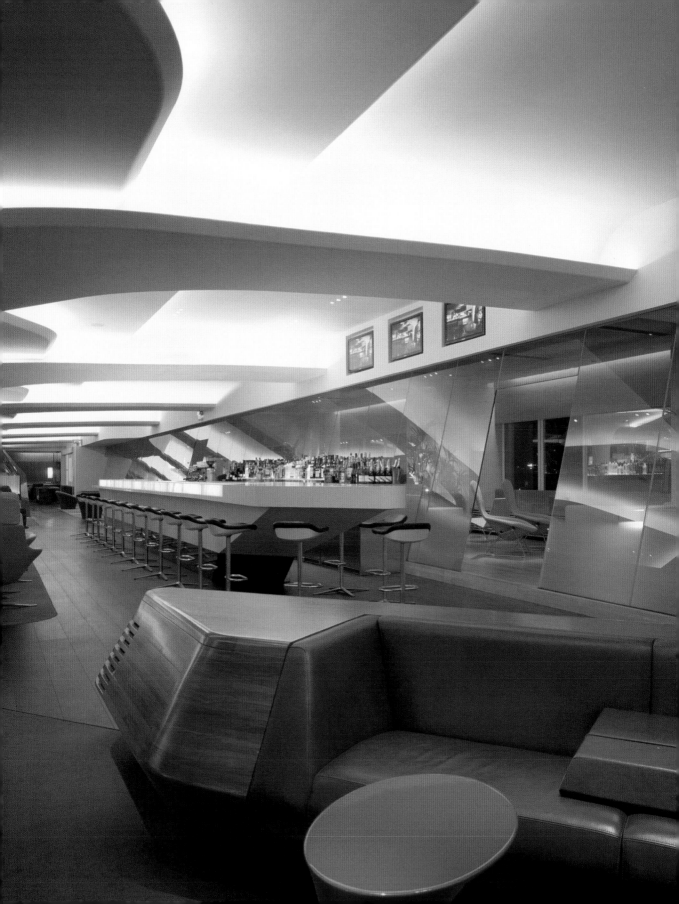

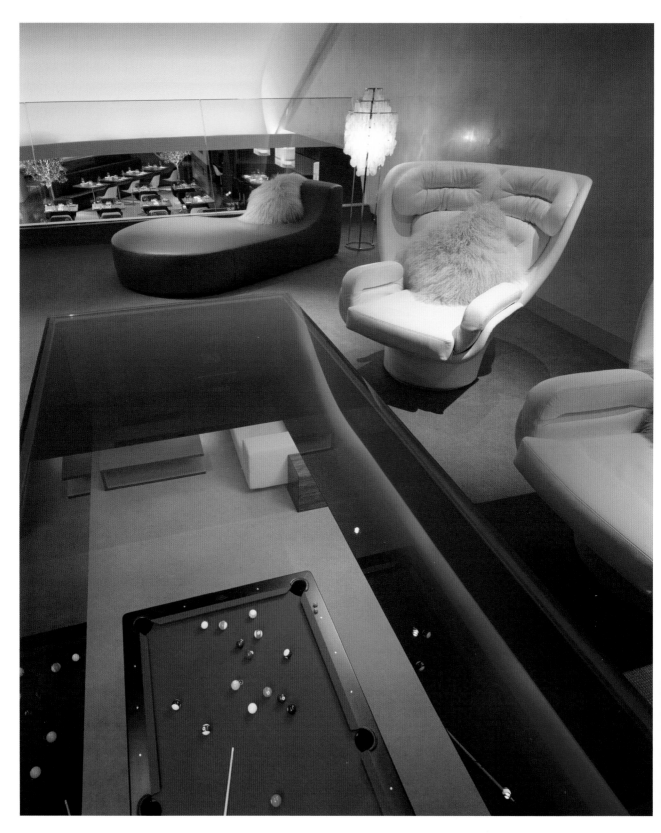

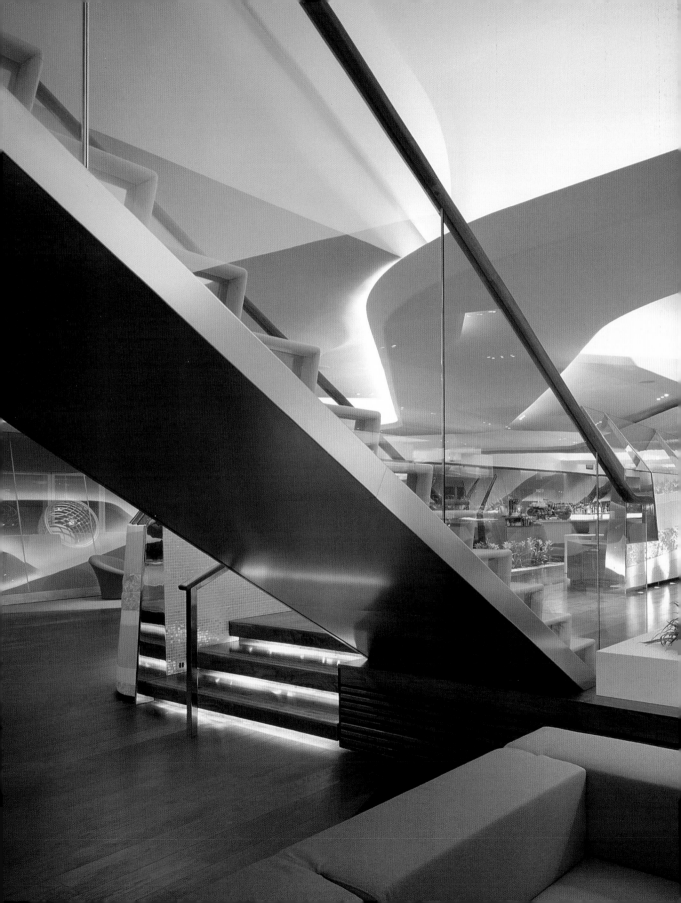

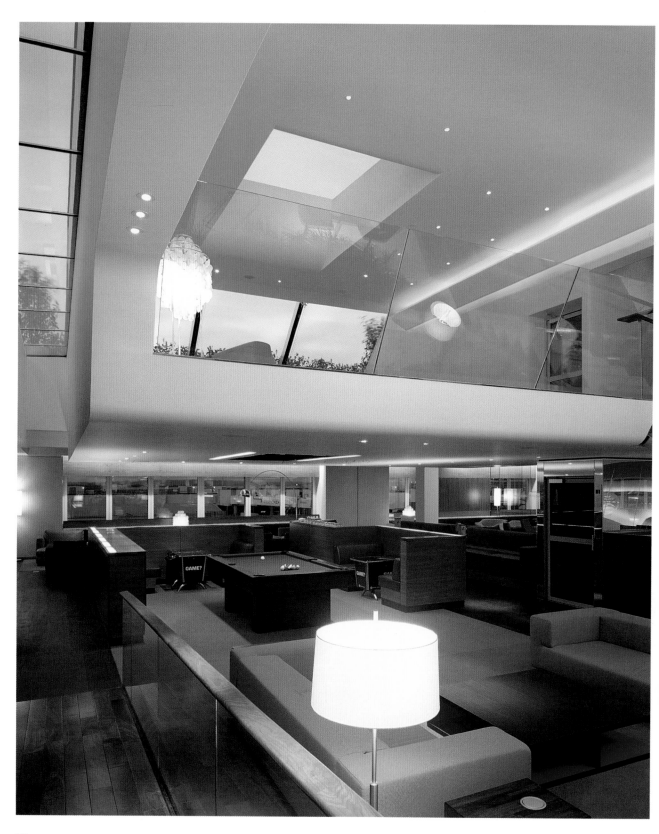

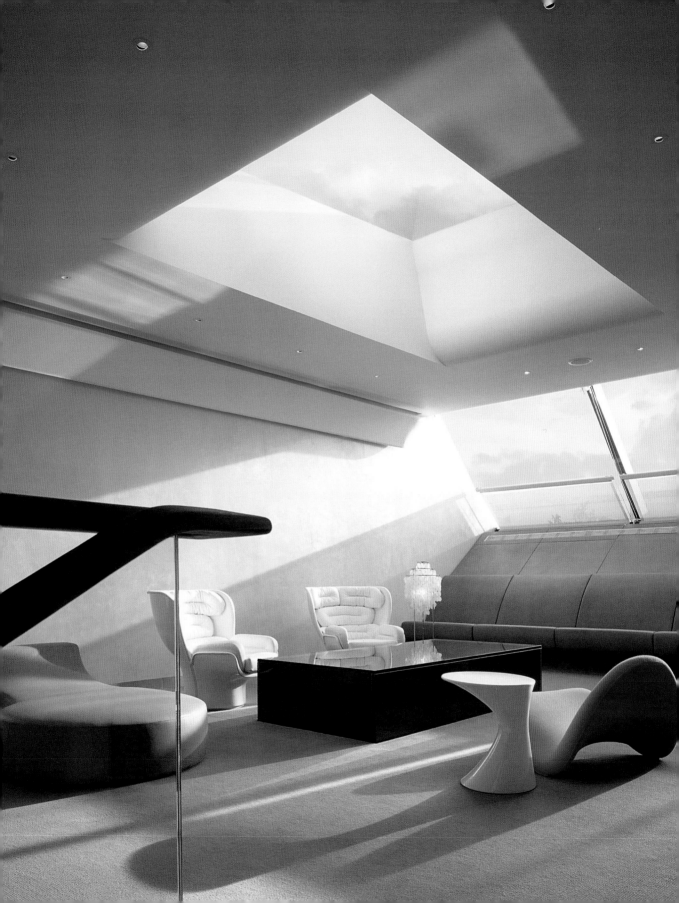

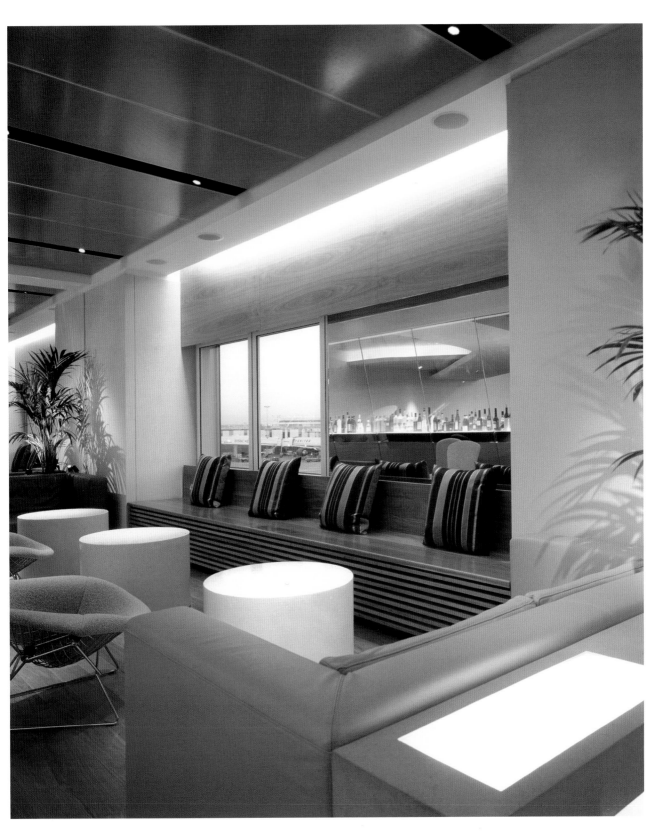

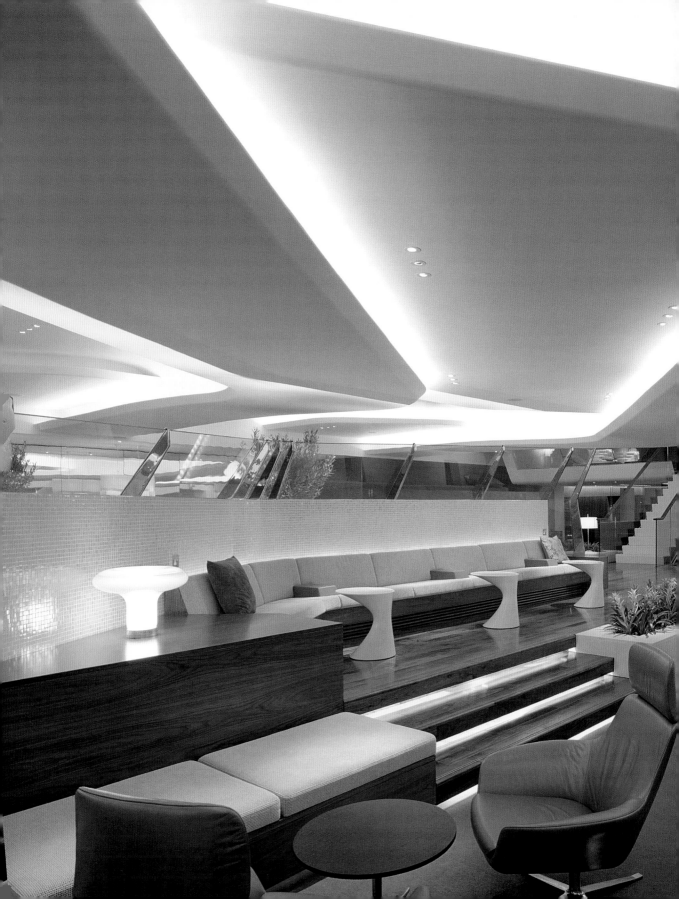

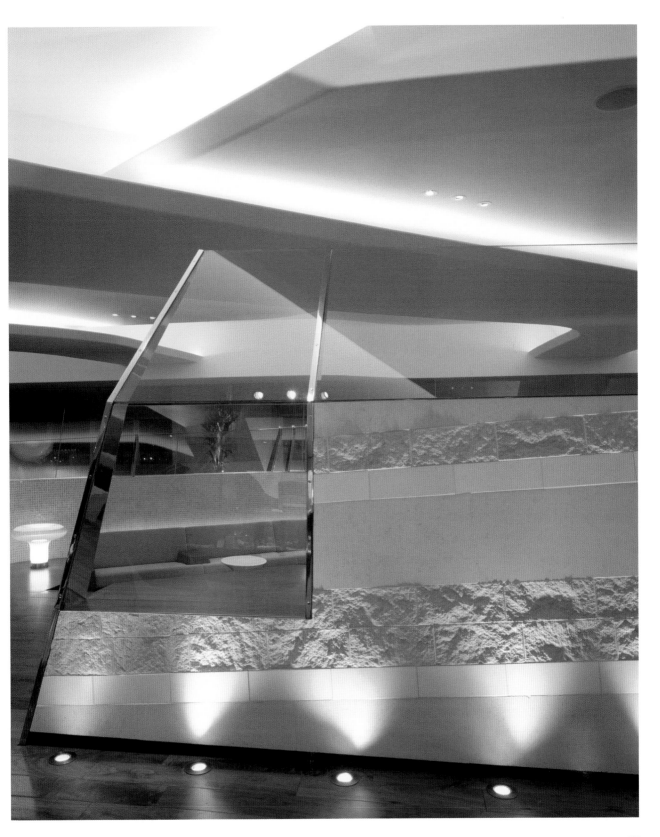

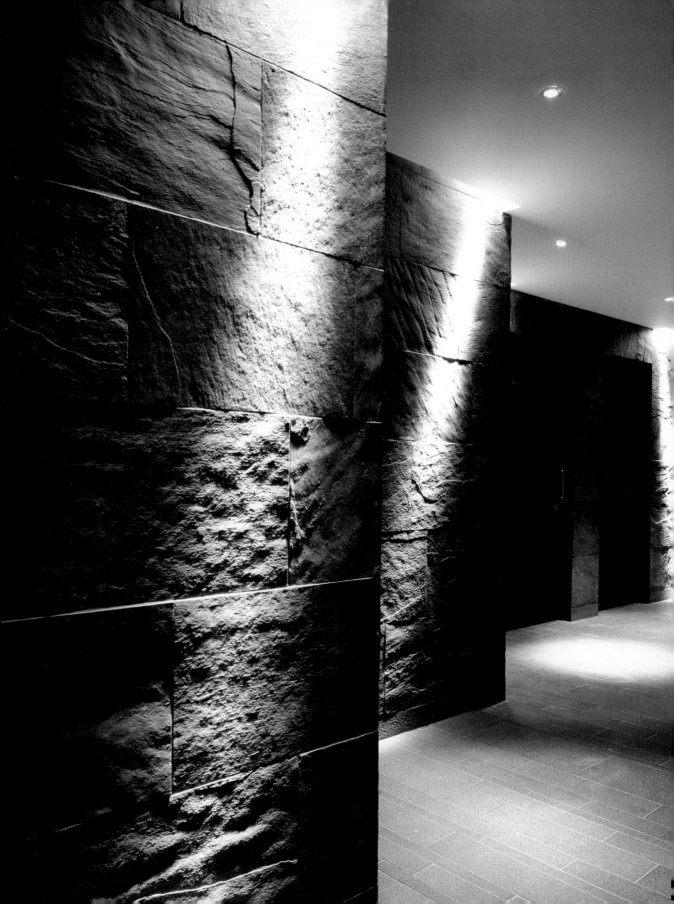

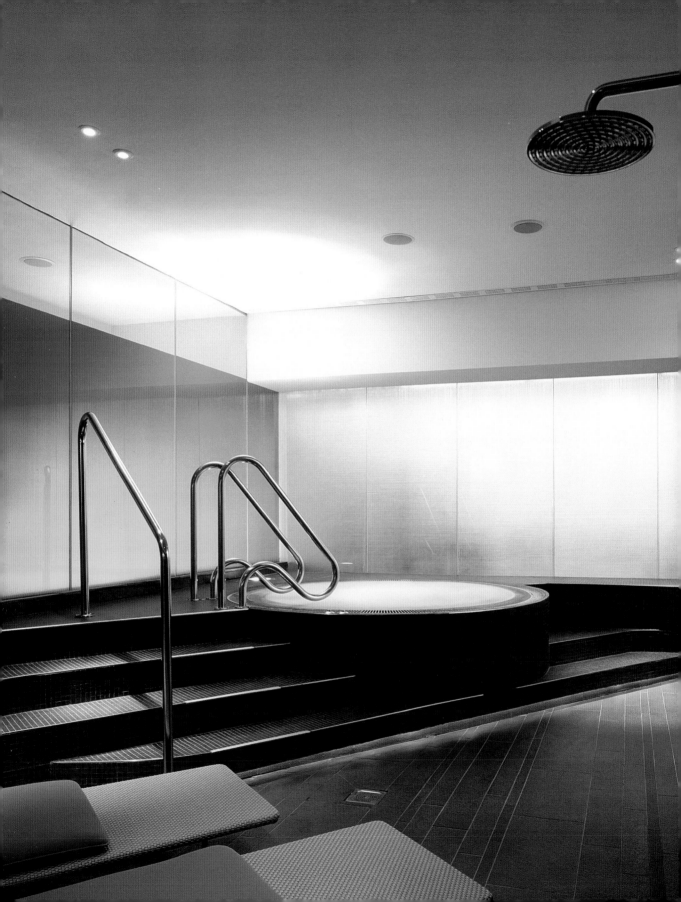

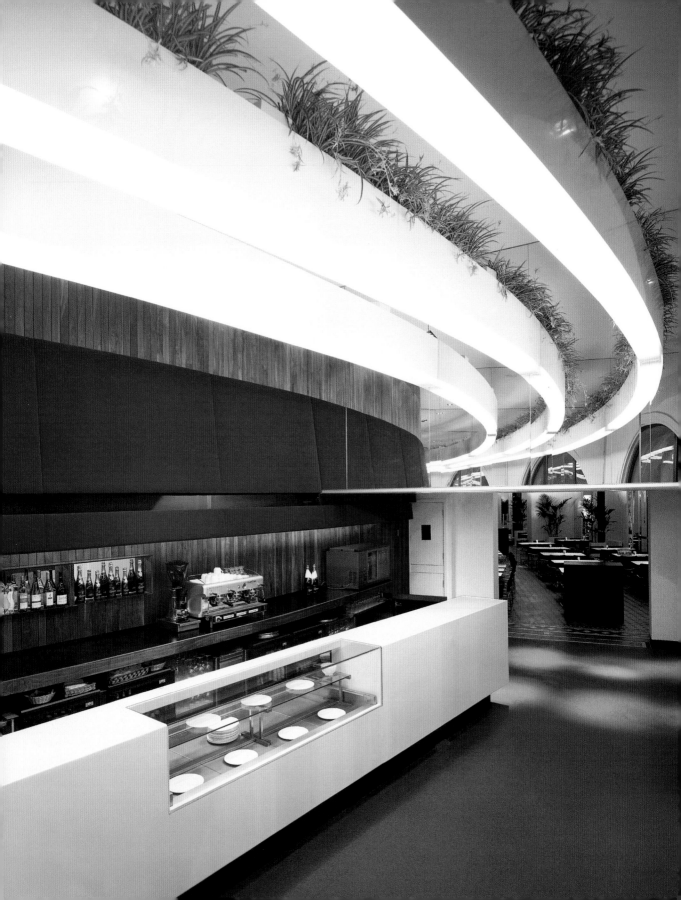

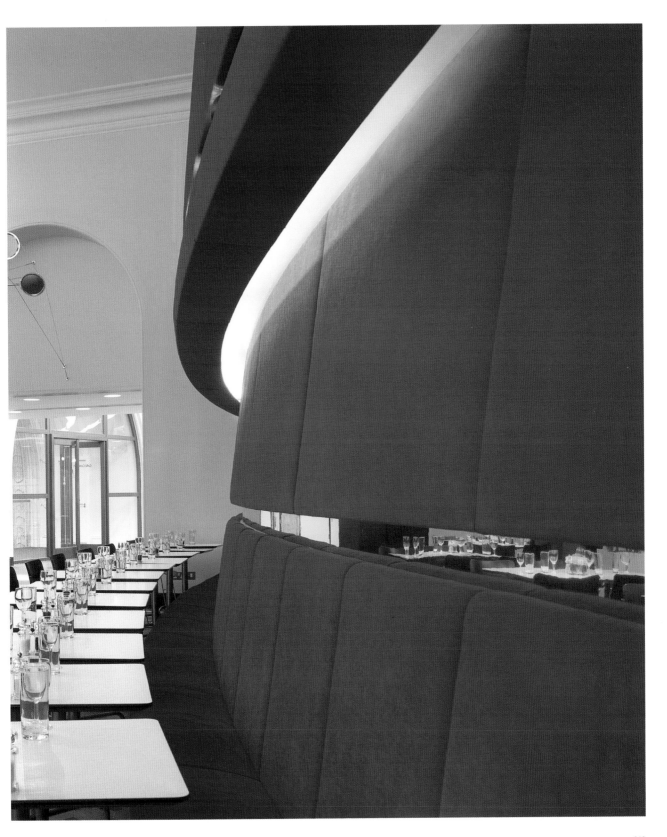

Softroom | Prince Consort Restaurant, Royal Albert Hall 2003

United Designers

United Designers

200 Tower Bridge Road, London SE1 2UN

P +44 20 7357 6006

F +44 20 7357 8008

www.united-designers.com

morell@united-designers.com

Keith Hobbs

1947
born in Kent, UK

1994
United Designers

United Designers specialise in the design of luxurious bars, restaurants, hotels and prestigious offices. Their work not only includes interior design, but also the design of exclusive furniture and the graphic design of logos, menus and advertising materials. United Designers also run their own company to manufacture their furniture designs. Since the studio was set up in 1994, United Designers have realised over 200 successful projects all over the world.

United Designers sind spezialisiert auf die Gestaltung luxuriöser Bars, Restaurants und Hotels sowie aufwendiger Büroräume. Dazu gehören neben dem Interiordesign auch der Entwurf von exklusiven Möbelstücken sowie die grafische Gestaltung von Logos, Speisekarten und Werbematerial. Außerdem betreiben United Designers ein eigenes Unternehmen zur Herstellung ihrer Möbelentwürfe. Seit der Gründung des Büros 1994 haben United Designers weltweit über 200 erfolgreiche Projekte realisiert.

United Designers sont spécialisés dans l'aménagement de luxueux bars, restaurants, hôtels et espaces de bureaux d'envergure. Outre la décoration intérieure, ceci comprend également la création de meubles exclusifs ainsi que la conception graphique de logos, de menus et de matériau publicitaire. United Designers exploitent également leur propre entreprise de fabrication des meubles qu'ils dessinent. Depuis la fondation du cabinet en 1994, United Designers ont réalisé avec succès plus de 200 projets de par le monde.

United Designers están especializados en la concepción de bares de lujo, restaurantes, hoteles y complejos espacios de oficinas. A ello se suma el diseño de interiores y la creación de muebles exclusivos, así como el diseño gráfico de logotipos, menús y material publicitario. United Designers poseen además una empresa propia para la fabricación de los diseños de sus muebles. Desde la fundación de su oficina en 1994, United Designers ha hecho realidad más de 200 proyectos internacionales de éxito.

United Designers sono specializzati nell'allestimento di bar, ristoranti e hotel di lusso come pure di raffinati ambienti per uffici: in tale attività rientrano, oltre al design di interni, anche la progettazione di mobili esclusivi e la realizzazione grafica di loghi, menù e materiale pubblicitario. Lo studio gestisce inoltre una sua azienda per produrre in proprio i mobili progettati. Dal 1994, anno della loro fondazione, United Designers hanno portato a termine con successo più di 200 progetti in tutto il mondo.

Interview | United Designers

How would you describe the basic idea behind your design work? Collaboration. Between clients and designer, the rest of the team and the designer and between designers themselves. It is essential that teamwork exists in the first instance. Then we immerse ourselves in the client's philosophy, the country where the project is located, the city, the building, local culture and society. Once this process has been carried out, the intellectual journey begins and the ideas are produced.

To what extent does working in London inspire your creativity? Enormously. London is one of the three greatest cities of the world due to its multicultural society, which is a breeding ground for innovative design of all disciplines. Our ideas, inspiration and energy are derived from this culture and then applied to wherever we are working around the world.

Is there a typical London style in contemporary architecture? No. The style reflects the city – constantly evolving.

Which project is so far the most important one for you? The Metropolitan Hotel – London's first modern "boutique" hotel – redefined the way Londoners viewed hotels. It is situated on London's most famous boulevard and still influential and successful today, ten years after its opening.

Wie würden Sie die Grundidee beschreiben, die hinter Ihren Entwürfen steht? Zusammenarbeit. Zwischen Auftraggeber und Designer, dem Designer und seinem Team und zwischen den Designern. Es ist entscheidend, dass von Anfang an im Team gearbeitet wird. Dann denken wir uns in die Philosophie des Kunden hinein, in das Land, in dem das Projekt realisiert wird, die Stadt, das Gebäude, die lokale Kultur und Gesellschaft. Sobald dieser Prozess abgeschlossen ist, beginnt die intellektuelle Reise, und die Ideen entstehen.

Inwiefern inspiriert London Ihre kreative Arbeit? Sehr. Mit seiner multikulturellen Gesellschaft, die den Nährboden für innovatives Design in allen Bereichen abgibt, ist London eine der drei großartigsten Städte der Welt. Wir ziehen unsere Ideen, Inspirationen und Energie aus dieser Kultur und übertragen sie auf die Orte der Welt, an denen wir gerade arbeiten.

Gibt es einen typischen Londoner Stil in der aktuellen Architektur? Nein. Der Stil ist wie die Stadt – ständig in Entwicklung.

Welches ist für Sie Ihr bislang wichtigstes Projekt? Das Metropolitan Hotel – Londons erstes modernes „Boutique-Hotel" – hat für die Londoner den Begriff Hotel neu definiert. Durch seine Lage an Londons berühmtesten Boulevard ist es heute – zehn Jahre nach seiner Eröffnung – noch immer einflussreich und erfolgreich.

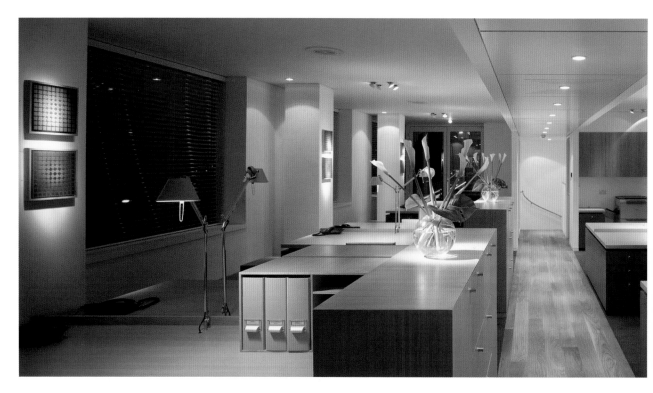

Quelle est, d'après vous, l'idée de base qui sous-tend votre travail de conception ? La collaboration. Entre le client et le designer, le designer et son équipe et entre les designers mêmes. Il est décisif de travailler en équipe dès le début. Ensuite, nous nous imprégnons de la philosophie du client, du pays dans lequel le projet est réalisé, de la ville, du bâtiment, de la culture et de la société locale. C'est à l'issue de ce processus que commence le voyage intellectuel et que surgissent les idées.

Dans quelle mesure Londres inspire-t-il votre créativité ? Énormément. Grâce à sa société multiculturelle, qui est le terreau d'un design innovant dans tous les domaines, Londres est l'une des trois villes les plus formidables au monde. Nos idées, notre inspiration et notre énergie découlent de cette culture et nous les appliquons là où nous travaillons de par le monde.

Y a-t-il un style typiquement londonien dans l'architecture contemporaine ? Non. Le style est comme la ville – en permanente évolution.

Quel est le projet le plus important pour vous à l'heure actuelle ? Le Metropolitan Hotel – le premier hôtel boutique moderne de Londres – a fait évoluer la façon dont les Londoniens perçoivent les hôtels. Il est situé sur le boulevard le plus connu de Londres, ce qui lui vaut, dix ans après son ouverture, une influence et un succès identiques.

¿Cómo definiría la idea básica que encierran sus diseños? Trabajo en común. Entre el cliente y el diseñador, el diseñador y su equipo y entre diseñadores. Trabajar en equipo desde un principio es decisivo. Después pensamos en la filosofía del cliente, el país en el que se realizará el proyecto, la ciudad, el edificio, la cultura local y la sociedad. Tan pronto como se ha finalizado ese proceso comienza el viaje intelectual y surgen las ideas.

¿En qué medida inspira la ciudad de Londres su trabajo creativo? Mucho. Con su sociedad multicultural que sienta la base para un diseño innovador en todos los ámbitos, Londres es una de las tres ciudades más fabulosas del mundo. Extraemos nuestras ideas, inspiraciones y energía de esta cultura y las trasladamos a los lugares del mundo en los que estamos trabajando en ese momento.

¿Existe un estilo típico londinense en la arquitectura actual? No. El estilo está, como la ciudad, en continuo desarrollo.

¿Cuál ha sido su proyecto más importante hasta el momento? El Metropolitan Hotel: el primer hotel boutique moderno de Londres ha redefinido para los londinenses el término hotel. Debido a su ubicación en el Boulevard más famoso de Londres, diez años después de su inauguración sigue contando con éxito y una gran capacidad de influencia.

Come descriverebbe l'idea originaria che sta alla base delle Sue creazioni? Collaborazione. Tra il committente e il designer, tra il designer ed il suo team e dei designer tra loro. È di fondamentale importanza che, fin dall'inizio, si faccia un lavoro di squadra. Poi ci immergiamo nella filosofia del cliente, nel paese in cui andrà realizzato il progetto, nella città, nell'edificio, nella cultura e nella società locale. Al termine di questo processo, incomincia il viaggio intellettuale e nascono le idee.

In che misura Londra ispira la Sua creatività? Molto. Con la sua società multiculturale, che funge da humus per la crescita di un design innovativo in tutti i settori, Londra è una delle tre città più entusiasmanti al mondo. È da questa cultura che traiamo le nostre idee, le nostre ispirazioni e la nostra energia per applicarle là dove ci capita di lavorare nel mondo.

Esiste uno stile tipico di Londra nell'architettura contemporanea? No, lo stile è come la città: in continua evoluzione.

Qual è per Lei il più importante tra i progetti realizzati finora? Il Metropolitan Hotel – il primo moderno "hotel boutique" di Londra – ha ridefinito per i Londinesi il concetto stesso di hotel. Situato com'è lungo il più famoso boulevard di Londra, questo hotel ancora oggi, a dieci anni dalla sua apertura, continua a fare tendenza ed a riscuotere successi.

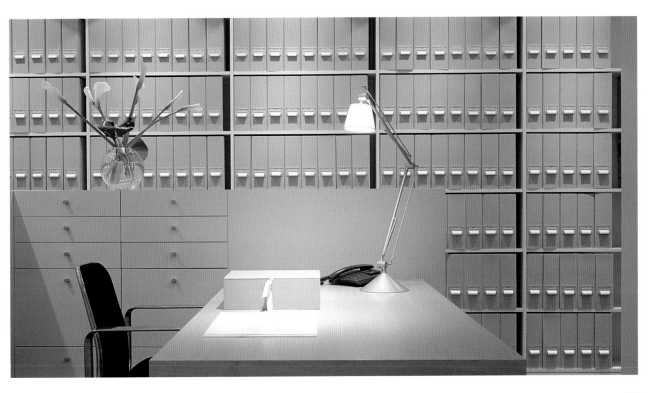

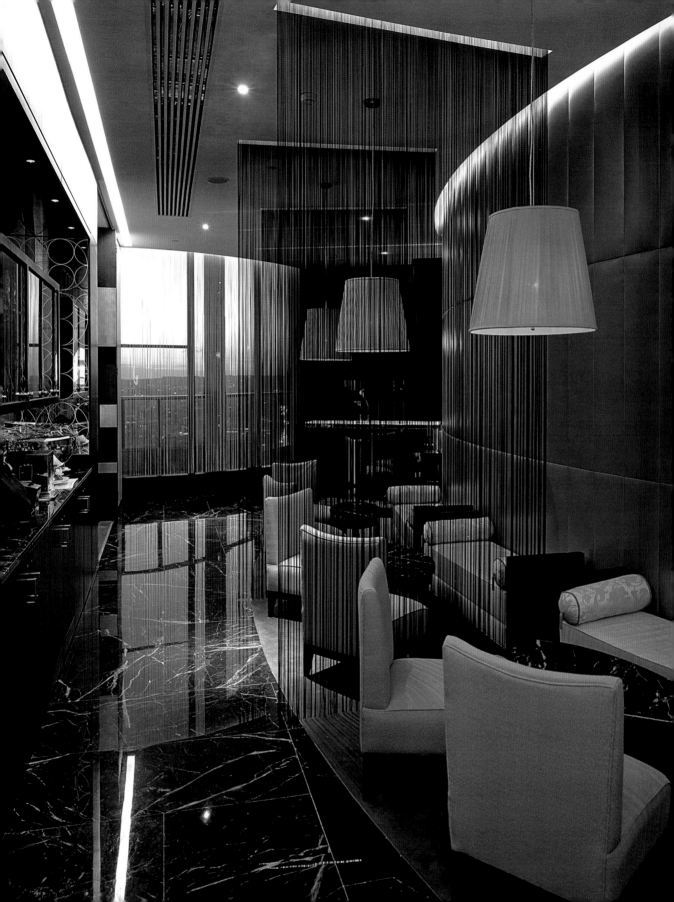

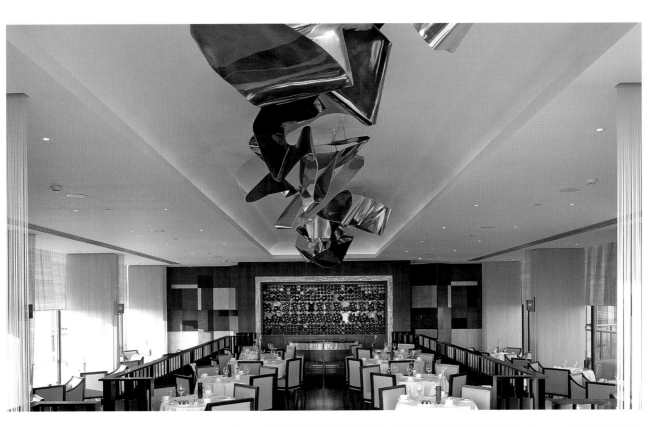

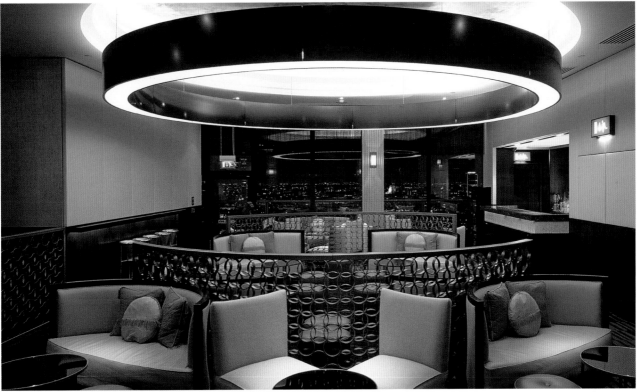

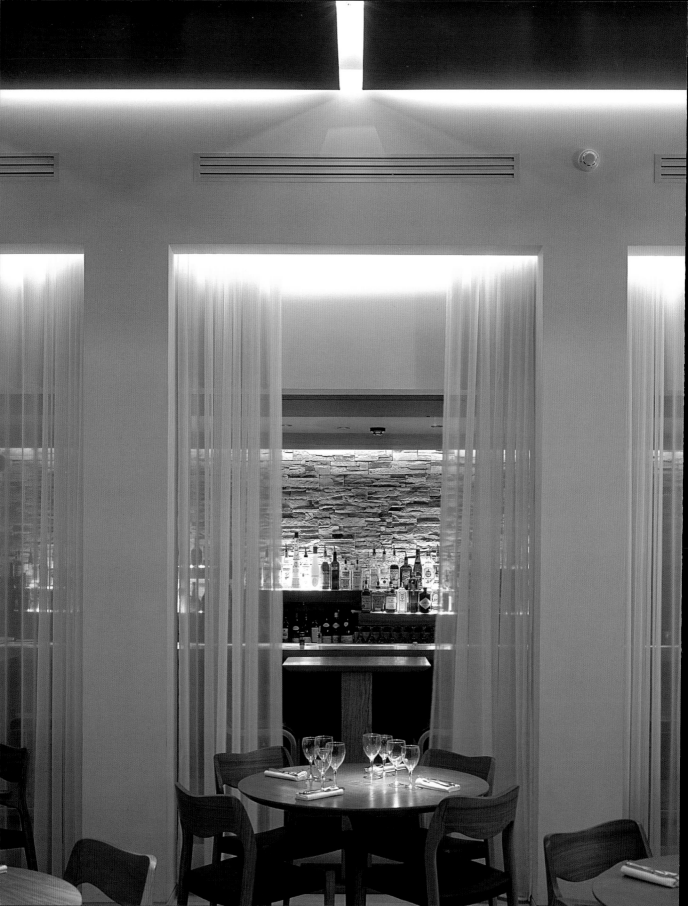

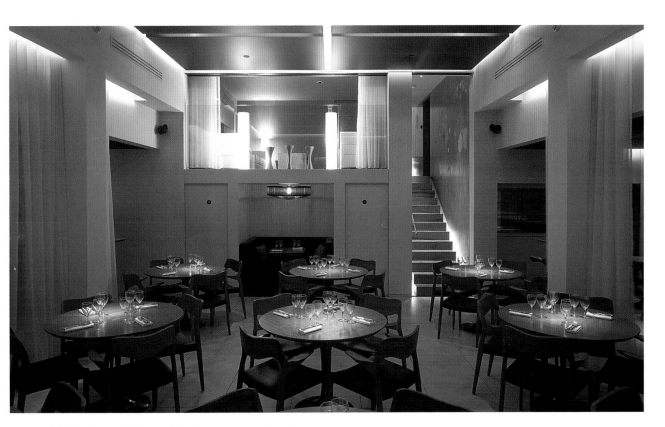

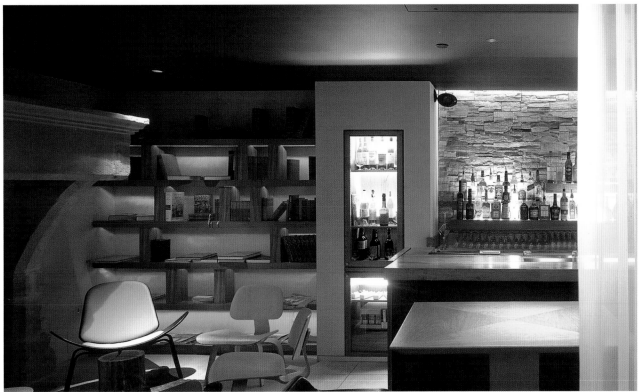

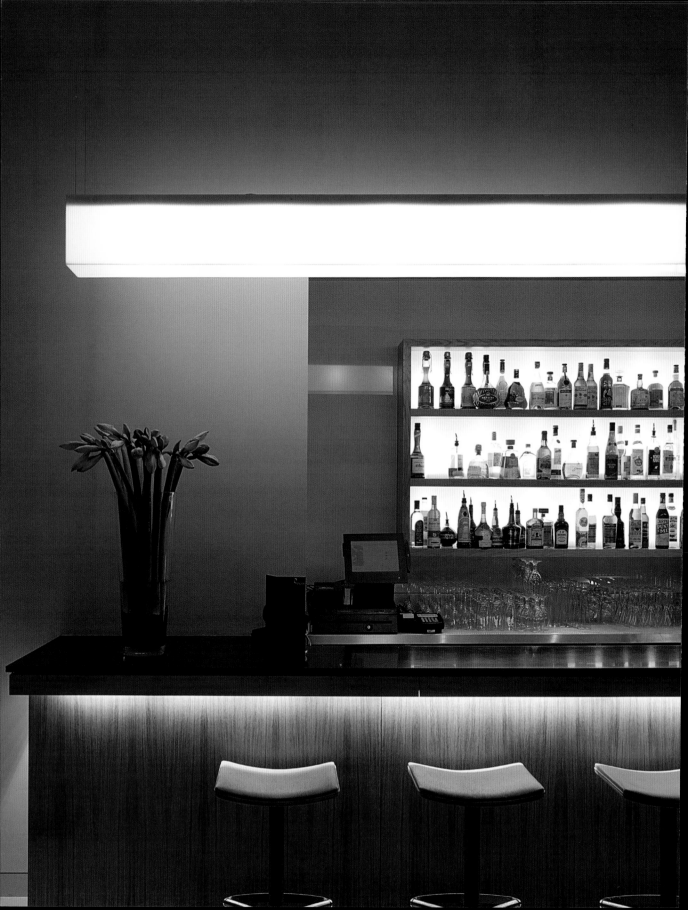

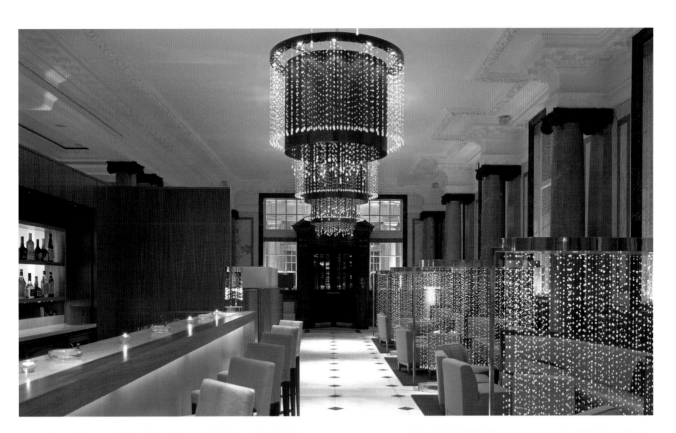

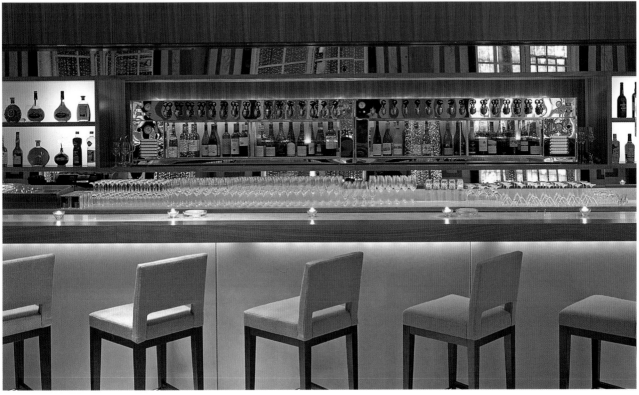

United Designers | Restaurant Pearl 2004 | left Shumi Bar 2003

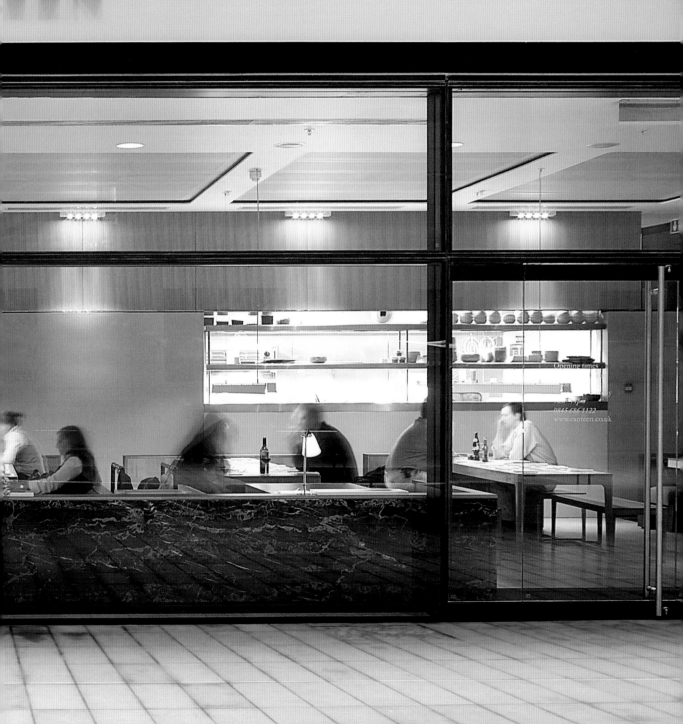

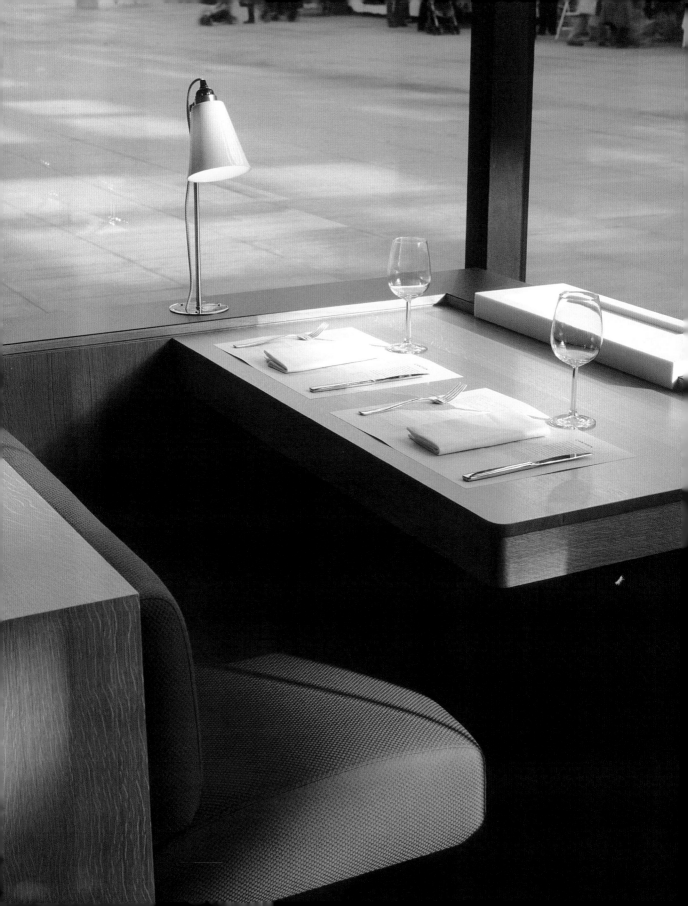

Universal Design Studio

Ground Floor, 35 Charlotte Road, London EC2A 3PG

P +44 20 7033 3881

F +44 20 7033 3882

www.universaldesignstudio.com

mail@universaldesignstudio.com

Jonathan Clarke

1967
born in Kent, UK

2002
joines Universal Design Studio

As a sister company to the design studio BarberOsgerby, Universal Design Studios were set up in 2001 together with architect Jonathan Clarke. The close, interdisciplinary collaboration between architects, product designers and interior designers under the same roof offers ideal conditions for the design of luxurious room settings, ranging from the overall concept to the smallest detail.

Als Schwesterunternehmen des Designbüros BarberOsgerby wurden Universal Design Studios im Jahre 2001 gemeinsam mit dem Architekten Jonathan Clarke gegründet. Die enge, interdisziplinäre Zusammenarbeit von Architekten, Produktdesignern und Interiordesignern unter einem Dach bietet die ideale Voraussetzung für die Gestaltung aufwendiger Rauminszenierungen, vom Gesamtkonzept bis zum Detail.

Universal Design Studios a été créé en 2001, en coopération avec l'architecte Jonathan Clarke, comme filiale du studio de design BarberOsgerby. La collaboration interdisciplinaire rapprochée d'architectes, de concepteurs de produits et de décorateurs d'intérieurs sous un même toit crée les conditions idéales à la création de mises en scène spatiales sophistiquées, du concept global jusque dans les détails.

Universal Design Studios se creó en 2001 como empresa afiliada al estudio de diseño Barber-Osgerby, en común con el arquitecto Jonathan Clarke. El trabajo colectivo e interdisciplinario de arquitectos, diseñadores de productos y diseñadores de interiores bajo un mismo techo ofrece las condiciones ideales para la compleja creación de espacios, abarcando desde el concepto general hasta el detalle.

Impresa consorella dello studio di design BarberOsgerby, Universal Design Studios sono stati fondati nel 2001 in cooperazione con l'architetto Jonathan Clarke. La stretta collaborazione interdisciplinare tra architetti, designer del prodotto e designer di interni in un'unica impresa offre i presupposti ideali per realizzare la messa in scena di ambienti raffinati, dalla concezione d'insieme fino al più piccolo dettaglio.

Interview | Jonathan Clarke

How would you describe the basic idea behind your design work? Rather than propose a particular style, Universal has an approach. We endeavor to identify and understand the parts which are important to each client whether a specific approach, a concept or materials. If working with a recognized brand, we quantify the brand's unique value. All these elements are then stitched into the development of a new idea.

To what extent does working in London inspire your creativity? Cities have a natural vitality and an ability to reinvent themselves. When working in a creative environment the evolution of the city is a constant source of inspiration. The clashes of culture and style are often where the best ideas originate.

Is there a typical London style in contemporary architecture? No I don't think so. However, what is London's best offer is being a truly world class city.

Which project is so far the most important one for you? Obviously the Stella McCartney stores were a defining moment for the studio as it brought much acclaim and fused the working relationship between Universal Design Studio and BarberOsgerby.

Wie würden Sie die Grundidee beschreiben, die hinter Ihren Entwürfen steht? Es ist eher eine Arbeitsweise als ein bestimmter Stil. Wir bemühen uns, die Elemente herauszuarbeiten und zu verstehen, die für unsere Auftraggeber wichtig sind, seien es ein spezieller Ansatz, ein Konzept oder Materialien. Wenn wir für eine bekannte Marke tätig sind, versuchen wir, das Besondere dieser Marke herauszuarbeiten. All diese Elemente werden dann zusammengefügt, um neue Ideen zu entwickeln.

Inwiefern inspiriert London Ihre kreative Arbeit? Städte haben eine natürliche Kraft und Fähigkeit, sich selbst immer wieder neu zu erfinden. Wenn man in einem kreativen Umfeld arbeitet, ist die Entwicklung der Stadt eine ständige Inspirationsquelle. Häufig entstehen dort, wo die Kulturen und Stile zusammentreffen, die besten neuen Ideen.

Gibt es einen typischen Londoner Stil in der aktuellen Architektur? Das glaube ich nicht. Londons größte Qualität ist es, eine echte Weltstadt zu sein.

Welches ist für Sie Ihr bislang wichtigstes Projekt? Ganz sicher waren die Stella McCartney Stores ein wichtiger Schritt für das Büro, da sie viel Beifall erhielten und die Zusammenarbeit mit BarberOsgerby begründeten.

Quelle est, d'après vous, l'idée de base qui sous-tend votre travail de conception ? C'est plutôt une façon de travailler qu'un style particulier. Nous nous efforçons de définir et de comprendre les éléments que nos clients jugent importants, qu'il s'agisse d'une approche, d'un concept ou de matériaux spécifiques. Quand nous travaillons pour une marque connue, nous essayons de faire ressortir ce qui lui est propre. Tous ces éléments s'assemblent alors pour développer une nouvelle idée.

Dans quelle mesure Londres inspire-t-il votre créativité ? Les villes ont une vitalité et une capacité naturelle à toujours se réinventer. Quand on travaille dans un environnement créatif, l'évolution de la ville est une source d'inspiration permanente. C'est souvent au point de rencontre des cultures et des styles qu'émergent les meilleures idées.

Y a-t-il un style typiquement londonien dans l'architecture contemporaine ? Je ne crois pas. Être véritablement cosmopolite, c'est l'un des plus grands avantages de Londres.

Quel est le projet le plus important pour vous à l'heure actuelle ? Les magasins Stella McCartney ont certainement été une étape importante pour le cabinet car ils ont été très applaudis et ont justifié la collaboration avec BarberOsgerby.

¿Cómo definiría la idea básica que encierran sus diseños? Se trata más bien de una forma de trabajo que de un estilo determinado. Hacemos el esfuerzo por establecer y entender los elementos que son importantes para el cliente, ya se trate de una aplicación determinada, un concepto o los materiales. Cuando trabajamos para una marca conocida intentamos extraer lo significativo de esa marca. Todos esos elementos se reúnen después para desarrollar nuevas ideas.

¿En qué medida inspira la ciudad de Londres su trabajo creativo? Las ciudades poseen una fuerza natural y una capacidad para reinventarse a sí mismas continuamente. Cuando se trabaja en un entorno creativo, el desarrollo de la ciudad se convierte en una constante fuente de inspiración. Con frecuencia las mejores ideas surgen en el punto en el que se encuentran las culturas y los estilos.

¿Existe un estilo típico londinense en la arquitectura actual? Yo creo que no. La gran cualidad de Londres es la de ser una verdadera metrópoli.

¿Cuál ha sido su proyecto más importante hasta el momento? Indudablemente los Stella McCartney Stores fueron un paso importante para el estudio ya que recibieron excelentes críticas y motivaron el trabajo en común con BarberOsgerby.

Come descriverebbe l'idea originaria che sta alla base delle Sue creazioni? È più un modo di lavorare che uno stile particolare. Il nostro sforzo è quello di identificare e comprendere gli elementi che stanno a cuore al nostro committente, che si tratti di un approccio particolare, di una concezione o di materiali. Se lavoriamo per una marca di fama, cerchiamo di identificare quale sia la sua particolarità. Alla fine uniamo tutti questi elementi in un insieme per sviluppare nuove idee.

In che misura Londra ispira la Sua creatività? Le città hanno una loro naturale vitalità e capacità di reinventarsi in continuazione. Per chi lavori in un ambito creativo, l'evoluzione della città è una continua fonte di ispirazione. E spesso le idee migliori nascono al punto di incontro tra culture e stili diversi.

Esiste uno stile tipico di Londra nell'architettura contemporanea? Non credo. La più grande qualità di Londra è di essere una vera metropoli.

Qual è per Lei il più importante tra i progetti realizzati finora? Sicuramente gli store di Stella McCartney sono stati un passo importante per il nostro studio, in quanto hanno raccolto il plauso di molti e sono stati all'origine delle collaborazione con BarberOsgerby.

Universal Design Studio | British Red Cross Headquarters 2005

Universal Design Studio collaborated with artist Damien Hirst on the now legendary Pharmacy restaurant. Although Pharmacy became a cult object almost as soon as it opened, it was not to be a commercial success. After it closed in 2003, Damien Hirst auctioned off the interior for the record amount of more than eleven million pounds.

Für das inzwischen legendäre Restaurant Pharmacy arbeiteten Universal Design Studio mit dem Künstler Damien Hirst zusammen. Pharmacy erlangte in kürzester Zeit Kultstatus, war allerdings kein kommerzieller Erfolg. Nach der Schließung im Jahr 2003 versteigerte Damien Hirst das Interieur für die Rekordsumme von über elf Millionen Pfund.

Pour le restaurant Pharmacy, devenu légendaire, Universal Design Studio a collaboré avec l'artiste Damien Hirst. Pharmacy est passé en un éclair au statut d'objet de culte, sans toutefois parvenir au succès commercial. Après sa fermeture en 2003, Damien Hirst a vendu l'intérieur aux enchères pour la somme record de plus de onze millions de livres.

Para el ya legendario Pharmacy, Universal Design Studio trabajó en común con el artista Damien Hirst. Pharmacy se convirtió en breve en un restaurante de culto, si bien no tuvo éxito comercial. Tras su cierre en 2003, Damien Hirst subastó todo el interior por una suma récord de más de once millones de libras.

Per l'ormai leggendario ristorante Pharmacy, Universal Design Studio ha collaborato con l'artista Damien Hirst. Pharmacy, pur essendo divenuto in breve tempo un locale di tendenza, non è stato un successo commerciale. Dopo la chiusura, avvenuta nel 2003, Damien Hirst ha messo all'asta gli arredamenti d'interni per la somma record di oltre undici milioni di sterline.

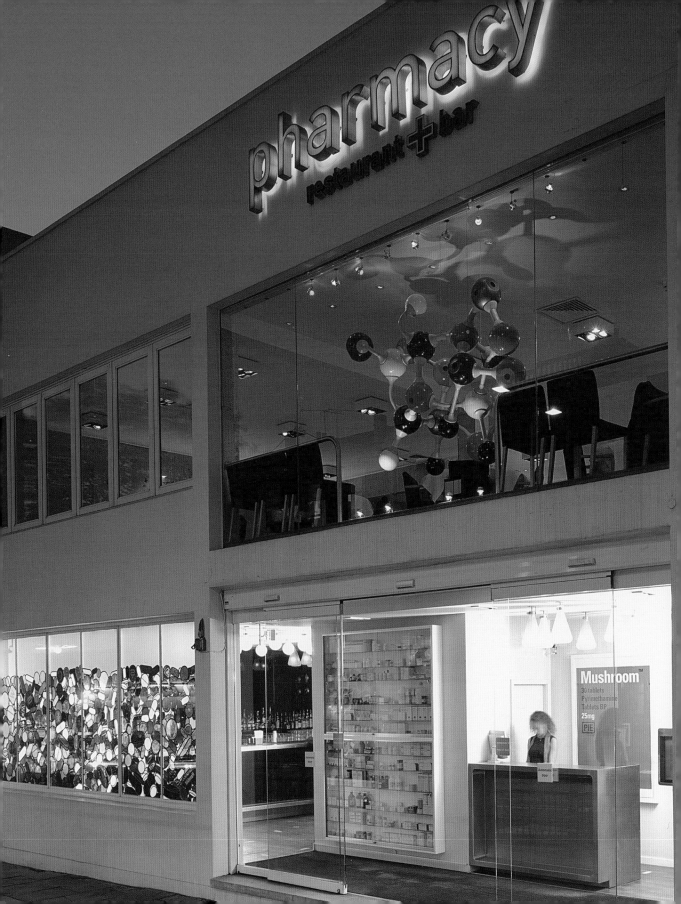

Helen Yardley

Helen Yardley

A-Z Studios, 3-5 Harwidge Street, London SE1 3SY

P +44 20 7403 7114

F +44 20 7403 8906

www.helenyardley.com

info@helenyardley.com

Helen Yardley

1954
born in Devon, UK

1986
A-Z Studios

Helen Yardley's textile designs – mainly carpets and wall hangings – adorn sites such as the Metropolitan Hotel, the new buildings of the House of Commons and the Royal Bank of Scotland. Helen Yardley also carries out commissions for private clients. Her attitude to design is, by her own admission, really quite simple: her designs are intended to be harmonious, and are beautifully made – the perfect combination of aesthetics and function.

Helen Yardleys Textilentwürfe – vornehmlich Teppiche und Wandbehänge – schmücken Orte wie das Metropolitan Hotel, die neuen Gebäude des Unterhauses oder die Royal Bank of Scotland. Daneben produziert Helen Yardley aber auch Kollektionen für private Kunden. Ihre Designhaltung ist, wie sie selbst sagt, eigentlich ganz einfach: Ihre Entwürfe sollen stimmig wirken und hervorragend verarbeitet sein – als perfekte Verbindung von Ästhetik und Funktion.

Les créations textiles d'Helen Yardley – essentiellement des tapis et des tentures – décorent des lieux tels que le Metropolitan Hotel, les nouveaux bâtiments de la Chambre basse ou la Royal Bank of Scotland. Parallèlement, Helen Yardley produit en outre des collections pour les clients privés. En fait, son approche de la création, dit-elle, est très simple : ses créations doivent avoir l'air harmonieuses et être exceptionnellement bien réalisées pour incarner l'accord parfait entre l'esthétique et la fonction.

Los bocetos textiles de Yardley, fundamentalmente alfombras y revestimientos murales decoran lugares como el Metropolitan Hotel, los nuevos edificios de la Cámara de los Comunes o el Royal Bank of Scotland. Paralelamente Helen Yardley produce también colecciones para clientes privados. Sus principios de diseño son en realidad muy simples, como también afirma ella: los bocetos debe tener efecto armónico y estar magníficamente elaborados; se trata de una fusión entre la estética y la perfección.

Le creazioni tessili di Helen Yardley – in particolar modo tappeti e arazzi – adornano luoghi come il Metropolitan Hotel, i nuovi edifici della Camera dei Comuni o la Royal Bank of Scotland. Ma nel contempo Helen Yardley produce anche collezioni per clienti privati. In realtà la concezione di design della Yardley è, a dire dell'artista stessa, molto semplice: le sue creazioni devono dimostrare una loro coerenza interna ed essere lavorate egregiamente, offrendo un perfetto connubio tra estetica e funzionalità.

Interview | Helen Yardley

How would you describe the basic idea behind your design work? You could say my designs are paintings for floors because colour is integral but they are not about "paint" as a medium. My shapes are clearly defined and solid, so I describe them as drawings for floors. The aesthetic isn't purely decorative; there are layers of meaning which have a personal and universal resonance.

To what extent does working in London inspire your creativity? The combination of that feeling of familiarity and the constant buzz of change is challenging and very energizing. It attracts new blood, which revives and regenerates it. I have worked in Bermondsey for twenty years. It used to be a seriously dodgy area but it has burst forth from the ashes and has now become almost too fashionable.

Is there a typical London style in contemporary architecture? Not as far as I have noticed ...

Which project is so far the most important one for you? Right now it is a project to design the mosaics for a swimming pool for a stunning new poolhouse designed by John Pardey Architects.

Wie würden Sie die Grundidee beschreiben, die hinter Ihren Entwürfen steht? Man könnte meine Entwürfe als Gemälde für den Boden bezeichnen, denn Farbe ist von grundlegender Bedeutung. Allerdings geht es nicht um „Farbe" als Medium. Die Formen sind fest und klar umrissen, darum verstehe ich sie als Zeichnungen für den Boden. Ihre Ästhetik ist nicht rein dekorativ, es gibt Bedeutungsebenen mit persönlichen und universellen Bezügen.

Inwiefern inspiriert London Ihre kreative Arbeit? Die Kombination aus Vertrautheit und den ständigen Veränderungen ist herausfordernd und anregend. London zieht immer neue Leute an – dadurch erneuert und regeneriert es sich. Seit 20 Jahren arbeite ich in Bermondsey. Früher war es eine eher zwielichtige Gegend, hat sich aber seitdem enorm gemacht und ist heute fast zu angesagt.

Gibt es einen typischen Londoner Stil in der aktuellen Architektur? Nicht dass ich wüsste ...

Welches ist für Sie Ihr bislang wichtigstes Projekt? Zurzeit der Entwurf von Mosaikfliesen für einen Pool in einem erstaunlichen neuen Schwimmbad von John Pardey Architects.

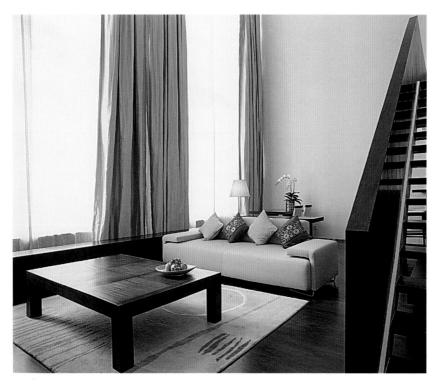

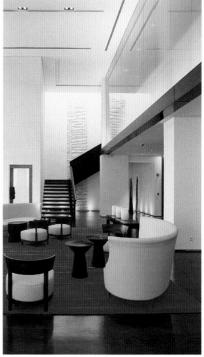

Quelle est, d'après vous, l'idée de base qui sous-tend votre travail de conception ? On pourrait qualifier mes dessins de tableaux au sol, car la couleur est essentielle. Mais il ne s'agit pas de la « couleur » en tant que moyen. Les formes sont solides, les lignes précises, c'est pourquoi je les décris comme des dessins au sol. Leur esthétique n'est pas purement décorative. Il y a des niveaux de signification avec des références personnelles et universelles.

Dans quelle mesure Londres inspire-t-il votre créativité ? Cette impression de familiarité alliée au bourdonnement permanent du changement a un effet provocateur et stimulant. Londres attire toujours du sang neuf qui le renouvelle et le régénère. Je travaille depuis 20 ans à Bermondsey. Autrefois, c'était un quartier plutôt douteux, qui a considérablement évolué depuis; maintenant, il est même un peu trop tendance.

Y a-t-il un style typiquement londonien dans l'architecture contemporaine ? Pas que je sache ...

Quel est le projet le plus important pour vous à l'heure actuelle ? Actuellement, c'est le dessin de carreaux de mosaïque pour un des bassins d'une étonnante nouvelle piscine conçue par John Pardey Architects.

¿Cómo definiría la idea básica que encierran sus diseños? Mis bocetos se podrían definir como pinturas para el suelo, ya que en ellos el color juega un papel fundamental. Ahora bien, no se trata sólo del "color" como medio. Las formas están definidas clara y sólidamente, por eso las describo como dibujos para el suelo. Su estética no es simplemente decorativa; existen en ella dimensiones de significado con resonancia personal y universal.

¿En qué medida inspira la ciudad de Londres su trabajo creativo? La combinación entre confianza y los constantes cambios es atractiva y constituye un reto. Londres siempre está atrayendo a gente nueva, con lo que se regenera y se renueva. Desde hace 20 años trabajo en Bermondsey. Antes era una zona más bien conflictiva pero desde entonces ha cambiado enormemente y hoy casi está demasiado de moda.

¿Existe un estilo típico londinense en la arquitectura actual? No que yo sepa ...

¿Cuál ha sido su proyecto más importante hasta el momento? Actualmente el boceto de azulejos de mosaico para una de las piscinas en el impresionante nuevo centro diseñado por John Pardey Architects.

Come descriverebbe l'idea originaria che sta alla base delle Sue creazioni? Si potrebbe dire che i miei progetti sono dipinti per il pavimento, perché il colore è di fondamentale importanza. Però non si tratta della "pittura" come mezzo: le forme sono solide e chiaramente definite, ecco perché li definisco come dei disegni per il pavimento. La loro estetica non è puramente decorativa, ci sono piani di significato che hanno riferimenti personali ed universali.

In che misura Londra ispira la Sua creatività? La combinazione di una sensazione di familiarità e costanti cambiamenti è provocante e stimolante. Londra continua ad attirare gente sempre nuova e facendo ciò si rinnova e si rigenera. Io lavoro da vent'anni a Bermondsey. Prima era una zona poco raccomandabile, ma col tempo è migliorata enormemente e oggi è quasi troppo alla moda.

Esiste uno stile tipico di Londra nell'architettura contemporanea? Non che io sappia ...

Qual è per Lei il più importante tra i progetti realizzati finora? Attualmente il design di tessere da mosaico destinate ad un bacino in una nuova, fantastica piscina coperta progettata da John Pardey Architects.

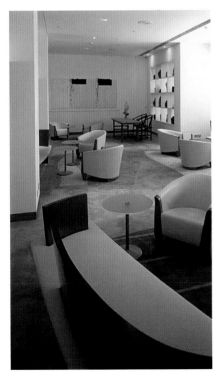
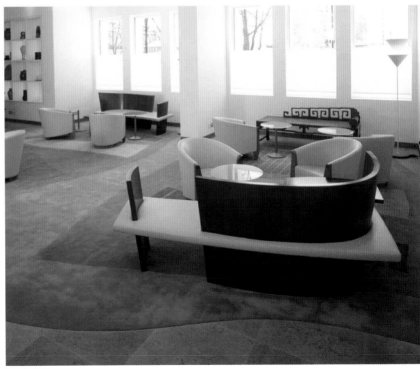

Helen Yardley | Metropolitan Hotel Bangkok 2003

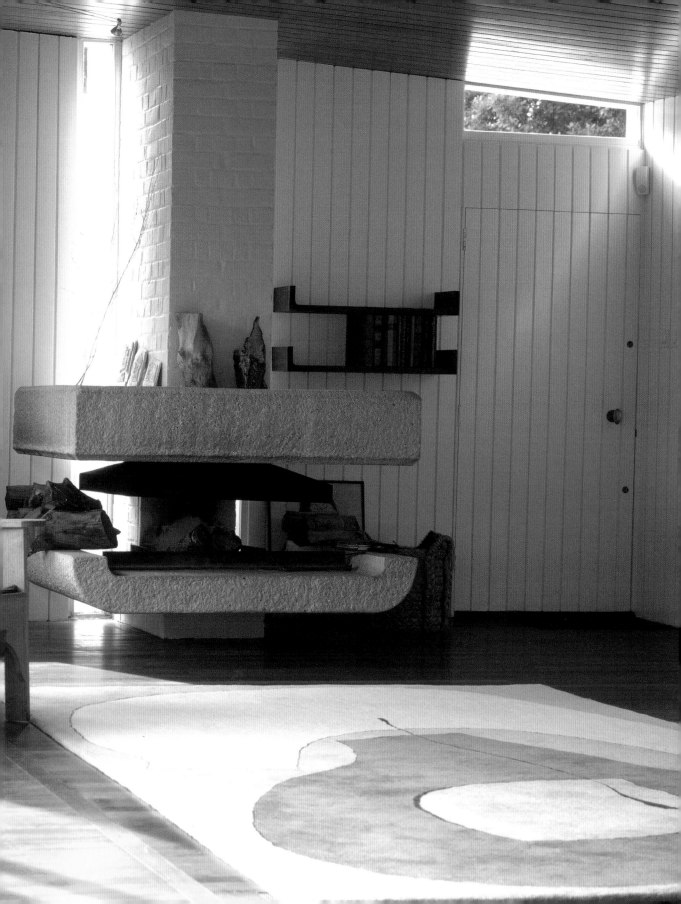

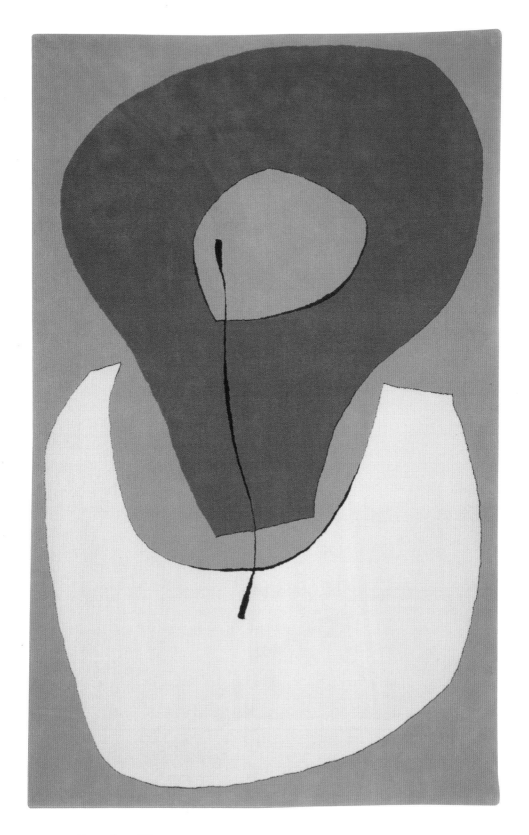

Helen Yardley | Spence House 2002

Helen Yardley | *Private House 2004* | left Fabric Moka 2005

Product Design

Shin Azumi

Shin Azumi

a studio, 12a Vicars Road, London NW5 4NL

P +44 20 7428 7501

F +44 20 7428 9214

www.shinazumi.com

mail@shinazumi.com

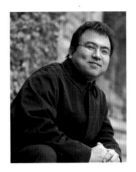

Shin Azumi

1965
born in Kobe, Japan

1995
AZUMI design unit
with Tomoko Azumi

2005
a studio

Shin Azumi from Japan is well-known as a successful furniture designer and designer of shops, restaurants and exhibitions. His work is based on the precise analysis of the respective task, from which he subsequently "distils" the idea for his design. Practical functionality is as important to him as the emotional quality of his designs.

Der Japaner Shin Azumi ist sowohl als Produkt- wie auch als Möbeldesigner und als Gestalter von Shops, Restaurants und Ausstellungen erfolgreich. Basis seiner Arbeit ist die präzise Analyse der jeweiligen Aufgabe, aus der er schließlich die Entwurfsidee „destilliert". Die praktische Funktionalität ist ihm dabei ebenso wichtig wie die emotionale Qualität seiner Entwürfe.

Le Japonais Shin Azumi connaît un égal succès comme créateur de produits et de meubles et comme concepteur de magasins, de restaurants et d'expositions. Son travail se fonde sur l'analyse précise de l'objectif en question, d'où est finalement « distillée » l'idée du projet. Pour lui, la fonctionnalité pratique est aussi importante que la qualité émotionnelle de ses projets.

El japonés Shin Azumi goza de éxito tanto como diseñador de productos como de mobiliario, comercios, restaurantes y exposiciones. La base de su trabajo es un análisis preciso de las diversas tareas, de las que finalmente extrae la idea para el esbozo. Para él la funcionalidad práctica resulta tan importante como la calidad emocional de sus diseños.

Il giapponese Shin Azumi riscuote successi sia come designer di prodotti e di mobili che come arredatore di negozi, ristoranti ed esposizioni. Il suo lavoro si basa su di una precisa analisi del compito affidatogli, al termine della quale egli "distilla" l'idea originaria del progetto; nell'ambito di questo processo, per Azumi è tanto importante la funzionalità pratica quanto la qualità emozionale delle sue creazioni.

Interview | Shin Azumi

How would you describe the basic idea behind your design work? I start by looking at all the phenomena around a brief objectively, and try to clarify the point to develop the project. I look at physical functionality as well as the effect of psychological functionality. I always try to create a maximum effect with a minimum solution.

To what extent does working in London inspire your creativity? Thinking about the whole creative culture in this city, a lot of interesting things are going on – art, theatre, music, film, fashion, graphic. There is a lot of opportunity to face to these. Those are often provocative, and letting me know the importance of being free from preconception.

Is there a typical London style in contemporary design? I do not believe there is a particular style. London has a tolerance to accept cultural diversity. If there is a design which is influenced by this creative atmosphere of this city, it could be a London design.

Which project is so far the most important one for you? LEM, a barstool produced by Lapalma.

Wie würden Sie die Grundidee beschreiben, die hinter Ihren Entwürfen steht? Ich beginne immer damit, dass ich alle Aspekte nüchtern betrachte, um den Kern einer Aufgabe herauszuarbeiten. Die eigentliche Funktion interessiert mich dabei ebenso wie die psychologische Wirkung. Ich versuche immer, mit möglichst einfachen Lösungen eine maximale Wirkung zu erzielen.

Inwiefern inspiriert London Ihre kreative Arbeit? Wenn man das gesamte kreative Leben dieser Stadt betrachtet, begegnet man einer Unmenge interessanter kultureller Angebote – Kunst, Theater, Musik, Film, Mode und Grafikdesign. Sie sind häufig provokativ und zeigen mir, wie wichtig es ist, frei von Vorurteilen zu sein.

Gibt es einen typischen Londoner Stil im aktuellen Design? Ich glaube nicht, dass es einen speziellen Stil gibt. London bietet einer großen kulturellen Vielfalt Platz. Man kann jeden Entwurf, der von dieser kreativen Atmosphäre beeinflusst ist, als Londoner Design bezeichnen.

Welches ist für Sie Ihr bislang wichtigstes Projekt? LEM, ein Barhocker, der von Lapalma produziert wird.

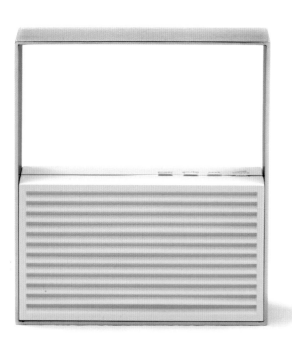
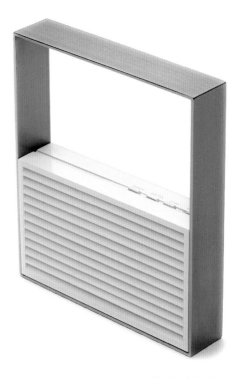

Quelle est, d'après vous, l'idée de base qui sous-tend votre travail de conception ? Je commence toujours par examiner objectivement tous les aspects pour dégager l'essentiel du projet. La fonction proprement dite m'intéresse autant que son effet psychologique. J'essaie toujours d'obtenir un effet maximum avec des solutions les plus simples possibles.

Dans quelle mesure Londres inspire-t-il votre créativité ? Quand on considère toute la vie créative de cette ville, on réalise qu'il y a une foule d'événements culturels intéressants – art, théâtre, musique, cinéma, mode et création graphique. Ils sont souvent provocants et me prouvent qu'il est important de se débarrasser des idées préconçues.

Y a-t-il un style typiquement londonien dans le design actuel ? Je ne pense pas qu'il y ait un style particulier. Londres a la faculté d'accepter une grande diversité culturelle. On peut qualifier de design londonien tout projet influencé par l'atmosphère créative de cette ville.

Quel est le projet le plus important pour vous à l'heure actuelle ? LEM, un tabouret de bar, produit par Lapalma.

¿Cómo definiría la idea básica que encierran sus diseños? Siempre empiezo contemplando todos los aspectos de forma racional para así poder extraer y trabajar el núcleo de un proyecto. Me interesan tanto la función en sí como el efecto psicológico. Siempre intento alcanzar una eficacia máxima a través de soluciones lo más sencillas posibles.

¿En qué medida inspira la ciudad de Londres su trabajo creativo? Si se observa la vida creativa de esta ciudad, uno se encuentra con innumerables e interesantes propuestas culturales en los ámbitos del arte, el teatro, la música, el cine, la moda y el diseño gráfico. Con frecuencia se trata de propuestas provocadoras que me hacen ver lo importante que es liberarse de prejuicios.

¿Existe un estilo típico londinense en el diseño actual? No creo que exista un estilo determinado. Londres ofrece una gran diversidad cultural. A cualquier boceto influido por esta atmósfera creativa se le puede dar el apelativo de diseño londinense.

¿Cuál ha sido su proyecto más importante hasta el momento? LEM, un taburete de bar fabricado por Lapalma.

Come descriverebbe l'idea originaria che sta alla base delle Sue creazioni? Comincio sempre osservando con lucidità tutti gli aspetti di un progetto, per chiarire quale ne sia il punto di partenza. In questa fase mi interesso tanto della funzione pratica quanto dell'effetto psicologico. Quello che io tento sempre di fare è di ottenere il massimo dell'effetto utilizzando soluzioni possibilmente semplici.

In che misura Londra ispira la Sua creatività? Se si considera l'intero panorama creativo di questa città, si scopre un'enorme quantità di offerte interessanti in tutti i settori della cultura: arte, teatro, musica, cinema, moda e design grafico. Queste offerte sono spesso provocatorie e mi dimostrano quanto sia importante essere liberi da preconcetti.

Esiste uno stile tipico di Londra nel design contemporaneo? Non credo che ci sia uno stile specifico. Londra dà spazio ad una grande molteplicità culturale: ogni progetto che sia influenzato dall'atmosfera di questa città può essere definito design di Londra.

Qual è per Lei il più importante tra i progetti realizzati finora? LEM, uno sgabello da bar prodotto da Lapalma.

Shin Azumi | KAI Chair 2006 | Edge Clock, with Tomoko Azumi 2001

Shin Azumi with Tomoko Azumi | Comb Chair 2005 | right Bench and a Half, Alice Mirrow Drawer 2004

Shin Azumi with Tomoko Azumi | LEM Stool 2000

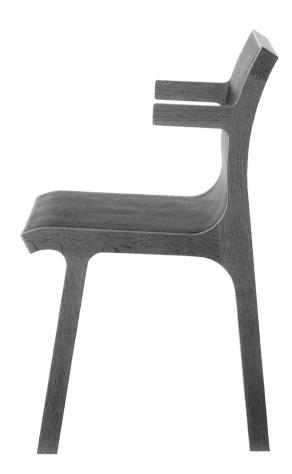

Shin Azumi found inspiration for the design of this chair in the traditional Japanese tatami mat. Although the chair appears at first sight to be hard and austere, the soft leather upholstery ensures that it is in fact pleasantly comfortable.

Für das Design dieses Stuhles ließ sich Shin Azumi durch die traditionelle japanische Tatami-Matte inspirieren. Obwohl der Stuhl auf den ersten Blick eher hart und streng wirkt, sorgt die weiche Lederpolsterung für ein überaus angenehmes Sitzgefühl.

Pour le design de cette chaise, Shin Azumi s'est laissé inspirer par le traditionnel tatami japonais. Bien que la chaise semble au premier abord plutôt dure et austère, le rembourrage de cuir moelleux procure une assise particulièrement agréable.

Para el diseño de esta silla Shin Azumi se dejó inspirar por la tradicional esterilla de tatami. Aunque, a primera vista, la silla parece dura y rígida, el suave acolchado de piel la hace muy confortable.

Per il design di questa sedia Shin Azumi si è fatto ispirare dal tatami, la tradizionale stuoia giapponese. Nonostante a prima vista la sedia faccia un'impressione piuttosto dura e austera, la morbida imbottitura in pelle offre un grande comfort di seduta.

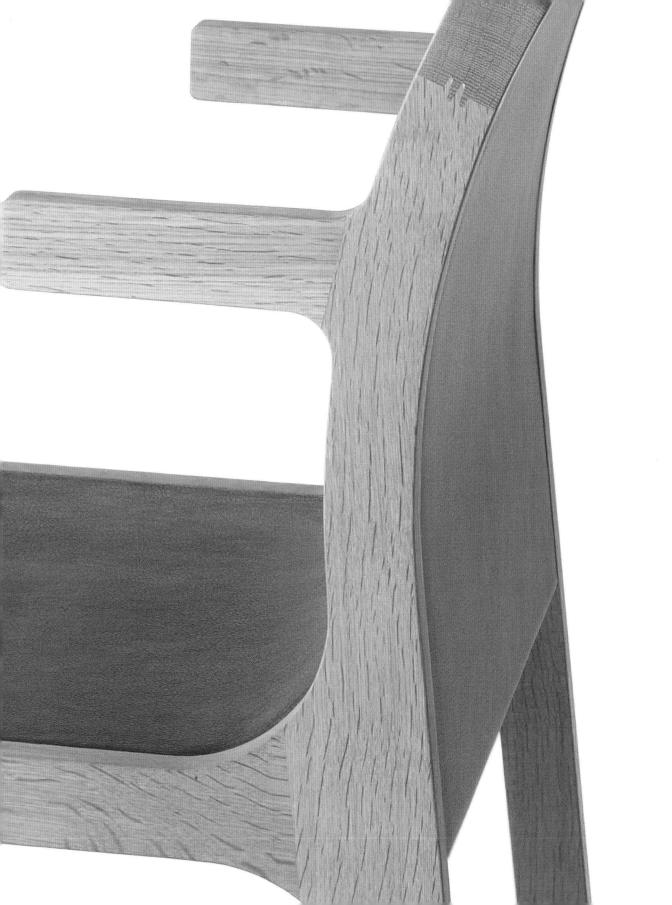

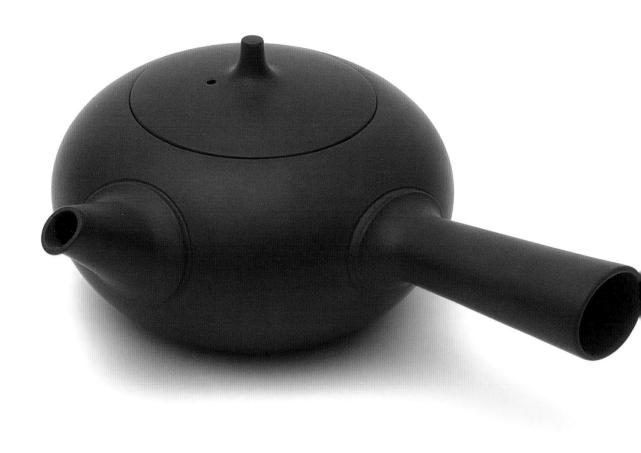

Shin Azumi | Yauatcha Tea Set & Sake Set 2006

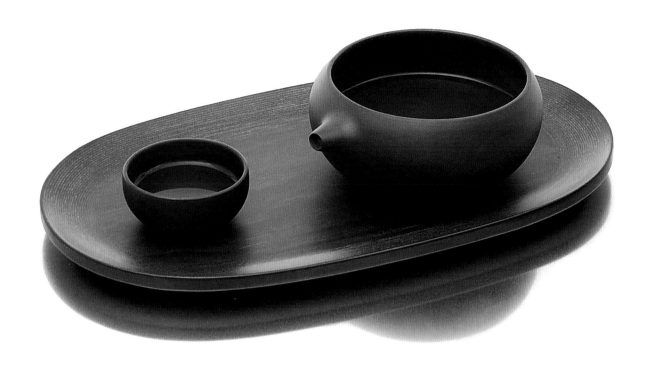

Shin Azumi | Yauatcha Tea Set & Sake Set, Paper Models 2006

Shin Azumi | Megaphone 2005

BarberOsgerby

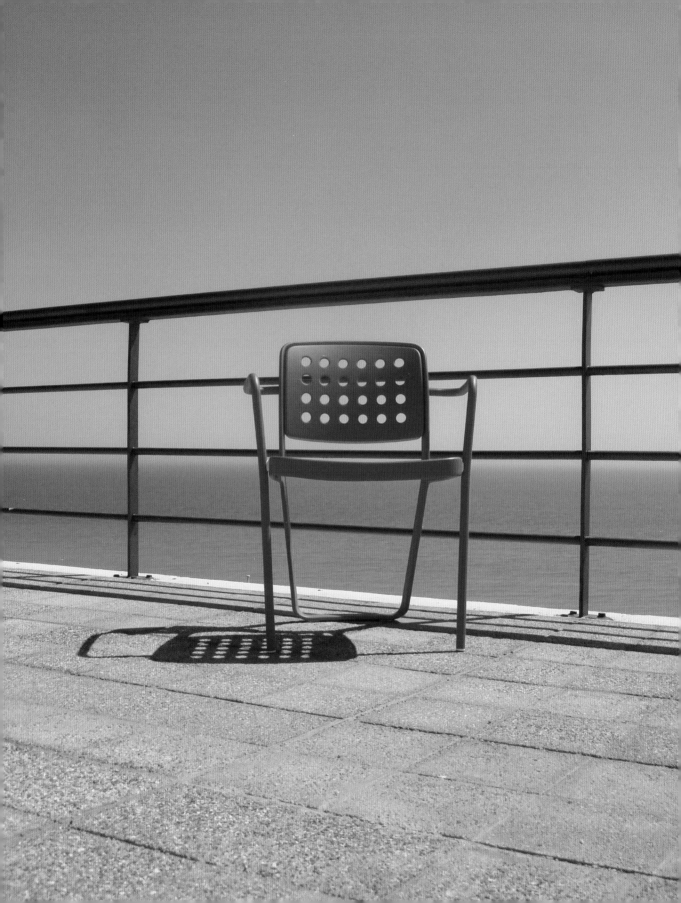

BarberOsgerby

Ground Floor, 35 Charlotte Road, London EC2A 3PG

P +44 20 7033 3884

F +44 20 7033 3882

www.barberosgerby.com

mail@barberosgerby.com

Edward Barber

1969
born in Shrewsbury, UK

Jay Osgerby

1969
born in Oxford, UK

1997
BarberOsgerby

Edward Barber and Jay Osgerby met as students at the Royal College of Art. Since 1996, they have worked together under the name BarberOsgerby to produce "things that people will find pleasing to use and own". The two designers are inspired by completely different sources: while one is stimulated by found objects on a flea market, the other is enthused by the functional aesthetics of ships and spaceships.

Edward Barber und Jay Osgerby lernten sich während des Studiums am Royal College of Art kennen. Seit 1996 gestalten sie unter dem Namen BarberOsgerby gemeinsam „Dinge, die Menschen gerne benutzen und besitzen möchten". Die Inspirationsquellen der beiden Designer sind sehr unterschiedlich: Während der eine sich gerne von Fundstücken auf dem Flohmarkt anregen lässt, begeistert sich der andere für die funktionale Ästhetik von Schiffen und Raumfahrzeugen.

Edward Barber et Jay Osgerby ont fait connaissance pendant leurs études au Royal College of Art. Depuis 1996, sous le nom de BarberOsgerby, ils créent des « objets que les gens aimeraient utiliser et posséder ». Les sources d'inspiration des deux designers sont très variées : tandis que l'un se laisse volontiers inspirer par des trouvailles sur le marché aux puces, l'autre s'enthousiasme pour l'esthétique fonctionnelle des bateaux et des vaisseaux spatiaux.

Edward Barber y Jay Osgerby se conocieron durante sus estudios en el Royal College of Art. Desde 1996 crean en común bajo el nombre BarberOsgerby "cosas que a las personas les gusta utilizar y poseer". Las fuentes de inspiración de ambos diseñadores son muy diferentes: mientras que uno se siente atraído por artículos de mercadillo, al otro le fascina la estética funcional de los barcos y vehículos espaciales.

Edward Barber e Jay Osgerby si sono conosciuti durante gli studi al Royal College of Art. Dal 1996 realizzano in comune, sotto il marchio BarberOsgerby, "oggetti che le persone desidererebbero usare e possedere". Le fonti d'ispirazione dei due designer non potrebbero essere più differenti: mentre uno ama ispirarsi ad oggetti trovati al mercatino delle pulci, l'altro si entusiasma per l'estetica funzionale di navi e navicelle spaziali.

Interview | BarberOsgerby

How would you describe the basic idea behind your design work? To design things that people will find pleasing to use and own. To look at different ways in which products can be manufactured, not necessarily by using new materials or by radical rethinking, but by using existing techniques in a more intelligent and original way.

To what extent does working in London inspire your creativity? London is a multi-layered mesh of diverse influences, information and of people. Living in London it is easy to feel that you are at the centre of things, and this creative energy pervades one's life. Despite its size, London is also in close proximity to areas of outstanding beauty, this juxtaposition of the busy and the quiet are most inspiring.

Is there a typical London style in contemporary design? There is no definable "style". Due to its important global position, London's design style reflects the international design world.

Which project is so far the most important one for you? The Loop Table was the first piece of furniture that we designed and put into production. It has proved to be the single most important piece so far.

Wie würden Sie die Grundidee beschreiben, die hinter Ihren Entwürfen steht? Dinge zu gestalten, die Menschen gerne benutzen und besitzen möchten. Neue Herstellungsmethoden zu finden, weniger durch Einsatz neuer Materialien oder radikales Umdenken, eher durch die intelligente und originelle Verwendung bekannter Techniken.

Inwiefern inspiriert London Ihre kreative Arbeit? London besteht aus einem vielschichtigen Netz unterschiedlicher Einflüsse, Informationen und Menschen. Wenn man in London lebt, spürt man, dass man sich im Zentrum der Dinge befindet, und diese kreative Energie durchdringt das Leben der Menschen. Trotz seiner Größe befindet sich London in direkter Nähe zu Orten von außerordentlicher Schönheit – dieser Gegensatz von Geschäftigkeit und Stille ist höchst inspirierend.

Gibt es einen typischen Londoner Stil im aktuellen Design? Es gibt keinen definierbaren „Stil". London hat eine bedeutende Stellung in der Welt und bietet daher ein Spiegelbild der internationalen Designszene.

Welches ist für Sie Ihr bislang wichtigstes Projekt? Der Loop Table war unser erstes Möbel, das in Serie produziert wurde. Bislang erwies er sich als unser wichtigster Einzelentwurf.

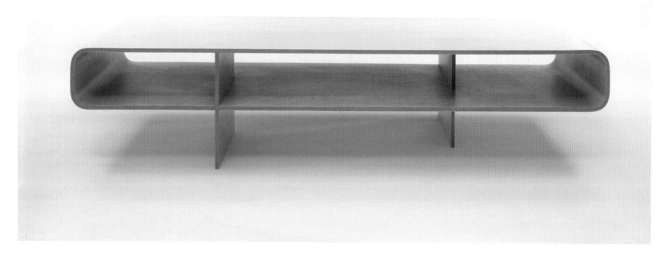

Quelle est, d'après vous, l'idée de base qui sous-tend votre travail de conception ? Créer des objets que les gens aimeraient utiliser et posséder. Trouver de nouvelles méthodes de fabrication, moins par l'utilisation de nouveaux matériaux ou par une réorientation radicale que par un emploi intelligent et original de techniques connues.

Dans quelle mesure Londres inspire-t-il votre créativité ? Londres consiste en un réseau multi-couche d'influences, d'informations et d'individus. En vivant à Londres, on a l'impression d'être au centre des choses et cette énergie créatrice imprègne la vie des individus. Malgré son étendue, Londres est à proximité immédiate de lieux d'une beauté exceptionnelle – ce contraste entre l'affairement et la tranquillité est extrêmement inspirant.

Y a-t-il un style typiquement londonien dans le design actuel ? Il n'y a pas de « style » définissable. Londres occupe une place importante dans le monde et reflète donc la scène internationale du design.

Quel est le projet le plus important pour vous à l'heure actuelle ? La Loop Table a été notre premier meuble produit en série. Jusqu'à maintenant, il s'est révélé être notre projet individuel le plus important.

¿Cómo definiría la idea básica que encierran sus diseños? Concebir cosas que a la gente le guste usar y poseer. Encontrar nuevos métodos de producción, no tanto a través de nuevos materiales o cambios radicales de concepción, sino más bien empleando técnicas ya conocidas de forma inteligente y original.

¿En qué medida inspira la ciudad de Londres su trabajo creativo? Londres está compuesto de una red diversa de influencias, informaciones y personas diferentes. Cuando se vive aquí se tiene la sensación de encontrarse en el centro de las cosas, y esa energía creativa se integra en la vida de las personas. A pesar de sus dimensiones, Londres está ubicado muy cerca de lugares de una belleza excepcional; y esta contraposición entre el ajetreo y la serenidad resulta claramente inspiradora.

¿Existe un estilo típico londinense en el diseño actuall? En Londres no es posible definir un "estilo". Londres ocupa un lugar significativo en el mundo y es un reflejo de la escena internacional del diseño.

¿Cuál ha sido su proyecto más importante hasta el momento? La Loop Table fue nuestro primer mueble producido en serie. Hasta el momento es considerado nuestro diseño individual más importante.

Come descriverebbe l'idea originaria che sta alla base delle Sue creazioni? Progettare oggetti che le persone desidererebbero usare e possedere; trovare nuovi metodi di produzione, non necessariamente utilizzando nuovi materiali o ripensando radicalmente tutto quanto applicando in maniera intelligente ed originale tecniche già note.

In che misura Londra ispira la Sua creatività? Londra consiste di una rete stratificata di influssi, informazioni e persone differenti. Chi vive a Londra sente di trovarsi al centro degli eventi, e questa energia creativa compenetra la vita delle persone. Pur essendo così grande, Londra ha nelle sue immediate vicinanze luoghi di una bellezza straordinaria: questa contrapposizione di attività e quiete è una grandissima fonte di ispirazione.

Esiste uno stile tipico di Londra nel design contemporaneo? Non esiste uno "stile" definibile. Londra svolge un ruolo importante nel mondo e, di conseguenza, il suo stile rispecchia tutto il panorama internazionale del design.

Qual è per Lei il più importante tra i progetti realizzati finora? Il Loop Table è stato il nostro primo oggetto di arredamento ad essere prodotto in serie, e finora si è rivelato il nostro progetto singolo più importante.

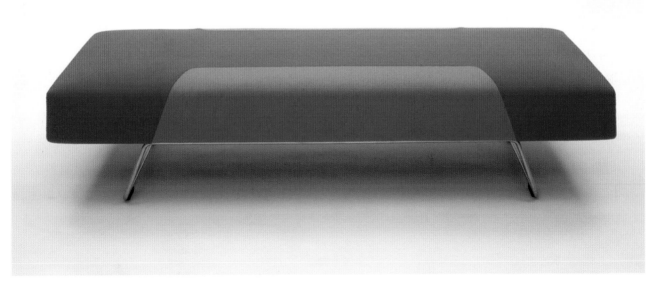

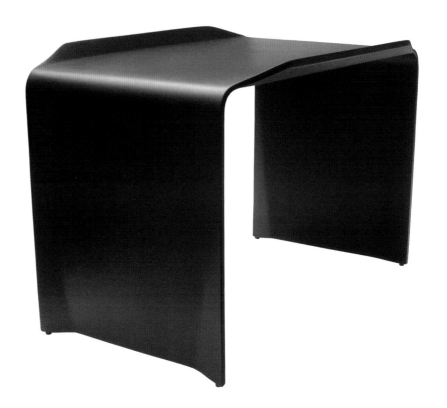

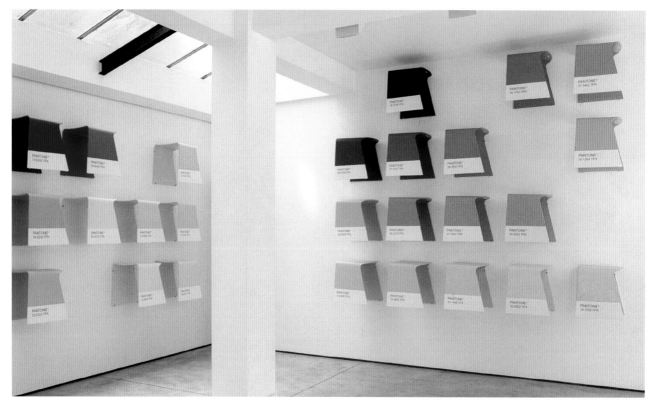

BarberOsgerby | Pilot Table 1999, Pantone Flight Stool 2005

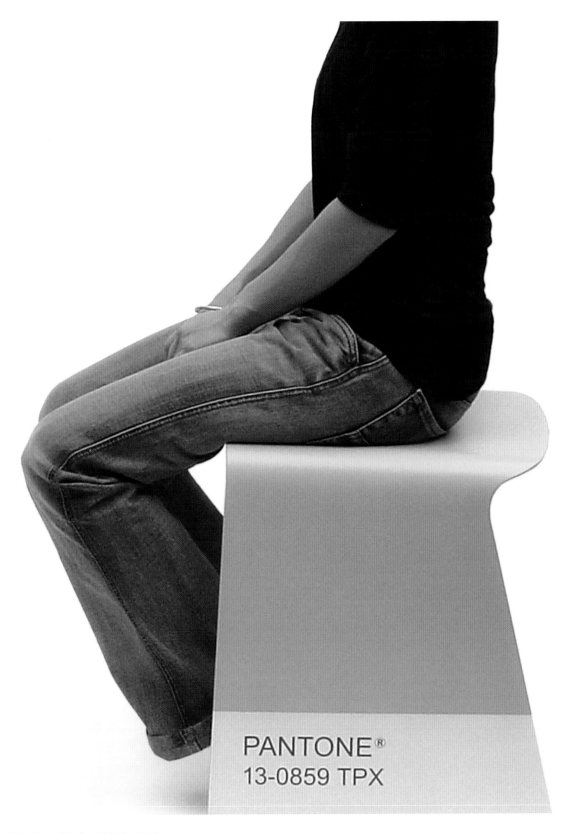

PANTONE®
13-0859 TPX

The Loop Table was the breakthrough for the BarberOsgerby design team. Made by Isokon Plus in London, the table is now included in collections in the Victoria and Albert Museum in London and the Museum of Modern Art in New York.

Der Loop Table bedeutete den Durchbruch für das Designteam BarberOsgerby. Von Isokon Plus in London produziert, ist der Tisch heute Teil der Sammlungen des Victoria and Albert Museum in London und des Museum of Modern Art in New York.

La Loop Table a permis à l'équipe de designers BarberOsgerby de percer. Produite par Isokon Plus à Londres, la table fait aujourd'hui partie des collections du Victoria and Albert Museum de Londres et du Museum of Modern Art de New York.

La Loop Table supuso el salto para el equipo de diseño BarberOsgerby. Fue producida por Isokon Plus en Londres, y es hoy parte integrante de las colecciones del Victoria and Albert Museum de Londres y del Museum of Modern Art de Nueva York.

Il Loop Table ha portato al successo il team di designer di BarberOsgerby. Prodotto a Londra da Isokon Plus, oggi questo tavolo fa parte delle collezioni del Victoria and Albert Museum di Londra e del Museum of Modern Art di New York.

BarberOsgerby | Shell Table 2001, Shell Chair 2004, Shelving 2004

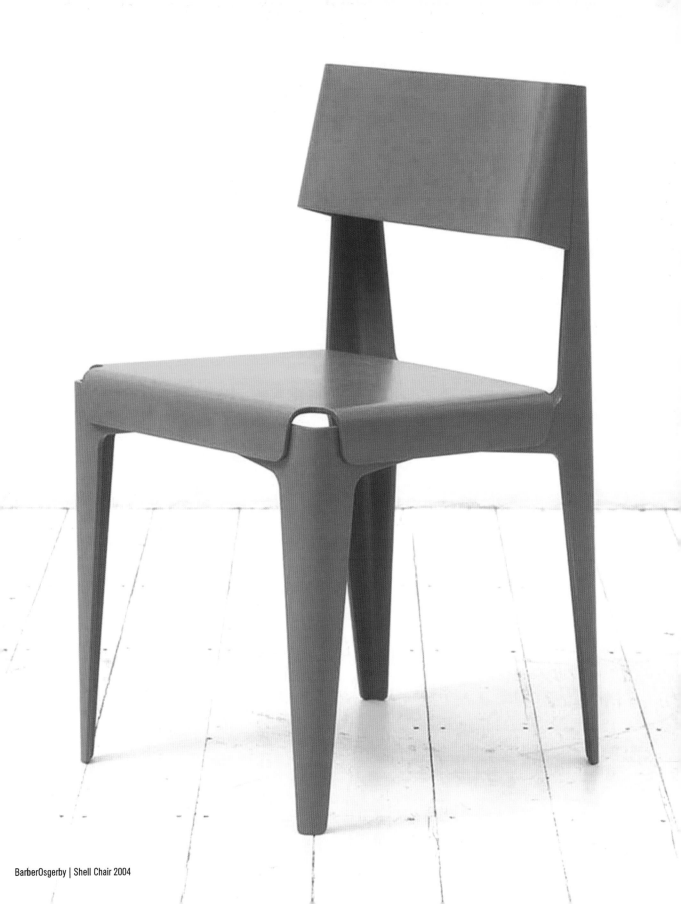

BarberOsgerby | Shell Chair 2004

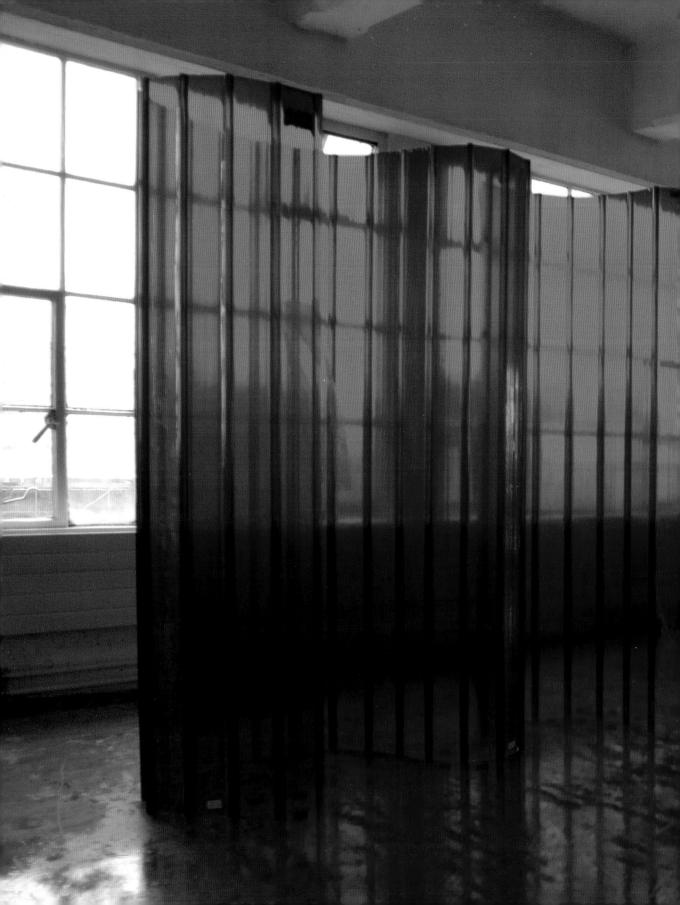

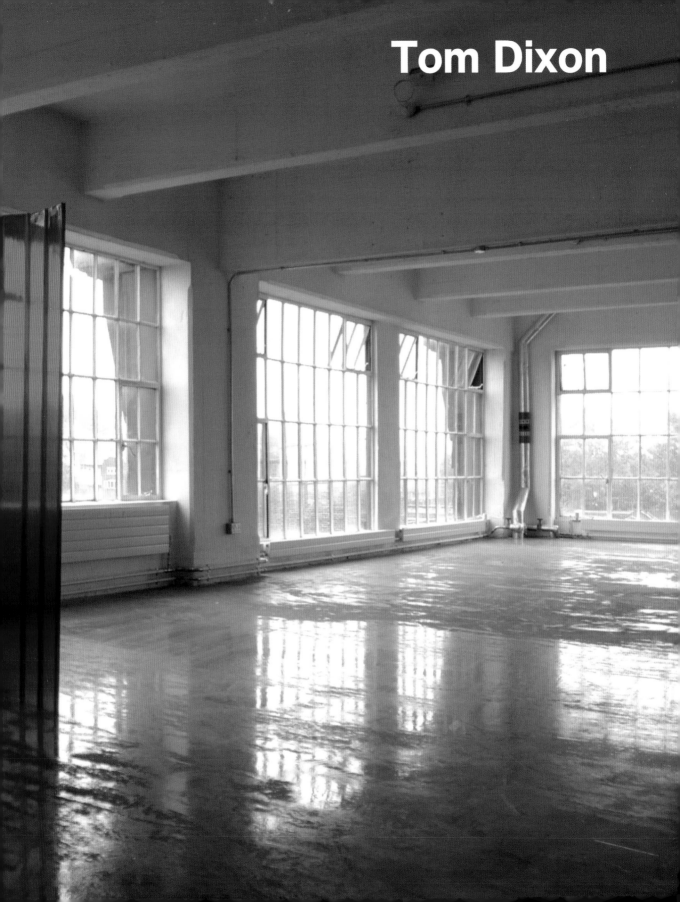

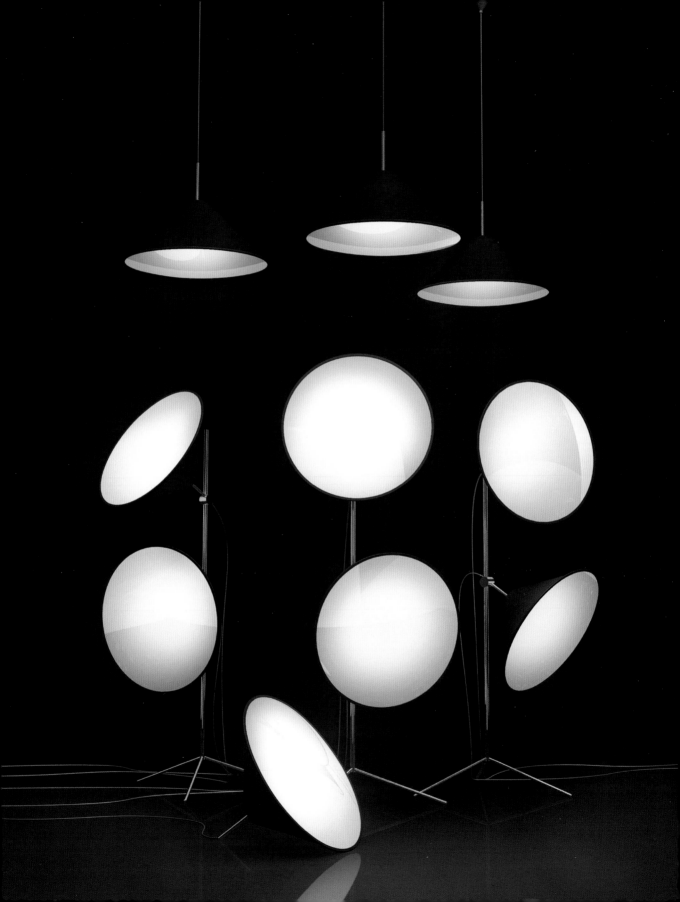

Tom Dixon

4 Northington Street, London WC1N 2JG

P +44 20 7400 0500

F +44 20 7400 0501

www.tomdixon.net

info@tomdixon.net

Tom Dixon

1959
born in Sfax, Tunesia

2002
Tom Dixon

Designer Tom Dixon hails from the post-punk era of the early eighties. Self-taught, he started out producing small series of furniture which he welded together himself from pieces of steel. Later he became head of design at Habitat and creative director for the Finnish furniture manufacturer Artek. In 2002 Tom Dixon set up a studio under his own name, where he develops innovative furniture and product designs with tremendous success.

Der Designer Tom Dixon entstammt der Post-Punk-Ära der frühen achtziger Jahre. Als Autodidakt vertrieb er zunächst Kleinserien von Möbeln, die er selbst aus Stahlteilen zusammenschweißte. Später arbeitete er als Designchef für Habitat und als Kreativdirektor für den finnischen Möbelhersteller Artek. 2002 gründete Tom Dixon ein Studio unter eigenem Namen, in dem er mit großem Erfolg innovative Möbel- und Produktdesigns entwickelt.

Le designer Tom Dixon est issu de l'ère post-punk du début des années quatre-vingt. En tant qu'autodidacte, il a d'abord distribué de petites séries de meubles qu'il soudait lui-même à partir de pièces en acier. Plus tard, il a travaillé comme chef du design chez Habitat et comme directeur de la création chez le fabricant de meubles finlandais Artek. En 2002, Tom Dixon a fondé un studio à son nom où il développe avec beaucoup de succès des designs innovants de meubles et de produits.

El diseñador Tom Dixon proviene de la era Post-Punk de principios de los ochenta. Como buen autodidacta, en un principio se dedicó a vender series reducidas de muebles que él mismo creaba soldando piezas. Posteriormente trabajó como jefe de diseño para Habitat y como director creativo del fabricante de muebles finlandés Artek. En 2002 Tom Dixon fundó un estudio con su nombre, en el que desarrolla muebles innovadores y productos de diseño con gran éxito.

Il designer Tom Dixon proviene dall'era post-punk dei primi anni Ottanta. Autodidatta, inizialmente mise in commercio piccole serie di mobili, prodotti in proprio saldando componenti di acciaio. Successivamente è stato capo del design per Habitat e direttore creativo per il produttore finlandese di mobili Artek. Nel 2002 Tom Dixon ha fondato l'omonimo studio, in cui sviluppa con grande successo design innovativi per mobili e prodotti industriali.

Interview | Tom Dixon

How would you describe the basic idea behind your design work? My designs evolved from a naïve interest in materials, engineering, manufacturing and sculpture. I like to look at things from an unexpert standpoint, and then try and make my own version.

To what extent does working in London inspire your creativity? In the time I have been working there, London has transformed itself from a cultural, gastronomic and industrial desert, into an international hub for everything from low cost airlines to international mafia, with extraordinary art galleries, restaurants, publishing, financial services and so much more happening in the city, but it has always been a good place to indulge in creativity as it is so big and so diverse.

Is there a typical London style in contemporary design? I don't think so.

Which project is so far the most important one for you? My next project is always the most important, the one I am just starting to think about, which is full of potential and unfettered with reality ... I am never so happy to look back at the things I did before.

Wie würden Sie die Grundidee beschreiben, die hinter Ihren Entwürfen steht? Meine Entwürfe entstanden aus einem naiven Interesse an Material, Technik, Herstellung und Bildhauerei. Ich betrachte die Dinge gerne von einem laienhaften Standpunkt, und versuche dann, eine eigene Idee zu entwickeln.

Inwiefern inspiriert London Ihre kreative Arbeit? Seit ich hier arbeite, hat sich London von einer kulturellen, gastronomischen und industriellen Wüste in einen internationalen Drehscheibe für alles Mögliche verwandelt – von Billig-Airlines bis hin zur internationalen Mafia. Inzwischen gibt es Kunstgalerien, Restaurants, Verlage, Banken und vieles mehr. Weil es so groß und vielfältig ist, war London jedoch immer schon ein guter Ort, um kreativ zu sein.

Gibt es einen typischen Londoner Stil im aktuellen Design? Ich würde sagen, nein.

Welches ist für Sie Ihr bislang wichtigstes Projekt? Das nächste Projekt ist immer das wichtigste, das, über das ich gerade anfange nachzudenken, das noch voller Möglichkeiten und frei von den Zwängen der Wirklichkeit ist ... Ich blicke nicht gerne zurück auf Dinge, die ich gemacht habe.

Tom Dixon | Wire Coat Rack

Quelle est, d'après vous, l'idée de base qui sous-tend votre travail de conception ? Mes dessins sont nés d'un intérêt naïf pour les matériaux, la technique, la fabrication et la sculpture. J'aime regarder les choses d'un œil profane et j'essaie ensuite d'en élaborer ma propre version.

Dans quelle mesure Londres inspire-t-il votre créativité ? Depuis que je travaille ici, Londres est passé du désert culturel, gastronomique et industriel au statut de plaque tournante internationale pour tout – des compagnies aériennes à bas prix à la mafia internationale. Il y a désormais des galeries d'art, des restaurants, des maisons d'édition, des banques et bien d'autres choses. Mais Londres a toujours été une ville propice à la création car elle est grande et multiple.

Y a-t-il un style typiquement londonien dans le design actuel ? Je dirais que non.

Quel est le projet le plus important pour vous à l'heure actuelle ? Le prochain projet est toujours le plus important, celui auquel je commence à réfléchir, qui est encore plein de potentialités et détaché des contraintes de la réalité … Je n'aime pas beaucoup regarder en arrière sur les choses que j'ai faites.

¿Cómo definiría la idea básica que encierran sus diseños? Mis bocetos surgieron de un simple interés por el material, la técnica, la fabricación y la escultura. Me gusta observar las cosas desde el punto de vista de un aficionado y a partir de ahí intento desarrollar ideas propias.

¿En qué medida inspira la ciudad de Londres su trabajo creativo? Desde que trabajo aquí Londres ha pasado de ser un desierto cultural, gastronómico e industrial a un foco internacional de todo lo imaginable, desde las compañías aéreas económicas hasta la mafia internacional. Entretanto existen galerías de arte, restaurantes, editoriales, bancos y mucho más. Sin embargo, debido a su tamaño y diversidad, Londres ha sido siempre un buen lugar para ser creativo.

¿Existe un estilo típico londinense en el diseño actual? Yo diría que no.

¿Cuál ha sido su proyecto más importante hasta el momento? El próximo proyecto es siempre el más importante, sobre el que en este momento comienzo a pensar, y el que aún está cargado de posibilidades y está libre de los condicionamientos de la realidad … No me gusta rememorar las cosas que he hecho en el pasado.

Come descriverebbe l'idea originaria che sta alla base delle Sue creazioni? Le mie creazioni sono nate da un ingenuo interesse per materiale, tecnica, produzione e scultura. Amo osservare le cose dal punto di vista del non addetto ai lavori, per poi tentare di sviluppare un'idea mia.

In che misura Londra ispira la Sua creatività? Da quando lavoro qui, Londra si è trasformata da quello che era un deserto culturale, gastronomico e industriale in un crocevia internazionale per tutto, dalle linee aeree a basso prezzo alla mafia internazionale: ora Londra ha gallerie d'arte, ristoranti, case editrici, banche e molto ancora. Ma proprio perché è così grande e varia, questa città è da sempre il luogo ideale per chi vuol essere creativo.

Esiste uno stile tipico di Londra nel design contemporaneo? Direi di no.

Qual è per Lei il più importante tra i progetti realizzati finora? Il mio progetto più importante è sempre il prossimo: quello su cui sto cominciando a riflettere, che è ancora pieno di potenzialità e libero dalle costrizioni della realtà … non mi piace voltarmi indietro a guardare quello che ho già fatto.

Tom Dixon | *Detail Wire Chair*

Designing lights is an important part of Tom Dixon's work. Recently he has also developed a large number of the most varied lighting objects, including clever geometric compositions such as the Diamond Light and simple, elegant shapes such as the shining silver Mirror Balls.

Die Gestaltung von Leuchten spielt in der Arbeit von Tom Dixon eine wichtige Rolle. In jüngster Zeit entwickelte er eine Vielzahl von höchst unterschiedlichen Lichtobjekten, darunter raffinierte geometrische Kompositionen wie das Diamond Light, aber auch schlichte, elegante Formen wie die silberglänzenden Mirror Balls.

La conception de lampes tient une grande place dans le travail de Tom Dixon. Récemment, il a créé de nombreux objets lumineux d'une extrême diversité, parmi lesquels des compositions géométriques raffinées comme le Diamond Light ou des formes simples et élégantes comme les Mirror Balls aux reflets argentés.

La concepción de la luz juega un papel importante en el trabajo de Tom Dixon. Al comienzo desarrolló numerosos objetos luminosos del más diverso carácter, entre los que se cuentan composiciones geométricas sofisticadas, como es el caso de la Diamond Light, o bien formas austeras y elegantes como las Mirror Balls de brillo plateado.

La creazione di lampade svolge un ruolo importante nel lavoro di Tom Dixon. Negli ultimi tempi ha progettato un gran numero di oggetti luminosi estremamente differenti tra loro, tra cui raffinate composizioni geometriche come il Diamond Light, ma anche forme sobrie ed eleganti come gli argentei Mirror Balls.

Tom Dixon | Copper Ball | right Pipe

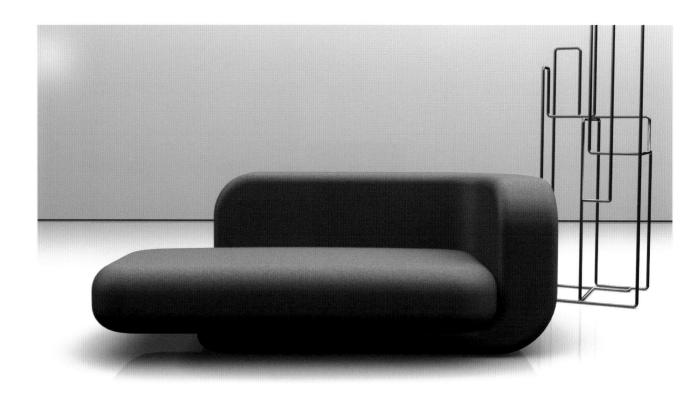

Soft System is the name Tom Dixon gave to this generously proportioned upholstered furniture. The modular system is ideal for a wide range of different combinations. The units are available in different sizes to use in living areas or large areas.

Soft System nennt Tom Dixon diese großzügig proportionierten Polstermöbel. Der modulare Aufbau des Systems erlaubt eine Vielzahl unterschiedlicher Kombinationen. Verschiedene Größen sind für den Einsatz im Wohnbereich oder für die Ausstattung großer Räume erhältlich.

Tom Dixon appelle Soft System ces canapés aux dimensions généreuses. La conception modulaire du système permet une multitude de combinaisons possibles. Il existe différentes tailles selon qu'ils sont utilisés pour l'aménagement d'appartements ou de grandes pièces.

A estos muebles tapizados generosamente proporcionados Tom Dixon les da el nombre de Soft System. La construcción modular del sistema permite llevar a cabo numerosas combinaciones diferentes. Existen diversas medidas para su uso en la vivienda o para amueblar grandes espacios.

Soft System è il nome dato da Tom Dixon a questi mobili imbottiti dalle generose proporzioni. La struttura modulare del sistema permette di ottenere numerose combinazioni differenti. È possibile ordinare mobili di varie misure, a seconda che siano destinati ad un'abitazione o all'arredamento di grandi spazi.

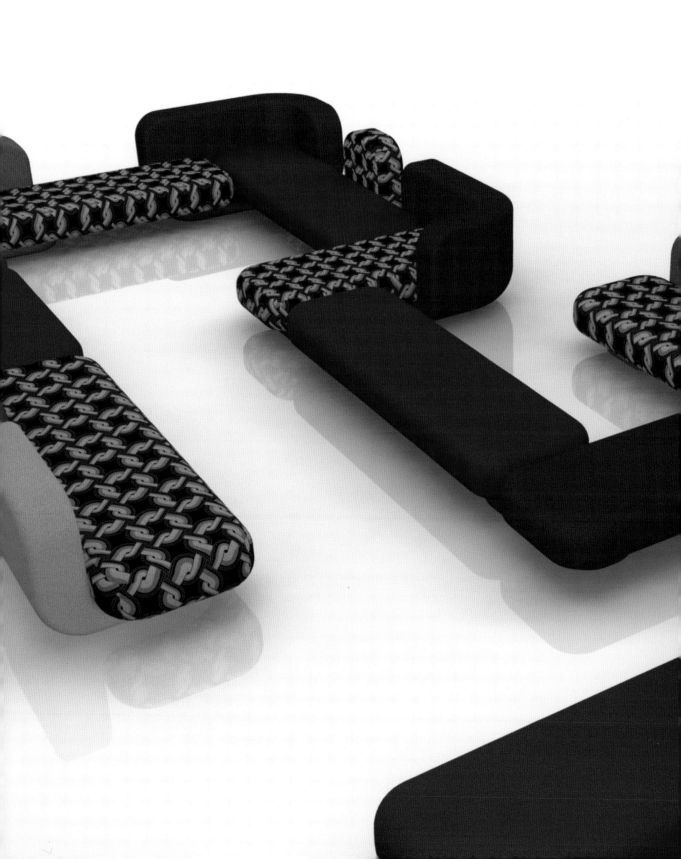

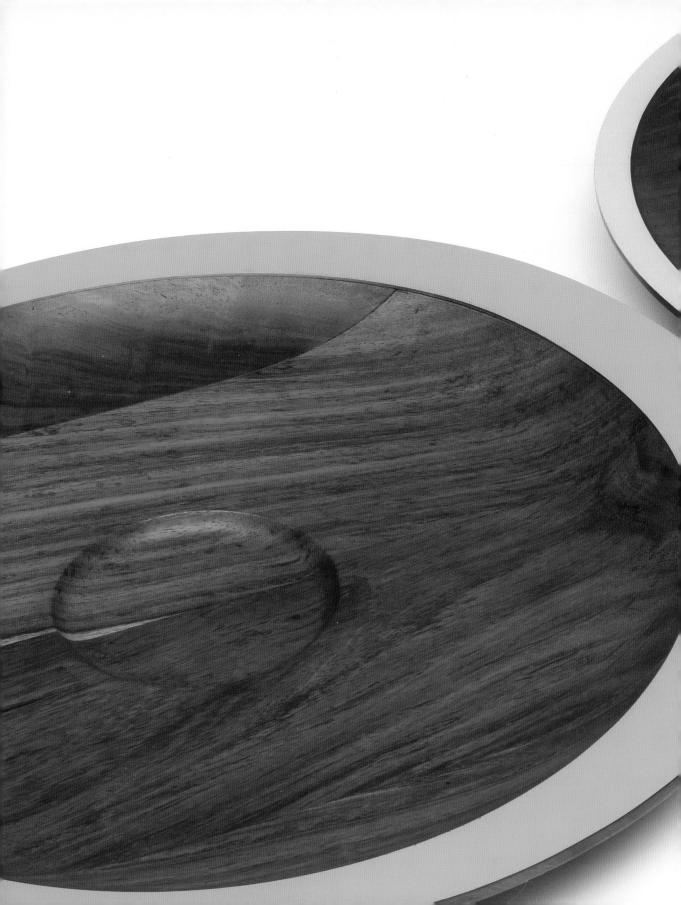

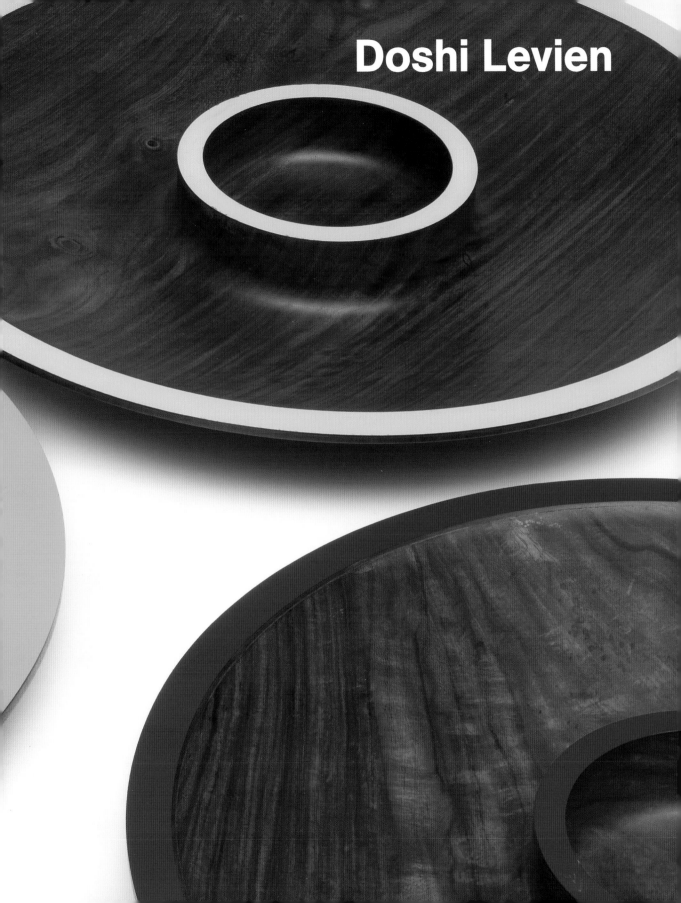

Doshi Levien

Doshi Levien

5 Tenter Ground, London E1 7NH

P +44 20 7375 1727

F +44 870 460 1681

www.doshilevien.com

mail@doshilevien.com

After graduating from the Royal College of Art, Jonathan Levien and Nipa Doshi worked in various design studios in London, Milan and India. In 2000, they set up the Doshi Levien studio. Their designs reflect their unique combination of poetry and irony, teamed with Jonathan Levien's European attitude and Nipa Doshi's Indian heritage.

Nach ihrem Studium am Royal College of Art arbeiteten Jonathan Levien und Nipa Doshi zunächst in Designbüros in London, Mailand und in Indien. Im Jahr 2000 gründeten sie das Büro Doshi Levien. Ihre Entwürfe spiegeln in ihrer eigenwilligen Mischung aus Poesie und Ironie sowohl die europäische Haltung Jonathan Leviens als auch die indische Herkunft Nipa Doshis wider.

A l'issue de leurs études au Royal College of Art, Jonathan Levien et Nipa Doshi ont d'abord travaillé dans des studios de design à Londres, Milan et en Inde. En l'an 2000, ils ont fondé le studio Doshi Levien. Leurs projets reflètent, dans leur mélange très volontaire de poésie et d'ironie, aussi bien l'attitude européenne de Jonathan Levien que l'origine indienne de Nipa Doshi.

Tras finalizar sus estudios en el Royal College of Art, Jonathan Levien y Nipa Doshi comenzaron a trabajar en estudios de diseño de Londres, Milán e India. En el año 2000 fundaron Doshi Levien. Sus bocetos reflejan una miscelánea peculiar de poesía e ironía que vincula además la visión europea de Jonathan Levien y la procedencia india de Nipa Doshi.

Una volta conclusi gli studi al Royal College of Art, Jonathan Levien e Nipa Doshi inizialmente hanno lavorato in studi di design a Londra, a Milano e in India, per poi aprire, nel 2000, lo studio Doshi Levien. Con la loro singolare mescolanza di poesia e ironia, le creazioni dei due designer rispecchiano tanto l'impostazione tipicamente europea di Jonathan Levien quanto la provenienza indiana di Nipa Doshi.

Nipa Doshi

1971
born in Bombay, India

Jonathan Levien

1972
born in Scotland, UK

2000
Doshi Levien

Interview | Doshi Levien

How would you describe the basic idea behind your design work? Jonathan and I bring together two very distinct and complementary approaches to our work. While Jonathan presents a European approach to design, my work is strongly influenced by my Indian upbringing.

To what extent does working in London inspire your creativity? In London, there is great access to everything we need to be creative. However, most of our inspiration comes from travelling to different parts of the world, so I think for us, London facilitates more than inspires the creative process.

Is there a typical London style in contemporary design? I can see people wanting to contaminate the purity of slick perfection and produce work that is more humane and down to earth. Design has become more diverse, more eclectic and more subjective.

Which project is so far the most important one for you? Our projects are all equally important as they all presented very different challenges. The Wellcome Trust installations were about communication through storytelling. For My World, we were free to give form to liminal spaces; between the unique and the mass-produced, the real and the imaginary, the ephemeral and the permanent.

Wie würden Sie die Grundidee beschreiben, die hinter Ihren Entwürfen steht? Bei Jonathan und mir kommen zwei sehr verschiedene, aber sich ergänzende Arbeitsansätze zusammen. Während Jonathan eine europäische Gestaltungsweise repräsentiert, ist meine Arbeit stark von meiner indischen Herkunft bestimmt.

Inwiefern inspiriert London Ihre kreative Arbeit? In London gibt es einen großartigen Zugang zu allem, was wir brauchen, um kreativ zu sein. Dennoch sind Reisen in alle Welt unsere größte Inspiration. Darum denke ich, dass London eher kreative Prozesse ermöglicht als inspiriert.

Gibt es einen typischen Londoner Stil im aktuellen Design? Ich sehe, dass Menschen mehr und mehr die Reinheit der glatten Perfektion durchbrechen und menschlichere, bodenständigere Arbeiten schaffen wollen. Design ist vielfältiger, eklektischer und subjektiver geworden.

Welches ist für Sie Ihr bislang wichtigstes Projekt? Unsere Projekte sind alle gleichermaßen wichtig, weil sie sehr unterschiedliche Herausforderungen bieten. Bei den Schaufensterinstallationen für den Wellcome Trust ging es um Kommunikation durch das Erzählen einer Geschichte. Für My World konnten wir Grenzbereichen eine Form geben – zwischen dem Einzelstück und dem Massenprodukt, dem Wirklichen und dem Erträumten, zwischen dem Kurzlebigen und dem Dauerhaften.

Quelle est, d'après vous, l'idée de base qui sous-tend votre travail de conception ? Jonathan et moi, nous réunissons deux approches du travail très différentes mais complémentaires. Tandis que Jonathan représente la conception européenne du design, mon travail est fortement influencé par mon origine indienne.

Dans quelle mesure Londres inspire-t-il votre créativité ? A Londres, nous avons facilement accès à tout ce qui nous est nécessaire pour être créatifs. Cependant, l'essentiel de notre inspiration vient de nos voyages à travers le monde. C'est pourquoi je pense que Londres favorise davantage le processus créatif qu'il ne l'inspire.

Y a-t-il un style typiquement londonien dans le design actuel ? Je vois que les hommes cherchent à rompre la pureté de la perfection lisse et à créer des œuvres plus humaines, plus proches de la terre. Le design est devenu plus multiple, plus éclectique et plus subjectif.

Quel est le projet le plus important pour vous à l'heure actuelle ? Nos projets sont tous pareillement importants car ils représentent tous des défis très différents. Dans le cas de l'agencement des vitrines pour le Wellcome Trust, il s'agissait de communiquer en racontant une histoire. Pour My World, nous avons pu donner une forme à des notions floues – situées entre l'objet unique et le produit de masse, le rêve et le réel, l'éphémère et le permanent.

¿Cómo definiría la idea básica que encierran sus diseños? Entre Jonathan y yo existen dos formas de enfoque del trabajo muy diferentes pero que se complementan entre sí. Mientras que Jonathan representa una forma de configuración europea, mi trabajo está intensamente determinado por mi procedencia india.

¿En qué medida inspira la ciudad de Londres su trabajo creativo? En Londres hay un acceso fabuloso a todo lo que necesitamos para ser creativos. Sin embargo la mayor parte de nuestra inspiración proviene de los viajes por todo el mundo. Por eso pienso que Londres más que inspirar facilita el proceso creativo.

¿Existe un estilo típico londinense en el diseño actual? Veo que las personas cada vez rompen más con la pureza de la perfección clara y desean crear trabajos más humanos y arraigados. El diseño se ha vuelto más diverso, ecléctico y subjetivo.

¿Cuál ha sido su proyecto más importante hasta el momento? Nuestros proyectos son todos igual de importantes puesto que ofrecen retos muy diversos. En las instalaciones de los escaparates para el Wellcome Trust se trataba de la comunicación a través del relato de una historia. Para My World pudimos modelar los límites de la forma, entre la pieza única y la producción masiva, la realidad y el sueño, lo duradero y lo efímero.

Come descriverebbe l'idea originaria che sta alla base delle Sue creazioni? Nel caso mio e di Jonathan, confluiscono due approcci al lavoro molto diversi eppure complementari: mentre Jonathan rappresenta un modo europeo di fare design, il mio lavoro è fortemente influenzato dalle mie origini indiane.

In che misura Londra ispira la Sua creatività? A Londra abbiamo accesso a tutto quanto ci serve per poter essere creativi. Ciò nonostante, gran parte della nostra ispirazione ci viene dai viaggi che facciamo in tutto il mondo. Per questo sono dell'idea che Londra, più che ispirare i processi creativi, li faciliti.

Esiste uno stile tipico di Londra nel design contemporaneo? Vedo che gli uomini desiderano rompere la purezza di una perfezione immacolata per creare opere più umane, più di questa terra. Il design è diventato più vario, eclettico e soggettivo.

Qual è per Lei il più importante tra i progetti realizzati finora? Tutti i nostri progetti hanno la stessa importanza, perché offrono provocazioni intellettuali molto differenti tra loro. Nel caso degli allestimenti di vetrine per la Wellcome Trust si trattava di comunicare raccontando una storia. Per My World abbiamo avuto modo di dare forma a delle zone di confine: tra il pezzo unico ed il prodotto di massa, tra il vero e l'immaginario, tra l'effimero ed il duraturo.

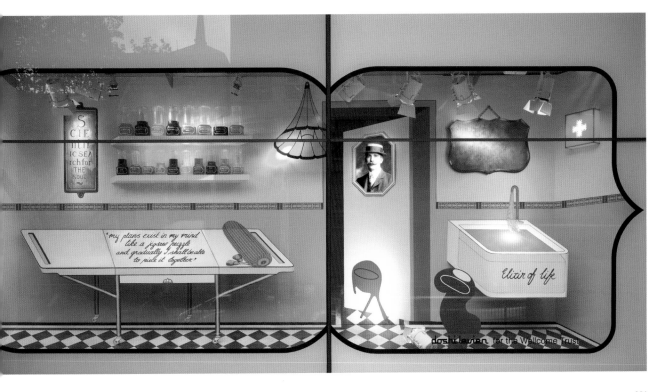

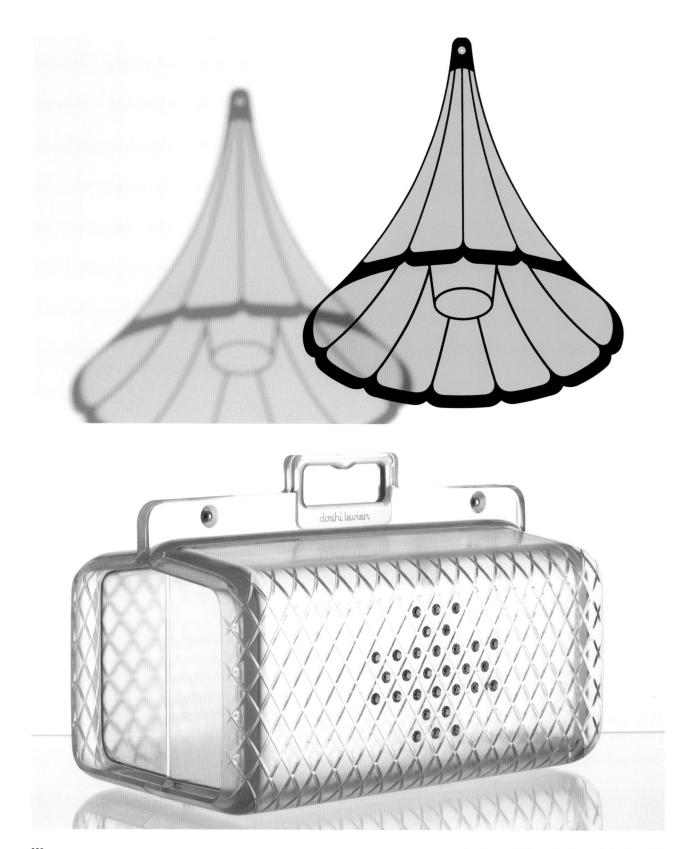

Doshi Levien | Wellcome Trust Soona, Doctor's Bag 2004

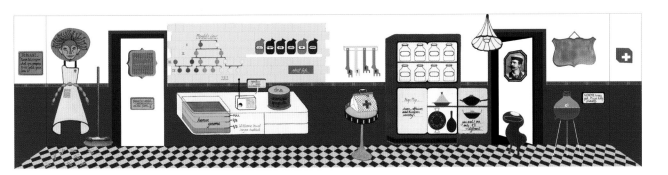

Doshi Levien | Wellcome Trust Recipe Book of Life, Sanger's Kitchen, Medicine Jars, 2004

Doshi Levien | My World Dress 2005 | left Wellcome Trust Healing Dress 2004

Doshi Levien | My World Installation 2005

Doshi Levien | My World Installation 2005

Doshi Levien designs both artistic objects and environments and extremely useful items for daily use. The glasses and cutlery they have designed for Habitat combine practical benefits with an independent and unmistakeable look.

Doshi Levien gestalten künstlerische Objekte und Environments, aber auch durchaus nützliche Gegenstände für den täglichen Gebrauch. Die Gläser und Besteckteile, die sie für das Einrichtungshaus Habitat entworfen haben, vereinen praktischen Nutzen mit einer eigenwilligen, unverwechselbaren Formensprache.

Doshi Levien conçoivent des objets et des environnements artistiques, mais aussi des choses utiles dans la vie quotidienne. Les verres et les couverts qu'ils ont dessinés pour les magasins d'ameublement Habitat allient utilité pratique et expression volontaire dans des formes reconnaissables entre toutes.

Doshi Levien diseñan ambientes y elementos artísticos, además de objetos prácticos para el uso diario. Las copas y cubiertos que han concebido para los almacenes de decoración Habitat vinculan la funcionalidad con un lenguaje de formas único e inconfundible.

Doshi Levien realizzano oggetti d'arte e environment, ma anche oggetti utili per l'uso quotidiano. I bicchieri e la posateria da loro disegnati per Habitat uniscono l'utilità pratica ad un linguaggio formale estroso ed inconfondibile.

Doshi Levien | Habitat Tableware 2001

Doshi Levien | Tefal Mosaic 2003

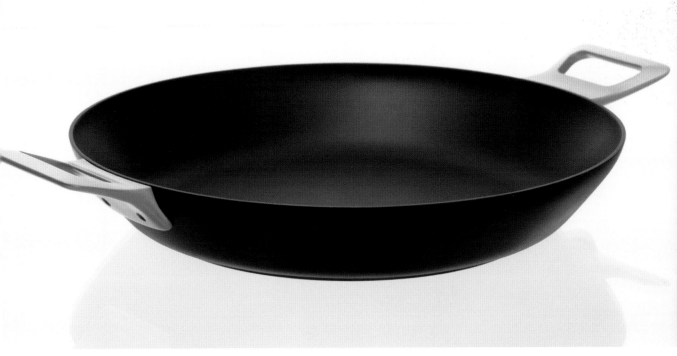

Doshi Levien | Tefal Mosaic 2003

Imagination

Imagination

25 Store Street, London WC1E 7BL

P +44 20 7323 3300

F +44 20 7326 5801

www.imagination.com

Imagination's design for its own office building caused a huge sensation in the eighties – and also instantly put its name on the lips of architects and designers everywhere. The company's spectrum ranges from event design and marketing to product design, architecture and interior design. Because it is multifaceted, Imagination can also provide complete solutions to complex tasks for major clients such as the BBC and British Telecom.

Der Aufsehen erregende Entwurf des eigenen Bürogebäudes machte Imagination Ende der achtziger Jahre unter Architekten und Designern schlagartig bekannt. Das Spektrum des Unternehmens reicht jedoch von Veranstaltungsdesign über Marketing bis hin zu Produktdesign, Architektur und Innenarchitektur. Durch seine interdisziplinäre Ausrichtung kann Imagination bedeutenden Auftraggebern – wie beispielsweise der BBC oder der British Telecom – auch für komplexe Aufgabenstellungen komplette Lösungen anbieten.

Grâce au projet de leur propre cabinet qui fit sensation, Imagination a accédé, à la fin des années quatre-vingt, à une soudaine célébrité parmi les architectes et les designers. La palette d'activités de l'entreprise s'étend cependant à la conception de manifestations, au design de produits, au marketing ainsi qu'à l'architecture et l'architecture intérieure. Grâce à son orientation pluridisciplinaire, Imagination est en mesure de proposer à d'importants donneurs d'ordre, tels que la BBC ou British Telecom, des solutions intégrées pour des objectifs de réalisations complexes.

A finales de los años ochenta su sensacional edificio de oficinas dio a conocer de golpe a Imagination entre arquitectos y diseñadores. La empresa tiene un campo de actividades que comprende concepciones para eventos, márketing, productos de diseño, arquitectura e interiores. Su organización interdisciplinaria le permite ofrecer a su significativa clientela, BBC y British Telecom entre otros, soluciones completas para labores complejas.

Alla fine degli anni Ottanta, progettando l'edificio destinato ad essere sua sede, Imagination destò grande scalpore e raggiunse improvvisa notorietà tra architetti e designer. Lo spettro d'attività dell'azienda si estende però dal design degli eventi al marketing fino al design del prodotto, all'architettura e all'architettura d'interni. Grazie alla sua impostazione interdisciplinare, Imagination è in grado di offrire ad importanti committenti – come ad esempio la BBC o la British Telecom – soluzioni complete anche per progetti complessi.

Douglas Broadley

1968
born in Glasgow, UK

1996
joines Imagination

2006
Global Creative Director

Interview | Douglas Broadley

How would you describe the basic idea behind your design work? One company, one community, one offer worldwide.

To what extent does working in London inspire your creativity? How could anyone fail to be inspired working in one of the greatest cities in the world?

Is there a typical London style in contemporary design? It has been said "first we shape our cities and then they shape us ..." Nowhere is that more apparent than London.

Which project is so far the most important one for you? The project for Ford Motor Company in Detroit is a great example of our work. A bold piece of customer focused creativity utilising our unique multi-sensory storytelling led approach. This was delivered by a seamlessly integrated multi-disciplinary group of our people from around the world, acting together as one. Great thinking, flawlessly executed.

Wie würden Sie die Grundidee beschreiben, die hinter Ihren Entwürfen steht? Ein Unternehmen. Eine Gemeinschaft. Ein Angebot. Und das weltweit.

Inwiefern inspiriert London Ihre kreative Arbeit? Wie könnte es irgendjemand nicht inspirieren, in einer der großartigsten Städte der Welt zu arbeiten?

Gibt es einen typischen Londoner Stil im aktuellen Design? Jemand hat einmal gesagt: „Erst formen wir unsere Städte – dann formen die Städte uns ..." Nirgendwo ist dies offensichtlicher als in London.

Welches ist für Sie Ihr bislang wichtigstes Projekt? Das Projekt für Ford in Detroit ist ein gutes Beispiel für unsere Arbeit. Eine kühne, auf den Kunden zugeschnittene kreative Arbeit, bei der wir mit Hilfe unseres einzigartigen, alle Sinne ansprechenden Ansatzes eine Geschichte erzählen konnten. Dies gelang uns durch die nahtlose Integration einer weltweiten, multidisziplinären Gruppe von Mitarbeitern, die als große Einheit zusammenarbeiteten. Großartige Ideen, makellos umgesetzt.

Quelle est, d'après vous, l'idée de base qui sous-tend votre travail de conception ? Une entreprise, une communauté, une offre. Et ce, à l'échelle mondiale.

Dans quelle mesure Londres inspire-t-il votre créativité ? Comment pourrait-on ne pas être inspiré quand on travaille dans l'une des villes les plus formidables au monde ?

Y a-t-il un style typiquement londonien dans le design actuel ? Quelqu'un a dit une fois : « D'abord nous façonnons nos villes – puis elles nous façonnent … ». Nulle part ailleurs ceci n'est plus évident qu'à Londres.

Quel est le projet le plus important pour vous à l'heure actuelle ? Le projet pour Ford à Détroit est très représentatif de notre travail. Une création audacieuse, taillée sur mesure pour ce client, avec laquelle nous avons pu raconter une histoire au moyen d'une approche unique, faisant appel à tous les sens. Nous avons réussi grâce à l'intégration sans faille d'un groupe de collaborateurs internationaux pluridisciplinaires, constituant une grande entité. Des idées géniales, impeccablement mises en œuvre.

¿Cómo definiría la idea básica que encierran sus diseños? Una empresa. Una comunidad. Una oferta. Y todo ello a nivel internacional.

¿En qué medida inspira la ciudad de Londres su trabajo creativo? ¿A quién no inspiraría trabajar en una de las ciudades más maravillosas del mundo?

¿Existe un estilo típico londinense en el diseño actual? Alguien dijo un día "primero modelamos nuestras ciudades y después las ciudades nos modelan a nosotros …". En ningún lugar se hace esto más patente que en Londres.

¿Cuál ha sido su proyecto más importante hasta el momento? El proyecto para Ford en Detroit es un buen ejemplo de nuestro trabajo. Un trabajo atrevido, creativo y hecho a medida de los clientes, en el que, gracias a nuestro planteamiento único que despierta todos los sentidos, pudimos contar una historia. Esto fue posible a través de la fusión de un grupo de colaboradores internacional y de múltiples disciplinas que trabajan como una gran unidad. Grandes ideas llevadas a la realidad de forma perfecta.

Come descriverebbe l'idea originaria che sta alla base delle Sue creazioni? Un'unica azienda. Un'unica comunità. Un'unica offerta. In tutto il mondo.

In che misura Londra ispira la Sua creatività? Come si potrebbe non essere ispirati dal fatto di lavorare in una delle più grandiose città del mondo?

Esiste uno stile tipico di Londra nel design contemporaneo? Qualcuno una volta ha detto: "Prima noi diamo forma alle nostre città, e poi le città danno forma a noi …". Non esiste luogo in cui questo sia tanto evidente quanto a Londra.

Qual è per Lei il più importante tra i progetti realizzati finora? Il progetto da noi realizzato per la Ford a Detroit è un buon esempio del nostro modo di lavorare: un audace lavoro creativo, tagliato su misura per il cliente, con il quale, grazie al nostro approccio unico e multisensoriale, siamo riusciti a raccontare una storia. La riuscita di questo progetto si spiega con la perfetta integrazione di un gruppo di collaboratori provenienti da tutto il mondo e dalle più diverse discipline, che hanno lavorato insieme come una grande unità. Idee grandiose, messe in atto in modo impeccabile.

Imagination designed the international press reception for over 800 guests on the occasion of the DVD issue of "Harry Potter and the Prisoner of Azkaban". The impressive design included – of course – the three-level Knight Bus and the unusual confectionery from Honeyduke's Sweetshop.

Anlässlich der DVD-Veröffentlichung des Filmes „Harry Potter und der Gefangene von Azkaban" stattete Imagination den internationalen Presseempfang für über 800 Gäste aus. Zu der eindrucksvollen Inszenierung gehörten selbstverständlich der dreistöckige Knight–Bus und die skurrilen Süßigkeiten aus Honeydukes Süßwarenladen.

Lors de la sortie en DVD du film « Harry Potter et le Prisonnier d'Azkaban », Imagination a équipé la réception de la presse internationale pour plus de 800 invités. L'impressionnante mise en scène comprenait bien entendu le Knight Bus à trois étages et les sucreries cocasses du magasin de bonbons Honeyduke.

Para la presentación al público del DVD de la película "Harry Potter y el Prisionero de Azkaban" Imagination concibieron una recepción de prensa que contó con más de 800 invitados. Dos de las representaciones más impresionantes fueron sin duda el Knight Bus de tres pisos y los extravagantes dulces del comercio Honeydukes.

In occasione dell'uscita del DVD del film "Harry Potter e il Prigioniero di Azkaban", Imagination ha provveduto ad allestire il ricevimento per la stampa internazionale, con più di 800 ospiti. Dell'imponente messa in scena facevano parte, ovviamente, il Knight Bus a tre piani e gli stravaganti dolci di Honeyduke.

Industrial Facility

Clerks Well House, 20 Britton Street, London EC1M 5UA

P +44 20 7253 3234

F +44 20 7253 3234

www.industrialfacility.co.uk

mail@industrialfacility.co.uk

Sam Hecht

1969
born in London, UK

Kim Colin

1961
born in California, USA

2002
Industrial Facility

Industrial Facility was established in 2002 by designer Sam Hecht and architect Kim Colin. When designing, they focus not only on the actual design object but also on the way it is incorporated in its spatial, functional and cultural setting. They endeavour to integrate ordinary and familiar aspects just as much as new and surprising ideas in their work.

Industrial Facility wurde 2002 von dem Designer Sam Hecht und der Architektin Kim Colin gegründet. Beim Entwurf steht für sie nicht nur das eigentliche Designobjekt im Mittelpunkt, sondern dessen Einbindung in sein räumliches, funktionales und kulturelles Umfeld. Dabei versuchen sie, das Bekannte und Vertraute ebenso wie neue, überraschende Ideen in ihr Design zu integrieren.

Industrial Facility a été créé en 2002 par le designer Sam Hecht et l'architecte Kim Colin. Pour eux, au stade du projet, il n'y a pas que l'objet design proprement dit qui est au centre, mais aussi son intégration dans un environnement spatial, fonctionnel et culturel. Ils essaient ainsi d'assimiler ce qui est connu et familier au même titre que des idées nouvelles et étonnantes dans leur design.

Industrial Facility fue fundado en 2002 por el diseñador Sam Hecht y la arquitecta Kim Colin. A la hora de proyectar, el centro no lo compone únicamente el objeto de diseño en sí sino su integración en el propio entorno cultural, funcional y espacial. Para ello pretenden incluir lo conocido y lo familiar al mismo nivel que ideas nuevas y sorprendentes.

Industrial Facility è stata fondata nel 2002 dal designer Sam Hecht e dall'architetta Kim Colin. Nella fase di ideazione, per i due non ha importanza solo l'oggetto di design in sé, ma anche il suo inserimento nel suo specifico contesto spaziale, funzionale e culturale. Nell'ambito di tale processo, Hecht e Collin tentano di integrare nel loro design tanto elementi noti e familiari quanto idee nuove e sorprendenti.

Interview | Industrial Facility

How would you describe the basic idea behind your design work? Simplicity that is inspirational.

To what extent does working in London inspire your creativity? Travel inspires me more, but certainly London has now become a great city to cycle in. And this gives me inspiration too.

Is there a typical London style in contemporary Design? What typifies London design is that it is atypical – there is no "one" style, but more a collective will to progress, to challenge, to test.

Which project is so far the most important one for you? Certainly the projects we are working on presently.

Wie würden Sie die Grundidee beschreiben, die hinter Ihren Entwürfen steht? Einfachheit, die inspiriert.

Inwiefern inspiriert London Ihre kreative Arbeit? Reisen inspiriert mich mehr. Allerdings ist London inzwischen zu einer Stadt geworden, in der man wunderbar Rad fahren kann – was ich ebenfalls sehr inspirierend finde.

Gibt es einen typischen Londoner Stil im aktuellen Design? London ist typischerweise untypisch. Es gibt nicht den einen Stil, eher einen gemeinsamen Willen zum Fortschritt, zur Herausforderung, zum Versuch.

Welches ist für Sie Ihr bislang wichtigstes Projekt? Sicherlich die Projekte, an denen wir gerade arbeiten.

Quelle est, d'après vous, l'idée de base qui sous-tend votre travail de conception ?
Une simplicité propice à l'inspiration.

Dans quelle mesure Londres inspire-t-il votre créativité ? Les voyages m'inspirent davantage. Toutefois, Londres est devenu entre-temps une ville où l'on peut très bien circuler à vélo – ce que je trouve particulièrement inspirant.

Y a-t-il un style typiquement londonien dans le design actuel ? Ce qui caractérise le design de Londres, c'est qu'il est atypique. Il n'y a pas un style, mais plutôt « une » volonté collective de progresser, de relever des défis et d'expérimenter.

Quel est le projet le plus important pour vous à l'heure actuelle ? Certainement ceux sur lesquels nous sommes en train de travailler.

¿Cómo definiría la idea básica que encierran sus diseños? Sencillez que inspira.

¿En qué medida inspira la ciudad de Londres su trabajo creativo? Viajar me inspira más. Sin embargo Londres se ha convertido entretanto en una ciudad en la que se puede andar en bici de maravilla, lo cual encuentro también inspirador.

¿Existe un estilo típico londinense en el diseño actual? Londres es típicamente atípico. Aquí no se da "el" estilo concreto, sino más bien un deseo común de progreso, de desafío y de experimentación.

¿Cuál ha sido su proyecto más importante hasta el momento? Seguramente en los que estamos trabajando actualmente.

Come descriverebbe l'idea originaria che sta alla base delle Sue creazioni? Una semplicità che sia capace di ispirare.

In che misura Londra ispira la Sua creatività? Viaggiare mi ispira di più. Bisogna dire però che Londra è diventata una città in cui si può muovere molto bene in bicicletta: e anche questa è una cosa che m'ispira molto.

Esiste uno stile tipico di Londra nel design contemporaneo? L'unica cosa tipica di Londra è la sua atipicità. Non c'è "uno" stile, piuttosto esiste una volontà collettiva di progredire, affrontare nuove sfide, sperimentare.

Qual è per Lei il più importante tra i progetti realizzati finora? Senza dubbio i progetti cui stiamo lavorando attualmente.

Industrial Facility designed this fan for the Japanese Muji chain. The typical Muji features – anonymous mimimalistic design combined with affordable functionality – are instantly evident in this item.

Diesen Ventilator gestalteten Industrial Facility für die japanische Muji-Kette. Die typischen Kennzeichen von Muji – anonymes, minimalistisches Design, kombiniert mit preiswerter Funktionalität – prägen auch dieses Produkt.

Industrial Facility a créé ce ventilateur pour la chaîne de magasins japonais Muji. Les signes distinctifs de Muji – un design anonyme et minimaliste associé à une fonctionnalité bon marché – se retrouvent également dans ce produit.

Industrial Facility diseñó este ventilador para la cadena japonesa Muji. Los rasgos distintivos de Muji son el diseño minimalista y anónimo combinado con la funcionalidad económica, que también caracteriza a este producto.

Industrial Facility ha creato questo ventilatore per la catena giapponese Muji. Anche questo prodotto si distingue per i tratti caratteristici tipici di Muji: un design anonimo e minimalista combinato a funzionalità a buon mercato.

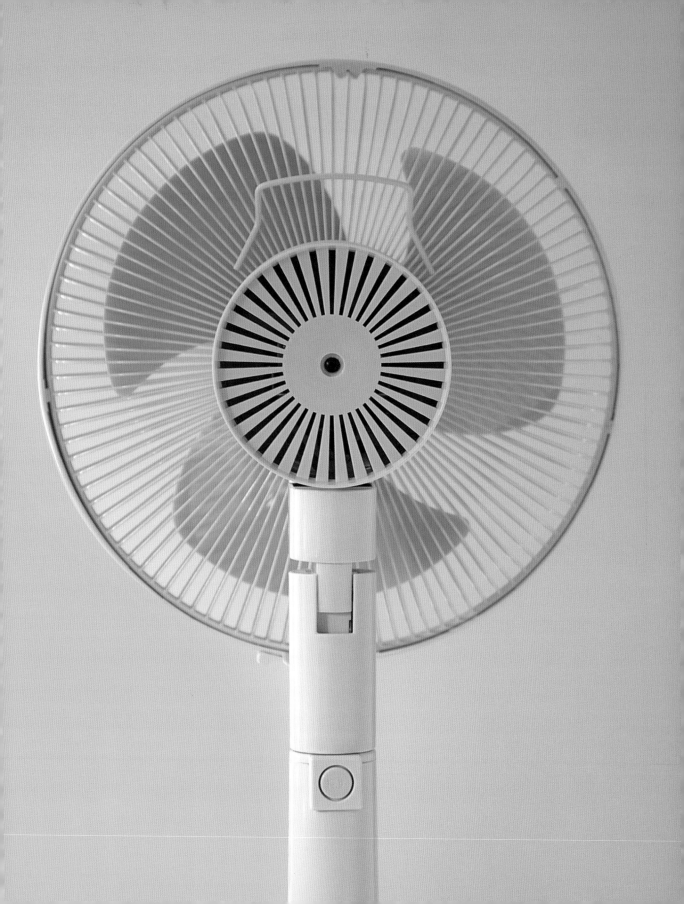

Industrial Facility | Duo Pen 2004 | left Takep Paper Cup 2005

Industrial Facility | Harrison Fisher Chantry Modern Knife Sharpener 2004

Inflate

Inflate

1 Helmsley Place, London E8 3SB

P +44 20 7249 3034

F +44 20 7275 9223

www.inflate.co.uk

info@inflate.co.uk

Nick Crosbie

1971
born in Buckinghamshire, UK

1993
Inflate

Inflate was founded in 1996 by Nick Crosbie. The name says it all: Inflate develops inflatable objects of all sizes, from CD cases and furniture to roofs and hall structures. The designs all share a slightly whimsical, ironic attitude that never questions the practical sense and benefit of the objects.

Inflate wurde 1996 von Nick Crosbie gegründet. Der Name ist Programm, Inflate entwickeln aufblasbare Objekte in allen Größen: von der CD-Hülle über Möbel bis hin zu Überdachungen und Hallenkonstruktionen. Gemeinsam ist allen Entwürfen eine leicht skurrile, ironische Attitüde, die jedoch den praktischen Sinn und Nutzen der Objekte nie in Frage stellt.

Inflate a été fondé en 1996 par Nick Crosbie. Son nom est son programme, Inflate développe des objets gonflables de toutes dimensions : pochettes de CD, meubles ainsi que toitures et constructions de halles. Tous les projets ont en commun un parti pris de bizarrerie et d'ironie légère qui ne remet nullement en question la fonction pratique et l'utilité des objets.

Inflate fue fundada por Nick Crosbie en 1996. El nombre lo dice todo: Inflate desarrolla objetos hinchables de todos los tamaños, desde fundas de CD pasando por muebles hasta cubiertas y construcciones de pabellones. Todos los bocetos están impregnados de una actitud ligeramente grotesca e irónica, que sin embargo jamás pone en duda el sentido práctico y la utilidad de los objetos.

Inflate è stata fondata nel 1996 da Nick Crosbie. Il nome è tutto un programma, in quanto Inflate progetta oggetti gonfiabili di tutte le misure: a cominciare dalla custodia per CD, passando per i mobili fino alle coperture a tettoia e alle costruzioni di padiglioni. Accomuna tutti i progetti un atteggiamento vagamente bizzarro, ironico, che tuttavia non mette mai in discussione il senso e l'utilità pratica degli oggetti realizzati.

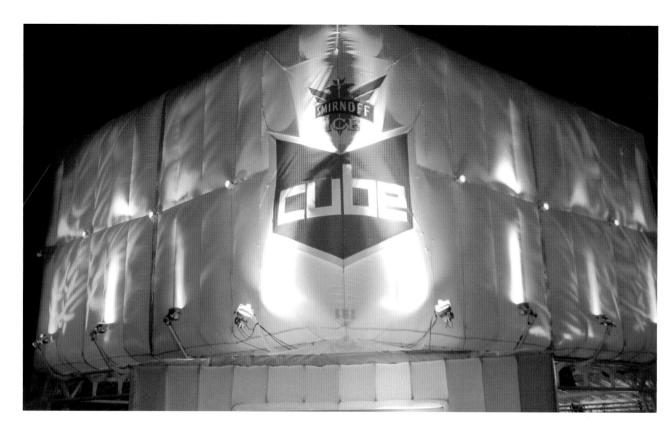

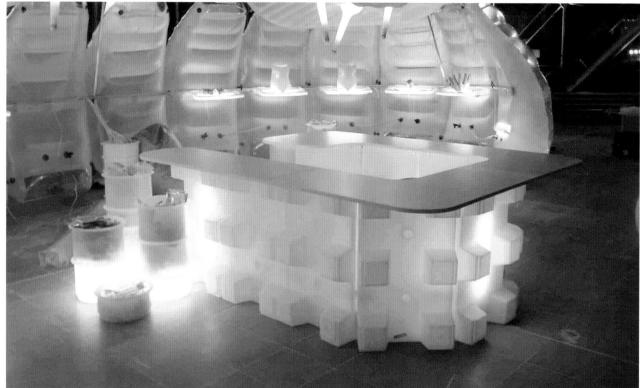

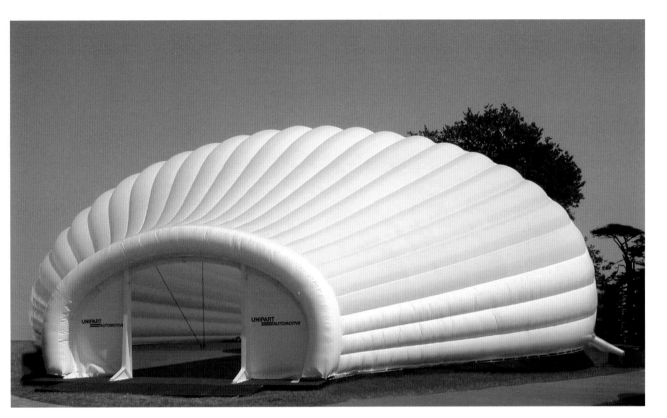

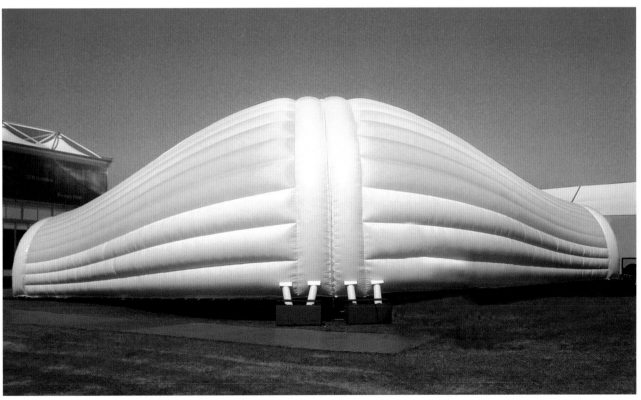

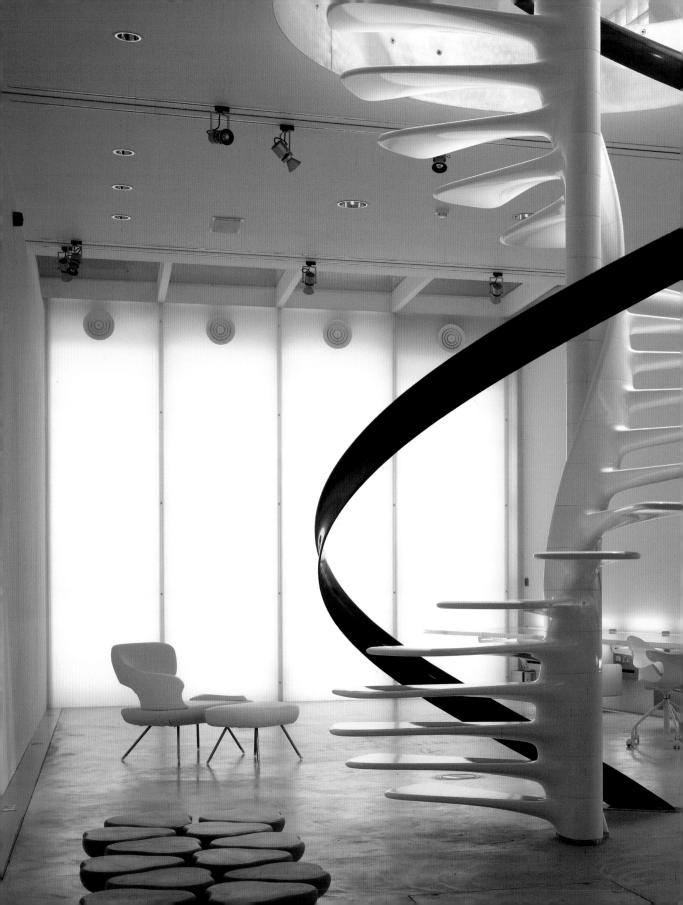

Lovegrove Studio

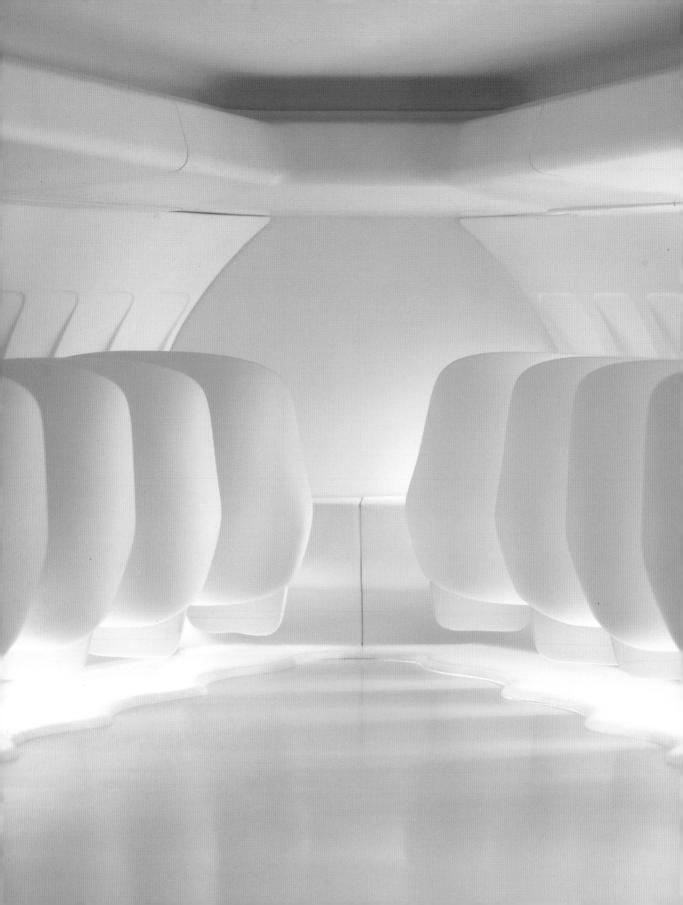

Lovegrove Studio

Studio X, 21 Powis Mews, London W11 1JN

P +44 20 7229 7104

F +44 20 7229 7032

mail@rosslovegrove.com

Ross Lovegrove

1958
born in Cardiff, UK

Miska Miller-Lovegrove

1954
born in Warsaw, Poland

1986
Lovegrove Studio

Gently rounded shapes inspired by nature and the use of high-tech materials are key characteristics of the designs by Ross Lovegrove. Lovegrove started out working for the German Frog Design studio in the eighties, contributing to designs such as the Sony Walkman and Apple Computers. In 1990 he started his own company in London: Studio X. Always on the lookout for something different, something unusual, Lovegrove is today widely regarded as one of the style-shaping artists of the 21st century.

Sanft geschwungene, von der Natur inspirierte Formen und die gleichzeitige Verwendung von High-Tech-Materialien zeichnen die Entwürfe von Ross Lovegrove aus. In den frühen achtziger Jahren arbeitete Lovegrove zunächst für das deutsche Designbüro Frog Design, unter anderem an Entwürfen für den Sony Walkman und für Apple-Computer. 1990 gründete er unter dem Namen Studio X in London sein eigenes Unternehmen: Immer auf der Suche nach dem Andersartigen, Ungewöhnlichen gilt Lovegrove heute als einer der stilbildenden Designer des 21. Jahrhunderts.

Des formes inspirées par la nature, doucement arrondies, et en même temps l'utilisation de matériaux de haute technologie caractérisent les projets de Ross Lovegrove. Au début des années quatre-vingt, Lovegrove a d'abord travaillé pour le studio de design allemand Frog Design, entre autres sur des projets pour le baladeur Sony et les ordinateurs Apple. En 1990, il a fondé sa propre entreprise à Londres sous le nom de Studio X : toujours à la recherche de la différence et de l'insolite, Lovegrove passe aujourd'hui pour l'un des concepteurs créateurs de style du 21ème siècle.

Los diseños de Ross Lovegrove se caracterizan al mismo tiempo por las formas ligeramente oscilantes, inspiradas en la naturaleza, y por el uso de materiales de alta tecnología. A principios de los años ochenta Lovegrove trabajó en el estudio de diseño alemán Frog Design proyectando bocetos para Sony Walkman y Apple Computers entre otros. En 1990 fundó en Londres su propia empresa bajo el nombre de Studio X. Su insaciable búsqueda de lo diferente y lo inhabitual ha llevado a Lovegrove a convertirse en uno de los diseñadores creadores de estilo del siglo XXI.

Le realizzazioni di Ross Lovegrove si distinguono per le forme dolcemente ricurve, ispirate dalla natura, e il contemporaneo utilizzo di materiali high-tech. Nei primi anni Ottanta Lovegrove iniziò lavorando per lo studio tedesco Frog Design, collaborando tra l'altro a progetti per il Walkman della Sony e per computer della Apple. Nel 1990 fondò a Londra la sua azienda dandole il nome di Studio X: sempre alla ricerca del diverso, dell'insolito, Lovegrove oggi è considerato uno dei designer decisivi per l'evoluzione stilistica del XXI secolo.

Interview | Ross Lovegrove

How would you describe the basic idea behind your design work? My work is a combination of research into materials technology and form. It is focussed on contemporary concepts that capitalise on advances in technological applications understanding that the artefacts we create are a representation of our civilisation and its artistic potential.

To what extent does working in London inspire your creativity? The fact that so many vital and original artists live and work here makes me believe that London has an atmosphere of earthed reality that is difficult to leave.

Is there a typical London style in contemporary design? No, absolutely no.

Which project is so far the most important one for you? I have not done it yet.

Wie würden Sie die Grundidee beschreiben, die hinter Ihren Entwürfen steht? Meine Arbeit ist eine Mischung aus Materialforschung und Formfindung. Ich versuche, zeitgemäße Konzepte zu entwickeln, das heißt den technischen Fortschritt zu nutzen, im Wissen, dass die Dinge, die wir hervorbringen, unsere Kultur und künstlerischen Möglichkeiten repräsentieren.

Inwiefern inspiriert London Ihre kreative Arbeit? Die Tatsache, dass so viele wichtige, originelle Künstler in London leben und arbeiten, lässt mich vermuten, dass es hier eine ganz spezifische bodenständige Atmosphäre gibt, von der man nicht mehr loskommt.

Gibt es einen typischen Londoner Stil im aktuellen Design? Nein, definitiv nicht.

Welches ist für Sie Ihr bislang wichtigstes Projekt? Auf das warte ich noch.

Quelle est, d'après vous, l'idée de base qui sous-tend votre travail de conception ? Mon travail combine la recherche sur les matériaux et l'élaboration de la forme. J'essaie de développer des concepts contemporains qui font appel au progrès technique, en sachant que les choses que nous créons représentent notre civilisation et son potentiel artistique.

Dans quelle mesure Londres inspire-t-il votre créativité ? Le fait que tant d'artistes éminents et originaux vivent et travaillent à Londres donne à penser qu'il existe ici une atmosphère propice à l'enracinement dont on se détache difficilement.

Y a-t-il un style typiquement londonien dans le design actuel ? Non, absolument pas.

Quel est le projet le plus important pour vous à l'heure actuelle ? Je l'attends encore.

¿Cómo definiría la idea básica que encierran sus diseños? Mi trabajo es una mezcla de investigación sobre materiales y concepción de formas. Intento desarrollar conceptos modernos, es decir, aprovechar el avance técnico, con la convicción de que los objetos que creamos son una representación de nuestra cultura y posibilidades artísticas.

¿En qué medida inspira la ciudad de Londres su trabajo creativo? El hecho de que en Londres trabajen y vivan tantos artistas originales me hace suponer que aquí existe un ambiente específico y arraigado del que uno no es capaz de desprenderse.

¿Existe un estilo típico londinense en el diseño actual? No, bajo ningún concepto.

¿Cuál ha sido su proyecto más importante hasta el momento? Aún lo estoy esperando.

Come descriverebbe l'idea originaria che sta alla base delle Sue creazioni? Il mio lavoro è una combinazione di studio dei materiali e ricerca formale. Tento di sviluppare concezioni moderne, mettendo a frutto quindi i progressi fatti dalla tecnica, ben sapendo che gli oggetti che creiamo rappresentano la nostra cultura e le sue potenzialità artistiche.

In che misura Londra ispira la Sua creatività? Il fatto che a Londra vivano e lavorino tanti artisti importanti ed originali mi induce a pensare che proprio in questo luogo esista un'atmosfera del tutto specifica a cui è difficile rinunciare.

Esiste uno stile tipico di Londra nel design contemporaneo? No, assolutamente no.

Qual è per Lei il più importante tra i progetti realizzati finora? Non mi è ancora capitato di realizzarlo

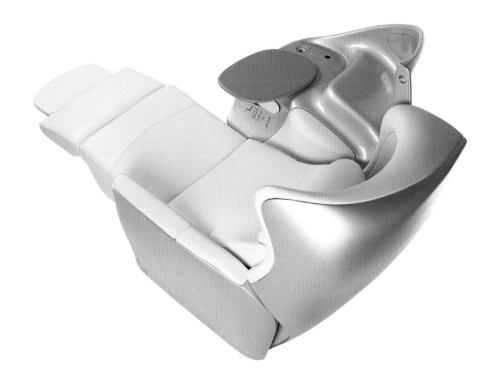

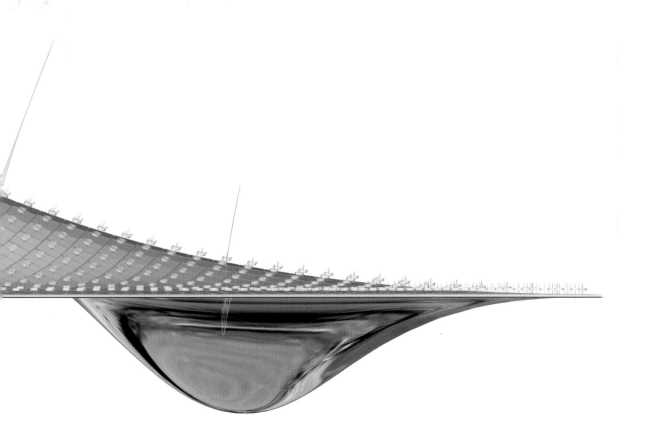

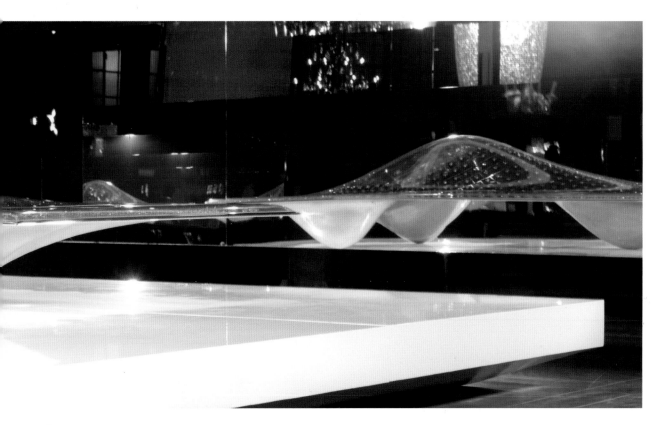

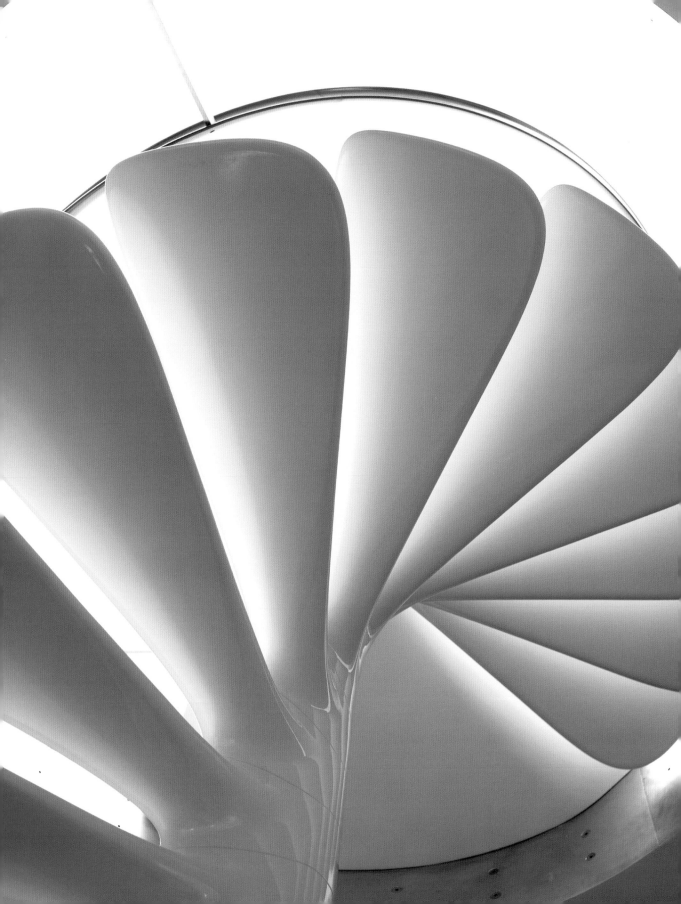

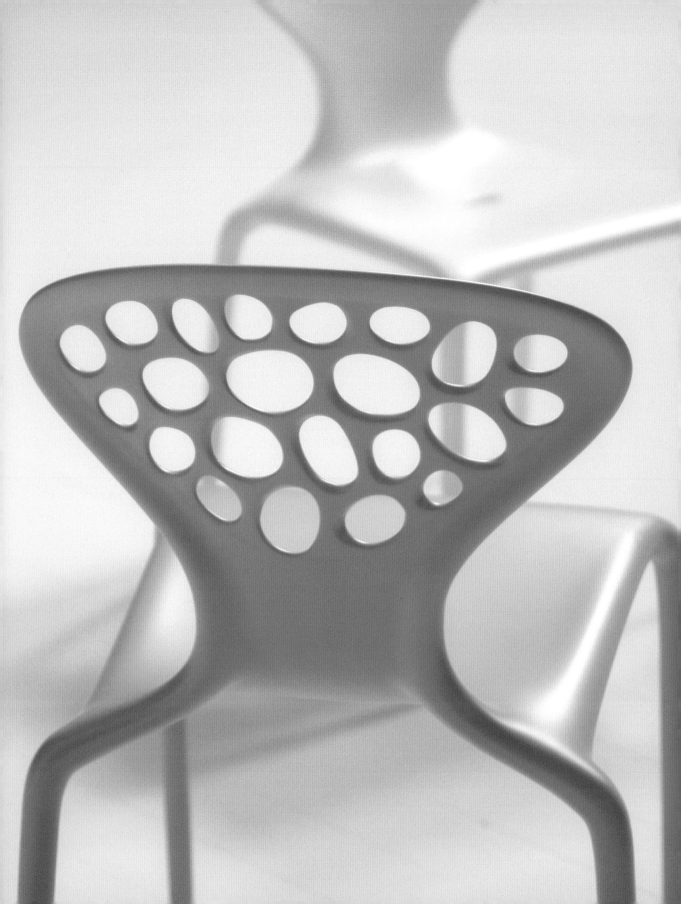

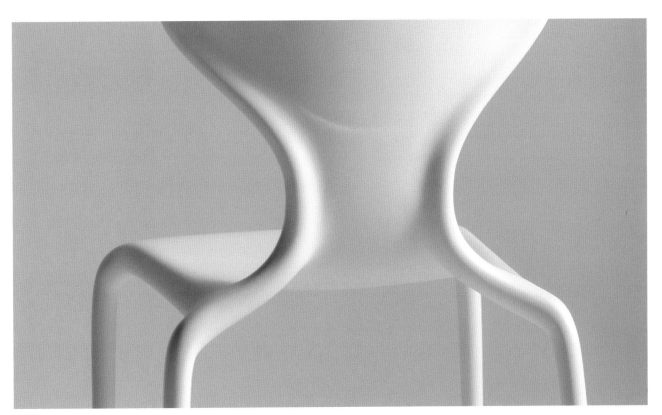

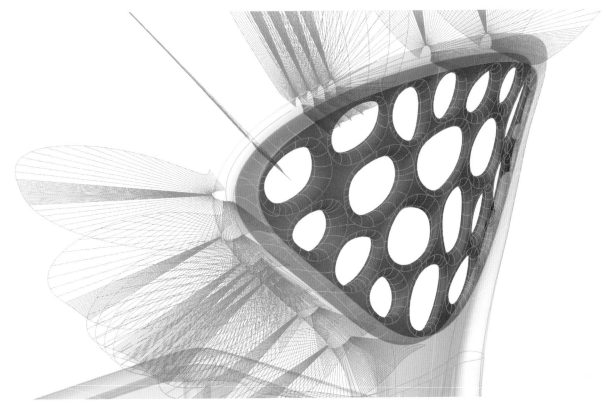

Lovegrove Studio | Moroso Supernatural Chair 2005

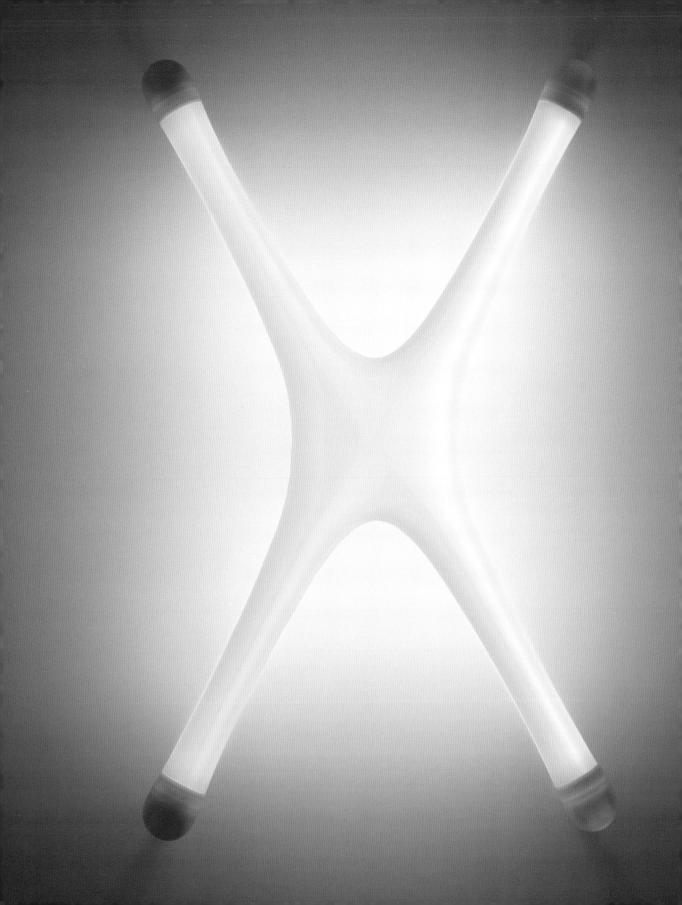

Marc Newson

Marc Newson

117-185 Gray's Inn Road, London WC1X 8EU

P +44 20 7287 9388

F +44 20 7287 9347

www.marcnewson.com

pod@marc-newson.com

Marc Newson

1963
born in Sydney, Australia

1992
studio in Paris

1997
studio in London

Marc Newson is regarded as one of the most versatile and influential designers of his generation. The native Australian moved from Paris to London in 1997, where he opened his own studio under the name of Marc Newson Ltd. His designs include furniture and household objects, bicycles and the interiors of entire aircraft. Many of his works have been included in leading exhibitions at the Museum of Modern Art in New York and the Centre Pompidou in Paris.

Marc Newson gilt als einer der vielseitigsten und einflussreichsten Designer seiner Generation. Der gebürtige Australier zog erst 1997 von Paris nach London, wo er unter dem Namen Marc Newson Ltd. sein eigenes Studio gründete. Seine Entwürfe umfassen Möbel und Haushaltsgegenstände ebenso wie Fahrräder oder die Innenausstattung von ganzen Flugzeugen. Viele seiner Arbeiten wurden in bedeutende Sammlungen aufgenommen, beispielsweise die des Museum of Modern Art, New York, oder des Centre Pompidou in Paris.

Marc Newson est considéré comme l'un des designers à multiples facettes les plus influents de sa génération. Cet australien d'origine n'a déménagé qu'en 1997 de Paris à Londres où il a créé son propre studio sous le nom de Marc Newson Ltd. Ses projets comprennent des meubles et des objets ménagers ainsi que des bicyclettes ou l'aménagement intérieur d'avions entiers. Nombre de ses travaux ont été intégrés à d'importantes collections comme celles du Museum of Modern Art de New York ou du Centre Pompidou à Paris.

A Marc Newson se le considera uno de los diseñadores más polifacéticos e influyentes de su generación. Australiano de nacimiento, se trasladó de París a Londres en 1997, donde fundó su propio estudio bajo el nombre Marc Newson Ltd. Sus diseños abarcan mobiliario, artículos de menaje, bicicletas o incluso el equipamiento de los interiores de aviones enteros. Muchos de sus trabajos han sido incluidos en colecciones de renombre, como es el caso de la del Museum of Modern Art de Nueva York o del Centre Pompidou de París.

Marc Newson è considerato uno dei designer più complessi ed influenti della sua generazione. Nato in Australia, Newson si è trasferito solo nel 1997 da Parigi a Londra, dove ha fondato il suo studio Marc Newson Ltd. Tra le sue creazioni si trovano mobili ed oggetti per la casa come pure biciclette o addirittura l'arredamento interno di interi aerei. Molti dei suoi lavori sono entrati a far parte di importanti collezioni, come per esempio il Museum of Modern Art di New York o il Centre Pompidou di Parigi.

Interview | Marc Newson

How would you describe the basic idea behind your design work? When I work on a new brief my approach is always the same ... I want to make something beautiful and to improve on what's already out there. Troubleshooting and problem solving, learning about and employing new technologies and manufacturing processes ... that's basically it ... and it is incredibly important to me that my work stands the test of time.

To what extent does working in London inspire your creativity? It doesn't specifically ... I can be inspired anywhere. I am more inspired by popular culture wherever I happen to be – that's what I find inspirational – not the environment – more what happens there ...

Is there a typical London style in contemporary design? I really don't know – and I don't really care actually!

Which project is so far the most important one for you? Everything I design is important to me – but if I had to pick one thing – I suppose it would have to be Kelvin 40 – the concept jet I designed for the Fondation Cartier. I was given carte blanche to design a piece of my choice. A dream project ... I enjoyed physically building it.

Wie würden Sie die Grundidee beschreiben, die hinter Ihren Entwürfen steht? Wenn ich an einer neuen Aufgabe arbeite, ist es immer das Gleiche ... ich möchte etwas Schönes schaffen und das, was es schon gibt, verbessern. Probleme erkennen und lösen. Neue Technologien und Herstellungsprozesse kennen lernen und anwenden ... das ist es im Wesentlichen ... und es ist unglaublich wichtig für mich, dass meine Arbeiten die Zeit überdauern.

Inwiefern inspiriert London Ihre kreative Arbeit? Nicht besonders ... ich lasse mich überall inspirieren. Ich werde durch die Alltagskultur inspiriert, egal wo ich bin. Das ist für mich die Inspiration – nicht der Ort, sondern das, was dort passiert ...

Gibt es einen typischen Londoner Stil im aktuellen Design? Ich weiß es wirklich nicht – und eigentlich interessiert es mich auch nicht!

Welches ist für Sie Ihr bislang wichtigstes Projekt? Alles, was ich gestalte, ist für mich auch wichtig. Doch wenn ich etwas auswählen müsste, wäre es wahrscheinlich Kelvin 40 – das Flugzeug-Konzept, das ich für die Fondation Cartier entworfen habe. Ich bekam freie Hand, ein Objekt meiner Wahl zu gestalten. Ein Traumprojekt ... es war toll, das tatsächlich bauen zu können.

Quelle est, d'après vous, l'idée de base qui sous-tend votre travail de conception ? Quand je travaille sur un nouvel objectif, c'est toujours la même chose ... je voudrais réaliser quelque chose de beau et améliorer ce qui existe déjà. Identifier et résoudre les problèmes. Découvrir et employer des technologies et des processus de fabrication modernes ... c'est cela, pour l'essentiel ... et pour moi, il est incroyablement important que mes travaux résistent à l'épreuve du temps.

Dans quelle mesure Londres inspire-t-il votre créativité ? Pas particulièrement ... je peux être inspiré n'importe où. C'est la culture populaire qui m'inspire, là où je me trouve. Voilà l'inspiration pour moi – pas le lieu, mais plutôt ce qui s'y passe ...

Y a-t-il un style typiquement londonien dans le design actuel ? Je ne sais vraiment pas – et à vrai dire, cela ne m'intéresse pas !

Quel est le projet le plus important pour vous à l'heure actuelle ? Tout ce que je crée est important pour moi. Mais si je devais vraiment choisir quelque chose, ce serait certainement Kelvin 40 – le concept de jet que j'ai réalisé pour la Fondation Cartier. J'avais carte blanche pour créer l'objet de mon choix. Un projet de rêve ... cela a été formidable, de pouvoir construire véritablement cette pièce.

¿Cómo definiría la idea básica que encierran sus diseños? Cuando trabajo en una nueva tarea siempre es lo mismo ... Me gustaría crear algo bello y mejorar lo ya existente; encontrar los problemas y solucionarlos. Conocer nuevas tecnologías y procesos de fabricación y aplicarlos ... de eso se trata esencialmente ... y para mí es increíblemente importante que mis trabajos perduren.

¿En qué medida inspira la ciudad de Londres su trabajo creativo? Nada en especial ... me dejo inspirar en todos los lugares. Me inspira la cultura de lo diario, me encuentre donde me encuentre. Esa es para mí la inspiración, no el lugar en sí sino lo que allí ocurre ...

¿Existe un estilo típico londinense en el diseño actual? ¡No lo sé y la verdad es que tampoco me interesa!

¿Cuál ha sido su proyecto más importante hasta el momento? Todo aquello que diseño es importante para mí. Pero si tuviera que elegir algo probablemente sería Kelvin 40, el concepto de avión que he diseñado para la Fondation Cartier. Se me dio mano libre para configurar un objeto de mi elección. Un proyecto de ensueño ... fue genial poder construirlo realmente.

Come descriverebbe l'idea originaria che sta alla base delle Sue creazioni? Quando lavoro ad un nuovo progetto, il mio approccio è sempre lo stesso ... desidero creare qualcosa di bello e migliorare quello che già esiste. Mettere a fuoco i problemi e risolverli. Acquisire dimestichezza con nuove tecnologie e processi di produzione per poi applicarli ... ecco, in sostanza si tratta di questo ... e per me è incredibilmente importante che le mie opere sopravvivano al passare del tempo.

In che misura Londra ispira la Sua creatività? Non particolarmente ... cerco la mia ispirazione dappertutto. La cultura popolare mi ispira, ovunque io mi trovi. Questa è la sorgente della mia ispirazione: non il luogo, ma quello che vi avviene ...

Esiste uno stile tipico di Londra nel design contemporaneo? Davvero non lo so – e se devo dire la verità, proprio non mi interessa!

Qual è per Lei il più importante tra i progetti realizzati finora? Tutto quello che realizzo è importante per me. Ma se dovessi scegliere uno dei miei lavori, probabilmente sarebbe Kelvin 40 – il progetto di aereo che ho disegnato per la Fondation Cartier. Mi era stata data carta bianca per progettare un oggetto a mio piacimento. Un progetto da sogno ... è stato veramente straordinario poterlo realizzare.

Marc Newson | Talby Mobile Phone 2003, HemiDiamond 2002

Marc Newson | Magis Coast Chair 2002

Marc Newson | Samsonite Luggage – Backpack, Shoulder Bag 2005

Marc Newson | G-Star Clothing Collection 2004

Marc Newson | G-Star Clothing Collection 2004

Marc Newson | G-Star Clothing Collection 2004

PDD

PDD

85-87 Richford Street, London W67HJ

P +44 20 8735 1111

F +44 20 8735 1133

www.pdd.co.uk

contact@pdd.co.uk

Simon Browning

born 1973
in Hertfordshire, UK

2005
joined PDD

The main focus of PDD's work is developing innovative designs for new products. Over 70 people are involved in every stage and aspect of the development: from brand strategy and trend analysis to the formal design and manufacture. In the more than 25 years of its history, PDD has worked for such well-known clients as Levi's, Polaroid, Olympus and Nestlé.

Der Schwerpunkt der Arbeit von PDD liegt auf der Entwicklung innovativer Designs für neue Produkte. Über 70 Mitarbeiter beschäftigen sich dabei mit allen Phasen und Aspekten der Entwicklung, von der Markenstrategie über Trendanalysen bis zum formalen Design und der Herstellung. In der mehr als 25-jährigen Bürogeschichte arbeitete PDD für so bekannte Auftraggeber wie Levi's, Polaroid, Olympus oder Nestlé.

Le travail de PDD porte essentiellement sur le développement de designs innovants pour de nouveaux produits. Plus de 70 employés se penchent sur toutes les phases et les aspects du développement : de la stratégie de marque au design formel et à la fabrication, en passant par les analyses de tendance. Au cours de plus de 25 ans d'histoire, le studio PDD a travaillé pour des clients aussi connus que Levi's, Polaroid, Olympus et Nestlé.

La base del trabajo de PDD se centra en el desarrollo de diseños innovadores para nuevos productos. Más de 70 colaboradores se ocupan de todas las fases y aspectos del desarrollo: desde la estrategia de la marca y los análisis de tendencias hasta el diseño formal y la fabricación. En los más de 25 años de historia del estudio, PDD ha contado con clientela conocida como Levi's, Polaroid, Olympus y Nestlé.

Il lavoro di PDD si concentra sull'elaborazione di design innovativi per nuovi prodotti. In tale intento, più di 70 collaboratori si occupano di tutte le fasi e tutti gli aspetti della realizzazione, dalla strategia di marca alle analisi di tendenza fino al design formale e alla produzione. Nei suoi più che 25 anni di storia, PDD ha lavorato per committenti del rango di Levi's, Polaroid, Olympus o Nestlé.

Interview | PDD

How would you describe the basic idea behind your design work? Our approach is holistic – based on understanding the context in which an object will exist and be used. PDD's people and processes are purely focused on identifying the most powerful end solutions – without designers imposing their own individual wants, desires and expression on the end product.

To what extent does working in London inspire your creativity? Inspiration here is drawn from global sources and comes together in a way that is reasonably distinct from other cities. To improve you need to work with the best – and anyone who shares that view will head for London at some point.

Is there a typical London style in contemporary design? London design never interprets a question in only one way. It relies on a broader awareness that can respond to a brief or an idea at face value.

Which project is so far the most important one for you? For us, comparison is impossible. One day we might be involved in developing a new medical device category and the next in apparel and footwear innovation or full-scale automotive interior modelling.

Wie würden Sie die Grundidee beschreiben, die hinter Ihren Entwürfen steht? Wir haben einen ganzheitlichen Ansatz – basierend auf dem Verständnis des Umfeldes, für das ein Objekt bestimmt ist und in dem es benutzt wird. Mitarbeiter und Arbeitsweise von PDD konzentrieren sich ausschließlich darauf, die bestmögliche Lösung zu finden – ohne dass die Designer das Endprodukt durch ihre individuellen Wünsche, Ziele oder Ausdrucksformen prägen wollen.

Inwiefern inspiriert London Ihre kreative Arbeit? Die Inspiration speist sich aus globalen Quellen. Sie fließen in London auf eine Weise zusammen, die sich von anderen Städten deutlich unterscheidet. Um sich zu verbessern, muss man mit den Besten zusammenarbeiten – jeder, der diesen Standpunkt teilt, macht sich irgendwann auf nach London.

Gibt es einen typischen Londoner Stil im aktuellen Design? Londoner Design beantwortet eine Frage niemals nur auf eine Weise. Es vertraut auf ein breites Spektrum an Kenntnissen, die unmittelbar auf eine Aufgabe oder eine Idee reagieren.

Welches ist für Sie Ihr bislang wichtigstes Projekt? Wir können unsere Projekte nicht miteinander vergleichen. Einen Tag sind wir an der Entwicklung eines neuen medizinischen Gerätes beteiligt, am nächsten Tag geht es um innovative Kleidung und Schuhmode, oder wir fertigen ein 1:1-Modell der Innenausstattung eines Autos an.

Quelle est, d'après vous, l'idée de base qui sous-tend votre travail de conception ? Nous avons une approche globale – basée sur la compréhension de l'environnement auquel l'objet est destiné et dans lequel il sera utilisé. Les collaborateurs et le mode de travail de PDD se concentrent exclusivement sur la recherche de la meilleure solution – sans que les designers ne tentent d'imposer au produit final leurs désirs, objectifs ou formes d'expression individuels.

Dans quelle mesure Londres inspire-t-il votre créativité ? L'inspiration se nourrit de sources globales qui se rejoignent à Londres de façon bien différente que dans d'autres villes. Pour se perfectionner, il faut travailler avec les meilleurs – quiconque partage ce point de vue viendra un jour à Londres.

Y a-t-il un style typiquement londonien dans le design actuel ? Le design londonien répond toujours de plusieurs manières à une question. Il se fonde sur un large spectre de connaissances qui répondent à une commande ou une idée.

Quel est le projet le plus important pour vous à l'heure actuelle ? Il est impossible de comparer nos projets. Un jour, nous participons au développement d'un nouvel appareil médical, un autre jour, il s'agit d'innovation dans l'habillement et la chaussure de mode, ou bien nous fabriquons une maquette à l'échelle 1/1 de l'aménagement intérieur d'une voiture.

¿Cómo definiría la idea básica que encierran sus diseños? Nuestro enfoque es global y está basado en la comprensión del entorno para el que se determina un objeto y en el que se utiliza. Tanto los trabajadores como la forma de trabajar de PDD se concentran única y exclusivamente en encontrar la mejor solución posible sin que los diseñadores impongan sus deseos personales, metas o formas de expresión en el producto final.

¿En qué medida inspira la ciudad de Londres su trabajo creativo? La inspiración es una serie de fuentes globales que en Londres se funden de un modo claramente diferente a otras ciudades. Para mejorar hay que trabajar con los mejores. Todos los que comparten esta opinión acaban viniéndose a Londres.

¿Existe un estilo típico londinense en el diseño actual? El diseño londinense jamás responde a una pregunta de un sólo modo. Descansa en un vasto espectro de conocimientos que reaccionan directamente a una tarea o a una idea. El diseño parece tener aquí la confianza en sí mismo para poder empezar de cero.

¿Cuál ha sido su proyecto más importante hasta el momento? Nuestros proyectos, no los podemos comparar los unos con los otros. Un día estamos implicados en el desarrollo de un nuevo aparato médico, y al día siguiente se trata de vestimenta innovadora o calzado, o bien realizamos el modelo 1:1 del equipamiento interior de un vehículo.

Come descriverebbe l'idea originaria che sta alla base delle Sue creazioni? Abbiamo un approccio globale, basato sulla comprensione dell'ambiente per cui un oggetto è destinato e in cui sarà usato. I collaboratori ed il modo di lavorare di PDD si concentrano esclusivamente su come trovare la migliore soluzione possibile, senza che i designer impongano al prodotto finale i loro propri desideri, obiettivi o forme espressive.

In che misura Londra ispira la Sua creatività? L'ispirazione qui si nutre alle sorgenti globali che a Londra confluiscono in un modo nettamente distinto da altre città. Per migliorarsi bisogna lavorare insieme ai migliori: chiunque condivida questo punto di vista, prima o poi, decide di andare a Londra.

Esiste uno stile tipico di Londra nel design contemporaneo? Il design londinese non interpreta mai una domanda in un solo senso. Può fare affidamento su un ampio spettro di conoscenze che reagiscono direttamente ad un compito o ad un'idea.

Qual è per Lei il più importante tra i progetti realizzati finora? Non è possibile confrontare tra loro i nostri progetti. Magari un giorno collaboriamo allo sviluppo di un nuovo apparecchio medico, e il giorno dopo ci occupiamo di abbigliamento e calzature innovative o realizziamo un modello in scala 1:1 dell'interno di un'automobile.

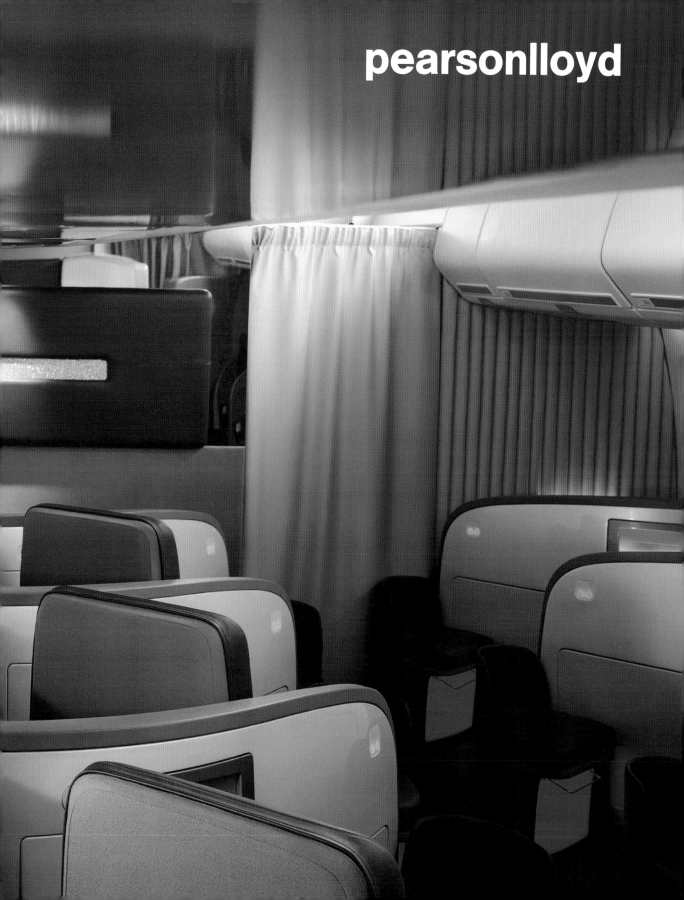

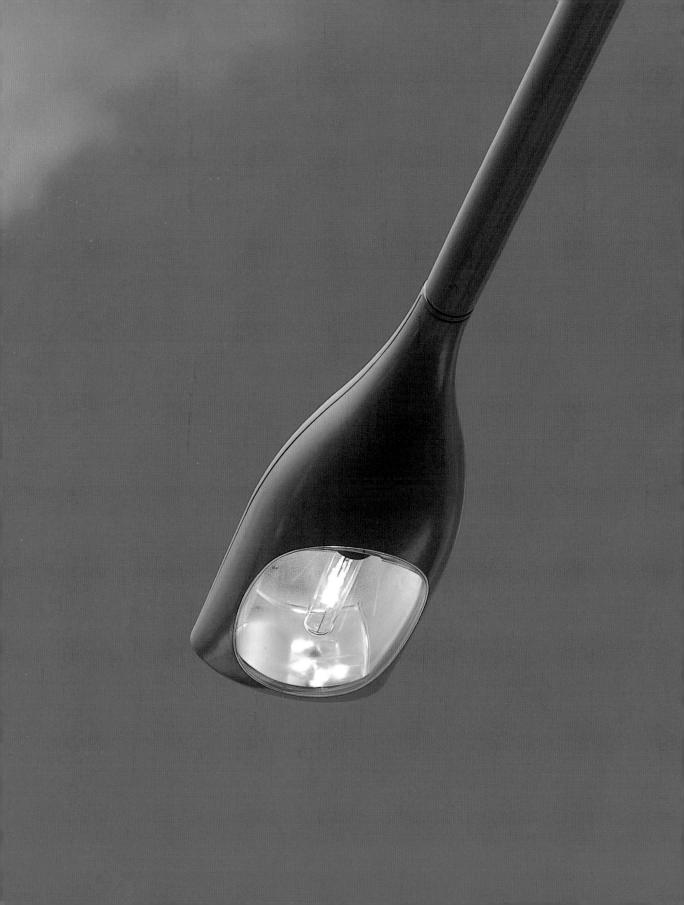

pearsonlloyd

42-46 New Road, London E1 2AX

P +44 20 7377 0560,

F +44 20 7377 0550

www.pearsonlloyd.co.uk

info@pearsonlloyd.co.uk

The work of Luke Pearson and Tom Lloyd includes product, industrial and furniture design, interior design and strategic consultations for their clients. Founded in 1997, the company now has an impressive core of top-class clients: from Walter Knoll and Virgin Atlantic to designing the fashion stores for Duffer of St. George. pearsonlloydd collaborated with Artemide to design new street lighting for the London borough of Westminster.

Die Arbeit von Luke Pearson und Tom Lloyd umfasst Produkt-, Industrie- und Möbeldesign, aber auch Innenarchitektur und die strategische Beratung ihrer Auftraggeber. 1997 gegründet, hat das Büro heute einen beachtlichen Stamm an hochkarätigen Kunden: von Walter Knoll über Virgin Atlantic bis hin zum Design der Modeläden von Duffer of St George. Für den Londoner Bezirk Westminster entwickelten pearsonlloyd in Zusammenarbeit mit Artemide eine neue Straßenbeleuchtung.

Les activités de Luke Pearson et de Tom Lloyd comprennent le design industriel, de produits et de meubles, mais aussi l'architecture intérieure et le conseil stratégique de leurs clients. Fondé en 1997, le cabinet a aujourd'hui un considérable fichier de clients de grande classe : de Walter Knoll à Virgin Atlantic en passant par le design des magasins de mode de Duffer of St George. Pour le quartier londonien de Westminster, pearsonlloyd a conçu, en collaboration avec Artemide, un nouvel éclairage de rues.

El trabajo de Luke Pearson y Tom Lloyd engloba el diseño de productos, industrial y de muebles, así como la arquitectura de interiores y el asesoramiento estratégico de sus clientes. El estudio fundado en 1997 cuenta hoy con una considerable paleta de clientes de alto standing, desde Walter Knoll y Virgin Atlantic hasta Duffer of St George que le encomendó el diseño de sus tiendas de moda. pearsonlloyd concibieron la iluminación de las calles del barrio de Westminster en cooperación con Artemide.

Il lavoro di Luke Pearson e Tom Lloyd comprende non solo design del prodotto, design industriale e design di arredamento, ma anche architettura d'interni e consulenza strategica ai committenti. Fondato nel 1997, lo studio ha oggi un considerevole numero di clienti prestigiosi: da Walter Knoll a Virgin Atlantic fino al design dei negozi di moda di Duffer of St. George. In cooperazione con Artemide, pearsonlloyd hanno ideato una nuova illuminazione stradale per il distretto londinese di Westminster.

Luke Pearson

1967
born in London, UK

Tom Lloyd

1966
born in London, UK

1997
pearsonlloyd

Interview | pearsonlloyd

How would you describe the basic idea behind your design work? We think that the culture and sophisticated world of furniture fused with the technological opportunity given to the industrial designer is where our focus lies.

To what extent does working in London inspire your creativity? London is a wonderful city full of diversity and intensity. It is a cultural engine with an intense spectrum from which to delve into for inspiration. Strangely, for us, London has little direct industry but this is far outweighed by its engine of creativity.

Is there a typical London style in contemporary Design? Not sure. I think eclectic springs to mind. Anything is possible.

Which project is so far the most important one for you? In terms of international impact and complexity the Upper Class Suite for Virgin Atlantic Airways. It is a wonderful challenge for a designer to work on "from the ground up" a new aircraft seat. Our design language was pivotal not just to the feel of the seats and their workings but also to the overall layout and functionality of the aircraft cabin and people interaction. The seat has been a resounding success not only in terms of Virgins business model but also in terms of customer feedback and design awards that it has won internationally.

Wie würden Sie die Grundidee beschreiben, die hinter Ihren Entwürfen steht? Für uns steht die Verbindung der hochwertigen, kultivierten Möbelwelt mit den technischen Möglichkeiten, die einem Industriedesigner zur Verfügung stehen, im Mittelpunkt.

Inwiefern inspiriert London Ihre kreative Arbeit? London ist eine wunderbare Stadt voller Vielfalt und Intensität. Es ist eine Kulturmaschinerie mit einem enormen Spektrum an Inspirationen, in die man eintauchen kann. Seltsamerweise hat London – für uns einen geringen Anteil an produzierender Industrie. Das wird jedoch durch seine kreative Kraft mehr als ausgeglichen.

Gibt es einen typischen Londoner Stil im aktuellen Design? Schwer zu sagen. Eklektizismus kommt einem in den Sinn. Alles ist möglich.

Welches ist für Sie Ihr bislang wichtigstes Projekt? Hinsichtlich der internationalen Bedeutung und Komplexität ohne Zweifel die Upper Class Suite für Virgin Atlantic Airways. Es ist eine großartige Aufgabe für einen Designer, einen Flugzeugsitz von Grund auf neu zu entwickeln. Unser Design bestimmte nicht nur die Form und Funktion der Sitze, sondern auch den Grundriss und die Abläufe innerhalb der Kabine. Der Sitz war ein großer Erfolg, nicht nur für das Geschäftsmodell von Virgin, sondern auch hinsichtlich des Feedbacks der Passagiere und der internationalen Preise, die wir für ihn erhielten.

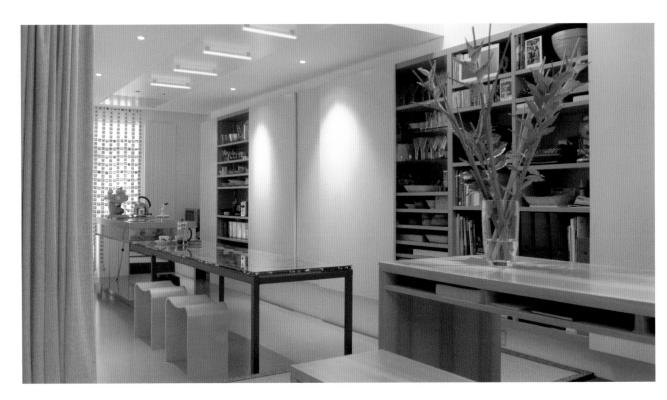

Quelle est, d'après vous, l'idée de base qui sous-tend votre travail de conception ? Pour nous, le point central est le lien du monde de l'ameublement sophistiqué, de grande valeur, avec les possibilités techniques dont dispose le designer industriel.

Dans quelle mesure Londres inspire-t-il votre créativité ? Londres est une ville merveilleuse pleine de diversité et d'intensité. C'est une machine à culture avec une large palette d'inspirations dans laquelle on peut puiser. Bizarrement, pour nous, Londres a peu d'industrie de production. Mais ceci est largement compensé par sa force créatrice.

Y a-t-il un style typiquement londonien dans le design actuel ? Difficile à dire. L'idée d'éclectisme vient tout de suite à l'esprit. Mais tout est possible.

Quel est le projet le plus important pour vous à l'heure actuelle ? En matière d'impact international et de complexité, l'Upper Class Suite pour Virgin Atlantic Airways. C'est une tâche formidable pour un designer de concevoir un siège d'avion depuis le début. Notre design a non seulement déterminé la forme du siège et ses fonctions, mais aussi la disposition et la fonctionnalité de la cabine de l'avion ainsi que l'interaction entre les individus. Le siège a remporté un grand succès, pas seulement par rapport au modèle commercial de Virgin, mais aussi au niveau des réactions des passagers et des prix internationaux qui nous ont été décernés.

¿Cómo definiría la idea básica que encierran sus diseños? Para nosotros, el vínculo entre el mundo del mueble refinado y de alta calidad con las posibilidades técnicas que un diseñador industrial tiene al alcance.

¿En qué medida inspira la ciudad de Londres su trabajo creativo? Londres es una ciudad maravillosa cargada de diversidad e intensidad. Es una maquinaria cultural con una enorme paleta de inspiraciones en las que uno se puede sumergir. Curiosamente Londres, para nosotros, cuenta con producción industrial escasa. Pero eso se compensa más que de sobra con su fuerza creativa.

¿Existe un estilo típico londinense en el diseño actual? Es difícil de decir. Por la cabeza pasa la idea de eclecticismo. Todo es posible.

¿Cuál ha sido su proyecto más importante hasta el momento? En términos de impacto internacional y complejidad, Upper Class Suite para Virgin Atlantic Airways. Para un diseñador, desarrollar un asiento de avión de forma completamente nueva es una labor increíble. Nuestro diseño definió no sólo la forma del asiento y su funcionamiento, sino también la planta y la funcionalidad de la cabina del avión y la interacción entre las personas. El asiento tuvo un éxito rotundo, no exclusivamente para el modelo de comerciode Virgin, sino además por las críticas de los pasajeros y los premios internacionales que recibimos por él.

Come descriverebbe l'idea originaria che sta alla base delle Sue creazioni? Al centro della nostra attenzione sta la fusione tra il mondo dell'arredamento, colto e ricercato, e le possibilità tecnologiche che sono a disposizione di un designer industriale.

In che misura Londra ispira la Sua creatività? Londra è una città meravigliosa, piena di aspetti diversi ed intensità. È una vera macchina culturale con un enorme spettro di ispirazioni in cui ci si può immergere. Ci sembra strano che Londra abbia una scarsa percentuale di industria produttiva, ma questo è più che controbilanciato dalla sua forza creativa.

Esiste uno stile tipico di Londra nel design contemporaneo? Difficile a dirsi. La prima cosa che viene in mente è l'eclettismo. Tutto è possibile.

Qual è per Lei il più importante tra i progetti realizzati finora? In termini di impatto internazionale e di complessità, la Upper Class Suite per Virgin Atlantic Airways. Progettare ex novo un sedile per aereo è un compito interessantissimo per un designer; il nostro design non ha definito solo la forma dei sedili e il loro funzionamento, ma anche la pianta e la funzionalità della cabina dell'aeromobile e l'interazione del pubblico. Il sedile è stato un grande successo non solo per il business della Virgin, ma anche in termini di reazioni della clientela e di premi internazionali che ci ha fruttato.

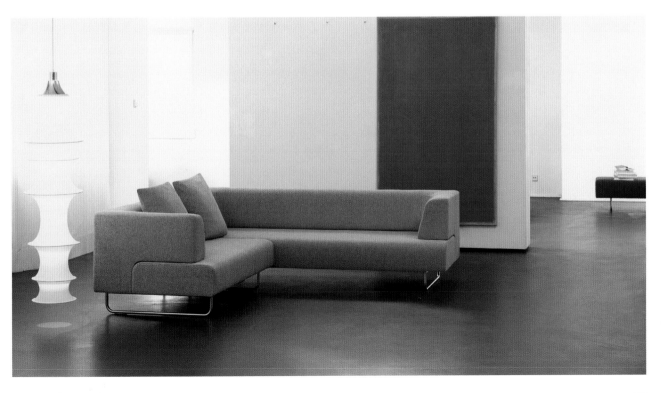

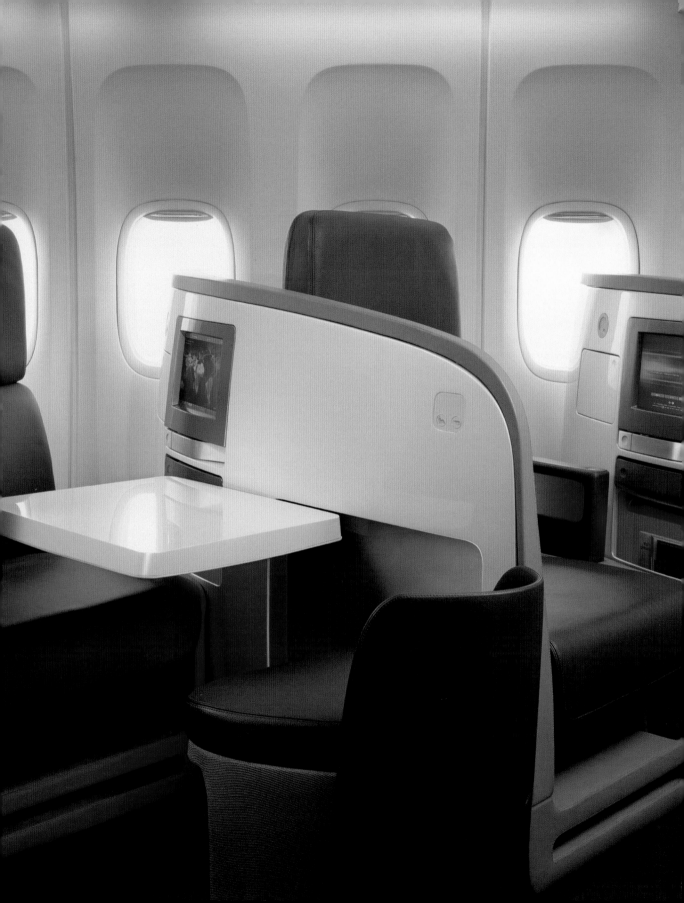

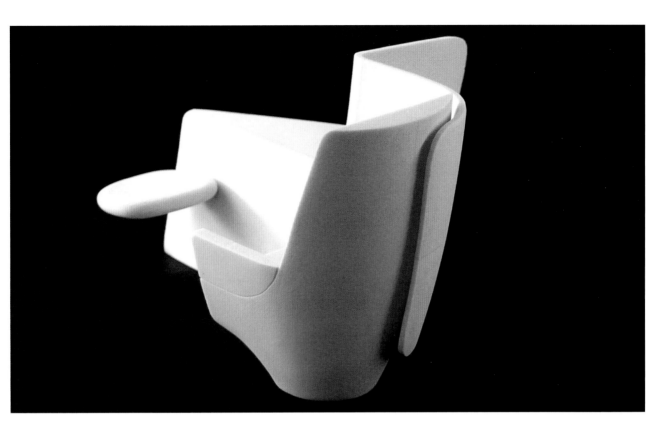

pearsonlloyd | Virgin Atlantic Airways Upper Class Suite 2003

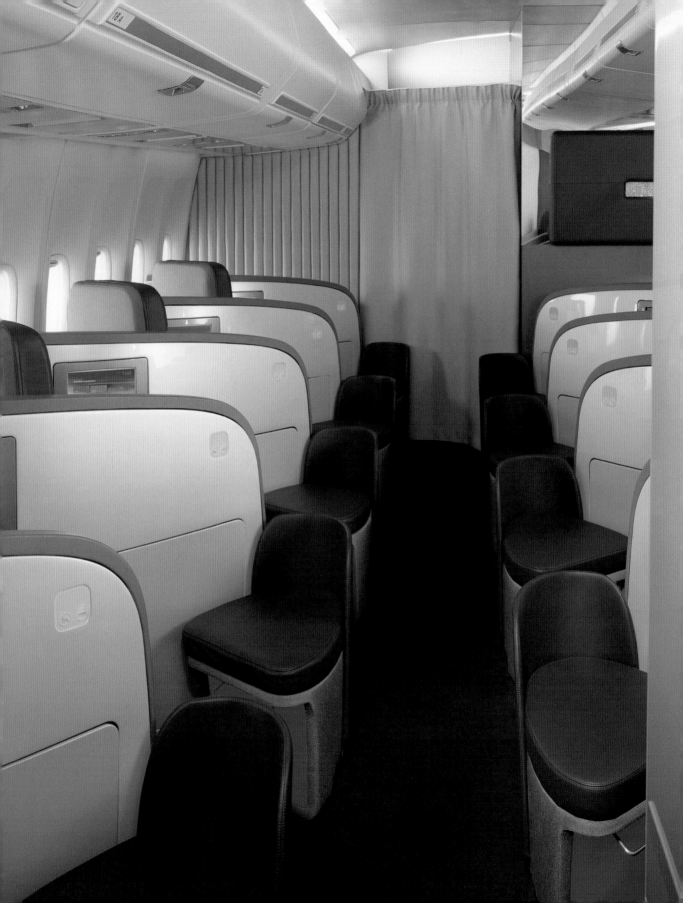

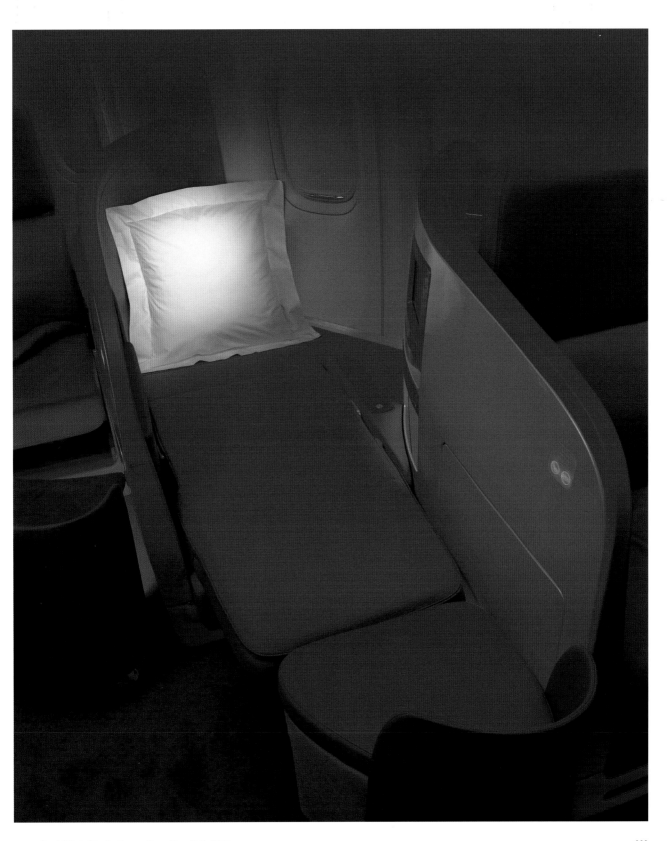

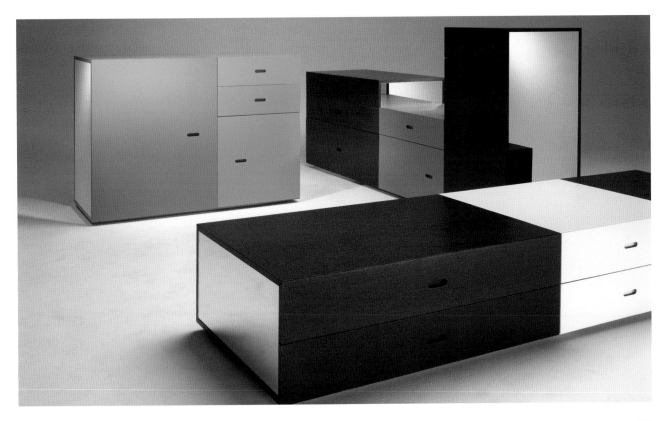

pearsonlloyd | Martinez Otero Horizon Storage Range 2005

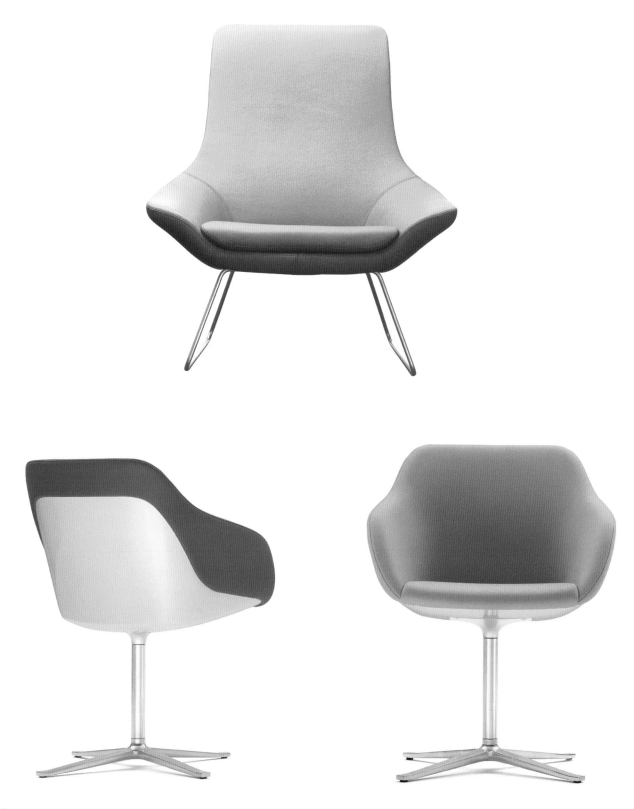

pearsonlloyd | Walter Knoll Flow 2001, Walter Knoll Turtle Shell Chair Series 2004

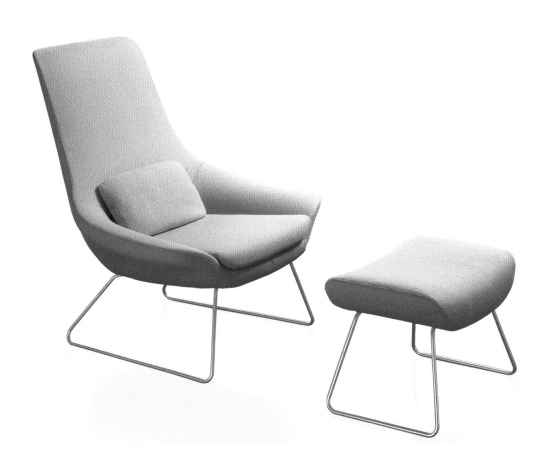

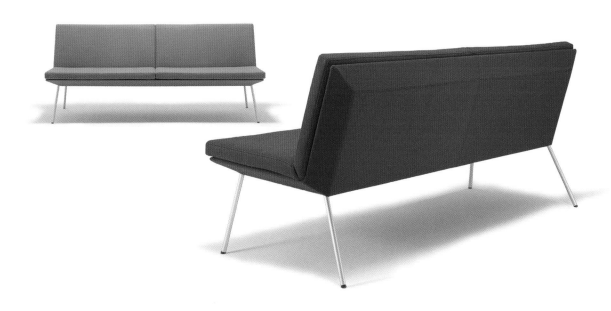

pearsonlloyd | Walter Knoll Flow 2001, Walter Knoll Kite Bench System 2002

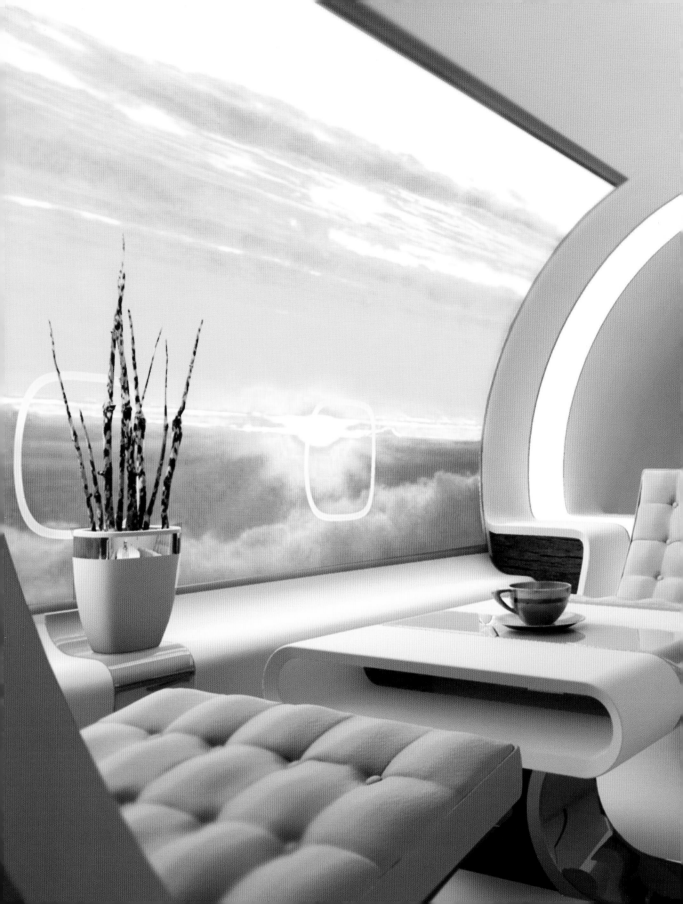

Seymourpowell

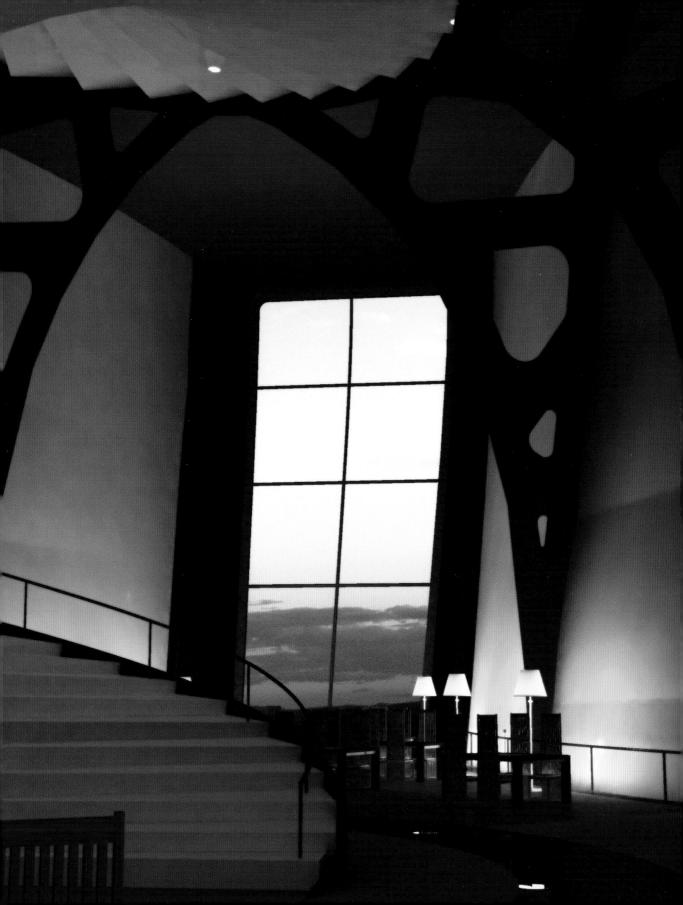

Seymourpowell

327 Lillie Road, London SW6 7NR

P +44 20 7381 6433

F +44 20 7381 9081

www.seymourpowell.com

design@seymourpowell.com

For Seymourpowell, design is not just the exterior form of a product. They define design as the integral element that combines function, use, appeal, manufacture and quality in an unmistakeable unit. This high standard has, over the past two decades, made Seymourpowell an extremely successful design team that now consists of six partners and 52 employees.

Für Seymourpowell umfasst das Design nicht nur die äußere Gestalt eines Produktes. Sie definieren Design als das integrale Element, das Funktion, Gebrauch, Anmutung, Herstellung und Qualität verbindet und zu einer unverwechselbaren Einheit formt. Dieser hohe Anspruch machte Seymourpowell in den vergangenen zwei Jahrzehnten zu einem höchst erfolgreichen Designteam, das heute aus sechs Partnern und 52 Mitarbeitern besteht.

Pour Seymourpowell, le design ne concerne pas que la configuration extérieure du produit. Le studio définit le design comme l'élément intégral qui associe fonction, utilisation, impression, fabrication et qualité pour former une unité évidente. Cette exigence extrême a fait de Seymourpowell, au cours des deux dernières décennies, une équipe de designers affichant une grande réussite et constituée aujourd'hui de six associés et 52 collaborateurs.

Para Seymourpowell el diseño no sólo encierra la concepción exterior del producto, sino que se define como elemento integral que vincula función, uso, gracia, fabricación y calidad conformando una unidad inconfundible. Partiendo de tales exigencias, Seymourpowell ha llevado a su equipo de diseño, que hoy cuenta con seis socios y 52 empleados, a alcanzar un éxito sin igual durante los últimos veinte años.

Per Seymourpowell il design non riguarda solo la forma esteriore di un prodotto, bensì si definisce come l'elemento integrale che collega tra loro funzione, uso, aspetto esteriore, produzione e qualità, dando forma a un'unità inconfondibile. Grazie a questa impostazione di alto profilo, durante gli ultimi due decenni Seymourpowell si è evoluto fino a diventare un team di designer di grande successo, che oggi conta sei partner e 52 collaboratori.

Dick Powell

1951
born in Great Kingshill, UK

Richard Seymour

1953
born in Scarborough, UK

Nick Talbot

1964
born in Dukhan, Quatar

David Fisher

1966
born Sutton-in-Ashfield, UK

Adrian Caroen

1968
born in Colchester, UK

1984
Seymourpowell

How would you describe the basic idea behind your design work? We put anthropology before technology and we value real innovation above mere novelty.

To what extent does working in London inspire your creativity? To a great degree. As London becomes ever more a meeting place for the world, then on a daily basis, without having to travel far, we get to see an incredible range of cultures, behaviours and attitudes. If these people can be said to represent potential customers for many of the products we design, then the exposure London gives us to all we see around us is hard to beat.

Is there a typical London style in contemporary design? There is no single style that typifies London today. Contemporary architecture in the capital covers everything from the monolithic Tate Modern to the sci-fi adventure of Foster's "Gherkin".

Which project is so far the most important one for you? I would have to say the ENV hydrogen fuel cell motorcycle, because it genuinely is about making things better, both for people and for the planet. Here is a motorcycle that is silent, doesn't pollute and looks great too!

Wie würden Sie die Grundidee beschreiben, die hinter Ihren Entwürfen steht? Bei uns steht der Mensch im Vordergrund, nicht die Technik, und wir schätzen echte Innovationen mehr als bloße Neuheiten.

Inwiefern inspiriert London Ihre kreative Arbeit? Zu einem hohen Anteil. Weil London immer mehr zum Treffpunkt der ganzen Welt wird, erlebt man täglich – ohne weit zu reisen – ein unglaubliches Spektrum unterschiedlicher Kulturen, Verhaltensweisen und Lebensstile. Wenn man nun davon ausgeht, dass die meisten dieser Menschen potenzielle Nutzer von Dingen sind, die wir gestalten, dann ist das Beobachtungsfeld, das London uns bietet, nur schwer zu übertreffen.

Gibt es einen typischen Londoner Stil im aktuellen Design? Heute gibt es keinen einzelnen Stil, der London kennzeichnen würde. Die zeitgenössische Architektur umfasst alles, von der monolithischen Tate Modern bis hin zum Science-Fiction-Abenteuer von Fosters „Gurke".

Welches ist für Sie Ihr bislang wichtigstes Projekt? Ich würde sagen, das ENV-Wasserstoff-Motorrad, denn dabei ging es wirklich um eine Verbesserung für die Menschen und für die Erde. Ein Motorrad, das leise ist, keine Abgase erzeugt und außerdem noch großartig aussieht!

Quelle est, d'après vous, l'idée de base qui sous-tend votre travail de conception ? Pour nous, l'homme est au premier plan, pas la technique ; et nous apprécions les véritables innovations, plus que les simples nouveautés.

Dans quelle mesure Londres inspire-t-il votre créativité ? Pour une large part. Parce que Londres devient de plus en plus un point de rencontre pour le monde entier, on est en présence, au quotidien – sans avoir à voyager bien loin – d'une multitude de cultures, de comportements et de styles de vie différents. Si l'on considère que la plupart de ces gens sont les utilisateurs potentiels des choses que nous créons, le champ d'observation que Londres nous offre est difficile à surpasser.

Y a-t-il un style typiquement londonien dans le design actuel ? On ne peut pas dire qu'il y ait aujourd'hui un style caractérisant Londres. L'architecture contemporaine couvre tout, de la monolithique Tate Modern à l'aventure de science-fiction qu'est le « concombre » de Foster.

Quel est le projet le plus important pour vous à l'heure actuelle ? Je dirais l'ENV, la moto à hydrogène, car il s'agit vraiment d'une amélioration pour l'homme et pour la terre. Une moto qui ne fait pas de bruit, ne pollue pas et dont le design est magnifiquement futuriste !

¿Cómo definiría la idea básica que encierran sus diseños? Nosotros anteponemos la persona a la técnica. Además apreciamos las innovaciones auténticas más que las simples novedades.

¿En qué medida inspira la ciudad de Londres su trabajo creativo? En gran medida. Puesto que Londres cada vez se convierte más en punto de encuentro del mundo entero, se vive diariamente, sin necesidad de viajar lejos, una increíble paleta de culturas diversas, modos de comportamiento y estilos de vida. Si se parte de la idea de que la mayoría de estas personas son usuarios potenciales de cosas que creamos nosotros, entonces el campo de observación que nos ofrece esta ciudad es prácticamente insuperable.

¿Existe un estilo típico londinense en el diseño actual? Hoy en día no existe un sólo estilo que pueda caracterizar a Londres. La arquitectura contemporánea comprende todo, desde el monolítico Tate Modern hasta la aventura de ciencia ficción del "pepino" concebido por Foster.

¿Cuál ha sido su proyecto más importante hasta el momento? Yo diría la motocicleta ENV propulsada por hidrógeno, ya que con ella se logró verdaderamente una mejora para la humanidad y el planeta. Una motocicleta silenciosa, que no emite gases, ¡y que además es preciosa!

Come descriverebbe l'idea originaria che sta alla base delle Sue creazioni? Noi preferiamo l'antropologia alla tecnologia ed apprezziamo più le vere innovazioni che le novità pure e semplici.

In che misura Londra ispira la Sua creatività? In misura notevole. Dato che Londra si sta trasformando sempre più in un punto d'incontro per tutto il mondo, ogni giorno, senza dover fare lunghi viaggi, è possibile entrare in contatto con un incredibile ventaglio di culture, comportamenti e stili di vita diversi. Se si parte dal presupposto che la maggior parte di queste persone sono potenziali utenti di oggetti che noi progettiamo, allora è chiaro che è difficile trovare un campo di osservazione paragonabile a quello offertoci da Londra.

Esiste uno stile tipico di Londra nel design contemporaneo? Non c'è un unico stile che caratterizzi Londra al giorno d'oggi. L'architettura contemporanea comprende di tutto, dal monolitico Tate Modern fino all'avventura fantascientifica del "cetriolo" di Foster.

Qual è per Lei il più importante tra i progetti realizzati finora? Direi la motocicletta alimentata a idrogeno ENV, perché nel caso di questo progetto si tratta davvero di una miglioria per gli uomini e per il pianeta. Una motocicletta silenziosa, che non inquina e, per di più, è incredibilmente bella da vedere!

Seymourpowell | Lufthansa Technik Project U 2004

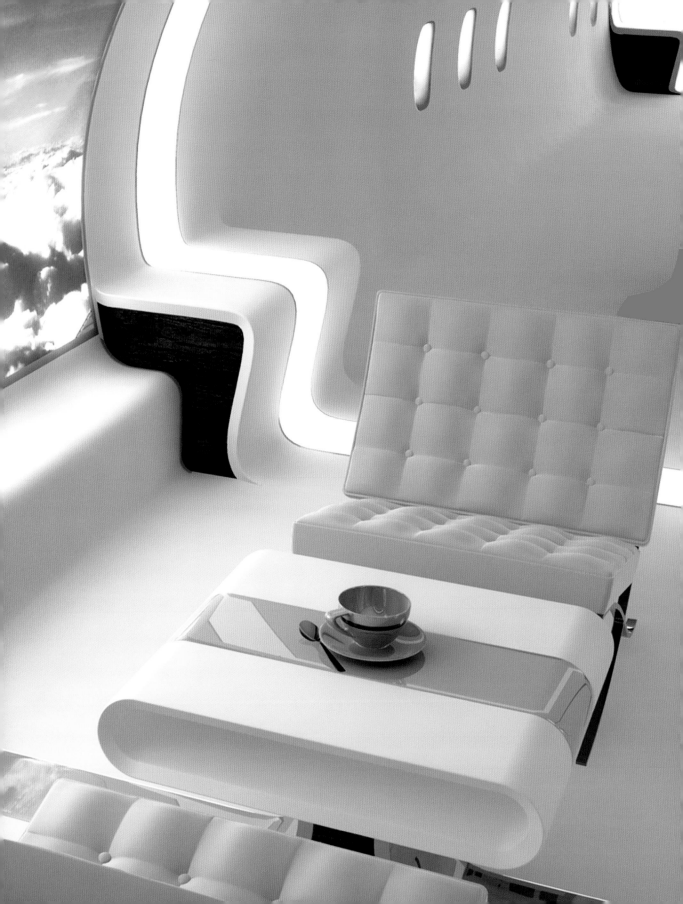

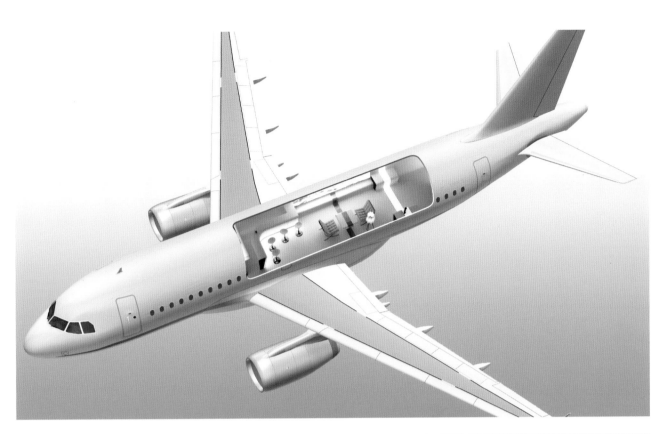

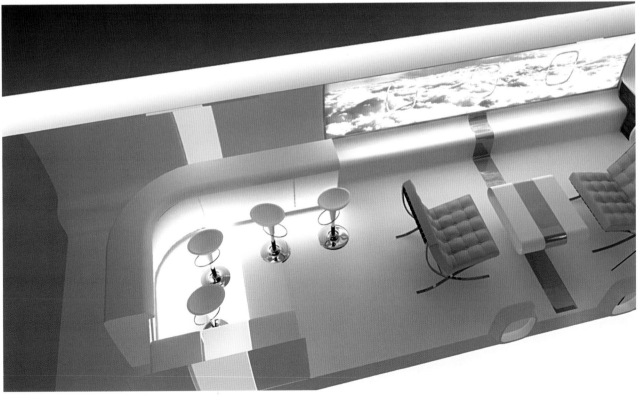

Seymourpowell developed this unique cooker in close collaboration with the manufacturer Mercury. As well as being made of innovative materials, the cooker is notable for its unusual controls. The control units are all concealed in the circular handle and are operated in a similar fashion to the gear lever on a motorbike.

In enger Zusammenarbeit mit dem Hersteller Mercury entwickelten Seymourpowell diesen neuartigen Küchenherd. Neben dem Einsatz innovativer Materialien zeichnet den Herd auch seine ungewöhnliche Bedienung aus: Sämtliche Regler verbergen sich in dem runden Handgriff und werden ähnlich wie die Gangschaltung eines Motorrads bedient.

C'est en étroite collaboration avec le fabricant Mercury que Seymourpowell a développé ce nouveau modèle de cuisinière. Elle se caractérise par l'emploi de matériaux innovants et par un maniement inhabituel : tous les réglages sont logés dans la poignée arrondie et fonctionnent comme les changements de vitesse d'une moto.

Seymourpowell desarrolló este novedoso fogón de cocina en estrecha colaboración con el productor Mercury. Junto a la introducción de materiales innovadores el objeto se caracteriza por su inusual modo de aplicación: Los reguladores están escondidos en un tirador circular y se utilizan de forma semejante al cambio de marchas de una motocicleta.

Seymourpowell ha realizzato questo inedito fornello da cucina in stretta collaborazione con il produttore Mercury. Oltre che per l'utilizzo di materiali innovativi, il fornello si distingue per il suo azionamento inconsueto: tutti i pulsanti sono nascosti nella maniglia rotonda e funzionano come il cambio di una motocicletta.

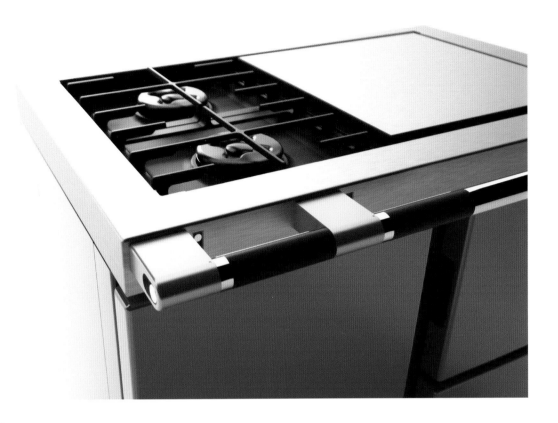

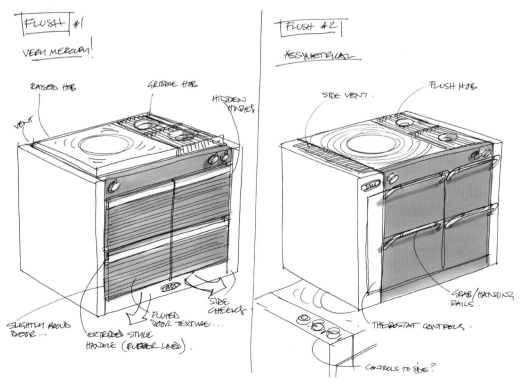

FLUSH #1

VERY MERCURY!

RAISED HOB

GRIDDLE HOB

HIDDEN HANDLES

VENT

SLIGHTLY PROUD DOOR ...

EXTRUDED STYLE HANDLE (RUBBER LINED).

FLUTED DOOR TEXTURE ...

SIDE CHEEKS

FLUSH #2

ASSYMETRICAL

SIDE VENT.

FLUSH HOB

GRAB/HANGING RAILS.

THERMOSTAT CONTROLS.

CONTROLS TO SIDE?

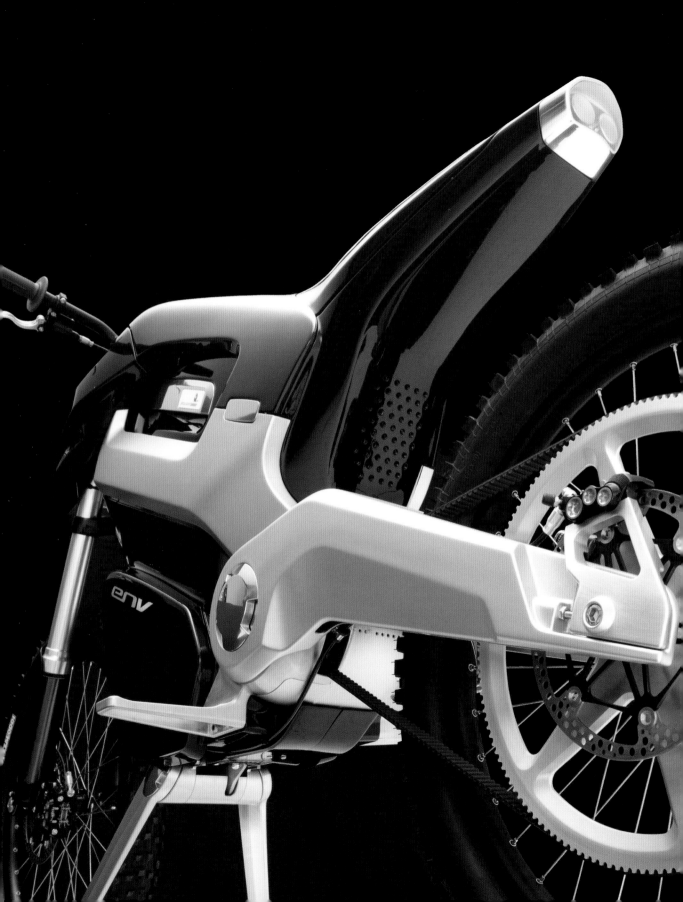

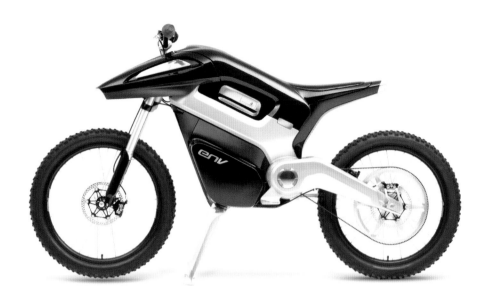

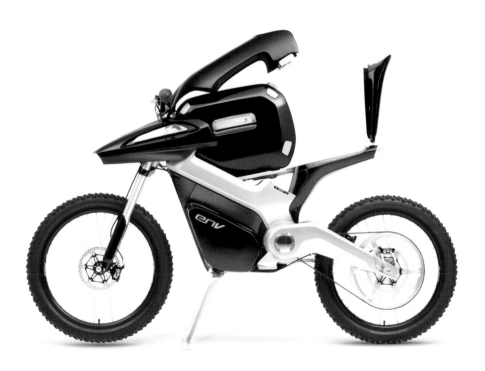

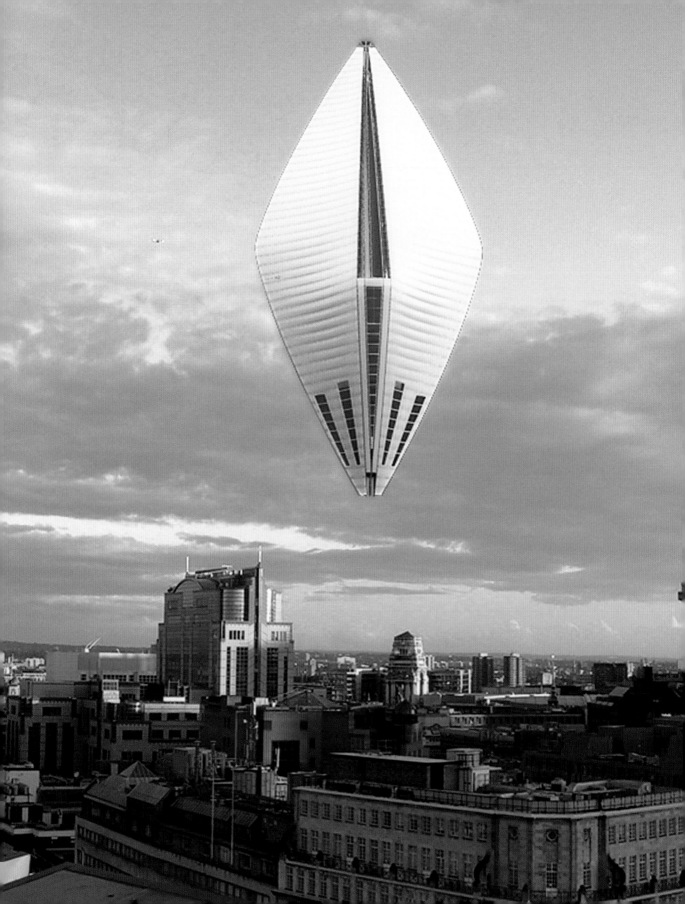

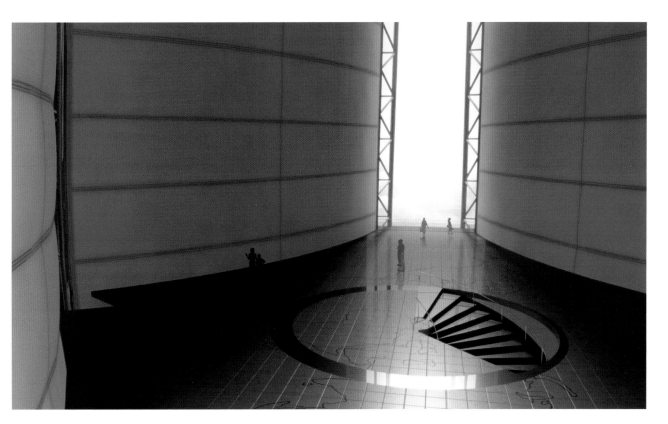

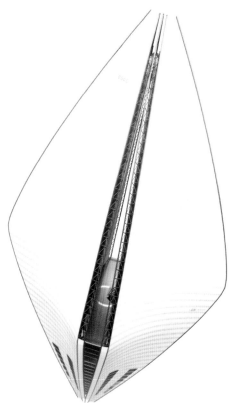

tangerine

tangerine

9 Blue Lion Place, 237 Long Lane, London SE1 4PU

P +44 20 7357 0966

F +44 20 7357 0784

www.tangerine.net

martin@tangerine.net

When developing new products, the team at tangerine first considers the wishes and needs of its clients and the people who will be using them. They are established in extensive investigations and analyses; only then do Tangerine look at the task with a designer's eye, thus creating aesthetic products of high practical value. Clients include world brands such as LG Electronics, Wilkinson Sword and Toyota.

Bei der Entwicklung von neuen Produkten und Designobjekten stehen für das Team von tangerine zunächst immer die Wünsche und Bedürfnisse der Kunden und der späteren Nutzer im Vordergrund. Diese ermitteln sie in durch aufwendige Untersuchungen und Analysen – dann erst sehen sie die Aufgabe mit den Augen der Designer und gestalten so ästhetische Produkte mit hohem Gebrauchswert. Zu den Auftraggebern von tangerine gehören Weltmarken wie LG Electronics, Wilkinson Sword oder Toyota.

Lors du développement de nouveaux produits et d'objets design, l'équipe de tangerine place d'abord toujours au premier plan les souhaits et les besoins de ses clients et des futurs utilisateurs. Celle-ci les détermine au moyen de recherches et d'analyses d'envergure – après quoi ils voient l'objectif avec des yeux de designer et créent alors des produits esthétiques d'une grande utilité. On compte parmi les clients de tangerine des marques de réputation mondiale comme LG Electronics, Wilkinson Sword ou Toyota.

Para el equipo de tangerine, los deseos y necesidades de los clientes y los posteriores usuarios son siempre prioritarios a la hora de desarrollar nuevos productos. Para ello lleva primero a cabo análisis e investigaciones completas, y sólo después comienza el trabajo desde el punto de vista del diseño, en el que se conciben productos estéticos con un alto valor de uso. Entre los cliente de tangerine figuran marcas internacionales como LG Electronics, Wilkinson Sword y Toyota.

Nella fase di progettazione di nuovi prodotti e oggetti di design, per il team di tangerine giocano un ruolo di primo piano innanzi tutto i desideri e le esigenze dei clienti nonché dei futuri utenti. Per identificare tali desideri ed esigenze, vengono effettuate complesse indagini ed analisi, solo al termine delle quali i designer cominciano a vedere il lavoro da svolgere nell'ottica loro propria, riuscendo così a creare prodotti estetici con alto valore d'uso. Tra i committenti di tangerine vi sono marche di fama mondiale come LG Electronics, Wilkinson Sword o Toyota.

Don Tae Lee

1968
born in Kangreung City, South Korea

Martin Darbyshire

1961
born in Lancashire, UK

Mike Woods

1970
born in Dorset, UK

Matt Round

1968
born in Newcastle under Lyme, UK

1988
tangerine

Interview | tangerine

How would you describe the basic idea behind your design work? We use design as a tool to deliver a meaningful difference for our clients and their business.

To what extent does working in London inspire your creativity? London is one of the most culturally diverse cities in the world with over 300 different languages spoken and where one out of ten people works within the creative industry sector.

Is there a typical London style in contemporary design? No.

Which project is so far the most important one for you? British Airways was the client, the Club World Seat the design. This product won the Grand Prix for Design Effectiveness from the Design Business Association. British Airways is now the most profitable airline and Club World is the profit engine of the business.

Wie würden Sie die Grundidee beschreiben, die hinter Ihren Entwürfen steht? Für uns ist Design ein Mittel, für unsere Kunden und ihre Unternehmen einen bedeutungsvollen Unterschied zu schaffen.

Inwiefern inspiriert London Ihre kreative Arbeit? London ist einer der kulturell vielfältigsten Orte der Welt, hier werden über 300 verschiedene Sprachen gesprochen, und zehn Prozent der Menschen arbeiten im kreativen Bereich.

Gibt es einen typischen Londoner Stil im aktuellen Design? Nein.

Welches ist für Sie Ihr bislang wichtigstes Projekt? Der Club World Seat für British Airways. Der Entwurf wurde von der Design Business Association mit dem Grand Prix für effektives Design ausgezeichnet. British Airways ist die zurzeit profitabelste Airline, mit der Club World als größtem Gewinnbringer.

Quelle est, d'après vous, l'idée de base qui sous-tend votre travail de conception ?
Pour nous, le design est un moyen de créer quelque chose de distinctif et d'expressif pour nos clients et leurs entreprises.

Dans quelle mesure Londres inspire-t-il votre créativité ? Londres est l'une des villes les plus multiculturelles du monde, on y parle plus de 300 langues différentes, et dix pour cent de ses habitants travaillent dans le secteur de la création.

Y a-t-il un style typiquement londonien dans le design actuel ? Non.

Quel est le projet le plus important pour vous à l'heure actuelle ? Le siège de la Club World pour British Airways. Ce projet a gagné le Grand Prix du design efficace, décerné par la Design Business Association. British Airways est actuellement la compagnie aérienne la plus rentable, la Club World étant son plus gros facteur de profit.

¿Cómo definiría la idea básica que encierran sus diseños? Para nosotros el diseño es un medio para proporcionar a nuestros clientes y sus empresas una diferencia cargada de significado.

¿En qué medida inspira la ciudad de Londres su trabajo creativo? Londres es uno de los lugares con mayor diversidad cultural del mundo, ya que aquí se hablan más de 300 lenguas diferentes y el diez por ciento de la gente trabaja en el entorno creativo.

¿Existe un estilo típico londinense en el diseño actual? No.

¿Cuál ha sido su proyecto más importante hasta el momento? El Club World Seat para British Airways. El diseño fue galardonado por la Design Business Association con el Grand Prix de diseño eficaz. British Airways es actualmente la línea aérea con mayor beneficio y el Club World una gran fuente de ingresos.

Come descriverebbe l'idea originaria che sta alla base delle Sue creazioni? Per noi il design è lo strumento con cui creare per i nostri clienti e le loro imprese qualcosa che rappresenti una differenza significativa.

In che misura Londra ispira la Sua creatività? Dal punto di vista culturale, Londra è uno dei luoghi più eterogenei del mondo: basti pensare che qui si parlano più di 300 lingue diverse e che una persona su dieci lavora nel settore creativo.

Esiste uno stile tipico di Londra nel design contemporaneo? No.

Qual è per Lei il più importante tra i progetti realizzati finora? Il Club World Seat per la British Airways: questo progetto è stato premiato dalla Design Business Association con il Grand Prix for Design Effectiveness. Se al momento la British Airways è la linea aerea con i più alti profitti, Club World è all'origine dei suoi guadagni.

The display shows:

> Tuesday 10/01
> 08:32

tangerine | Fastap Mobile Phone 2006

Fashion Design

Christopher Bailey

Manolo Blahnik

Ozwald Boateng

Carlo Brandelli

Jasper Conran

CUTLER AND GROSS

Georgina Goodman

Richard James

Stephen Jones Millinery

Stella McCartney

Philip Treacy

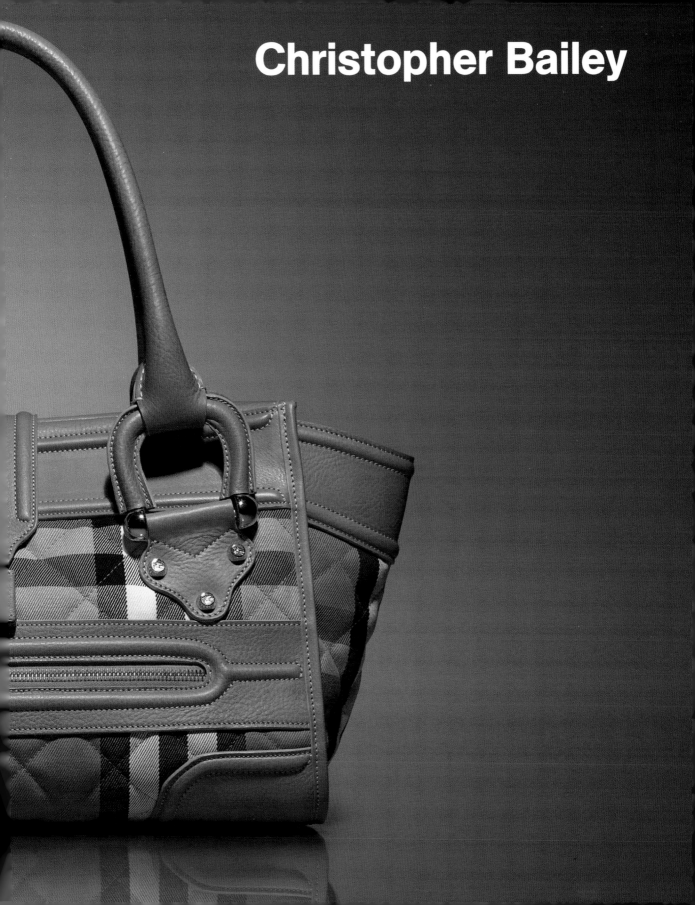

Christopher Bailey

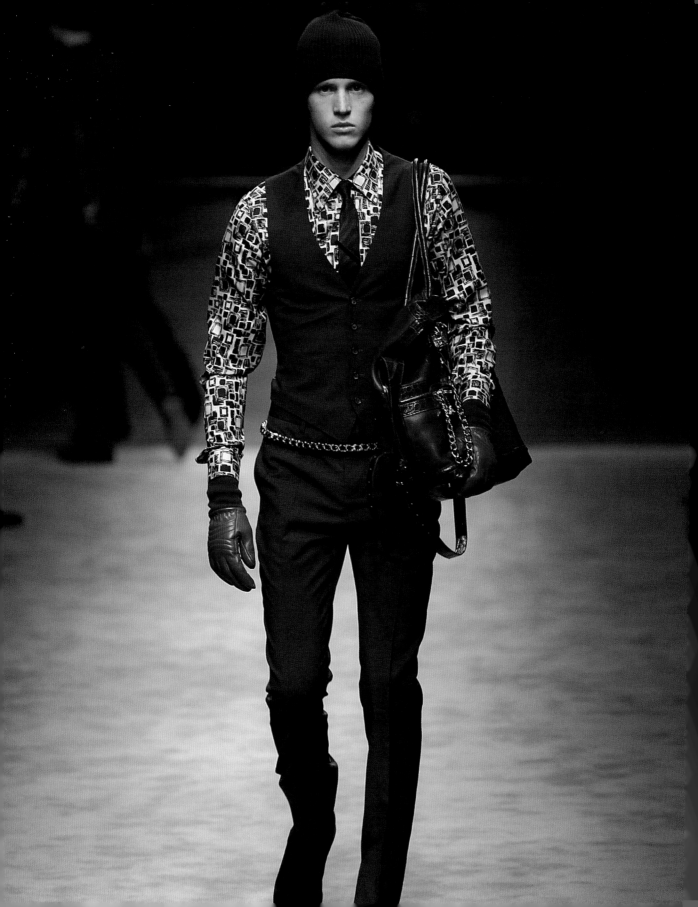

Christopher Bailey

Burberry, 58-59 Haymarket, London SW1Y 4BL

P +44 20 7968 0000

F +44 20 7968 0393

www.burberry.com

Christopher Bailey

1971
born in Yorkshire, UK

2001
joined Burberry

Bailey started out working for Donna Karan in New York and for Gucci Womenswear before becoming Burberry's Design Director in 2001. At Burberry, one of Britain's oldest and best-known luxury brands, Bailey is responsible for the collections and accessories as well as the company's overall appearance and each season's advertising campaigns.

Bailey arbeitete zunächst für Donna Karan in New York und für Gucci Womenswear, bevor er im Jahre 2001 als Designdirektor zu Burberry wechselte. Für Burberry – eine der ältesten und bekanntesten britischen Luxusmarken – verantwortet Bailey sämtliche Kollektionen und Accessoires sowie das generelle Erscheinungsbild des Unternehmens und die Werbekampagnen der jeweiligen Modesaison.

Bailey a d'abord travaillé pour Donna Karan à New York et pour Gucci Womenswear avant de devenir en 2001 directeur du design chez Burberry. Pour Burberry – l'une des plus anciennes et des plus célèbres marques de luxe britanniques – Bailey est le responsable de toutes les collections et accessoires ainsi que de l'image de marque de l'entreprise et des campagnes de publicité selon la saison de mode.

Antes de pasar a ser el director de diseño de Burberry en 2001, Bailey había trabajado primeramente para Donna Karan en Nueva York y Gucci Womenswear. En Burberry, una de las marcas de lujo más antiguas y famosas de Inglaterra, Bailey es responsable de las colecciones completas y los accesorios, además de la imagen de la empresa y las campañas publicitarias de las diversas temporadas.

Prima di diventare, nel 2001, direttore del design per Burberry, Bailey inizialmente ha lavorato per Donna Karan a New York e per Gucci Womenswear. Per Burberry, una delle più antiche e note marche di lusso britanniche, Bailey è responsabile di tutte le collezioni e gli accessori nonché dell'immagine generale dell'azienda e delle campagne pubblicitarie per le singole stagioni di moda.

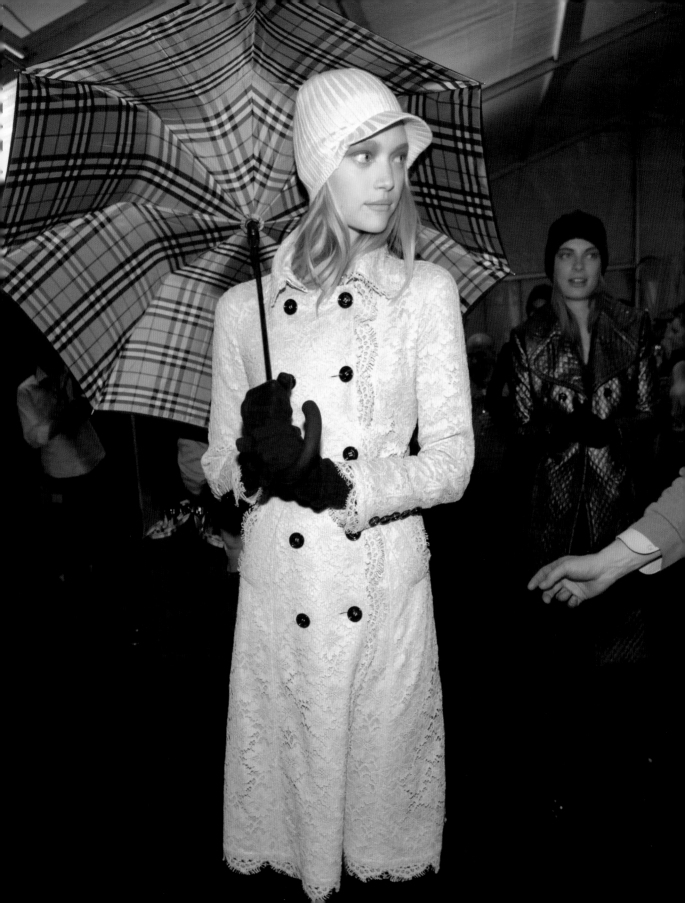

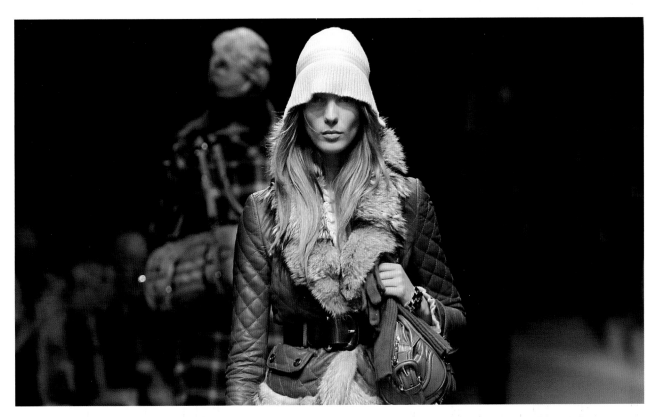

Christopher Bailey | Burberry Prorsum Autumn/Winter Collection 2006/07, Flagship Store

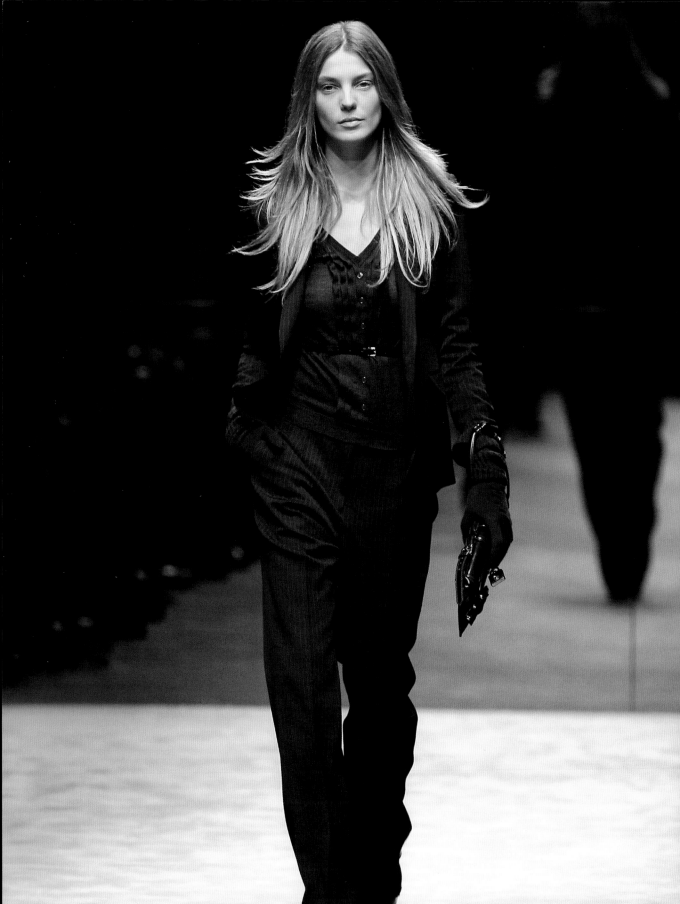

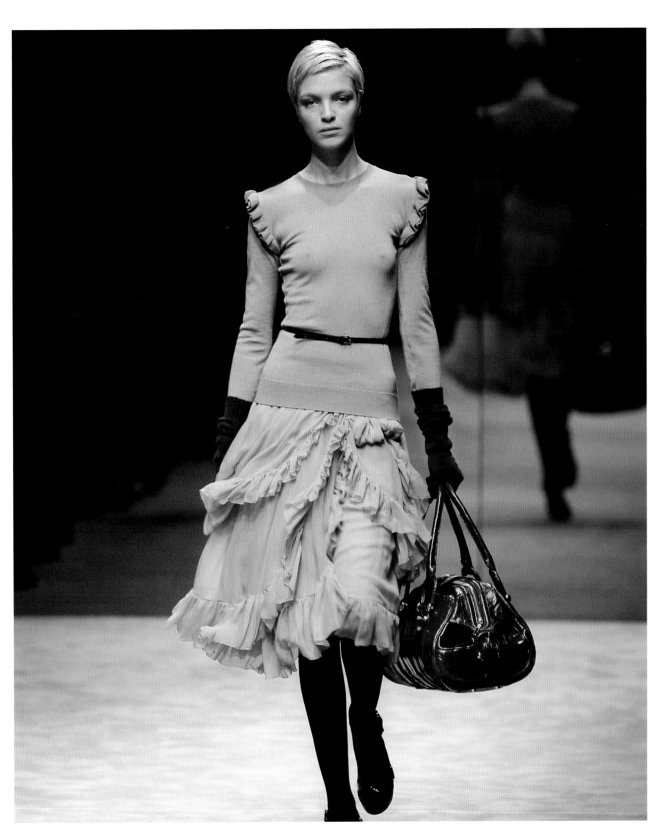

Christopher Bailey | Burberry Prorsum Autumn/Winter Collection 2006/07

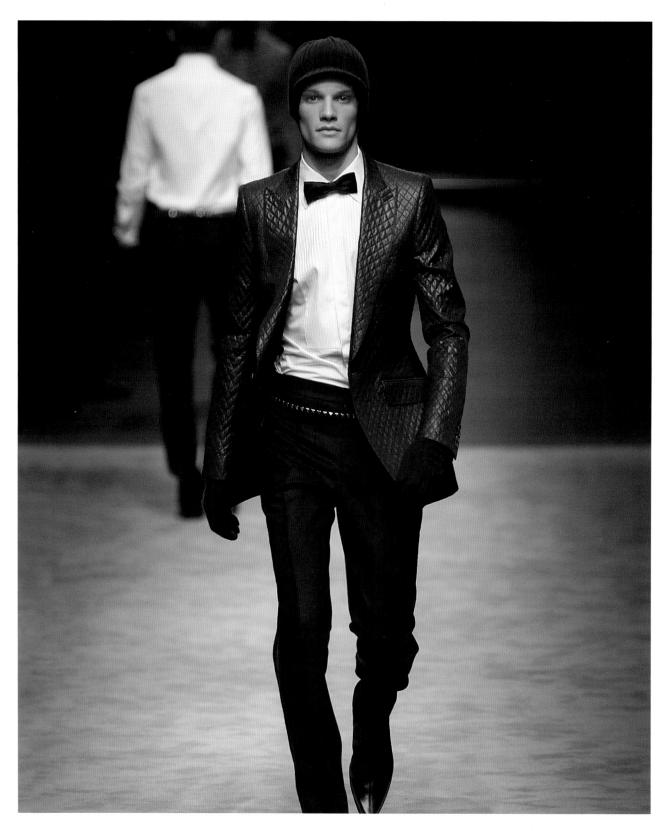

Christopher Bailey | Burberry Prorsum Autumn/Winter Collection 2006/07

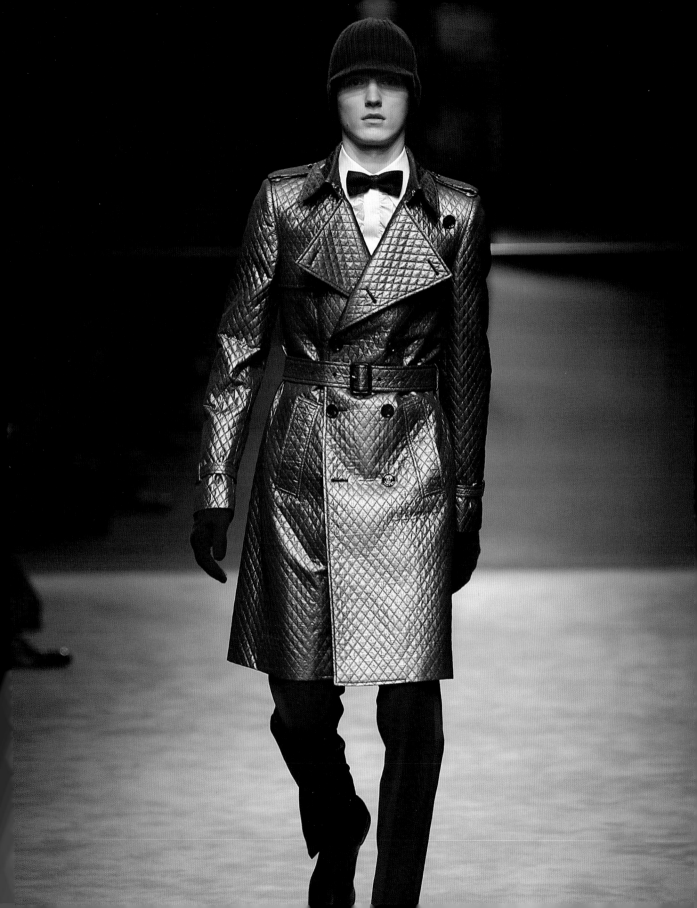

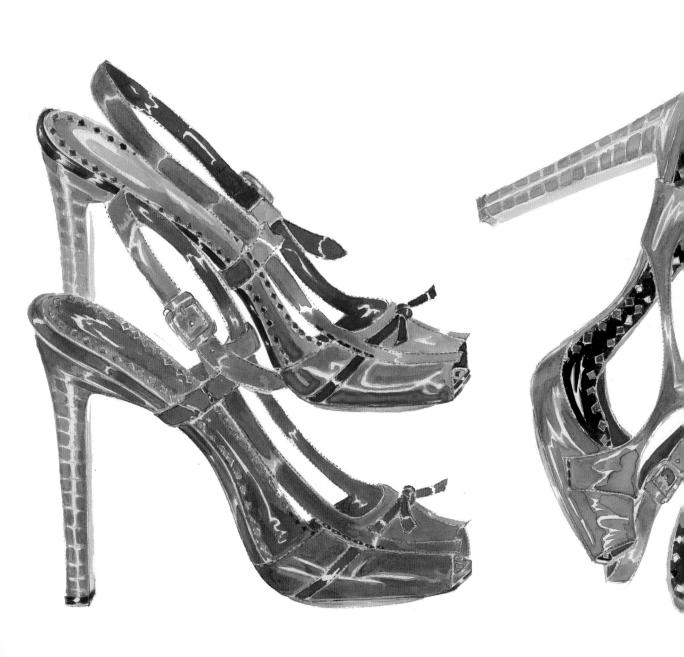

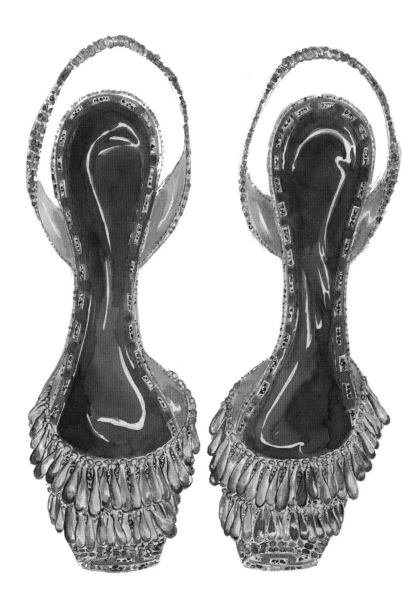

Manolo Blahnik

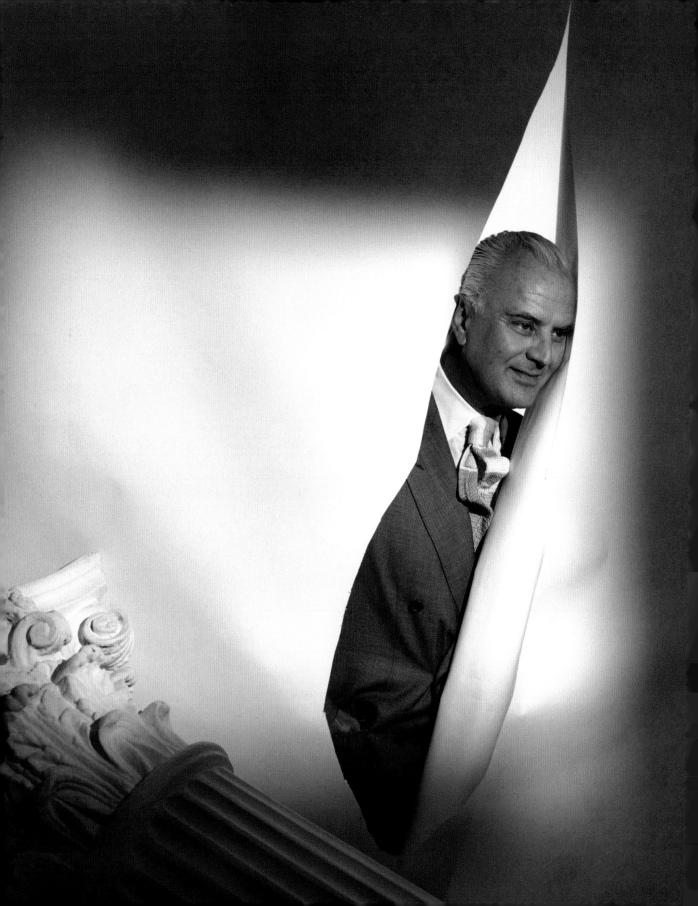

Manolo Blahnik

Manolo Blahnik Int Ltd, 297 King's Road, London SW3 5EP

P +44 20 7352 8622

F +44 20 7351 7314

Manolo Blahnik

1942
born on Canary Islands, Spain

1972
shoes for Zapata

1973
Blahnik buys Zapata

Born on the Canary Islands, Manolo Blahnik grew up on a banana plantation. His path to London in the sixties was a circuitous one. His first job was as a photo reporter before the then editor-in-chief of Vogue US convinced him to design his first shoe collection. His exceptional designs and well-known clients, such as Bianca Jagger and Paloma Picasso, soon made Manolo Blahnik one of the most famous shoe designers in the world.

Geboren auf den Kanarischen Inseln, wuchs Manolo Blahnik auf einer Bananenplantage auf. Über Umwege gelangte er Ende der sechziger Jahre nach London. Dort arbeitete er zunächst als Fotore-porter, bevor er auf Anregung der damaligen Chefredakteurin der US-Vogue seine erste Schuhkollek-tion entwarf. Seine außergewöhnlichen Entwürfe und prominente Kundinnen wie Bianca Jagger oder Paloma Picasso machten Manolo Blahnik zu einem der weltweit bekanntesten Schuhdesigner.

Né sur les îles Canaries, Manolo Blahnik a grandi sur une plantation de bananes. Par des chemins détournés, il est arrivé à Londres à la fin des années soixante. Il y a d'abord travaillé comme repor-ter-photographe, avant de créer sa première collection de chaussures, à l'instigation de la rédactrice en chef d'alors du magazine Vogue US. Ses créations extraordinaires et des clientes célèbres telles que Bianca Jagger ou Paloma Picasso ont fait de Manolo Blahnik l'un des designers de chaussures les plus connus au monde.

Manolo Blahnik nació en las Islas Canarias y creció en un platanar. Tras varios rodeos acabó final-mente instalándose en Londres a finales de los años sesenta. Allí comenzó primero a trabajar como reportero fotográfico, antes de que concibiera su primera colección de calzado, incitado por la que entonces era jefa de redacción de Vogue US. Sus inhabituales diseños y prominentes clientas, como Bianca Jagger y Paloma Picasso, convirtieron a Manolo Blahnik en uno de lo diseñadores de calzado más conocidos en todo el mundo.

Nato alle Canarie, Manolo Blahnik crebbe in una piantagione di banane e giunse a Londra per vie traverse verso la fine degli anni Sessanta. Qui lavorò dapprima come fotoreporter, per poi realizzare la sua prima collezione di scarpe su suggerimento dell'allora caporedattrice di Vogue US. L'assoluta originalità delle sue creazioni e la fama di illustri clienti come Bianca Jagger o Paloma Picasso hanno fatto di Manolo Blahnik uno dei designer di calzature più famosi del mondo.

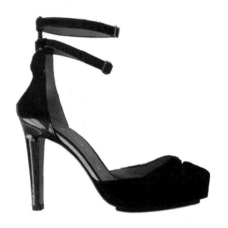

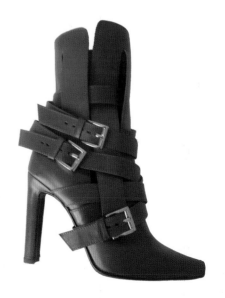

Manolo Blahnik | Duchessa, Fetisho 2006 | left Portrait Manolo Blahnik

Interview | Manolo Blahnik

How would you describe the basic idea behind your design work? It is difficult for me to pin point one basic idea, because there could be so many of them – a film, a smell, a flower, a line from a novel ... but at the heart of it all, there is always quality and craftsmanship – without that, my ideas are worth nothing.

To what extent does working in London inspire your creativity? London is an exciting city, and even if there are some parts of it that have changed radically since I first got here, it still manages to inspire me. It's the energy of the city, which is very particular to it.

Is there a typical London style in contemporary fashion design? London has always had its own place in fashion. It always pushes boundaries as far as it can. It's been doing it since the 1960s, and still continue to do so.

Which project is so far the most important one for you? That is not a question I can answer easily, because in a way they are all important to me, but at the same time, I have a short attention span and lose interest in what I have already done. What is important for me is the one that is yet to come.

Wie würden Sie die Grundidee beschreiben, die hinter Ihren Entwürfen steht? Es fällt mir schwer, eine Grundidee zu benennen. Es gibt so viele Einflüsse – ein Film, ein Duft, eine Blume, eine Zeile aus einem Roman ... am Ende stehen jedoch immer Qualität und Handwerk – ohne diese wären meine Ideen wertlos.

Inwiefern inspiriert London Ihre kreative Arbeit? London ist eine aufregende Stadt, und obwohl sich – seit ich zum ersten Mal herkam – einige Viertel radikal verändert haben, gelingt es ihr noch immer, mich zu inspirieren. Es ist die Energie der Stadt, die hier wirklich etwas Besonderes ist.

Gibt es einen typischen Londoner Stil im aktuellen Modedesign? London hatte in der Modewelt schon immer seinen besonderen Stellenwert. Hier werden die Grenzen immer so weit wie möglich ausgeweitet. Dies ist schon seit den sechziger Jahren so, und es wird auch künftig so sein.

Welches ist für Sie Ihr bislang wichtigstes Projekt? Das ist natürlich nicht ganz leicht zu beantworten, da sie alle wichtig für mich sind. Allerdings ist meine Aufmerksamkeitsspanne nur kurz, und ich verliere das Interesse an dem, was hinter mir liegt. Wichtig ist immer das, was gerade auf mich zukommt.

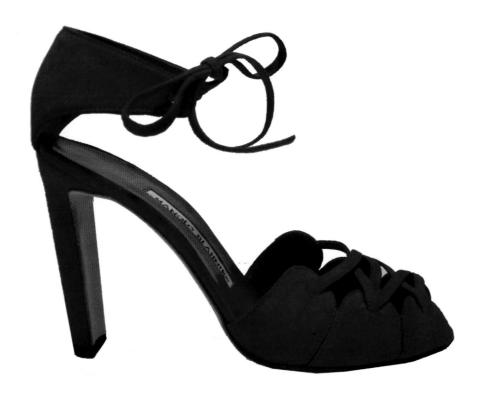

Quelle est, d'après vous, l'idée de base qui sous-tend votre travail de conception ? J'ai du mal à exprimer une idée de base. Il y a tellement d'influences – un film, un parfum, une fleur, une ligne dans un roman ... mais finalement, tout est toujours centré sur la qualité et l'artisanat – sans cela, mes idées n'auraient aucune valeur.

Dans quelle mesure Londres inspire-t-il votre créativité ? Londres est une ville stimulante, et bien que certains quartiers aient radicalement changé depuis le jour de mon arrivée, elle réussit toujours à m'inspirer. C'est l'énergie de la ville qui est très particulière ici.

Y a-t-il un style typiquement londonien dans la création de mode actuelle ? Londres a toujours occupé une place particulière dans le monde de la mode. Ici, les frontières sont toujours repoussées aussi loin que possible. C'est comme cela depuis les années soixante et cela ne va pas changer.

Quel est le projet le plus important pour vous à l'heure actuelle ? Ce n'est pas facile de répondre à cette question car ils sont naturellement tous importants pour moi. Mais en même temps, j'ai une période d'attention assez courte, si bien que je ne m'intéresse plus à ce qui est derrière moi. L'important, c'est toujours ce qui vient à moi.

¿Cómo definiría la idea básica que encierran sus diseños? Me resulta difícil nombrar una idea básica. Son tantas las influencias: una película, un aroma, una flor, una frase de novela ... y al final siempre surge como resultado la calidad y el trabajo artesanal, puesto que sin ellos mis ideas carecerían de valor.

¿En qué medida inspira la ciudad de Londres su trabajo creativo? Londres es una ciudad excitante, y aunque desde la primera vez que vine algunas partes de la ciudad se han transformado radicalmente, continúa inspirándome. Es la energía de la ciudad, que aquí se trata realmente de algo especial.

¿Existe un estilo típico londinense en el diseño de moda actual? En el mundo de la moda, Londres siempre ha mantenido un puesto privilegiado. Aquí se llevan los límites al extremo. Así ocurre desde los años sesenta y así seguirá siendo.

¿Cuál ha sido su proyecto más importante hasta el momento? Naturalmente eso no es tan fácil de responder, puesto que para mí todos son importantes. Sin embargo no presto atención a largo plazo y suelo perder el interés por lo ya realizado. Lo importante es lo que me está esperando.

Come descriverebbe l'idea originaria che sta alla base delle Sue creazioni? Non è facile citare un'unica idea originaria. Sono così tante le cose che possono influenzare, un film, un profumo, un fiore, una riga di un romanzo ... al termine, però, si trovano sempre qualità e lavoro artigianale: senza di loro, le mie idee non varrebbero niente.

In che misura Londra ispira la Sua creatività? Londra è una città entusiasmante e nonostante alcuni quartieri della città, da quando sono arrivato per la prima volta, siano profondamente cambiati, riesce ancora ad ispirarmi. È l'energia della città che qui è davvero qualcosa di molto speciale.

Esiste uno stile tipico di Londra nel design di moda contemporaneo? Londra ha sempre avuto un suo ruolo speciale nel mondo della moda. Qui si tenta sempre di allargare il più possibile le frontiere: si è cominciato a farlo già a partire dagli anni Sessanta e sarà così anche in futuro.

Qual è per Lei il più importante tra i progetti realizzati finora? Rispondere a questa domanda non è davvero facile, perché in un certo senso sono tutti importanti per me. Devo dire, però, che non dispongo di un ampio margine di attenzione e perdo in fretta interesse per quello che ho fatto in passato. Per me è sempre importante quello che sta per venire.

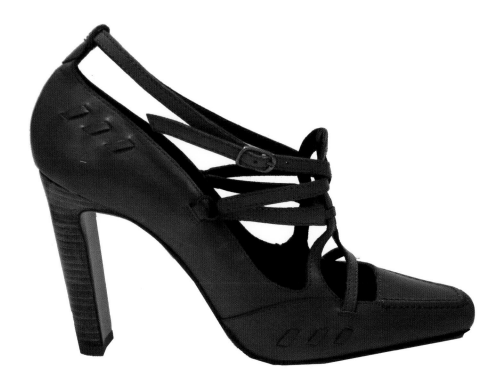

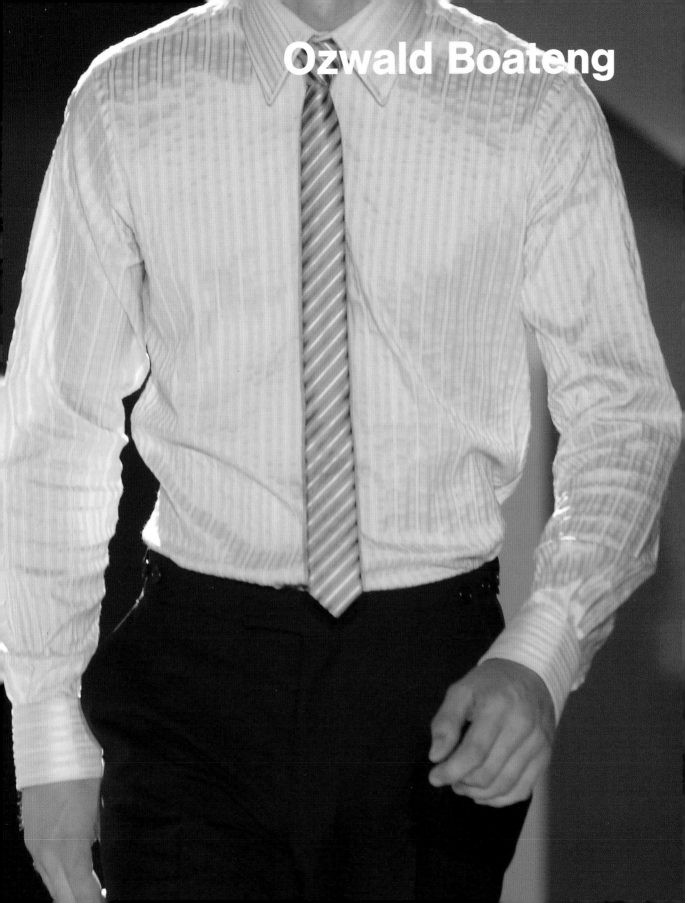

Ozwald Boateng

12a Savile Row, London W18 3PQ

P +44 870 777 1377

F +44 20 7738 1107

www.ozwaldboateng.co.uk

info@bespokecoutureltd.co.uk

Ozwald Boateng

1967
born in London, UK

1995
Vigo Street Store

2002
Savile Row Headquarters

The fashion designer Ozwald Boateng made his name with his "bespoke couture" – made-to-measure gentlemen's fashions that combine classic design with unusual colours and elegant cuts. Ozwald Boateng grew up in North London. After qualifying as an IT specialist, Boateng made the move to the world of fashion at the age of 23. His clothes are notable for their excellent fabrics, superlative craftsmanship and unmistakable styles.

Der Modedesigner Ozwald Boateng wurde bekannt durch seine „bespoke couture" – maßgeschneiderte Herrenmode, die klassisches Design mit außergewöhnlichen Farben und eleganten Schnitten verbindet. Ozwald Boateng wuchs in Nordlondon auf. Im Alter von 23 Jahren wechselte der ursprünglich zum IT-Fachmann ausgebildete Boateng in die Modebranche. Neben dem unverwechselbaren Stil zeichnen sich seine Stücke durch exzellente Stoffe und sorgfältigste Verarbeitung aus.

Le couturier de mode Ozwald Boateng s'est fait connaître par sa « bespoke coutre » – une mode masculine sur mesure qui allie un style classique avec des couleurs inhabituelles et des coupes élégantes. Ozwald Boateng a grandi au nord de Londres. A 23 ans, Boateng, pourtant technicien IT de formation, passe dans le domaine de la mode. Outre son style facilement reconnaissable, ses vêtements se caractérisent par d'excellentes étoffes et une finition irréprochable.

El moderno diseñador Ozwald Boateng se hizo conocido a través de su "bespoke couture" – moda de caballero hecha a medida que combina colores atípicos y cortes elegantes. Ozwald Boateng creció en el norte de Londres. A los 23 años cambió su formación inicial como especialista en Tecnologías de la Información por el mundo de la moda. A parte de por su estilo inconfundible, sus creaciones destacan por los excelentes tejidos y la cuidada elaboración.

Lo stilista di moda Ozwald Boateng ha raggiunto la notorietà grazie alla sua "bespoke couture": moda maschile su misura che unisce un design classico a colori insoliti e tagli eleganti. Ozwald Boateng cresciuto nella zona nord di Londra, abbandonò il settore informatico all'età di 23 anni per entrare nel mondo della moda. Oltre ad avere uno stile inconfondibile, i suoi capi d'abbigliamento si distinguono per la preziosità delle stoffe e l'estrema accuratezza della lavorazione.

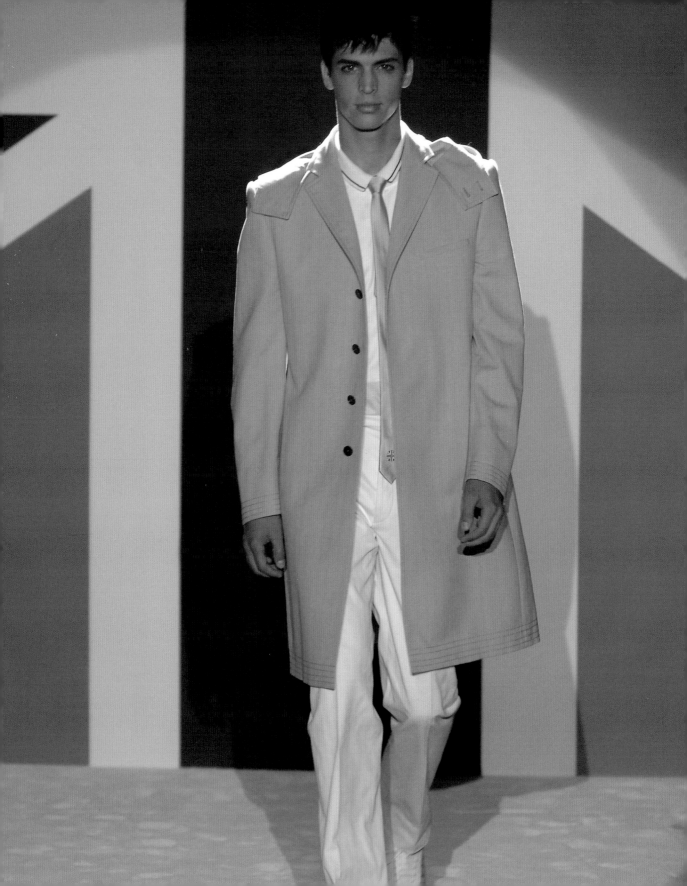

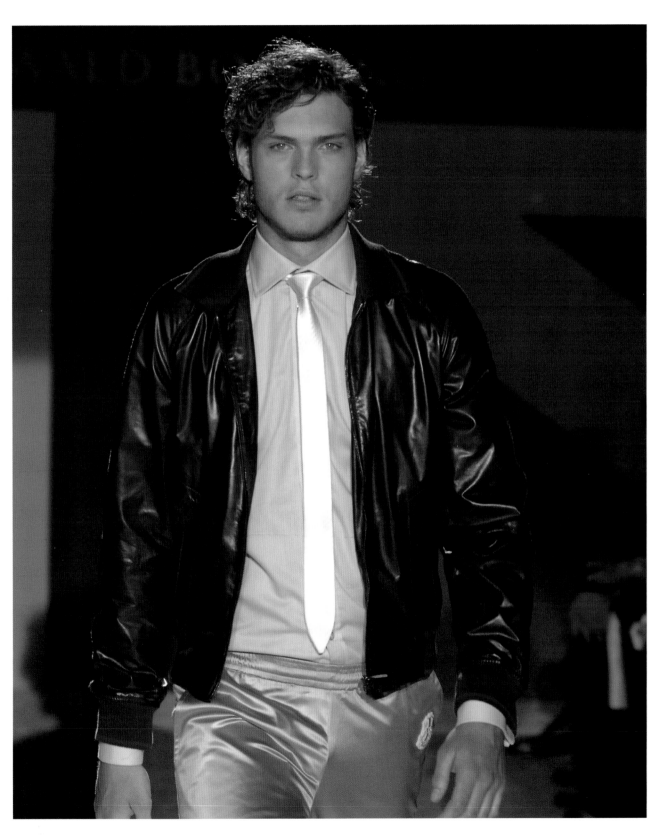

Carlo Brandelli

Carlo Brandelli

Kilgour, 8 Savile Row, London W1S 3PE

P +44 20 7734 6905

F +44 20 7287 8147

www.8savilerow.com

kilgour@8savilerow.com

Carlo Brandelli

born in London, UK

1993
Squire Menswear Brand

2003
joines Kilgour

Carlo Brandelli was born in London of Italian parents. He grew up in a world of fashion cutters and artisans, from whom he learnt the main principles of tailoring and fashion design. In the mid-nineties Brandelli collaborated with fashion photographer Nick Knight and legendary graphic designer Peter Saville to create a radical new aesthetic on the borderline between fashion and art for his label, Squire. Since 2003, Carlo Brandelli has been creative director of Kilgour on Savile Row.

Carlo Brandelli wurde als Sohn italienischer Eltern in London geboren. Er wuchs in einer Umgebung von Modeschneidern und Kunsthandwerken auf, von denen er die wichtigsten Grundlagen des Schneiderns und der Modegestaltung erlernte. Mitte der neunziger Jahre schuf Brandelli mit dem Modefotografen Nick Knight und dem legendären Grafikdesigner Peter Saville für sein Label Squire eine radikal neue Ästhetik an der Schnittstelle zwischen Mode und Kunst. Seit 2003 ist Carlo Brandelli Kreativdirektor von Kilgour in der Savile Row.

Carlo Brandelli est né à Londres de parents italiens. Il a grandi dans un environnement de tailleurs de mode et d'artisans d'art, qui lui ont appris les bases essentielles du métier de tailleur et de la création de mode. Au milieu des années quatre-vingt-dix, avec le photographe de mode Nick Knight et le légendaire graphiste Peter Saville, Brandelli a créé pour sa marque Squire une esthétique radicalement nouvelle à la frontière de la mode et de l'art. Depuis 2003, Carlo Brandelli est directeur de la création chez Kilgour à Savile Row.

Carlo Brandelli, hijo de padres italianos, nació en Londres. Creció en el entorno de la sastrería y el arte manual, donde aprendió las bases del corte y la creación de moda. A mediados de los años noventa, acompañado del fotógrafo de moda Nick Knight y el legendario diseñador gráfico Peter Saville concibió para su marca Squire una nueva y radical estética en los límites entre la moda y el arte. Desde 2003 Carlo Brandelli es director creativo de Kilgour en Savile Row.

Carlo Brandelli, nato a Londra da genitori italiani, crebbe in un ambiente di sarti di moda e artigiani artistici, dai quali apprese le tecniche fondamentali della sartoria e della creazione di moda. Verso la metà degli anni Novanta Brandelli, in collaborazione con il fotografo di moda Nick Knight e il leggendario designer grafico Peter Saville, ha creato per la sua marca Squire un'estetica radicalmente nuova, situata al punto di intersezione tra moda e arte. Dal 2003 Carlo Brandelli è direttore creativo di Kilgour in Savile Row.

Interview | Carlo Brandelli

How would you describe the basic idea behind your design work? Firstly I always try to keep things very simple, then you must have a perspective, understand context, principles, heritage. If you make things very clear people will see the "truth" of the design.

To what extent does working in London inspire your creativity? I can't say that the city inspires me or that it ever did, however a perfect notion that I have in my mind of what London is I always carry with me. I have these ideas of the real essence/culture and history of all major cities that I have been to and this is what you use as reference when you think.

Is there a typical London style in contemporary fashion design? London style fashion design is invariably about creativity and moving forward and always producing something new. This way to work is not always chic or elegant, that is why many collections vary from season to season.

Which project is so far the most important one for you? The "spot" work I think is my favourite. To produce new design with such a recognisable shape is the challenge. Size, balance, proportion – you have to deal with design in millimetres so it's far harder to make it work visually and to adapt it not only to one product but many products.

Wie würden Sie die Grundidee beschreiben, die hinter Ihren Entwürfen steht? Ich bemühe mich, die Dinge möglichst einfach zu machen. Man muss einen eigenen Blickwinkel finden, Zusammenhänge, Prinzipien und Traditionen verstehen. Wenn man dies klar herausarbeitet, wird das eigentliche Wesen eines Entwurfes sichtbar.

Inwiefern inspiriert London Ihre kreative Arbeit? Ich kann nicht sagen, dass die Stadt mich je inspiriert hätte. Dennoch trage ich eine bestimmte Vorstellung der Stadt immer in mir. Wesen, Kultur und Geschichte aller wichtigen Städte, in denen ich war, haben sich mir eingeprägt und sind wichtige Bezugspunkte für mich.

Gibt es einen typischen Londoner Stil im aktuellen Modedesign? Mode aus London ist kreativ und zukunftsweisend. Immer wieder entsteht etwas Neues. Dies führt nicht immer zu schicken oder eleganten Entwürfen. Darum verändern sich viele Kollektionen von Saison zu Saison.

Welches ist für Sie Ihr bislang wichtigstes Projekt? Spot ist wohl mein Favorit. Ein neues Design mit einem so hohen Wiedererkennungswert zu schaffen, ist eine große Herausforderung. Größe, Balance und Proportion spielen eine wichtige Rolle. Dabei geht es um Millimeter, und es ist schwer, die gewünschte optische Wirkung zu erzielen, zumal wenn es sich nicht um einen Einzelentwurf, sondern um eine ganze Reihe von Produkten handelt.

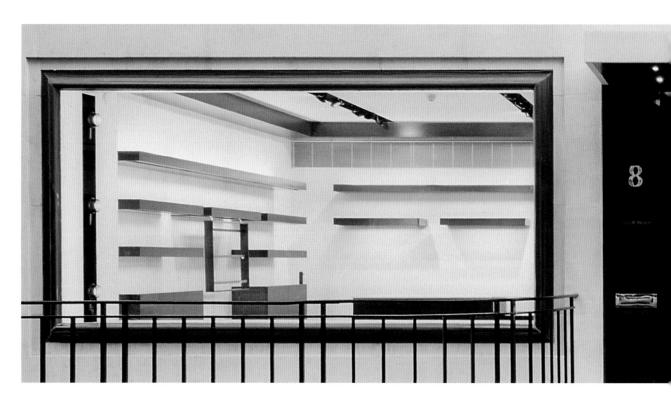

Quelle est, d'après vous, l'idée de base qui sous-tend votre travail de conception ? Je m'efforce de faire les choses le plus simplement possible. Il faut trouver un angle de vue, comprendre le contexte, les principes et les traditions. Quand tout cela ressort clairement, l'« authenticité » du design devient évidente.

Dans quelle mesure Londres inspire-t-il votre créativité ? Je ne peux pas dire que la ville m'ait jamais inspiré. Cependant, j'ai toujours en moi une image parfaite de ce qu'est Londres. L'essence, la culture et l'histoire des villes importantes où je suis allé se sont imprimées en moi et sont devenues des points de repère essentiels pour moi.

Y a-t-il un style typiquement londonien dans la création de mode actuellel ? La mode qui vient de Londres est créative, futuriste et génératrice de nouveauté. Cela ne débouche pas toujours sur des créations chic et élégantes. C'est pourquoi de nombreuses collections varient de saison en saison.

Quel est le projet le plus important pour vous à l'heure actuelle ? Je pense que Spot est mon préféré. Créer un nouveau design à ce point reconnaissable représente un véritable défi. Les dimensions, l'équilibre et les proportions jouent un grand rôle. C'est une question de millimètres, et c'est difficile d'obtenir l'effet optique voulu, spécialement quand il ne s'agit pas d'un seul produit mais de toute une série.

¿Cómo definiría la idea básica que encierran sus diseños? Me esfuerzo por hacer las cosas de la forma más sencilla posible. Se debe encontrar un ángulo de visión propio; comprender relaciones, principios y tradiciones. Una vez aclarado esto, se hace visible la esencia de un diseño.

¿En qué medida inspira la ciudad de Londres su trabajo creativo? No puedo decir si la ciudad me ha inspirado en algún momento. Sin embargo llevo conmigo una idea propia de Londres. La cultura e historia de todas las ciudades importantes en las que he estado me han marcado y se han convertido en importantes puntos de referencia para mí.

¿Existe un estilo típico londinense en el diseño de moda actual? La moda de Londres es creativa y futurista. Constantemente surge una nueva creación. Esto no siempre lleva a diseños elegantes o sofisticados. Por eso de una temporada a otra muchas colecciones se transforman.

¿Cuál ha sido su proyecto más importante hasta el momento? Spot es mi favorito. Crear un nuevo diseño con una forma tan reconocible es un verdadero reto. El tamaño, el equilibrio y la proporción juegan un papel importante. A veces se trata de milímetros y es difícil obtener el efecto óptico deseado, especialmente teniendo en cuenta que no se trata de un boceto único sino de toda una serie de productos.

Come descriverebbe l'idea originaria che sta alla base delle Sue creazioni? Io tento sempre di rendere le cose quanto più semplici possibile. È necessario trovare una visuale propria, comprendere contesti, principi e tradizioni. Una volta che si sia chiarito bene tutto ciò, la vera natura di un progetto diviene visibile.

In che misura Londra ispira la Sua creatività? Non posso dire che la città mi abbia mai ispirato. Tuttavia porto sempre con me una certa idea di questa città. L'essenza, la cultura e la storia di tutte le città più importanti in cui sono stato si sono impresse nella mia immaginazione e sono per me un importante punto di riferimento.

Esiste uno stile tipico di Londra nel design di moda contemporaneo? La moda nata a Londra è creativa e di avanguardia: qui nasce in continuazione qualcosa di nuovo. Questo non vuol dire che tutto sia chic o elegante, ecco perché tante collezioni variano molto da una stagione all'altra.

Qual è per Lei il più importante tra i progetti realizzati finora? Spot è senz'altro il mio favorito. Riuscire a produrre un nuovo design con una forma tanto riconoscibile è una grande sfida: misura, equilibrio e proporzione, tutto gioca un ruolo determinante. Si tratta solo di millimetri, ed è difficile raggiungere l'effetto ottico desiderato, specie se si considera che non si tratta di un unico progetto, bensì di tutta una serie di prodotti.

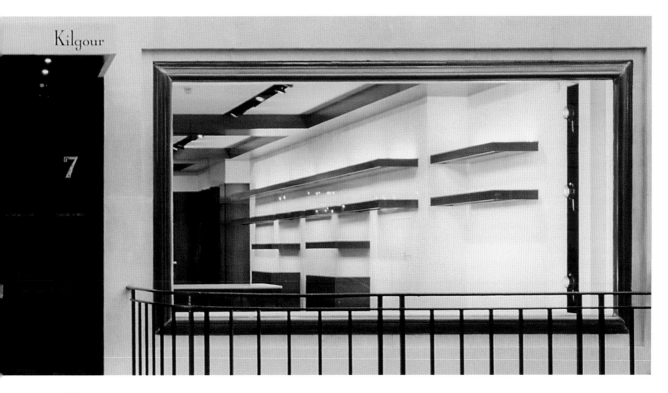

Carlo Brandelli | Kilgour Store

Carlo Brandelli | Kilgour Tie | left Kilgour Mohair Suit 2006

Jasper Conran

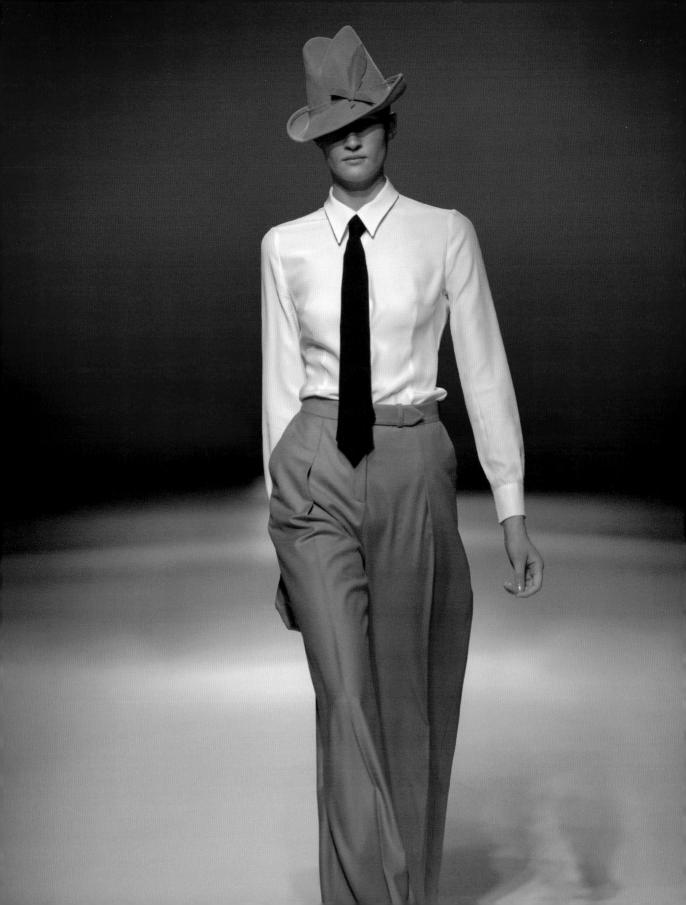

Jasper Conran

36 Sackville Street, London W1S 3EQ

P +44 20 7292 9080

F +44 20 7292 9081

www.jasperconran.com

info@jasperconran.com

Jasper Conran

1959
born in London, UK

1978
first womenswear collection

1985
first menswear collection

Son of the legendary Sir Terence Conran, Jasper Conran was destined to follow in his father's footsteps. He became interested in fashion design at an early age. He presented his first women's collection when he was just 18. Today, Jasper Conran designs a wide range of products – from fashion and furniture to dishes and cutlery. Conran's luxurious flagship store in Mayfair in London is presented as a complete work of art. Today, the Jasper Conran brand is one of the UK's highest-grossing brands.

Als Sohn des legendären Sir Terence Conran wurde Jasper Conran der Beruf des Designers gleichsam in die Wiege gelegt. Sehr früh schon beschäftigte er sich mit Modedesign: Kaum 18 Jahre alt präsentierte er seine erste Damenkollektion. Inzwischen gestaltet Jasper Conran eine enorme Produktpalette – von Mode über Möbel bis hin zu Geschirr und Bestecken. Seinen luxuriösen Flagship-Store in London-Mayfair hat Conran als eine Art Gesamtkunstwerk gestaltet. Die Marke Jasper Conran gehört heute zu den umsatzstärksten Designlabels in England.

Fils du légendaire Sir Terence Conran, Jasper Conran a pratiquement reçu le métier de designer au berceau. Il s'est consacré très tôt au design de mode : à peine âgé de 18 ans, il présentait déjà sa première collection féminine. Entre-temps, Jasper Conran est devenu le créateur d'une large palette de produits – articles de mode, vaisselle, couverts et meubles. Conran a conçu son luxeux magasin amiral à Londres Mayfair comme une œuvre d'art total. La marque Jasper Conran est aujourd'hui l'un des plus gros chiffres d'affaires parmi les marques de design en Angleterre.

Al hijo del legendario Sir Terence Conran la profesión de diseñador le viene ya de la cuna. Desde muy pronto comenzó a ocuparse del diseño de la moda: a los 18 años presentaba su primera colección de ropa femenina. Ahora Jasper Conran presenta una enorme paleta de producción que incluye moda, mobiliario, loza y cubertería. Su lujosa Flagship Store en Londres Mayfair está concebida como una especie de obra de arte completa. Jasper Conran es hoy una de las marcas de diseño de mayor índice de ventas de Inglaterra.

Essendo figlio del leggendario Sir Terence Conran, Jasper Conran in un certo senso era naturalmente predestinato a diventare designer: cominciò, infatti, molto presto ad occuparsi di design di moda, tanto che a 18 anni scarsi già presentava la sua prima collezione di moda femminile. Ormai Jasper Conran progetta un'enorme gamma di prodotti, che va dalla moda ai mobili fino a stoviglie e posateria. Il lussuoso flagship store di Conran a Londra Mayfair è stato concepito dallo stilista come una sorta di "Gesamtkunstwerk". La Jasper Conran è oggi uno dei marchi di design che vantano il più alto volume d'affari in Inghilterra.

Interview | Jasper Conran

How would you describe the basic idea behind your design work? For me it's difficult to identify one basic idea or motivating force behind my work. I would say that I have always been inspired by my English heritage and I return to that and try to re-interpret that in everything I do.

To what extent does working in London inspire your creativity? I find London incredibly inspirational. Although I love to travel, I increasingly find that exploring London ever more deeply can be just as satisfying.

Is there a typical London style in contemporary fashion design? I think it's an attitude really. Maybe a certain respect for tradition tinged with irony. Perhaps it's more of a British style than a London style.

Which project is so far the most important one for you? Whatever I'm working on at the time becomes the most important thing to me. I can't rest until I'm satisfied but once it's finished I quite happily move on to the next thing.

Wie würden Sie die Grundidee beschreiben, die hinter Ihren Entwürfen steht? Es fällt mir schwer, eine einzelne Idee oder Motivation für meine Arbeit zu nennen. Ich würde aber sagen, dass mich die englische Tradition seit jeher inspiriert hat. Immer wieder komme ich auf sie zurück und versuche, sie in allem, was ich tue, neu zu interpretieren.

Inwiefern inspiriert London Ihre kreative Arbeit? Ich finde London unglaublich inspirierend. Obwohl ich sehr gerne reise, finde ich es mindestens genauso anregend, London immer genauer zu erkunden.

Gibt es einen typischen Londoner Stil im aktuellen Modedesign? Ich denke es ist eher eine Haltung, vielleicht ein bestimmter Respekt gegenüber Traditionen mit einem Hauch von Ironie. Doch vielleicht ist dies eher ein britischer Stil als ein Londoner Stil.

Welches ist für Sie Ihr bislang wichtigstes Projekt? Immer das, woran ich gerade arbeite. Ich kann nicht innehalten, bevor ich zufrieden bin. Doch sobald ein Projekt abgeschlossen ist, freue ich mich schon auf das nächste.

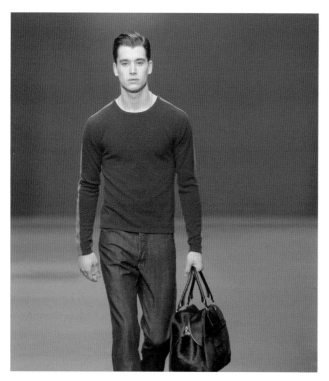

Quelle est, d'après vous, l'idée de base qui sous-tend votre travail de conception ? Il m'est difficile d'identifier l'idée ou la motivation qui guide mon travail. Je dirais que j'ai toujours été inspiré par la tradition anglaise. C'est toujours à elle que je reviens et j'essaie de la réinterpréter dans tout ce que je fais.

Dans quelle mesure Londres inspire-t-il votre créativité ? Je trouve que Londres est une source d'inspiration incroyable. Bien que j'adore voyager, je trouve qu'explorer Londres de plus en plus profondément est tout aussi stimulant.

Y a-t-il un style typiquement londonien dans la création de mode actuelle ? Je pense que c'est plutôt une attitude, peut-être une sorte de respect, teinté d'ironie, vis-à-vis des traditions. Mais c'est peut-être davantage un style britannique qu'un style londonien.

Quel est le projet le plus important pour vous à l'heure actuelle ? Ce sur quoi je travaille justement est toujours le plus important pour moi. Je ne peux pas m'arrêter avant d'être entièrement satisfait. Mais une fois qu'un projet est terminé, je passe avec plaisir au suivant.

¿Cómo definiría la idea básica que encierran sus diseños? Me resulta difícil mencionar una única motivación o idea para mi trabajo. En cualquier caso, la tradición inglesa me ha inspirado desde siempre. Siempre la retomo e intento reinterpretarla en todo lo que hago.

¿En qué medida inspira la ciudad de Londres su trabajo creativo? Londres es inmensamente inspirador. Aunque me gusta mucho viajar, me parece igual de apasionante lanzarme a descubrir esta ciudad cada vez más profundamente.

¿Existe un estilo típico londinense en el diseño de moda actual? Creo que es más bien una postura, tal vez un cierto respeto frente a tradiciones, con un toque de ironía. Aunque probablemente se trate de un estilo británico más que de un estilo londinense.

¿Cuál ha sido su proyecto más importante hasta el momento? Siempre en lo que estoy trabajando en el momento. No puedo parar hasta estar totalmente satisfecho. Pero en el momento que he finalizado un proyecto ya estoy ilusionado con el siguiente.

Come descriverebbe l'idea originaria che sta alla base delle Sue creazioni? Mi riesce difficile citare un'unica idea o motivazione che sia all'origine del mio lavoro. Direi però che la tradizione inglese mi ispira da sempre. È a lei che ritorno ogni volta ed è lei che tento di reinterpretare in tutto ciò che faccio.

In che misura Londra ispira la Sua creatività? Trovo che Londra sia un'incredibile fonte di ispirazione. Nonostante io ami molto viaggiare, mi sembra che sia almeno altrettanto stimolante esplorare Londra sempre più in profondità.

Esiste uno stile tipico di Londra nel design di moda contemporaneo? Credo che sia piuttosto un atteggiamento, forse un certo rispetto nei confronti delle tradizioni, unito ad un pizzico di ironia. Forse questo è più uno stile britannico che non uno tipicamente londinese.

Qual è per Lei il più importante tra i progetti realizzati finora? È sempre il progetto cui sto lavorando al momento. Non posso fermarmi finché non sono soddisfatto. Ma appena un progetto si conclude, comincio a pregustare quello che verrà.

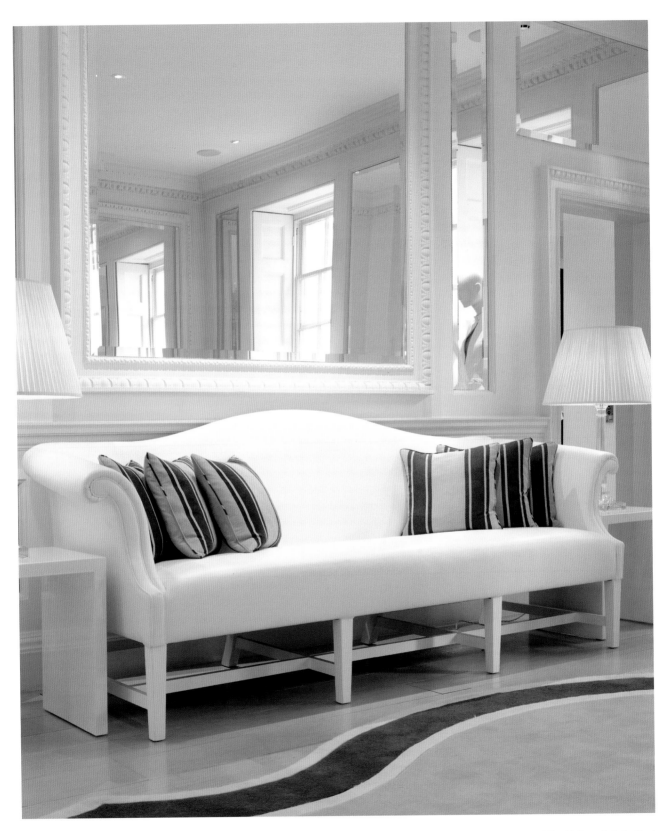

Jasper Conran | Flagship Store Sackville Street

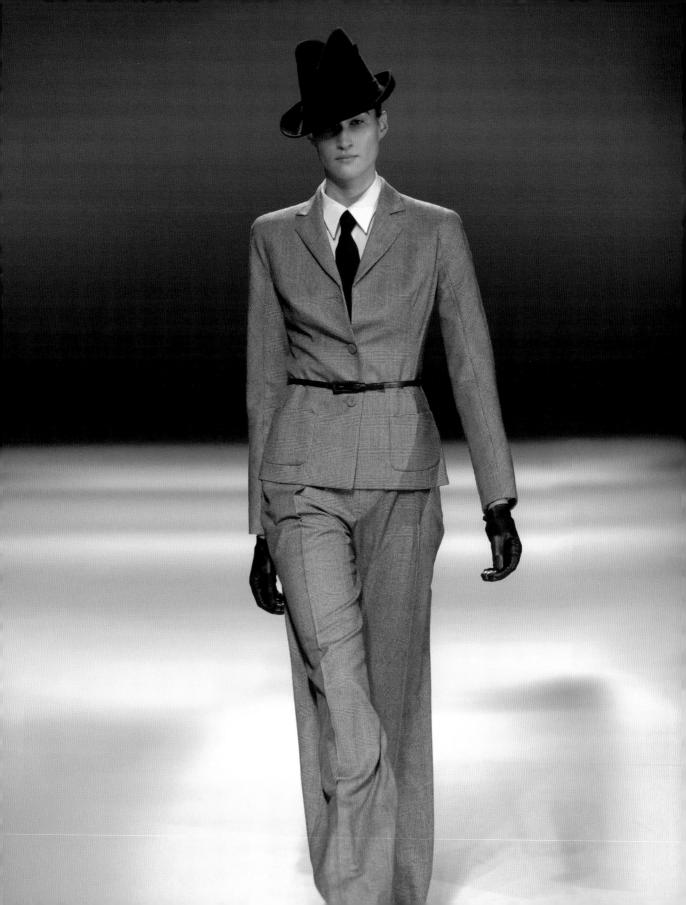

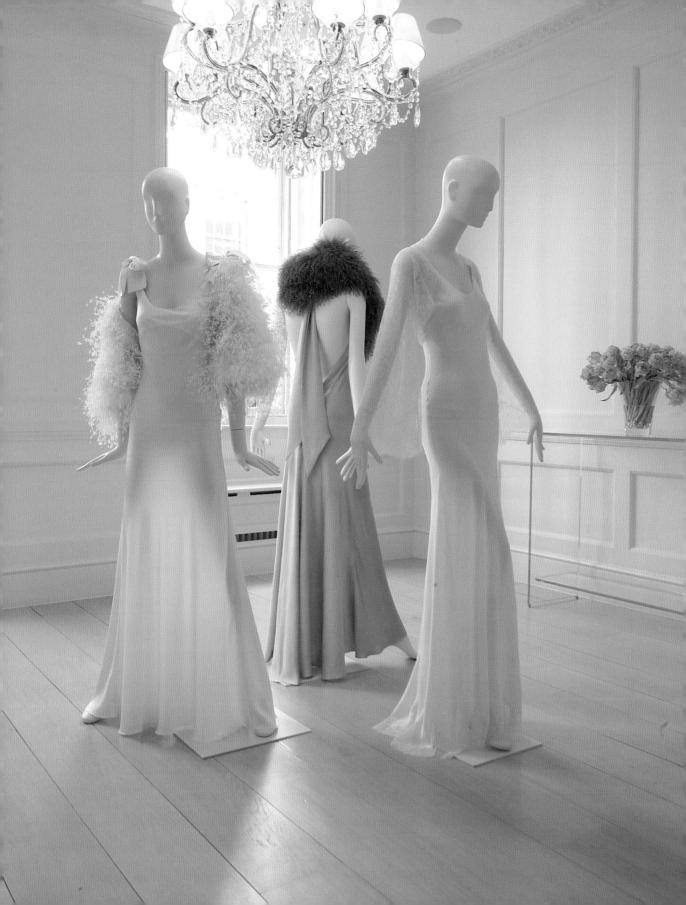

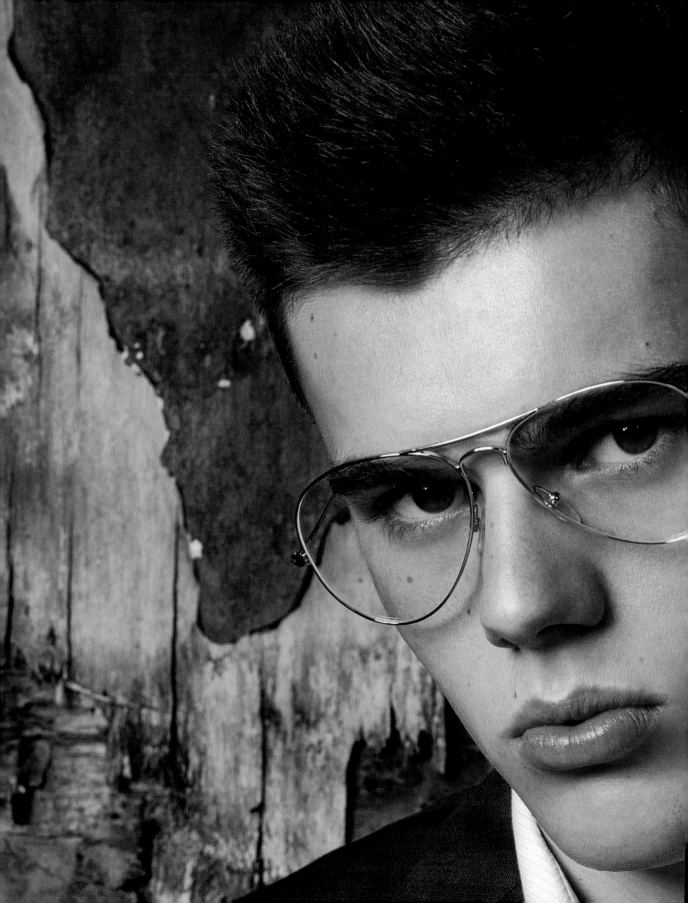

CUTLER AND GROSS

CUTLER AND GROSS

16 Knightsbridge Green, London SW1X 7QL

P +44 20 7590 9030

F +44 20 7584 5702

www.cutlerandgross.com

info@cutlerandgross.com

Graham Cutler

1938
born in London, UK

Tony Gross

1939
born in London, UK

1971
CUTLER AND GROSS

Graham Cutler and Tony Gross have been designing original and fashionable spectacles since 1969. Original frames from the seventies and eighties have long been collector's items, fetching prices of up to 1.000 pounds. As their current collections show, Cutler and Gross have lost nothing of their creativity and feeling for styling – even their latest designs promise to be the classics of tomorrow.

Seit 1969 gestalten Graham Cutler und Tony Gross originelle und modische Brillen. Originalgestelle aus den siebziger und achtziger Jahren sind längst begehrte Sammlerstücke, für die bis zu 1.000 Pfund gezahlt werden. Wie ihre aktuellen Kollektionen zeigen, haben Cutler and Gross bis heute nichts von ihrer Kreativität und Stilsicherheit eingebüßt – auch die neuen Entwürfe versprechen, zu Klassikern von morgen zu werden.

Depuis 1969, Graham Cutler et Tony Gross dessinent des lunettes originales et à la mode. Certaines montures d'origine des années soixante-dix et quatre-vingt sont depuis longtemps des pièces de collection convoitées, pour lesquelles on débourse jusqu'à 1.000 livres. Ainsi qu'en témoignent les collections actuelles, Cutler et Gross n'ont rien perdu de leur créativité et de leur assurance stylistique – les nouvelles esquisses sont appelées à devenir les classiques de demain.

Desde 1969 Graham Cutler y Tony Gross diseñan gafas originales y de moda. Las monturas originales de los años setenta y ochenta son desde hace mucho tiempo objetos que ambicionan los coleccionistas y por los que se llega a pagar hasta 1.000 libras. Cutler and Gross no han perdido su creatividad y convicción de estilo, como muestran sus colecciones actuales, y sus nuevas concepciones prometen ser los clásicos de mañana.

Già nel 1969 Graham Cutler e Tony Gross iniziarono a creare occhiali originali ed alla moda. Montature originali degli anni Settanta ed Ottanta sono ormai da tempo ricercatissimi pezzi da collezione, per cui non è raro pagare fino a 1.000 sterline. Ma ancora oggi, come dimostrano le loro attuali collezioni, Cutler e Gross non hanno perso nulla della loro creatività e sicurezza stilistica: anche le nuove creazioni promettono di diventare classici di domani.

Interview | CUTLER AND GROSS

How would you describe the basic idea behind your design work? The glasses must function well. They must be well made and built to last. They must have sex-appeal.

To what extent does working in London inspire your creativity? London is the loveliest city in the world noted for its originality and speed of change.

Is there a typical London style in contemporary fashion design? London style must incorporate a degree of eccentricity.

Which project is so far the most important one for you? Most recently my collaboration with Comme des Garçons.

Wie würden Sie die Grundidee beschreiben, die hinter Ihren Entwürfen steht? Die Brillen müssen gut zu gebrauchen, hochwertig und langlebig sein. Sie müssen Sex-Appeal haben.

Inwiefern inspiriert London Ihre kreative Arbeit? London ist die großartigste Stadt der Welt, bekannt für ihre Originalität und rasanten Veränderungen.

Gibt es einen typischen Londoner Stil im aktuellen Modedesign? Londoner Stil beinhaltet immer ein gewisses Maß an Exzentrik.

Welches ist für Sie Ihr bislang wichtigstes Projekt? Zurzeit meine Zusammenarbeit mit Comme des Garçons.

Quelle est, d'après vous, l'idée de base qui sous-tend votre travail de conception ? Les lunettes doivent être fonctionnelles, de bonne qualité et faites pour durer. Elles doivent également avoir du sex-appeal.

Dans quelle mesure Londres inspire-t-il votre créativité ? Londres est la ville la plus fabuleuse au monde, connue pour son originalité et la rapidité des changements.

Y a-t-il un style typiquement londonien dans la création de mode actuellel ? Le style londonien contient toujours une certaine dose d'excentricité.

Quel est le projet le plus important pour vous à l'heure actuelle ? Actuellement, ma collaboration avec Comme des Garçons.

¿Cómo definiría la idea básica que encierran sus diseños? Las gafas deben funcionar bien, ser duraderas y de alta calidad. Y deben tener sex-appeal.

¿En qué medida inspira la ciudad de Londres su trabajo creativo? Londres es la ciudad más fantástica del mundo, conocida por su originalidad y sus vertiginosos cambios.

¿Existe un estilo típico londinense en el diseño de moda actual? El estilo londinense incluye una cierta dosis de excentricidad.

¿Cuál ha sido su proyecto más importante hasta el momento? Actualmente mi trabajo en colaboración con Comme des Garçons.

Come descriverebbe l'idea originaria che sta alla base delle Sue creazioni? Gli occhiali devono essere pratici da usare, di ottima qualità e fatti per durare. Devono avere sex-appeal.

In che misura Londra ispira la Sua creatività? Londra è la più bella città al mondo, nota per la sua originalità e per la velocità fulminea dei suoi mutamenti.

Esiste uno stile tipico di Londra nel design di moda contemporaneo? Lo stile londinese comporta sempre un certo grado di eccentricità.

Qual è per Lei il più importante tra i progetti realizzati finora? Attualmente la mia collaborazione con Comme des Garçons.

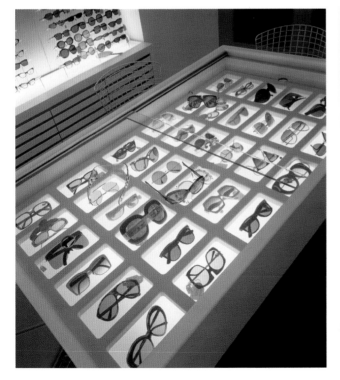

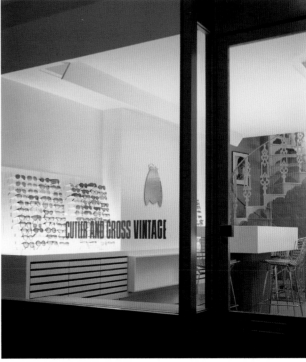

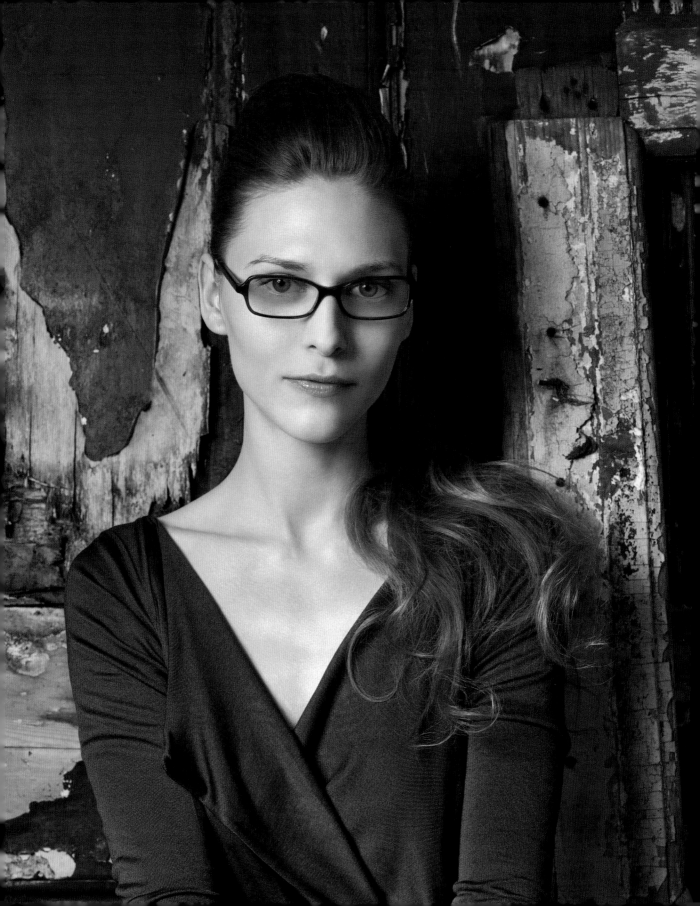

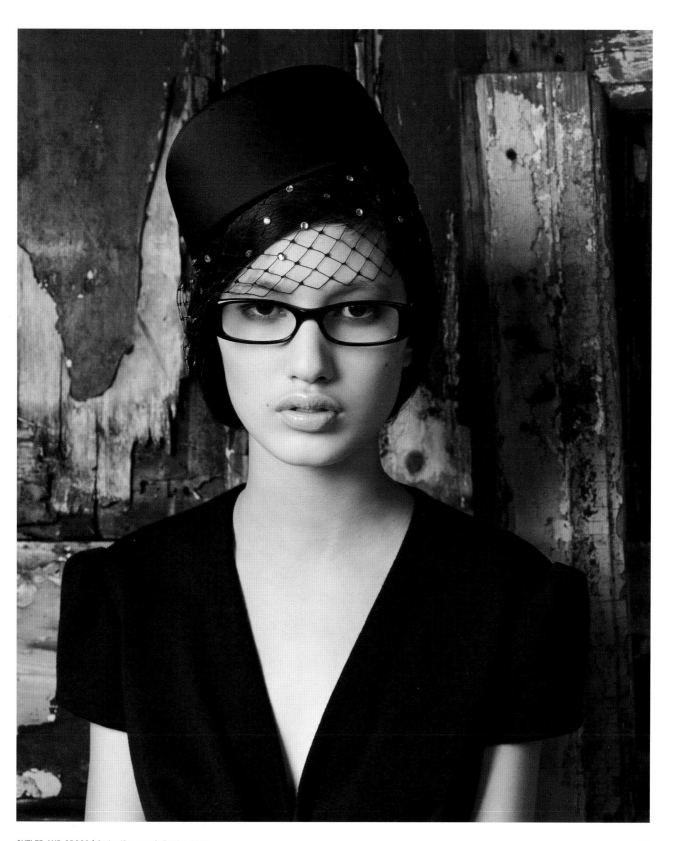

Georgina Goodman

Georgina Goodman

12/14 Shepherd Street, London W1J 7JF

P +44 20 7499 8599

F +44 20 7499 8598

www.georginagoodman.com

info@georginagoodman.com

Georgina Goodman

1965
born in Brighton, UK

2002
first couture collection

Consistency, clarity, plausibility and a passionate commitment to work are the secrets of shoe designer Georgina Goodman's success. Before embarking on her career as a designer, Georgina Goodman became thoroughly acquainted with the industry by working for various fashion magazines. She opened her flagship store in the heart of London in December 2002, and today her shoes, fashions, bags and accessories are extremely popular all over the world.

Beständigkeit, Klarheit, Wahrhaftigkeit und leidenschaftliche Hingabe an die Arbeit, das ist das Erfolgsrezept der Schuhdesignerin Georgina Goodman. Bevor sie selbst als Gestalterin Karriere machte, hatte Georgina Goodman die Branche zunächst als Mitarbeiterin verschiedener Modezeitschriften kennen gelernt. Ihren Flagship-Store im Herzen Londons eröffnete sie im Dezember 2002. Inzwischen vertreibt sie weltweit mit großem Erfolg Schuhe, Mode, Handtaschen und Accessoires.

Constance, clarté, sincérité et dévouement passionné sont la recette du succès de la créatrice de chaussures Georgina Goodman. Avant de faire elle-même carrière comme créatrice, Georgina Goodman avait fait connaissance avec ce secteur en collaborant à divers magazines de mode. Elle a ouvert son magasin amiral au cœur de Londres en décembre 2002. Entre-temps, elle distribue, avec un énorme succès dans le monde entier, chaussures, articles de mode, sacs à main et accessoires.

Permanencia, claridad, autenticidad y dedicación apasionada al trabajo componen la receta del éxito de la diseñadora de calzado Georgina Goodman. Antes de que comenzara a hacer carrera como creadora, Georgina Goodman trabajó en el mundo de la moda para diversas revistas. Su Flagship Store, ubicada en el corazón de Londres, fue inaugurada en diciembre de 2002. Entretanto vende con gran éxito calzado, moda, accesorios, y bolsos por todo el mundo.

Costanza, chiarezza, autenticità e una dedizione appassionata al lavoro: questa è la ricetta del successo della designer di calzature Georgina Goodman. Prima di fare carriera come stilista, la Goodman aveva avuto modo di conoscere il settore lavorando come collaboratrice di numerose riviste di moda. Il suo flagship store ha aperto i battenti in pieno centro di Londra nel 2002 e ormai i prodotti da lei commercializzati in tutto il mondo con grande successo includono scarpe, moda, borsette ed accessori.

Interview | Georgina Goodman

How would you describe the basic idea behind your design work? The concept of "all is one". My designs appeal to the more artistic woman as we are a non-conformist label. We are not afraid to use colour and bold shapes. I think about shoes in sculptural terms.

To what extent does working in London inspire your creativity? The cultural diversity of London is well known. Everywhere you look, as you drive to work, walk with your child in the park or have lunch with friends, there is something that will inspire and excite your creative pulse.

Is there a typical London style in contemporary fashion design? London has a more relaxed, urban-bohemian look than you will find in other European countries. People who live in London are not afraid to express their individuality in the way they dress.

Which project is so far the most important one to you? Organic design, shape and form which was mastered by the architectural concept of Frank Lloyd Wright later seen commercialised in the work of Charles and Ray Eames. This concept has helped me shape my aesthetic.

Wie würden Sie die Grundidee beschreiben, die hinter Ihren Entwürfen steht? „Alles ist eins" ist das Konzept. Meine Entwürfe sprechen eher künstlerisch orientierte Frauen an, denn wir sind eine unangepasstes Label. Wir haben keine Angst vor Farben und gewagten Formen. Ich verstehe Schuhe als Skulpturen.

Inwiefern inspiriert London Ihre kreative Arbeit? Die kulturelle Vielfalt Londons ist wohlbekannt. Wohin man auch sieht, während man zur Arbeit fährt, mit seinem Kind im Park spazieren geht oder mit Freunden zu Mittag isst, findet man etwas Inspirierendes, das den kreativen Puls anregt.

Gibt es einen typischen Londoner Stil im aktuellen Modedesign? In London findet man einen entspannteren, städtisch-bohemienhafteren Look als in anderen europäischen Ländern. Die Menschen in London scheuen sich nicht, ihre Individualität durch ihre Kleidung zum Ausdruck zu bringen.

Welches ist für Sie Ihr bislang wichtigstes Projekt? Das organische Design, Gestalt und Form, wie es im architektonischen Konzept von Frank Lloyd Wright zu finden ist und später in den Arbeiten von Charles und Ray Eames kommerzialisiert wurde. Dieses Konzept half mir sehr dabei, meine eigene Ästhetik zu entwickeln.

Quelle est, d'après vous, l'idée de base qui sous-tend votre travail de conception ?
Le concept repose sur l'idée que « tout est un ». Mes créations interpellent des femmes sensibles à l'art car nous sommes une marque non-conformiste. Nous n'avons pas peur des couleurs ni des formes hardies. Quant à moi, je vois la chaussure comme une sculpture.

Dans quelle mesure Londres inspire-t-il votre créativité ? La diversité culturelle de Londres est bien connue. Où que l'on regarde, en allant au travail, en promenade avec son enfant au parc ou en déjeunant avec des amis, il y a toujours quelque chose qui vous inspirera et touchera la corde sensible de la création.

Y a-t-il un style typiquement londonien dans la création de mode actuelle ? Londres a un caractère plus relax, urbain et bohème à la fois, que les autres villes européennes. Les gens à Londres n'ont pas peur d'exprimer leur individualité à travers l'habillement.

Quel est le projet le plus important pour vous à l'heure actuelle ? Le design organique, la configuration et la forme, que l'on rencontre dans le concept architectural de Frank Lloyd Wright et qui fut commercialisé plus tard dans les travaux de Charles et Ray Eames. Ce concept m'a beaucoup aidé à développer ma propre esthétique.

¿Cómo definiría la idea básica que encierran sus diseños? El concepto es "todo es uno". Mis bocetos atraen más bien a mujeres de orientación artística, puesto que nosotros somos una marca no conformista No tenemos miedo a los colores y las formas atrevidas. Yo pienso los zapatos como esculturas.

¿En qué medida inspira la ciudad de Londres su trabajo creativo? Londres es conocido por su diversidad cultural. Se mire donde se mire, ya sea de camino al trabajo, dando un paseo con un hijo por el parque o comiendo con los amigos, siempre se aprecia algo inspirador que incita el pulso creativo.

¿Existe un estilo típico londinense en el diseño de moda actual? En Londres se encuentra un look más relajante, urbano y bohemio que en otros países europeos. Los habitantes de Londres no sienten vergüenza de mostrar su individualidad a través de su vestimenta.

¿Cuál ha sido su proyecto más importante hasta el momento? El diseño orgánico, figura y forma que se desprende del concepto arquitectónico de Frank Lloyd Wright y más tarde se comercializó en los trabajos de Charles y Ray Eames. Ese concepto me ayudó mucho a desarrollar mi propia estética.

Come descriverebbe l'idea originaria che sta alla base delle Sue creazioni? "Tutto è uno": questo è il concetto di base. Le mie creazioni si rivolgono a donne di orientamento artistico perché siamo una marca anticonformista. Non abbiamo paura di usare il colore e forme audaci. Per me le calzature sono delle sculture.

In che misura Londra ispira la Sua creatività? La molteplicità culturale di Londra è ben nota. Ovunque si guardi, andando in macchina al lavoro, o passeggiando con il proprio bambino nel parco, o durante un pranzo con amici, continuamente si trova qualcosa che ispira e stimola la creatività.

Esiste uno stile tipico di Londra nel design di moda contemporaneo? Londra ha un aspetto più rilassato, più urbano e bohemien di altre città europee. Chi vive a Londra non ha paura di esprimere la propria individualità con il suo modo di vestirsi.

Qual è per Lei il più importante tra i progetti realizzati finora? Il design, la figura e la forma organici, così come erano presenti nella concezione architettonica di Frank Lloyd Wright e come successivamente sono stati commercializzati nell'opera di Charles e Ray Eames. Questa concezione mi ha molto aiutato a sviluppare la mia estetica individuale.

Georgina Goodman | Tate, Kaela 2006 | left Camouflage

Georgina Goodman | Scarf 2006

Georgina Goodman | Elba, Cadee 2006

Richard James

Richard James

29 Savile Row, London W1S 2EY

P +44 20 7434 0605

F +44 20 7287 2256

www.richardjames.co.uk

mail@richardjames.co.uk

Richard James
born in Wales, UK

Sean Dixon

1992
establishing Richard James
fashion house

Richard James is widely regarded as one of the leading renovators of Savile Row, London's famous address for menswear. In the midst of classic traditional businesses – some well over 100 years old – Richard James opened his shop in 1992 in partnership with Sean Dixon, presenting brightly coloured shirts, smart ties and elegant suits in a loft-like ambience. Since then, Richard James has received numerous international awards and been named "British Menswear Designer of the Year".

Richard James gilt als einer der wichtigsten Erneuerer in der Savile Row, der berühmten Adresse für Herrenmode in London. Zwischen klassischen, zum Teil weit über 100 Jahre alten Traditionsgeschäften eröffnete Richard James zusammen mit Sean Dixon 1992 sein Geschäft, in dem er in loftähnlicher Atmosphäre farbenfrohe Hemden, schicke Krawatten und elegante Anzüge präsentierte. Richard James wurde seither mit vielen internationalen Preisen ausgezeichnet, unter anderem als „British Menswear Designer of the Year".

Richard James est considéré comme l'un des rénovateurs les plus importants de Savile Row, la célèbre rue de la mode masculine à Londres. Entre les magasins classiques, porteurs d'une tradition parfois vieille de plus d'un siècle, Richard James a ouvert son magasin avec Sean Dixon, en 1992, dans lequel il a présenté des chemises aux couleurs gaies, des cravates chic et des costumes élégants dans une atmosphère de loft. Depuis, Richard James a reçu de nombreux prix internationaux, entre autres celui du « British Menswear Designer of the Year ».

Richard James es considerado uno de los más importantes renovadores de Savile Row, la famosa calle de Londres para moda masculina. En 1992, entre establecimientos clásicos, algunos con más de cien años de tradición, Richard James y Sean Dixon abrieron su comercio dotándolo de un ambiente de loft. En él presentan sus camisas de colores alegres y corbatas y trajes elegantes. Desde entonces Richard James ha sido premiado con numerosos galardones internacionales, entre ellos el de "British Menswear Designer of the Year".

Richard James è considerato uno dei più importanti innovatori di Savile Row, il rinomato indirizzo della moda maschile a Londra. In mezzo a classici negozi che in parte vantano una tradizione più che centenaria, nel 1992 Richard James ha aperto insieme a Sean Dixon un negozio in cui presentava in un'atmosfera da loft camicie dai colori sgargianti, cravatte chic e abiti eleganti. Da allora Richard James è stato insignito di numerosi premi internazionali, tra cui quello di "British Menswear Designer of the Year".

Interview | Richard James

How would you describe the basic idea behind your design work? I design in the boundaries of classic English menswear, with in these confines I can be as subtle or eccentric as I want because the classicness and Englishness keeps it grounded and wearable.

To what extent does working in London inspire your creativity? London in general and Savile Row in particular inspire me totally.

Is there a typical London style in contemporary fashion design? I think there is a very definite attitude in London. People were clothes less self-consciously here than anywhere else in the world. London leads because of this.

Which project is so far the most important one for you? At present our new store at 19 Clifford Street which will open in March 2007. This shop will only sell bespoke tailoring and unique products which will be sold in very limited quantities exclusively to that store. I'm also working on our first store outside of the UK which will also open in March next year in Roppongi, Tokyo.

Wie würden Sie die Grundidee beschreiben, die hinter Ihren Entwürfen steht? Ich entwerfe innerhalb der Vorgaben der klassischen englischen Herrenmode. Dadurch kann ich so subtil oder exzentrisch sein, wie ich will – der klassische und typisch englische Stil sorgt immer dafür, dass meine Entwürfe bodenständig und tragbar bleiben.

Inwiefern inspiriert London Ihre kreative Arbeit? London im Allgemeinen und die Savile Row im Besonderen sind für mich die totale Inspiration.

Gibt es einen typischen Londoner Stil im aktuellen Modedesign? Ich finde, dass es in London eine ganz bestimmte Haltung gibt. Die Leute hier kleiden sich viel unbefangener als irgendwo sonst – darum ist London in der Welt führend.

Welches ist für Sie Ihr bislang wichtigstes Projekt? Zurzeit unser neues Geschäft in der Clifford Street 19, das im März 2007 eröffnet wird. Hier soll es nur maßgeschneiderte Kleidung geben und Sonderanfertigungen, die in limitierter Stückzahl ausschließlich in diesem Laden verkauft werden. Außerdem planen wir gerade unser erstes Geschäft außerhalb Großbritanniens, das ebenfalls nächsten März in Roppongi, Tokio, öffnen soll.

Richard James | Red Cufflink 2002, Suit 2006

Quelle est, d'après vous, l'idée de base qui sous-tend votre travail de conception ?
Je crée dans les normes de la mode masculine anglaise classique. Ainsi, je peux être aussi subtil et excentrique que je veux – le style classique et typiquement anglais fait que mes créations sont toujours mettables et bien enracinées.

Dans quelle mesure Londres inspire-t-il votre créativité ? Londres en général, et Savile Row en particulier, sont pour moi une totale source d'inspiration.

Y a-t-il un style typiquement londonien dans la création de mode actuellel ? Je trouve qu'il y a une attitude bien définie à Londres. Ici, les gens s'habillent de façon bien plus naturelle que nulle part ailleurs – c'est pourquoi Londres est leader dans le monde.

Quel est le projet le plus important pour vous à l'heure actuelle ? En ce moment, notre nouveau magasin au 19, Clifford Street, qui s'ouvrira en mars 2007. Il n'y aura que de la confection sur mesure et des créations uniques qui seront vendues en nombre limité exclusivement à ce magasin. De plus, nous projetons notre premier magasin en dehors de la Grande-Bretagne qui s'ouvrira également en mars prochain à Roppongi, Tokyo.

¿Cómo definiría la idea básica que encierran sus diseños? Diseño dentro de los límites de la moda masculina clásica siendo lo sutil y excéntrico que desee. El típico clásico estilo inglés se encarga siempre de que mis diseños sean arraigados y ponibles.

¿En qué medida inspira la ciudad de Londres su trabajo creativo? Londres en general y la Savile Row en especial son para mí la inspiración absoluta.

¿Existe un estilo típico londinense en el diseño de moda actual? Creo que en Londres hay una postura claramente definida. Aquí la gente se viste de forma mucho menos tímida que en cualquier otro sitio. Por eso Londres está a la cabeza internacionalmente.

¿Cuál ha sido su proyecto más importante hasta el momento? En este momento nuestro comercio de Clifford Street 19, que será inaugurado en marzo de 2007. En él se venderán exclusivamente prendas hechas a medida y confecciones especiales que serán vendidas unicamente en esta tienda en número limitado. Además estamos planeando nuestro primer comercio fuera de Gran Bretaña, que también abrirá sus puertas el próximo marzo en Roppongi, Tokio.

Come descriverebbe l'idea originaria che sta alla base delle Sue creazioni? La mia attività di stilista si svolge entro i parametri della classica moda maschile inglese. In tal modo posso essere tanto sottile o eccentrico quanto voglio: lo stile, classico e tipicamente inglese, fa sì che le mie creazioni restino genuine ed indossabili.

In che misura Londra ispira la Sua creatività? Londra in generale e Savile Row in particolare sono per me una fonte d'ispirazione totale.

Esiste uno stile tipico di Londra nel design di moda contemporaneo? Trovo che a Londra esista un atteggiamento tutto particolare: la gente qui si veste con molta più disinvoltura che altrove – è per questo motivo che Londra ha una funzione trainante a livello mondiale.

Qual è per Lei il più importante tra i progetti realizzati finora? Attualmente il nostro nuovo negozio in Clifford Street 19, che verrà aperto nel marzo 2007. Qui sarà possibile acquistare solo abbigliamento su misura e pezzi unici, che verranno venduti in quantità limitata esclusivamente in questo negozio. Inoltre, stiamo progettando il nostro primo negozio al di fuori della Gran Bretagna, che aprirà anch'esso i battenti nel marzo del prossimo anno a Roppongi, Tokio.

Richard James | Shirt 2006, Fragrance 2003

Richard James | Suit 2006

Stephen Jones Millinery

36 Great Queen Street, Covent Garden, London WC2B 5AA

P +44 20 7242 0770

F +44 20 7242 0796

www.stephenjonesmillinery.com

shop@stephenjonesmillinery.com

Stephen Jones

1957
born in Cheshire, UK

1980
Millinery salon
in Covent Garden established

By his own admission, it was a lucky coincidence that Stephen Jones became a milliner – there was a milliner's workshop just next door to where he trained as a tailor. Key characteristics of his designs are asymmetry, eccentricity and angular humour. His latest collection is a journey through time that starts in the eighties and moves on to the following decade, each stage being determined by a specific colour and theme, from the Designer Decade and New Age to Deconstruction and Future Baroque.

Durch Zufall, sagt Stephen Jones, sei er Hutmacher geworden: Als er seine Ausbildung als Schneider absolvierte, lag die Werkstatt der Hutmacher gerade nebenan. Kennzeichen seiner Entwürfe sind Asymmetrie, Exzentrik und schräger Witz. Seine aktuelle Kollektion versteht sich als Zeitreise von den achtziger Jahren bis in das nächste Jahrzehnt, wobei jeder Phase eine bestimmte Farbe und Thematik zugeordnet ist – von der Designer Decade über New Age, Deconstruction bis hin zum Future Baroque.

Stephen Jones prétend qu'il est devenu chapelier par hasard : juste à côté de l'endroit où il suivait une formation de tailleur se trouvait l'atelier des chapeliers. Asymétrie, excentricité et humour décalé sont les caractéristiques de ses dessins. Sa collection actuelle ambitionne d'être un voyage dans le temps, des années quatre-vingt à la prochaine décennie, où chaque période se voit attribuer une couleur et un thème propre – Designer Decade, New Age, Deconstruction, Future Baroque.

Según cuenta Stephen Jones él es sombrerero por casualidad. Cuando hizo su formación de sastre tenía la fábrica de sombreros justo al lado. Sus diseños se caracterizan por las formas asimétricas, la excentricidad y una estrambótica gracia. Su actual colección se interpreta como un viaje en el tiempo de los años ochenta a la década posterior, en el que cada fase se ajusta a un determinado color y temática: la Designer Decade, la New Age, la Deconstrucción y hasta el Future Baroque.

Fu per caso – racconta l'interessato – che Stephen Jones divenne stilista di cappelli: subito accanto al luogo in cui svolse il suo apprendistato da sarto, infatti, si trovava un laboratorio di cappellai. Tipici delle sue creazioni sono asimmetria, eccentricità e un'arguzia stravagante. La sua collezione attuale è concepita come un viaggio nel tempo spaziante dagli anni Ottanta al decennio che verrà, laddove ogni fase è contraddistinta da un certo colore e una precisa tematica: dalla Designer Decade passando per la New Age e la Deconstruction fino al Future Baroque.

Interview | Stephen Jones

How would you describe the basic idea behind your design work? To create a fantasy that you put on your head that transports you to the place and person you want to be.

To what extent does working in London inspire your creativity? The juxtaposition of tradition and innovation. London being at the crossroads of the English speaking world is therefore a totally multicultural society and a unique blend of fashion and music.

Is there a typical London style in contemporary fashion design? Yes, but as a Londoner it is impossible to define, which is actually why the "style anglaise" is so popular in Europe, Japan and the United States. But to real Londoners it is undefinable and allusive.

Which project is so far the most important one for you? AWOL, the stamp hat, the silhouette of a hat but not an actual a hat.

Wie würden Sie die Grundidee beschreiben, die hinter Ihren Entwürfen steht? Ein Fantasiegebilde zu schaffen, das man sich auf den Kopf setzen kann und das einen an den Ort versetzt, an dem man gerne wäre, und in die Person verwandelt, die man gerne wäre.

Inwiefern inspiriert London Ihre kreative Arbeit? Der Gegensatz von Tradition und Innovation. London als Knotenpunkt innerhalb der englischsprachigen Welt ist absolut multikulturell. Außerdem gibt es hier eine einzigartige Mischung aus Modewelt und Musikszene.

Gibt es einen typischen Londoner Stil im aktuellen Modedesign? Sicher, aber ich als Londoner kann ihn unmöglich definieren. Vielleicht ist der „Style anglais" gerade deshalb in Europa, Japan und den Vereinigten Staaten so populär, weil er für die echten Londoner so schwer greifbar und zu beschreiben ist.

Welches ist für Sie Ihr bislang wichtigstes Projekt? AWOL, der ausgestanzte Hut, eher die Silhouette eines Hutes als ein tatsächlicher Hut.

Quelle est, d'après vous, l'idée de base qui sous-tend votre travail de conception ? Créer une fantaisie qui se mette sur la tête, qui vous transporte là où vous souhaiteriez être et qui vous transforme en la personne que vous aimeriez être.

Dans quelle mesure Londres inspire-t-il votre créativité ? Le contraste entre la tradition et l'innovation. Londres, point de jonction au sein du monde anglophone, est complètement multiculturel. En outre, il y a ici un mélange unique de mode et de musique.

Y a-t-il un style typiquement londonien dans la création de mode actuelle? Certainement, mais en tant que Londonien, je suis incapable de le définir. Le « style anglais » est peut-être aussi populaire en Europe, au Japon et aux Etats-Unis parce qu'il est difficilement palpable et impossible à décrire pour les Londoniens.

Quel est le projet le plus important pour vous à l'heure actuelle ? AWOL, le chapeau découpé, plus la silhouette d'un chapeau qu'un véritable chapeau.

¿Cómo definiría la idea básica que encierran sus diseños? Crear una fantasía que llevas en la mente, te traslada al lugar en el que se deseas estar y te transforma en la persona que deseas ser.

¿En qué medida inspira la ciudad de Londres su trabajo creativo? La conjugación entre tradición e innovación. Londres como punto de enlace del mundo de habla inglesa es absolutamente multicultural. Además aquí existe una mezcla excepcional del mundo de la moda y la escena musical.

¿Existe un estilo típico londinense en el diseño de moda actual? Por supuesto, pero es imposible que yo, como londinense, lo pueda definir. Quizá el "style anglais" es actualmente tan popular en Europa, Japón y Estados Unidos porque para los verdaderos londinenses es difícil de describir y comprender.

¿Cuál ha sido su proyecto más importante hasta el momento? AWOL, el sombrero troquelado; más bien la silueta de un sombrero que un sombrero real.

Come descriverebbe l'idea originaria che sta alla base delle Sue creazioni? Creare una fantasia che, una volta messa in testa, porti nel luogo in cui ci si vorrebbe trovare e trasformi nella persona che si vorrebbe essere.

In che misura Londra ispira la Sua creatività? La contrapposizione di tradizione e innovazione. Londra, in quanto crocevia all'interno del mondo anglofono, ha un carattere profondamente multiculturale. Inoltre, qui si mescolano in modo davvero singolare il mondo della moda e quello della musica.

Esiste uno stile tipico di Londra nel design di moda contemporaneo? Certo, ma in quanto londinese non mi è possibile definirlo. È forse proprio per questo che lo "style anglais" gode di tanta popolarità in Europa, Giappone e negli Stati Uniti: perché resta tanto difficile da cogliere e descrivere per i veri londinesi.

Qual è per Lei il più importante tra i progetti realizzati finora? AWOL, il cappello ritagliato, più la silhouette di un cappello che un cappello vero e proprio.

Stella McCartney

Stella McCartney

30 Bruton Street, London W1J 6LG

P +44 20 7518 3100

www.stellamccartney.com

shop@stellamccartney.com

Stella McCartney

1971
born in London, UK

2001
establishing
Stella McCartney
fashion house

After spending four years as the creative director at Chloé in Paris, Stella McCartney set up her own fashion label under her own name. The opening of her flagship store in New York in 2002 was followed by others in London and Los Angeles in 2003. In addition to extremely successful collections for H&M and Adidas, Stella McCartney has also designed extravagant and exclusive stage costumes for musicians such as Madonna and Annie Lennox.

Nachdem Stella McCartney zunächst vier Jahre als Kreativdirektor für Chloé in Paris gearbeitet hatte, gründete sie 2001 ein Modelabel unter ihrem eigenen Namen. 2002 eröffnete ihr Flagship-Store in New York, 2003 folgten London und Los Angeles. Neben höchst erfolgreichen Kollektionen für H&M und Adidas entwarf Stella McCartney auch ebenso extravagante wie exklusive Bühnenkleider für Musikerinnen wie Madonna oder Annie Lennox.

Après avoir travaillé pendant quatre ans comme directrice de la création chez Chloé à Paris, Stella McCartney a fondé en 2001 sa propre marque de mode. En 2002, elle a ouvert son magasin amiral à New York ; Londres et Los Angeles ont suivi en 2003. Outre des collections triomphales pour H&M et Adidas, Stella McCartney a également créé des costumes de scène, aussi extravagants qu'exclusifs, pour des musiciennes telles que Madonna et Annie Lennox.

Después de que trabajara durante cuatro años como directora creativa de Chloé en París, Stella McCartney fundó en 2001 una marca de moda con su propio nombre. En 2002 abría su Flagship Store en Nueva York, a la que siguieron en 2003 Londres y Los Ángeles. Además de sus famosísimas colecciones para H&M y Adidas, Stella McCartney crea vestuario de escenario para cantantes como Madonna y Annie Lennox.

Dopo aver lavorato per quattro anni come direttore creativo per Chloé a Parigi, nel 2001 Stella McCartney ha fondato l'omonimo marchio di moda. Nel 2002 ha aperto il suo flagship store a New York, cui han fatto seguito nel 2003 Londra e Los Angeles. Oltre a disegnare collezioni di grande successo per H&M e Adidas, Stella McCartney ha creato anche costumi di scena, tanto stravaganti quanto esclusivi, per cantanti come Madonna o Annie Lennox.

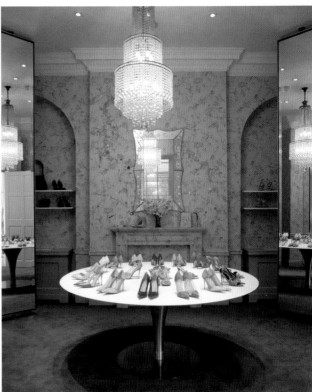

Stella McCartney | Flagship Store | right Autumn/Winter Collection 2006/07

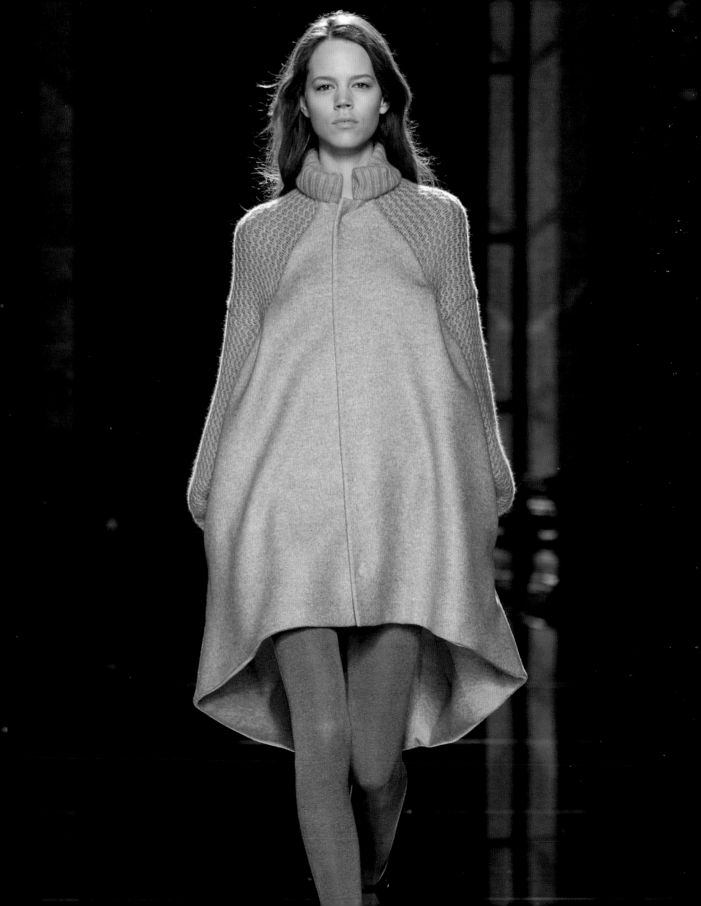

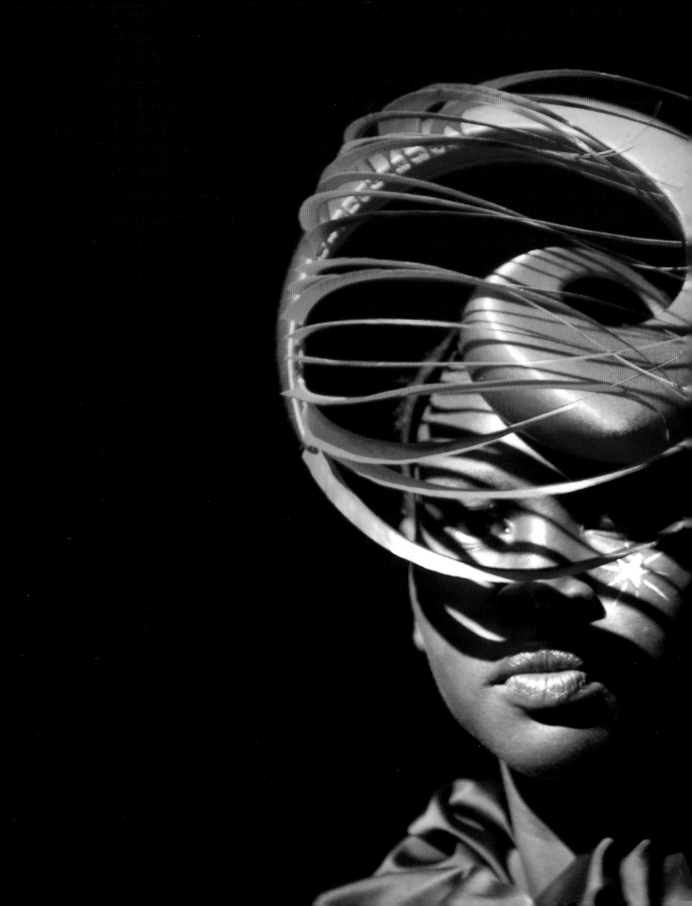

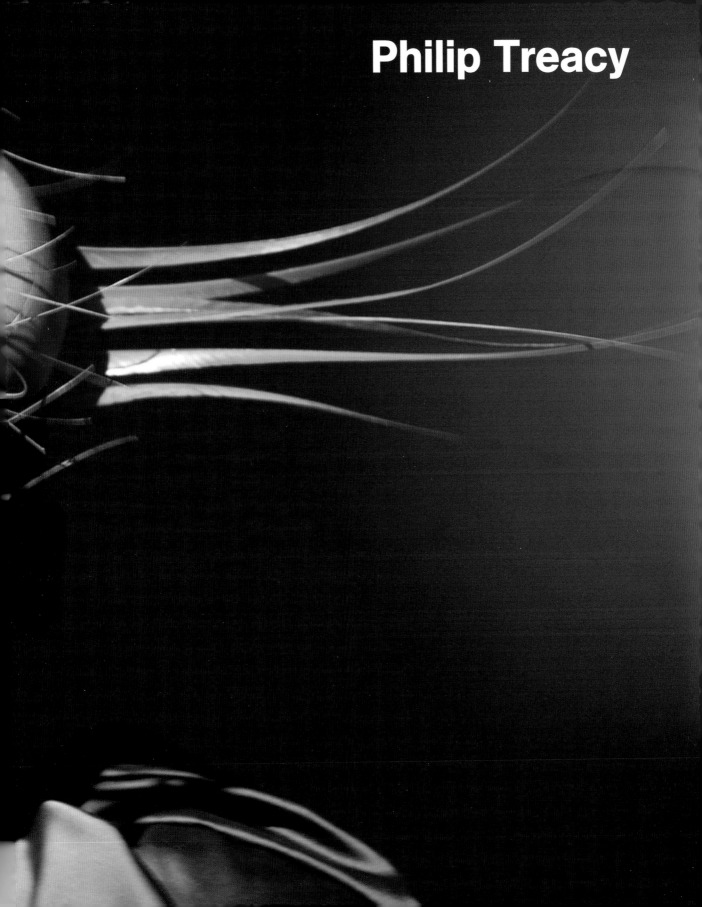

Philip Treacy

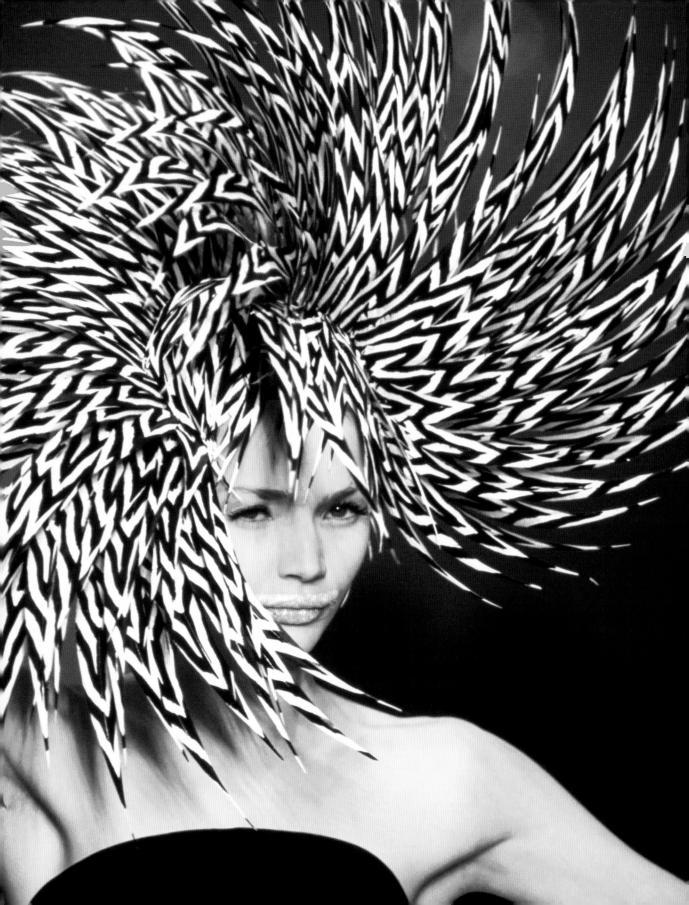

Philip Treacy

Studio, 69 Elizabeth Street, London SW1 W9PJ

P +44 20 7730 3992

F +44 20 7824 8262

www.philiptreacy.co.uk

sales-pr@philiptreacy.co.uk

Philip Treacy

1967
born in Ahascragh,
County Galway, Ireland

1991
showroom and workshop for
couture hats

1993
first fashion show

1994
Elizabeth Street Shop,
Belgravia

Surreal and sculptural: these two words perfectly sum up the extravagant designs by Phillip Treacy. He was born in a tiny village in the west of Ireland, and as a child was already designing clothes and hats for his sisters' dolls. While studying at the Royal College of Art, he decided to specialise in hat design. Thanks in no small part to the enthusiastic support of style icon Isabelle Blow, Treacy soon became a world famous, celebrated star designer.

Surreal und skulptural: Diese Schlagworte beschreiben treffend die extravaganten Entwürfe von Philip Treacy. Geboren in einem kleinen Ort im Westen Irlands, entwarf er schon als Kind Kleider und Hüte für die Puppen seiner Schwester. Während seiner Ausbildung am Royal College of Art spezialisierte er sich schließlich auf Hutdesign. Nicht zuletzt durch die enthusiastische Unterstützung der Stil-Ikone Isabella Blow wurde Treacy innerhalb kürzester Zeit zu einem weltweit bekannten und gefeierten Stardesigner.

Surréel et sculptural : ces mots-clés décrivent parfaitement les extravagants projets de Philip Treacy. Né dans un petit village, à l'ouest de l'Irlande, enfant, il dessinait déjà des vêtements et des chapeaux pour les poupées de sa sœur. Au cours de sa formation au Royal College of Art, il s'est finalement spécialisé dans le design de chapeaux. Entre autres grâce au soutien enthousiaste de l'icône du style Isabella Blow, Treacy est devenu, en très peu de temps, un des designers vedettes, connu et fêté dans le monde entier.

Surrealista y escultural: estos son los términos que describen a la perfección las extravagantes creaciones de Philip Treacy. Nacido en una pequeña población del oeste de Irlanda, ya de niño diseñaba ropa y sombreros para las muñecas de su hermana. Durante su formación en el Royal College of Art se especializó exclusivamente en el diseño de sombreros. En muy poco tiempo y en parte gracias al apoyo del icono del estilo, Isabella Blow, Treacy se convirtió en un diseñador estrella celebrado en todo el mundo.

Surreale e sculturale: sono queste le parole d'ordine capaci di descrivere in maniera appropriata le stravaganti creazioni di Philip Treacy. Nato in una piccola località dell'Irlanda occidentale, già da bambino si dedicava alla creazione di vestiti e cappellini per le bambole della sorella. Durante i suoi studi al Royal College of Art, infine, si specializzò in design di cappelli. Soprattutto grazie al sostegno entusiasta ricevuto dalla regina della moda londinese, Isabella Blow, Treacy è divenuto in brevissimo tempo un divo del design, apprezzato ed acclamato in tutto il mondo.

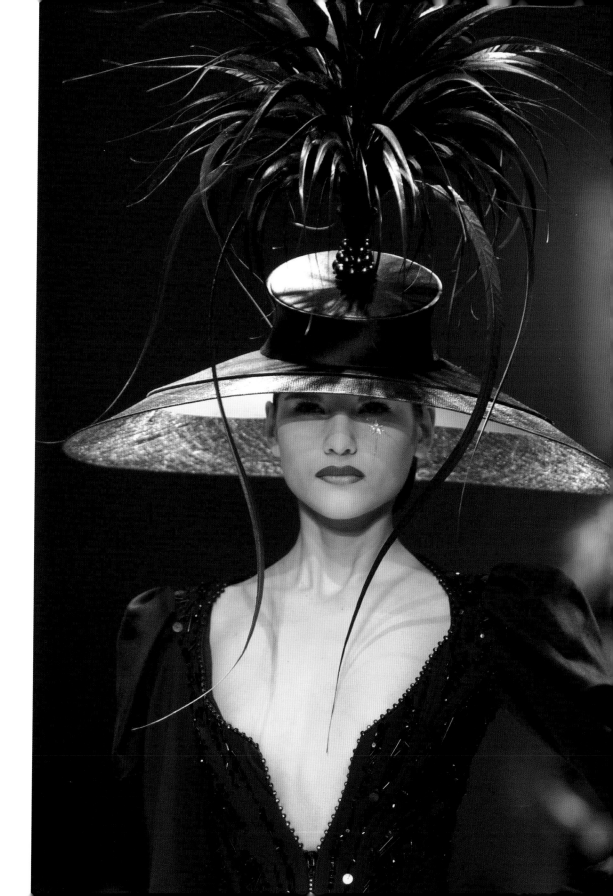

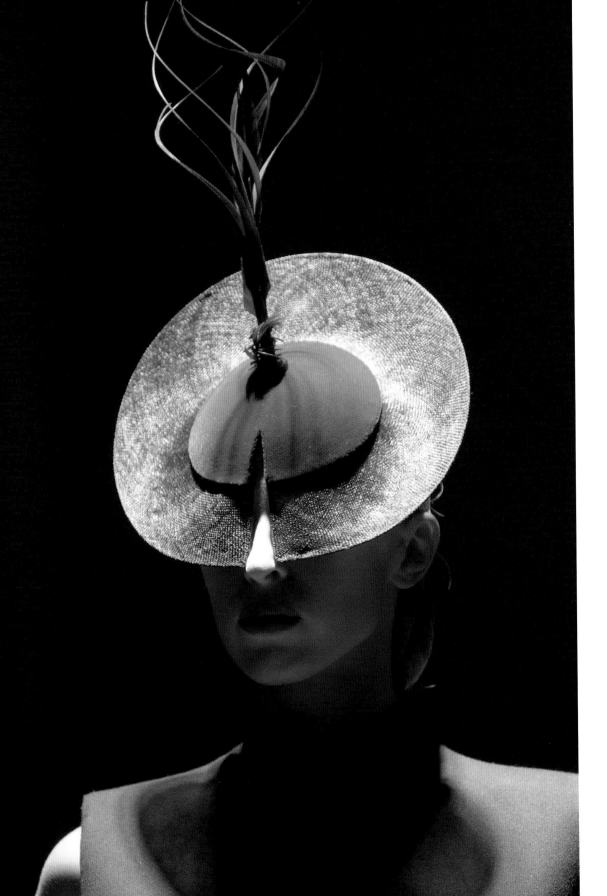

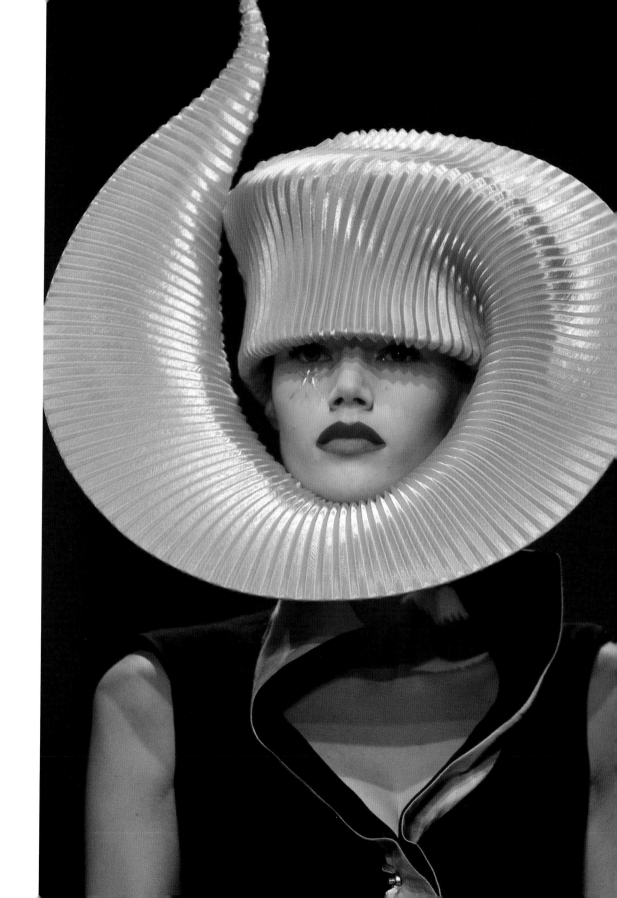

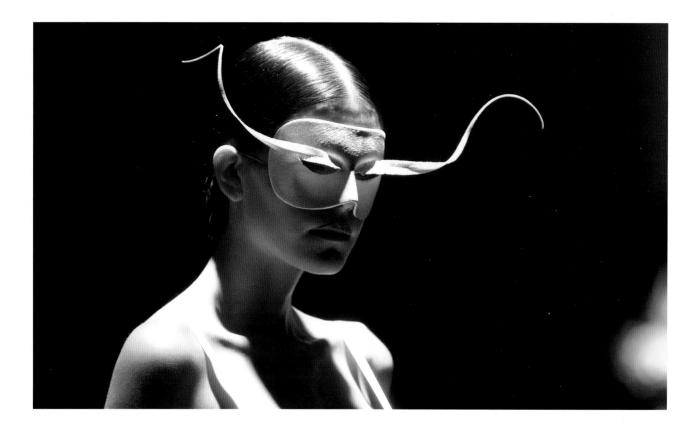

"I would like to see people still being enchanted by hats in the 21st century", is one of Philip Treacy's wishes. And there is no doubt at all he will manage that, as is evident from his creations for clients as diverse as Queen Elizabeth, Grace Jones and Naomi Campbell.

„Ich möchte dafür sorgen, dass Hüte die Menschen auch im 21. Jahrhundert noch begeistern", wünscht sich Philip Treacy. Durch seine extravaganten Kreationen für so unterschiedliche Kundinnen wie die englische Königin, Grace Jones oder Naomi Campbell gelingt ihm das mit Sicherheit.

« Je voudrais faire en sorte que les gens continuent de trouver attrayants les chapeaux au 21ème siècle » : tel est le souhait de Philip Treacy. Avec ses créations extravagantes pour des clientes aussi différentes que la reine d'Angleterre, Grace Jones ou Naomi Campbell, il y parviendra assurément.

"Quiero encargarme de que también en el siglo XXI las personas se sigan sintiendo atraídas por los sombreros"; éste es el deseo de Philip Treacy. Y sin duda lo ha conseguido a través de sus extravagantes creaciones, que fascinan a clientas muy diferentes como la Reina de Inglaterra, Grace Jones o Naomi Campbell.

"Vorrei far sì che anche nel XXI secolo i cappelli continuino ad affascinare le persone" – questo si augura Philip Treacy. E di certo ci riuscirà, con le sue stravaganti creazioni pensate per clienti tanto differenti tra loro come la regina d'Inghilterra, Grace Jones o Naomi Campbell.

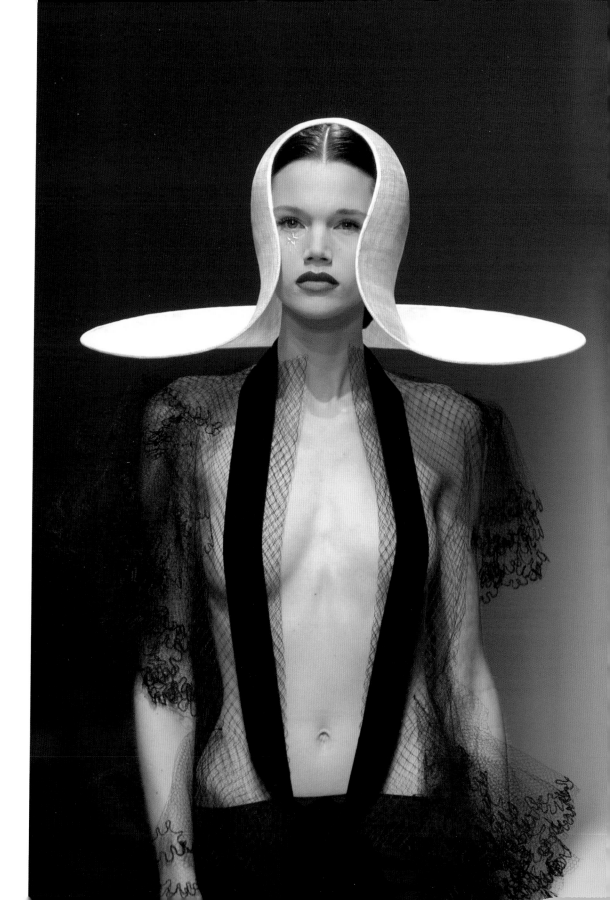

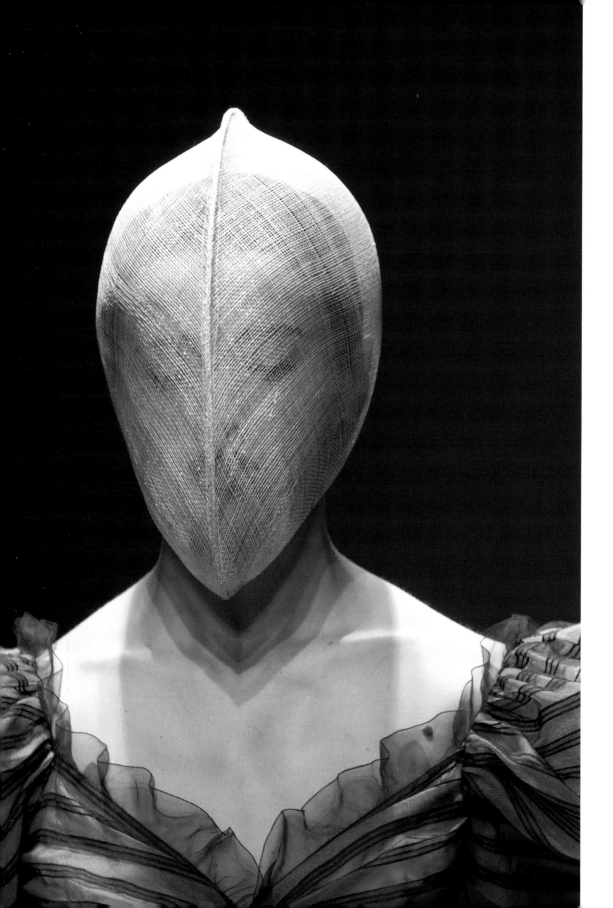

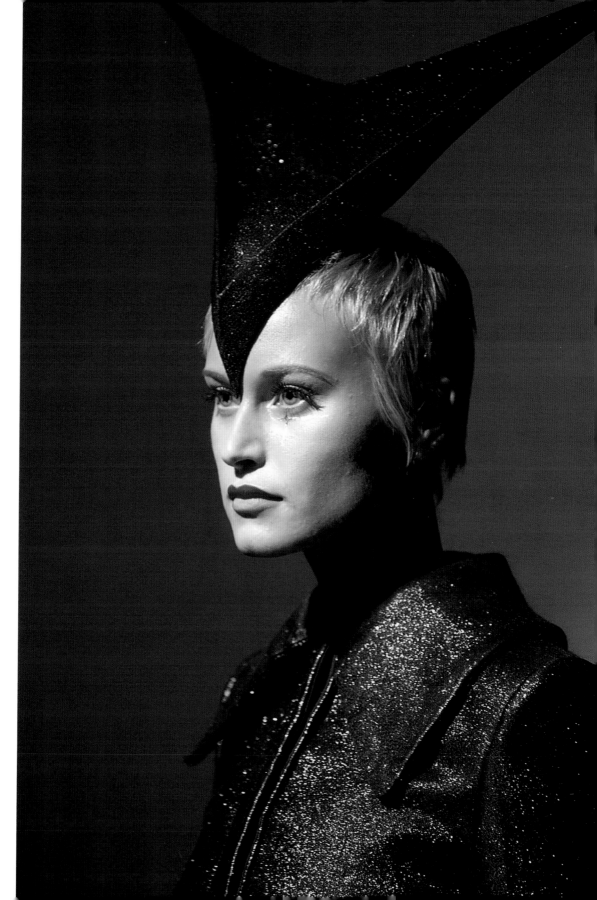

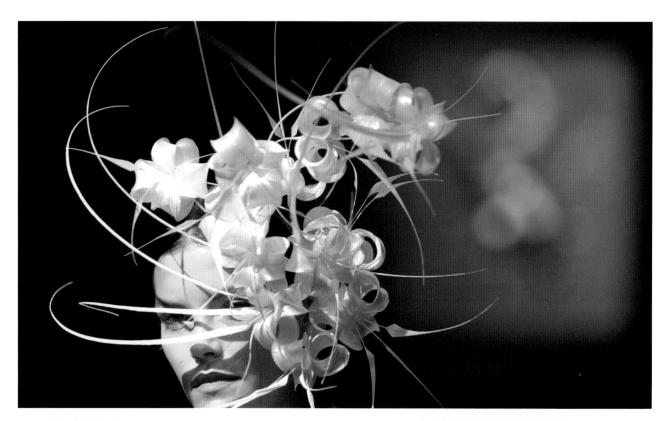

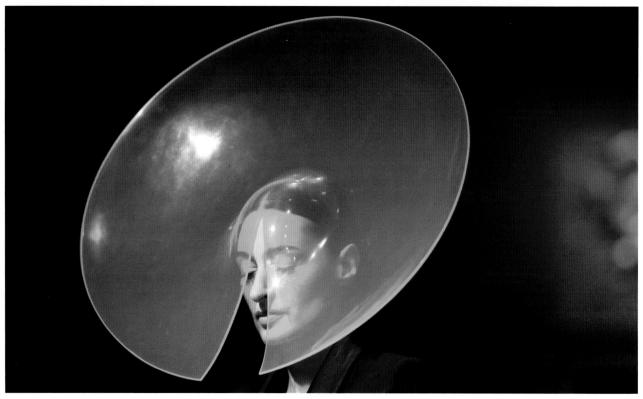

Philip Treacy | Hat Collection 2006

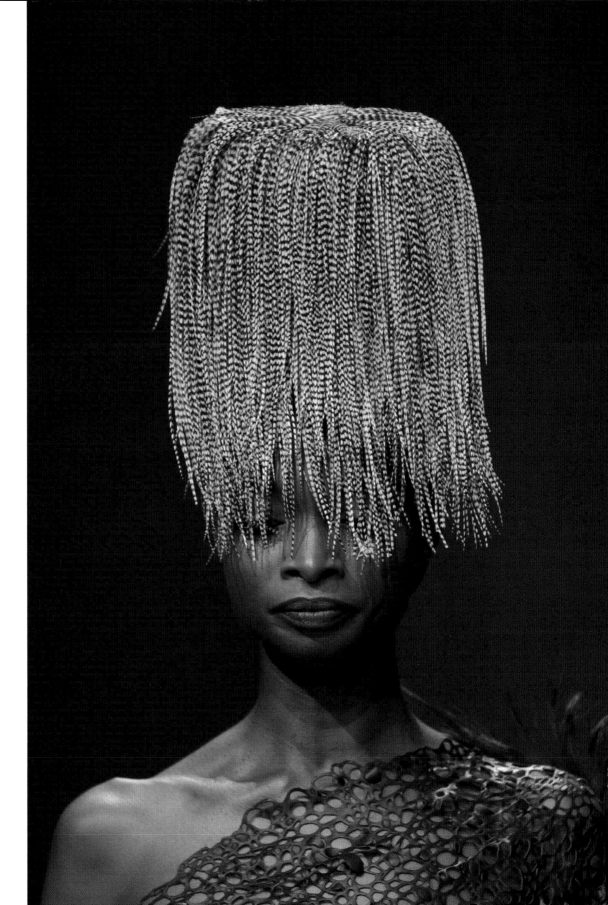

Photo Credits

Architecture

Adjaye/Associates
Steven Heller 21
Lyndon Douglas 16 left, 18-20, 22-31

Alsop Architects
Morley von Sternberg 16 centre left, 32/33, 37-45
Alan Lai (Alsop Architects) 34, 51, 52, 54 top, 55
Roderick Coyne (Alsop Architects) 36, 46-50, 53, 54 bottom
Alsop Architects 35

Stephen Davy Peter Smith
Zanda Olsen 56/57
Hélène Binet 58
Andrew Lamb / Savon Ltd. 59
Stephen Davy Peter Smith 60, 61
Nick Hofton / Hofton & Crow 66, 67
Lyndon Douglas 62-65

drmm
Alex de Rijke 68-72, 73 right
Michael Mack 73 left

FAT
Fat Ltd. 16 right, 74-79

Foster and Partners
Nigel Young (Foster and Partners) 16 centre right, 80-97

Tony Fretton Architects
Hélène Binet 98-100, 102, 103
John Balsom 101

Haworth Tompkins
Philip Vile 17, 104-106, 108, 110, 111
Andy Chopping 107
Haworth Tompkins 109

Hopkins Architects
Paul Tyagi 112-114, 116, 121
Tom Miller 115
Richard Davies 117, 119

Lifschutz Davidson Sandilands
LDS 122-124, 125-127 (CGI: Hayes Davidson)

Henning Stummel Architects
Luke Caulfield 128-135

Interior Design

blockarchitecture
Leon Chew 138-140, 142-145
Mark Cremer 141

DAAM
Richard Glover 146-148
Mark Mercer 150-153
DAAM 149

JESTICO + WHILES
James Morris 136 centre right, 154/155, 160-163
JESTICO + WHILES 156-159, 164-167

Pentagram
Ed Reeve 136 centre left, 168-170, 172-177
Phil Sayer 171

Project Orange
Peter Grant 178/179, 184-187
Gareth Gardner 136 right, 180, 182, 183, 188-199
Project Orange 181

Softroom
Joseph Burns 200-202, 218, 219
Richard Davies 137, 204-217
Softroom 203

United Designers
Edmund Sumner 220/221, 224-229, 231
United Designers 222, 223
Chris Gascoigne 230

Universal Design Studio
Universal Design Studio 136 left, 236, 237, 240, 241
Simon Phipps 232-234, 238, 239, 248
Edward Baber 235

Helen Yardley
Helen Yardley 242-251